Masterpieces of
WESTERN
AMERICAN ART

WESTERN AMERICAN ART

J. Gray Sweeney

CRESCENT BOOKS
New York • Avenel

Copyright © 1991 by M&M Books
All rights reserved under International and Pan-American
Copyright Conventions.

No part of this book may be reproduced or transmitted in any
form or by any means electronic or mechanical including photo-
copying, recording, or by any information storage and retrieval
system, without permission in writing from the publisher.

This 1996 edition is published by Crescent Books,
a division of Random House Value Publishing, Inc.,
40 Engelhard Avenue, Avenel, New Jersey 07001.

Crescent Books and colophon are trademarks
of Random House Value Publishing, Inc.

Random House
New York • Toronto • London • Sydney • Auckland
http://www.randomhouse.com/

Printed and bound in China

A CIP catalog record for this book is
available from the Library of Congress.

(Previous pages) Albert Bierstadt, *Last of the Buffalo*

Measurements of the paintings are in inches, height before width.

All photographs are courtesy of their respective museums and
owners, except for the following: page 66, photo by Stan Wan;
page 78, Buffalo Bill Historical Center; pages 82, 114, 167, 173,
Cecile Keefe; page 142, Rosenthal Art Slides; and page 168,
Robert C. Jenks, Jenks Studio. The photograph on page 54 is by
the National Geographic Society. The photograph on page 71 is
Smithsonian Institution Photo No. 71-3048. The photograph on
page 105 is by David Bohl.

ISBN 0-517-18493-1

8 7 6 5 4 3 2 1

CONTENTS

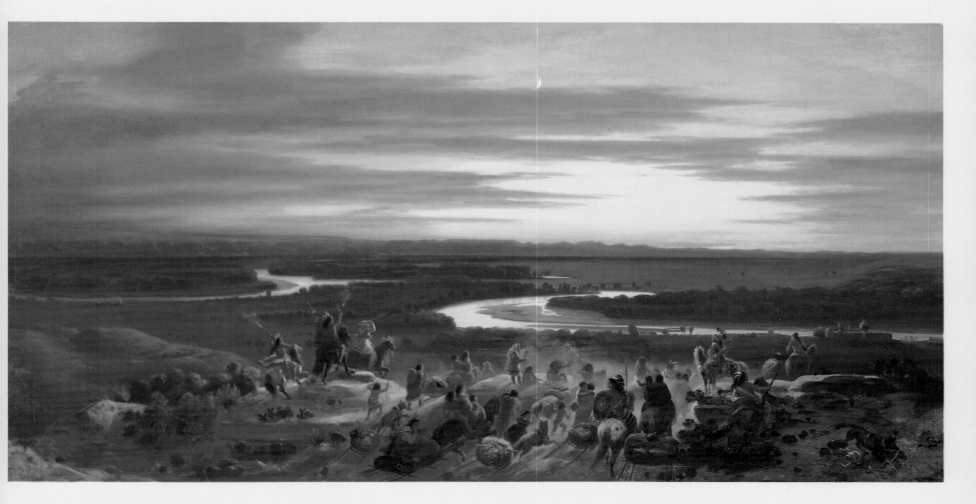

Introduction:

The West as Image and Myth

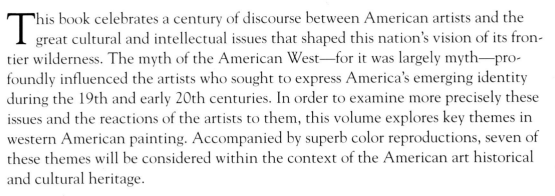

This book celebrates a century of discourse between American artists and the great cultural and intellectual issues that shaped this nation's vision of its frontier wilderness. The myth of the American West—for it was largely myth—profoundly influenced the artists who sought to express America's emerging identity during the 19th and early 20th centuries. In order to examine more precisely these issues and the reactions of the artists to them, this volume explores key themes in western American painting. Accompanied by superb color reproductions, seven of these themes will be considered within the context of the American art historical and cultural heritage.

The history of western American art has been written many times. Indeed no single volume could capture the astonishing richness of subjects and images that comprise this aspect of American painting. Numerous monographs on individual artists, notably George Catlin, George Caleb Bingham, Frederic Remington, and Charles M. Russell, have appeared during the last decade alone; the quantity of scholarly investigations of particular artists, issues, and approaches to the subject is nearly overwhelming. Presented with the works reproduced here are some of the provocative results of this recent scholarship, which will provide readers with a strong sense of the new views of western art that have emerged in the past decade, thanks to a new generation of historians.

It should be recognized at the outset that since the Bicentennial of 1976, the traditional account of western history has been completely revised. New readings of the nation's intellectual, political, economic, and social history have helped illuminate the historical and cultural context in which images of the West were created. At the same time, art historians have begun to ask new and sometimes difficult questions about the meaning of western art. Although this volume has been written in this spirit of revisionism for a popular audience, it attempts to address some of the complex questions raised by a serious reinterpretation of western American painting.

To the popular mind, the old West is often seen as a romantic place peopled with easily identifiable heroes and easily identifiable villains, with pioneers and settlers who were unfailingly good and with Indians who were invariably bad. This stereotypical concept first emerged in American painting and popular literature during the 19th century, reached its zenith in the cowboy art that first began to appear in the mid-19th century and flourished at century's end in the works of Frederic Remington and Charles M. Russell, and has been perpetuated in recent decades by Hollywood. It remains today a nearly permanent feature of the American imagination.

Recent scholarly studies have revealed that beneath the idealized images of the cowboy and the romantic depictions of the noble Indian, underlying even the sublime images of the wilderness painted by Albert Bierstadt and Thomas Moran, were serious issues of nationalism, colonial expansion, racism, and the cultural stereotyping of Indians, women, and men. These issues had a powerful impact on the way artists represented the events and personalities of the period. Nostalgia and idealization, two extremely potent ingredients for many artists picturing life in the West for a largely eastern audience, retained much of their currency through the early decades of the present century.

From the time of the new nation's birth, artists felt a need to fashion glorious images of the European–American civilization that was expanding westward. These images were often created in response to the impassioned appeals of politicians

The Coming of the White Man
JOSHUA SHAW

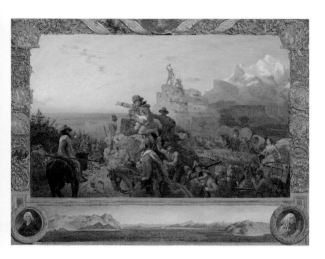

Westward the Course of Empire Takes Its Way
EMANUEL GOTTLIEB LEUTZE

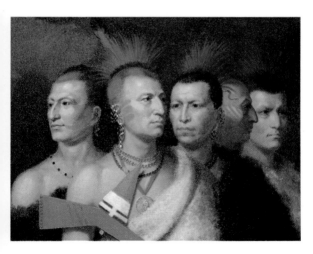

*Young Omahaw, War Eagle,
Little Missouri, and Pawnees*
CHARLES BIRD KING

from Thomas Jefferson to Theodore Roosevelt as they called upon their country-men to fill the empty spaces on the map of the continent with a new democratic and entrepreneurial civilization. Through the 19th century, painted images of early explorers—from Columbus, Ponce de Leon, and the Pilgrim fathers to the French *voyageurs*, fur trappers, and the pathfinder Daniel Boone—gave impetus to those Americans who looked to visual imagery to motivate or justify their westward migrations. The compelling dream of a better and more prosperous life in the West persuaded thousands of settlers to uproot, leave their families and homes, and move west. The first chapter of this volume presents a selection of images that reveal the power of this myth in directing American migration during the last century.

Around the middle of the 19th century Americans acted as though they actually believed that progress was God. The immensely powerful doctrine known as mani-fest destiny, that is, the belief that America was divinely ordained to create an empire stretching from the Atlantic to the Pacific and from Canada to Mexico, provided intellectual justification and emotional stimulus for millions of Americans seeking to emigrate west. "Westward the course of empire takes its way!" "Go West young man! Go West!" These were the rallying cries of the period. The discovery of gold in California in 1848 and the prospect of vast agricultural lands in the far West further excited the popular imagination. This continent that Americans were determined to conquer and unite was—or so it seemed—a land of wealth and con-tentment. The reality of westward migration, however, was another matter, for access to the riches of the West presented many hazards. For thousands who made the overland journey by wagon train or on foot in the 1840s and 1850s the way was long and difficult. It took months to trek from the traditional jumping-off point in Independence, Missouri, to the "promised lands" of California and Oregon, and many died along the way. Then, in 1869, the longstanding national ambition to construct a transcontinental railroad from New York to San Francisco was finally realized. Not only did this technological wonder dramatically speed the passage of settlers traveling west, it also created a great thoroughfare for commerce, marking the symbolic fulfillment of Columbus' dream of going west to reach the riches of the East. Through numerous idealized and heroic images, some of which appear in the second chapter of this volume, painters helped promote the ideology that stim-ulated America to conquer new lands.

One of the most significant problems confronting those who favored unlimited westward expansion was the presence of the Native Americans. Two distinct atti-tudes toward the indigenous population emerged very early in the period: one held that the Indian was a noble figure, worthy of respect and preservation; the other, that the Native American was an impediment to progress and needed to be elimi-nated. Individual artists responded to both ideas. There were even those, like George Catlin, John Mix Stanley, and others, who created theater-like entertain-ments to accompany exhibitions of their works in their immensely popular Indian galleries. Some artists merely sought to capitalize on the popular fascination with the exotic Native American, but others, Catlin and Karl Bodmer for example, made careful studies of the rapidly disappearing tribes. Their interest in the culture and ethnography of the Indian, however, failed to offset the common belief that the Native American was an adversary who had to be removed. At the same time, many artists, ambivalent about the Indian's demise, experienced profound regret and nostalgia over the loss of the native cultures. These sentiments were most effectively captured in paintings based on the legend of Hiawatha and in the work of Henry Farny.

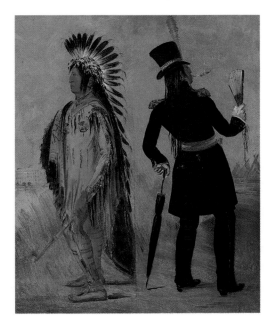

*Pigeon's Egg Head (The Light) Going to
and Returning from Washington*
GEORGE CATLIN

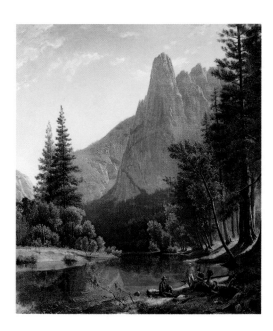

On the Mariposa Trail
VIRGIL WILLIAMS

In one of the most important recent studies of the West, scholar Richard Slotkin documented in memorable detail the dominant attitude toward Native Americans that emerged after the Revolutionary War and colored the politics and cultural values of the day. Essentially this viewpoint held that the Indian was wanting in culture, in morals, and ultimately in race and therefore, in order for the new American empire to flourish and take full control of the continent, the Indian had to be destroyed. This ideology produced what Slotkin termed "the fatal environment" with its tragic consequences for Indian civilization. The all too common phrase "the only good Indian is a dead Indian" echoed with devastating consequences from the highest echelons of government to the most remote frontier outposts. Other recent studies by Reginald Horsman and Roy Harvey Pearce have illuminated the cultural connections between such racist attitudes and the burning issue of African-American slavery and their effect on the all too fragile union of the new nation.

The theme of race as it pertained to the Native Americans provided artists with a broad range of subject matter. It manifested itself in images that showed Indians abducting and sexually molesting white women, Indians attacking settlers in wagon trains and on railroads, and Indians battling the U. S. army. Not only did the stereotype of the hostile and dangerous Indian provide artists with a wide variety of subjects to paint, it also gave those with an eye on their bankrolls a lucrative theme to exploit. Artists, no less than politicians, found that one relatively easy path to success lay in portraying the Native American as heinous. So prevalent were pictures of the savage Indian during the 19th century that the myth persisted well into the 20th century, where it was picked up and embellished by Hollywood. The third and fourth chapters of this volume survey contrasting images of the Native American—the noble Indian and the savage Indian—and the transformation of the conflict of cultures into art.

Another theme in the history of western American painting arose early in the 19th century when artists of the Hudson River School discovered the scenic potential of the Catskills and Niagara Falls. But it was not until the 1860s that a second generation of painters like Albert Bierstadt and Thomas Moran traveled beyond the Mississippi in search of inspiration. By the 1870s, with the completion of the transcontinental railroad, the West was opened for tourism, and the artists' paintings of remote wilderness settings, like the Yosemite Valley of California, the Yellowstone region, and the Grand Canyon in Arizona, were welcomed by easterners eager to know more of the nation's sublime West. Influenced in part by artists' visions, Congress established the first national parks to preserve the natural beauty of these unique landscapes for future generations. At the same time that artists helped countless Americans see the landscapes of the West as potentially valuable real estate, as will be discussed in the fifth chapter, they also saw in the frontier lands spiritual values worth preserving. Their paintings were testaments to national pride in the region's scenic grandeur.

Around the turn of the century, with the immensely popular works of Frederic Remington in particular, the cowboy emerged as a potent new protagonist in the western myth—an unconstrained figure riding into a golden sunset, the ideal embodiment of masculine virtue and freedom. While the romantic vision of the mythic cowboy was pervasive, recent scholarly studies by Lonn Taylor and others have shown that it was an enormous feast on little food. The reality of the cowpuncher's life was hardly romantic, consisting primarily of unending hard work and low pay. Moreover, while most "canvas" cowboys were white, the flesh and blood

*Hahn Pulled His Gun and Shot Him
Through the Middle*
NEWELL CONVERS WYETH

Pueblo of Taos
VICTOR HIGGINS

variety were more often Hispanic, African-American, or of mixed race. If the cowboy of myth has lived on to the present day, the era of the real cowboy was relatively brief. It began in the 1870s as a result of the mass appetite for processed beef in the growing eastern cities, the development of refrigerated railroad cars to bring the product to market, and the intensive centralization and capitalization of the meat processing industry. The heyday of the cowboy ended around 1900 when the introduction of barbed wire fences, the closing of the great expanses of government lands to free grazing, and, most of all, the expansion of the railroads into the West brought an end to the long cattle drives.

The cowboy was further enshrined as a symbol of the easy freedom of western life, thanks to the enormously popular Wild West Shows of Buffalo Bill. At the same time, another symbol of freedom of the western plains with which William Frederick Cody had been associated—the American bison—was emerging as a mythic figure in its own right. Ironically, the buffalo became a powerful symbol, like the cowboy, of all that the West had come to mean in the American imagination, at the moment that both man and beast were passing from the stage of national history. The sixth chapter of this book will consider the cowboy and the buffalo and their significance as prime symbols in the western myth.

The final theme explored in this volume began with the dawning of the 20th century. Flooded by European immigrants with little connection to the history and ideologies that inspired earlier westward migrations, the nation was transformed from its frontier origins to become an urban and industrial society. It was not a coincidence that artists of this era discovered the "Land of Enchantment," New Mexico, where remnants of a simpler way of life persisted in the cultures of the Pueblo Indians and the Hispanic-Americans. Painters from the East and Midwest who settled in the ancient villages of Taos and Santa Fe were infatuated with primitivism and cultural relativism, which had great appeal for a modern American civilization. In capturing on canvas what they saw—and to a large degree what they imagined— some of these artists continued to practice a conventional academic style of painting, while a few, most notably Georgia O'Keeffe and Ernest Blumenschein, brought the formal innovations of avant-garde modernism to their western subjects. The artists' diverse responses to New Mexico are evident in the works reproduced in the seventh chapter.

Today, more than a century after the census and historian Frederick Jackson Turner officially declared the frontier closed, interest in the myth of the West is at a new peak. Recently, scores of publications and exhibitions and several films and television shows have attested to the enormous popular fascination with this perennial feature of our national heritage. Many scholars and curators are seeking anew the true meaning of western art and the often obscure motives behind its production and consumption. As is invariably the case with any large and potentially controversial area of study, each generation unearths, in its investigation, a reflection of the cultural, social, and intellectual concerns of its own period.

The paintings reproduced in this volume are intended to stimulate such a renewal of interest in the art of the American West. It is hoped that the accompanying commentaries will propose fruitful ways of viewing the paintings, both as significant works of art and as complex artifacts reflecting the great cultural and political questions of their time. These paintings are objects worthy of thoughtful inquiry because they speak of the values and issues that continue to be central to the American experience.

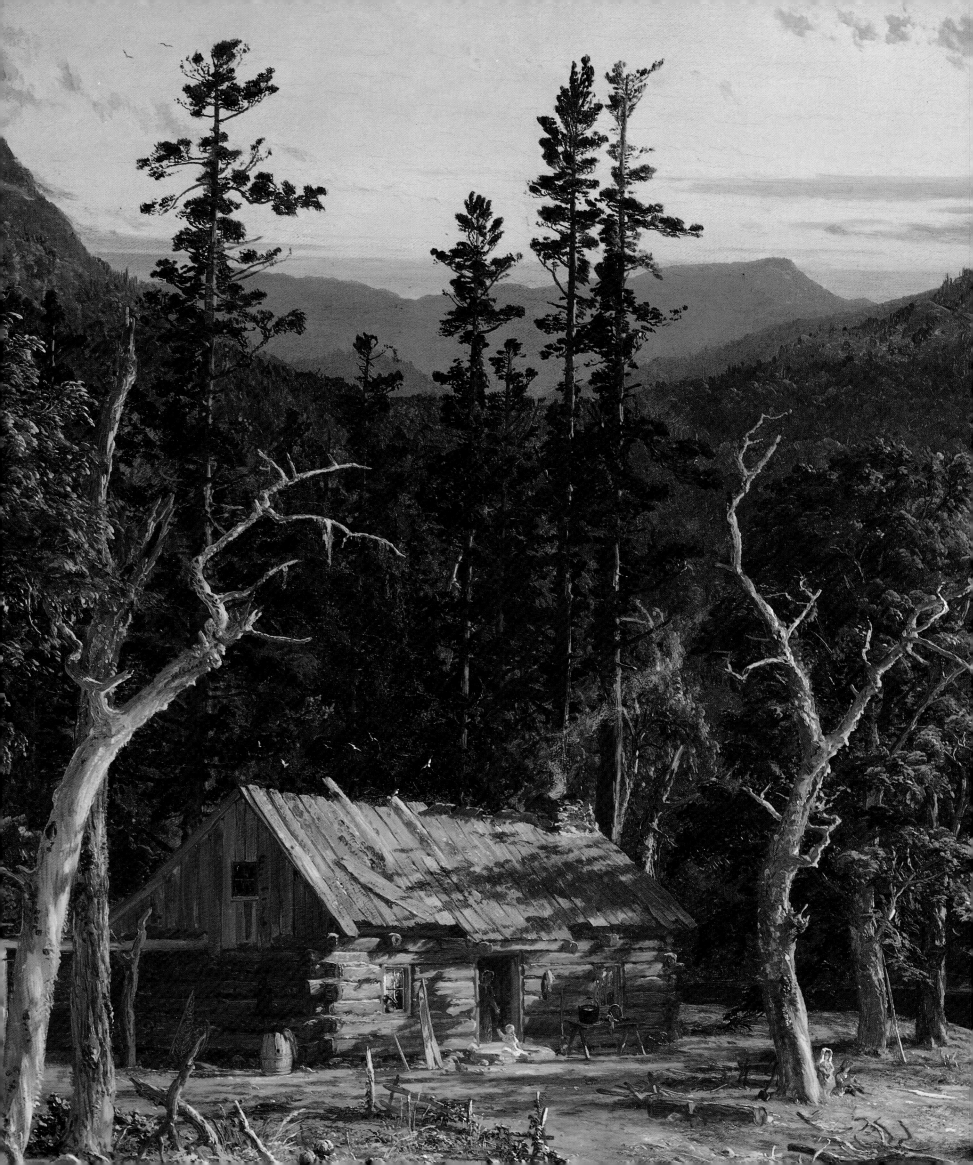

Claiming and Settling the Wilderness

Claiming and Settling the Wilderness

Paintings that idealized the claiming and settling of the wilderness played a crucial role in forging the myth of the American West. These works depicted a young nation engaged in a lofty mission of civilization justified by its enterprising nature and by its self-proclaimed technological, cultural, and religious superiority over the indigenous population. With the European conquest of the New World portrayed as nothing less than an historical inevitability, it is ironic that according to 20th-century historians, Christopher Columbus' discovery of America was actually unintentional. The explorer had been searching for a route to the riches of China and had stumbled on America by mistake—without even realizing it. As a further irony, he misnamed the Native Americans of the Caribbean Islands *los Indios*, taking them to be the people of the East Indies.

Throughout history artists in their work have commonly reflected the dominant cultural values and aspirations of their times. So it was in 19th-century America. The painter was not a social critic but simply one who labored loyally to validate the imperial aspirations of the expanding nation. Bierstadt, Shaw, Moran, Remington, and Keith were among those whose images confirmed and even strengthened the popular resolve to establish a transcontinental empire stretching from the Atlantic to the Pacific.

Like most of their countrymen, these artists believed that the great events of their time had been foreshadowed by the legendary New World exploits of Spanish, French, and English explorers from 1492 onward. They also believed that the events of their own time—for example, the glorious national rush to realize Columbus' dream of reaching the riches of the East by going westward—foreshadowed even greater achievements in the future. This concept was called "typology," and writers and artists used it boldly to assert that America's destiny, rooted in the past and forged in the present, *was* the future. Thus, as we shall see, when Frederic Edwin Church depicted Reverend Hooker and his company of brave Puritans trekking through the wilderness in 1636 to establish Hartford, Connecticut, he was endeavoring to inspire his contemporaries in the 1840s and 1850s to fulfill America's self-proclaimed historical destiny.

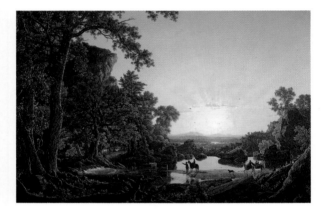

Hooker and Company Journeying Through the Wilderness from Plymouth to Hartford, in 1636
FREDERIC EDWIN CHURCH

A Home in the Wilderness
SANFORD ROBINSON GIFFORD

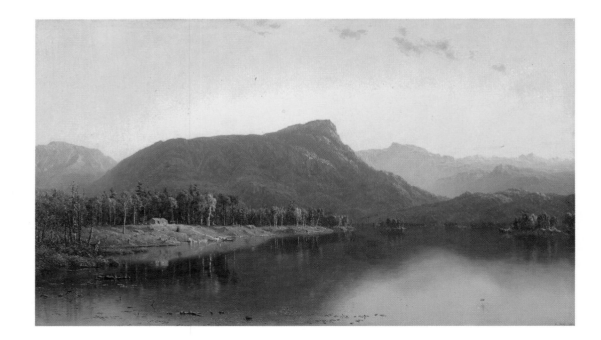

◀◀
The Backwoods of America (detail)
JASPER F. CROPSEY

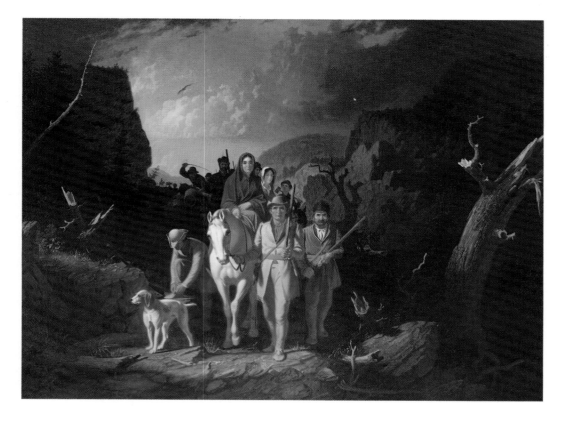

Daniel Boone Escorting a Band of Settlers Through the Cumberland Gap
GEORGE CALEB BINGHAM

By the middle of the 19th century, American artists had begun to create figures of heroic dimensions in order to affirm and amplify America's divinely sanctioned place in the drama of Christian history. Among those so glorified were the early fur traders and trappers and the half-wild, half-civilized mountain men, forerunners of the cowboys who would themselves be "heroicized" later in the century. But the unquestionable arch-hero of western expansion was "the pathfinder," Daniel Boone. By the middle of the century he had achieved mythic proportions. Perhaps no painting more typified this attitude than George Caleb Bingham's *Daniel Boone Escorting a Band of Settlers Through the Cumberlaned Gap*, in which the Kentucky pioneer was seen as the quintessential settler moving west, an American Moses leading his "chosen" people to the promised land.

Also at midcentury, the Hudson River School artists Thomas Cole and Jasper Cropsey created works that celebrated the yeoman frontier farmer. The man of the soil was seen as happy and virtuous, the backbone of an emerging nation of independent farmers carving homesteads out of the wilderness. Only a few very intellectually sophisticated artists, such as Sanford Gifford, created pictures like *A Home in the Wilderness* and *Hunter Mountain, Twilight* that subtly questioned the idealization in Cole and Cropsey's sylvan views of frontier life.

As romantic fantasy, artists' images of well-tended, seemingly prosperous frontier farms, like their images of explorers and pioneers on the trail, were irresistible; many uprooted themselves and moved westward as a consequence. In a seminal study entitled *The Virgin Land: The American West as Symbol and Myth*, historian Henry Nash Smith concluded that the dream of the western wilderness transformed into a fertile garden by the yeoman farmer was an extremely powerful force in the American experience. In the backwoods of the nation, a mythic drama of expansion was being enacted, predicated upon the vision of the West as the future home of an agrarian society. With the passage of time, however, a fundamentally urban and industrial civilization emerged and the dream of the western garden lost its power. "But the image of an agricultural paradise in the West," Smith wrote, "embodying group memories of an earlier, a simpler, and it was believed, a happier state of society long survived as a force in American thought and politics."

Columbus Landing in San Salvador

ALBERT BIERSTADT, 1830–1902

1893. Oil on canvas, 80 × 120 in.
The City of Plainfield, New Jersey, Cultural and
Heritage Commission.

The World's Columbian Exposition, held in Chicago in 1893, celebrated American achievement in the 400 years since Christopher Columbus' discovery of the New World. To commemorate the event that gave rise to the fair—and perhaps to bolster his sagging popularity—Albert Bierstadt created a monumental canvas depicting Columbus' arrival in the Americas. But the work was not exhibited at the fair; the artist withdrew the picture, perceiving a bias on the part of the selection committee in favor of younger artists.

This grand painting, rich in mythic imagery, treats Columbus' landing on the Caribbean island of San Salvador like the arrival of a white god. The carefully manipulated setting features a cathedral-like canopy of trees and palms that frames the scene, carrying the viewer's eye from the shadowy foreground to the brilliant light on the distant beach and turquoise sea. On the shore, Columbus and his men, with exaggerated, theatrical gestures, raise the sword, a symbol of military conquest, and the cross, a symbol of religious authority. In the distance, crosses on the sails of the three ships further suggest the Christian nature of the venture that brought European civilization to the New World. Greeting the conquerors is a group of Indians, genuflecting and offering gifts of melons and gourds. At left are other gifts, including a sea turtle, shells, and fruit, and overhead, coconut palms suggest the Eden-like bounty of the land.

The image of Native Americans willingly submitting to the Europeans no doubt offered Bierstadt's audience a satisfying sense of reassurance. After all, it had been only three years since the battle of Wounded Knee brought an end to the Indian Wars and even less time since the historian Frederick Jackson Turner had declared the American frontier closed. Furthermore, in depicting the first white claim to the Caribbean, the painting anticipated a time when the expanding American nation might include some, if not all, of the West Indian islands discovered by Columbus. As it happened, only five years passed between the completion of this work and America's occupation of Cuba and Puerto Rico during the Spanish-American War.

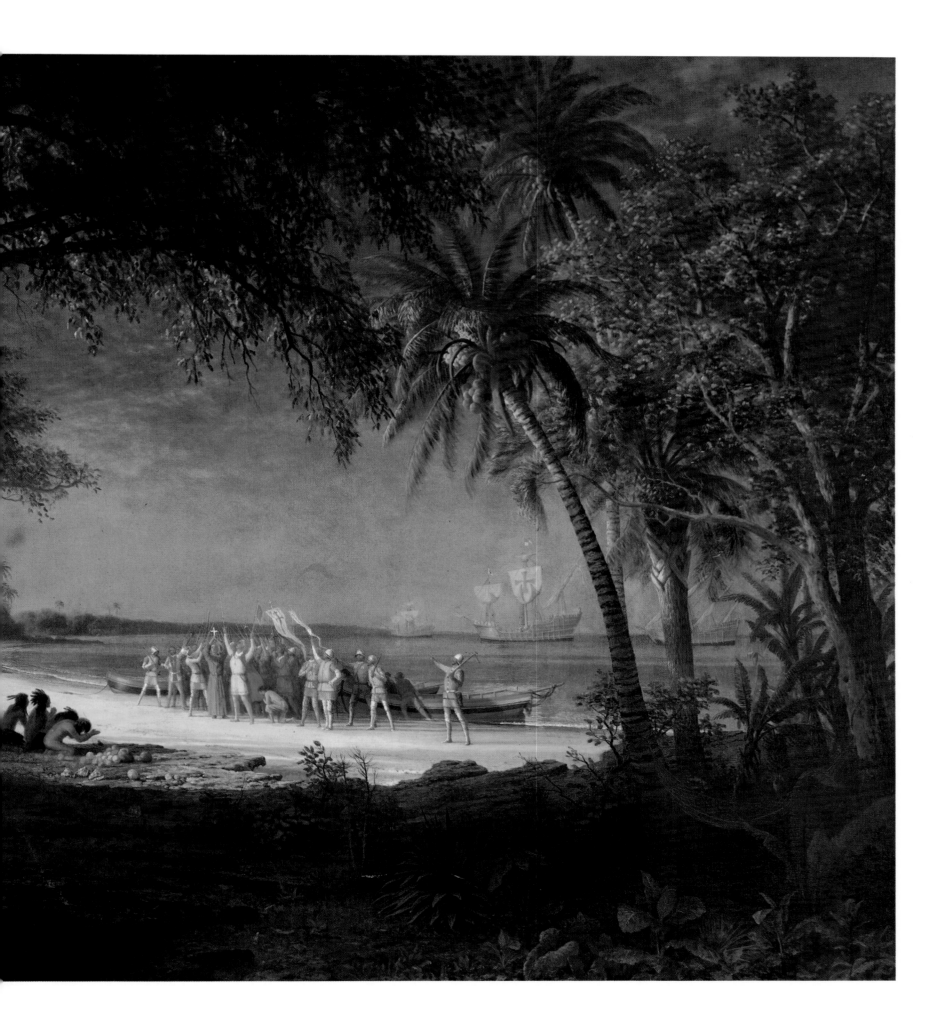

The Coming of the White Man

JOSHUA SHAW, 1776 or 1777–1860

1850. Oil on canvas, 25¼ × 36⅜ in.
The Elisabeth Waldo-Dentzel Collection, Northridge, California.

The Coming of the White Man by Joshua Shaw was created to appeal to the mid-19th century market for images that showed Indians submitting to the white man's power. Like the Native Americans in Bierstadt's *Columbus Landing in San Salvador*, painted over 40 years later (pages 14–15), Shaw's Indians kneel on the shoreline in attitudes of submission as a European ship appears on the horizon. The Native Americans are rendered like works of neoclassical sculpture, but unlike Bierstadt's figures, they are virtually faceless. Their bodily expressions betray their fear at the appearance of the European sailing ship, and their primitive stone weapons, in marked contrast to the swords and muskets of the conquistadors, suggest that such apprehension is well-founded. A bloody scalp in the foreground to the right of the figures reminds Shaw's viewers that Native Americans considered the taking of human scalps as natural and lawful behavior and that it would require European civilization to deliver them from such primitive customs. The belief in the divinely inspired mission of the European conquerors is underscored by the golden light that permeates the scene and by the flock of birds—suggestions of heavenly harbingers—approaching the land.

The English-born Shaw was persuaded to emigrate to the United States by Benjamin West, a prominent American expatriate artist living in London. Arriving in America in 1817, he settled in Philadelphia where he established a reputation as one of the nation's first landscape painters. He frequently depicted the arrival of the first white explorers in the New World. Perhaps the work reproduced here was based on John G. Chapman's painting of Columbus' voyage, *The First Ship*, which was exhibited at the National Academy of Design in 1837.[1] Or it may allude to the explorations of Giovanni Verrazano, a Florentine navigator who in 1524 explored the coast of North America from Cape Fear, North Carolina, to Cape Breton, Nova Scotia. If the latter, it is likely that Shaw drew inspiration from the 1837 account of Verrazano's landing in the New World by George W. Greene.

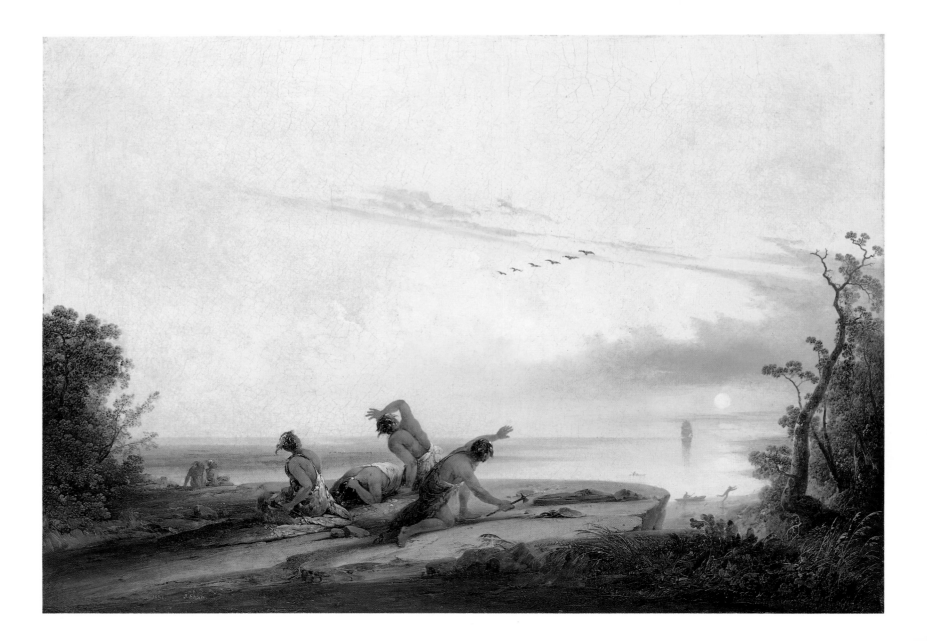

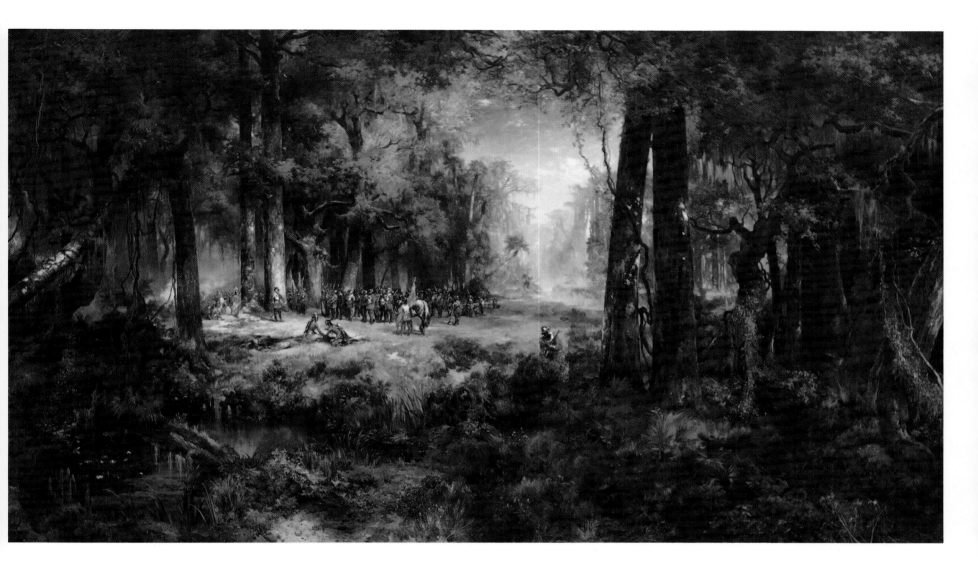

Ponce de Leon in Florida, 1513

THOMAS MORAN, 1837–1926

1877. Oil on canvas, 64 x 116 in.
National Cowboy Hall of Fame and Western
Heritage Center, Oklahoma City.

After the Centennial of 1876, which marked the 100th anniversary of the signing of the Declaration of Independence, American artists became intensely interested in the early history of the new country—a time when the West was still defined by the thin line of European civilization along the Eastern seaboard. Among these artists was Thomas Moran, the English-born landscape painter, who sought in works like *Ponce de Leon in Florida, 1513* to capture the nation's heroic past.

Moran first became interested in the Spanish explorer, Juan Ponce de Leon, and his search for the fountain of youth while visiting Saint Augustine, Florida, in February 1877 to make sketches for an article in *Scribner's Monthly* promoting tourism. Upon his return to his studio in Newark, New Jersey, the artist commenced work on this large canvas in which he portrayed an early confrontation between Native Americans and their European conquerors.

A profusion of lush vegetation frames a central clearing where the drama is depicted. The faces and figures of the Spaniards are painted with considerable color and specificity and an almost theatrical attention is paid to their clothing and equipment. By contrast, relatively little care is taken with the Indians, except for the two faceless yet submissive females in the lower center of the clearing. While the human encounter is the painting's principal focus, it is the dark interior of the swamp that seems to have captured Moran's artistic imagination. Towering above, and dwarfing, the Europeans are the huge, dark, ancient groves of cypress and moss-covered live oak. At left in the watery foreground are beautiful and seductive semitropical flowers and water lilies, and the disturbing hint of alligators and other dangerous inhabitants of the swamp. Nearby, to the right, a single figure with a musket and morion helmet peers cautiously into the dark jungle growth. Some trees in the forest interior appear almost menacing, filled with a vitalistic power far more deadly than that of the docile natives.

As with his great western landscapes of Yellowstone and the Grand Canyon, Moran created *Ponce de Leon in Florida, 1513* in the hope of selling it to the government for display in the U. S. Capitol. His failure to do so probably had more to do with sectional politics than with aesthetics.

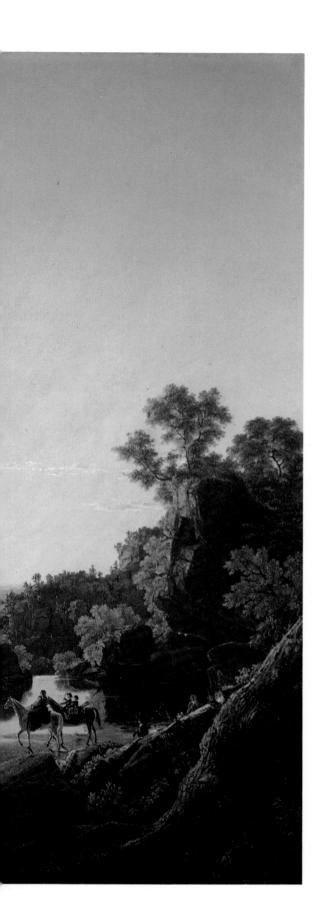

Hooker and Company Journeying Through the Wilderness from Plymouth to Hartford, in 1636

FREDERIC EDWIN CHURCH,
1826–1900

1846. Oil on canvas, 40¼ x 60³/₁₆ in.
Wadsworth Atheneum, Hartford, Connecticut.

When Americans in the late 20th century think of the Wild West, they typically conjure up visions of the vast prairies, mountains, and deserts that lie west of the Mississippi River. But their 19th-century forefathers could still recall a time when all of the territory west of the narrow strip of Eastern seaboard represented an unexplored wilderness. For these people, the late 17th- and early 18th-century treks into the frontier were still inspirational, leading many to make their own westward migrations.

One of the nation's earliest and most famous expeditions was led by Reverend Thomas Hooker, who journeyed in 1636 from the recently established colony of Plymouth, Massachusetts, to Hartford, Connecticut, where he founded a new settlement. It was a trek of only 100 miles, but, like other such colonial American penetrations into the western wilderness, it was fraught with hardship.

Frederic Edwin Church, the leading artist of the second generation of the Hudson River School, painted Hooker's westward journey in 1846, just one year before nationalistic passions, which were reaching a fever pitch, erupted in a war with Mexico. Stirring historical images such as this one helped justify the American politics of expansion that in large part gave rise to the conflict.[2]

A golden light pervades the scene, suggesting a divine blessing upon the groups of figures, arranged by the artist in poses evocative of the flight of the Holy Family into Egypt, or the wanderings of the Israelites in the wilderness. Typology—the concept that events in the Bible foreshadowed and gave meaning to events in American history—was used by artists like Church, Albert Bierstadt, and Thomas Moran to justify the belief that America had a "manifest destiny" to build a great new empire on the North American continent stretching from the Atlantic to the Pacific. This divinely ordained mission, in the view of one of Church's contemporaries, would be carried out by a ". . . band of serious, hardy, enterprising hopeful settlers, ready to carve out, for themselves and their posterity, new and happy homes in a wilderness—there to sink the foundations for a chosen Israel—there to till, create, replenish, extend trade, spread the gospel, spread civilization, spread liberty[3]

DETAIL ▶▶

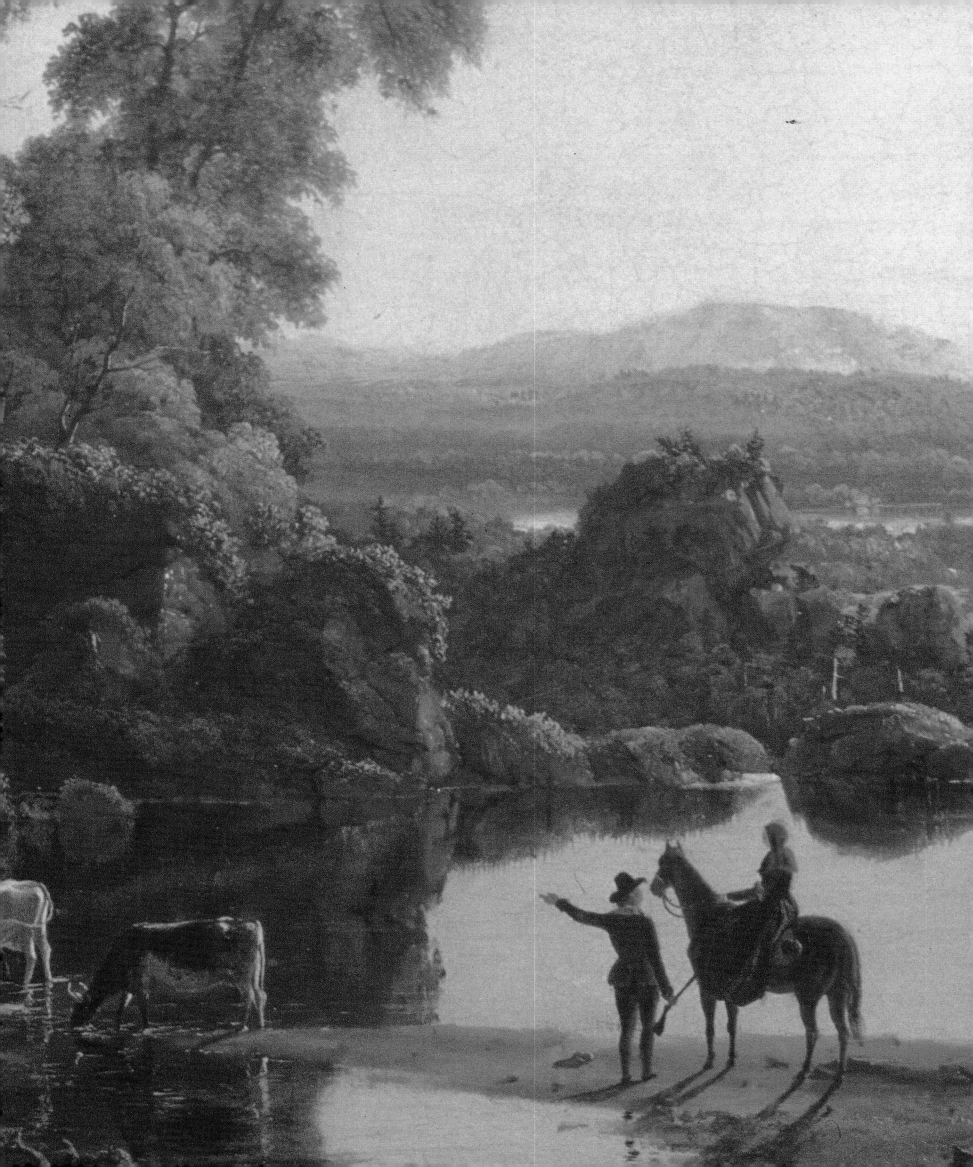

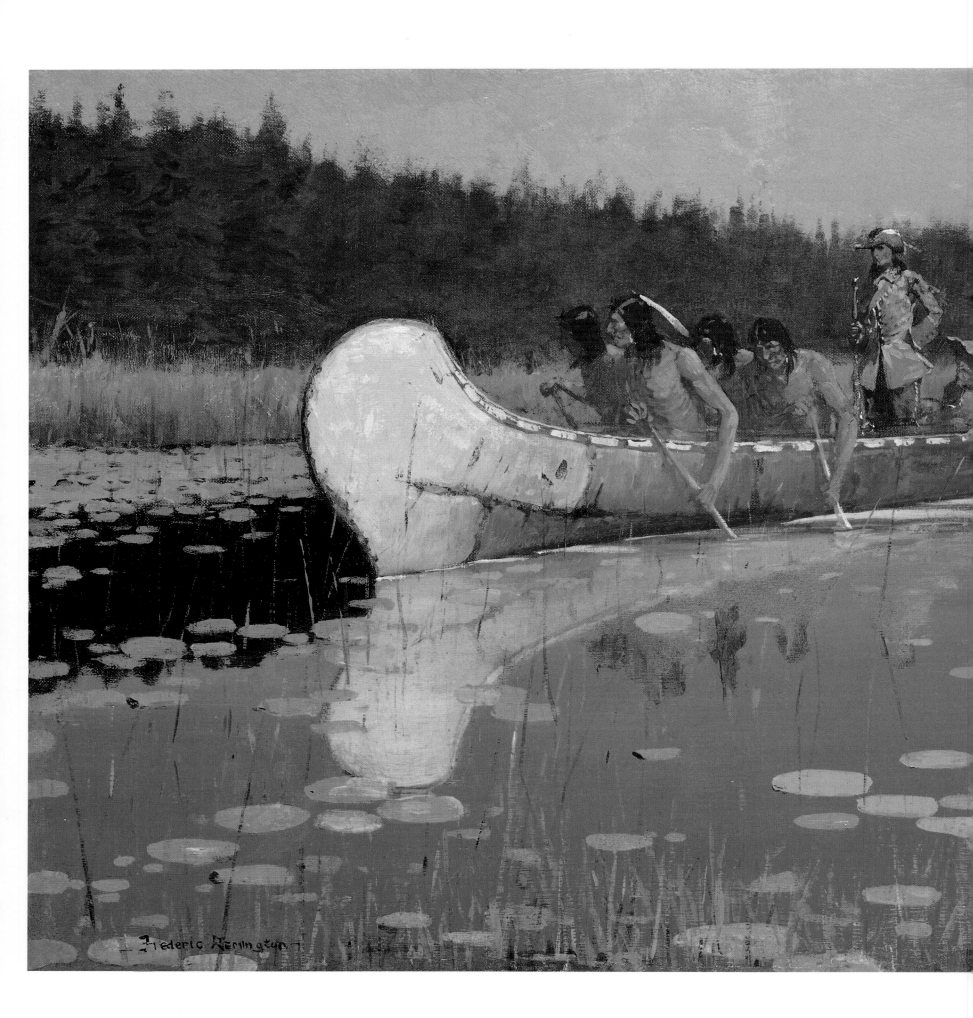

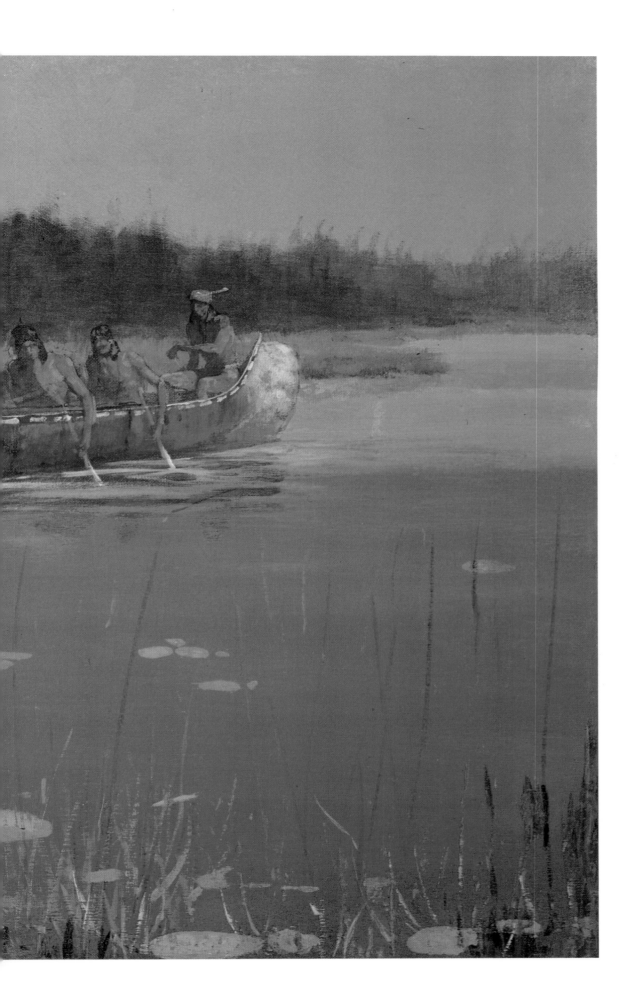

Radisson and Groseilliers

FREDERIC REMINGTON, 1861–1909

1906. Oil on canvas, 17 × 29¾ in.
Buffalo Bill Historical Center, Gift of Mrs. Karl
Frank, Cody, Wyoming.

In 1905, Frederic Remington created 11 works depicting the great explorers of North America for the popular magazine *Collier's*. Among these—and the only extant painting in the series—was *Radisson and Groseilliers*, a tribute to Pierre Esprit Radisson (circa 1636-1710) and his brother-in-law, the self-appointed lord, Sieur Des Groseilliers. Like many of their fellow explorers and fur traders, these adventurers were freebooting, bloodthirsty, and exploitative. They also shared the adventurer's treacherous existence, as recounted in manuscripts attributed to Radisson and published in 1885 to great controversy about their veracity.

With singular poetic quiet, *Radisson and Groseilliers* depicts the French explorers traveling in a large Indian birchbark canoe during their journey down the St. Lawrence River, across the Great Lakes and what is now the United States border with Canada, and finally into the lake country of Minnesota. While the lily-covered water over which the canoe silently moves is a visual delight with its brilliant blue reflection of the sky and the explorers, it is—as usual—the figures in the picture that are of particular interest to the artist. Indeed, Remington's image of the French explorer standing boldly in the canoe, musket in hand, his adventurous companion beside him, seems larger than life. Characteristically for Remington, the Native Americans, bare chested and animalistic in their facial features, are merely passive witnesses.

Shortly after he painted them, Remington became dissatisfied with the illustrative style of the great explorers series, and he destroyed all of them except *Radisson and Groseilliers*. Perhaps he saved this canvas because it had some particular personal significance for him, or it may have simply reminded him of his own serene surroundings on Ingleneuk, a picturesque island on the St. Lawrence River, near Ogdensburg, New York, where he had established a studio. Perhaps his experiments in photography—begun around the time that he painted the picture—found an aesthetic appeal in the painting's blurred water lilies seen from the perspective of the water's surface.

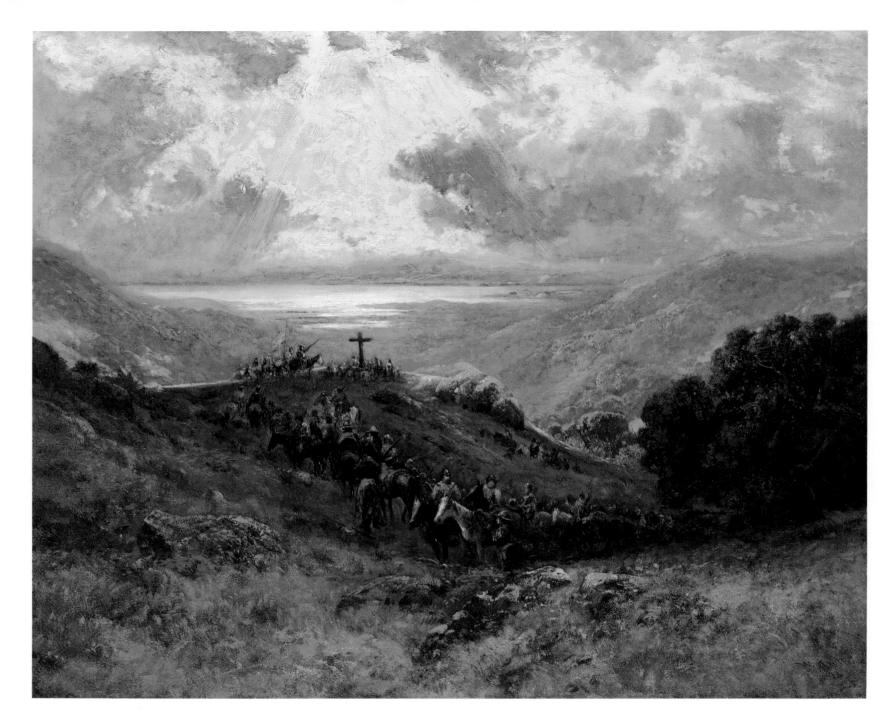

The Discovery of San Francisco Bay

WILLIAM KEITH, 1839–1922

1896. Oil on canvas, 40 x 50 in.
The Elisabeth Waldo-Dentzel Collection, Northridge, California.

By the 1890s the West was largely settled, and Americans, looking back over a century of territorial expansion, sought images to confirm and justify their domination of the continent. One painting created to provide a visual sanction for the forging of America's empire was William Keith's *The Discovery of San Francisco Bay*. Painted in 1896—at the height of the Gilded Age—this large picture was completed for a competition and purchased with great ostentation for the then huge sum of $25,000

by Mrs. Phoebe Hearst, wife of the famous newspaper publisher and politician, William Randolph Hearst.

The painting re-creates the moment on November 2, 1769, when the Spanish governor of Baja California—fearing that other nations might attempt to conquer the fertile lands on the Pacific Coast—ascended a commanding hill, later known as Sweeney's Ridge, pointed his sword at a cross and, in the custom of the day, claimed the land for God and King.

Although the actual historical event was quite simple, it becomes rich in pomp and circumstance in Keith's depiction, which was after all intended for the new aristocracy of California, personified by the immensely wealthy and powerful Hearsts. Not only is the ceremony witnessed in Keith's imagination by a large group of soldiers and their Indian attendants, it is also blessed by a burst of radiant, golden light. The use of this

powerful symbolic device would have been seen by Keith's patrons as offering typological confirmation of and justification for America's conquest of California, the new promised land.

One of the most important works of Keith's later period, the painting represents a renewal of the artist's style, after his invigorating contact with the leading Tonalist painter of the day, George Inness, to whom Keith played host in San Francisco in 1890. It is painted with heavy impasto and possesses the bold handling of color that characterized Keith's later period. Both Keith and Inness shared an interest in the vitalistic philosophy of the religious philosopher, Emanuel Swedenborg, and were concerned with a spiritual vision of nature that was expressed in their art through a veil of moody tonalist light.

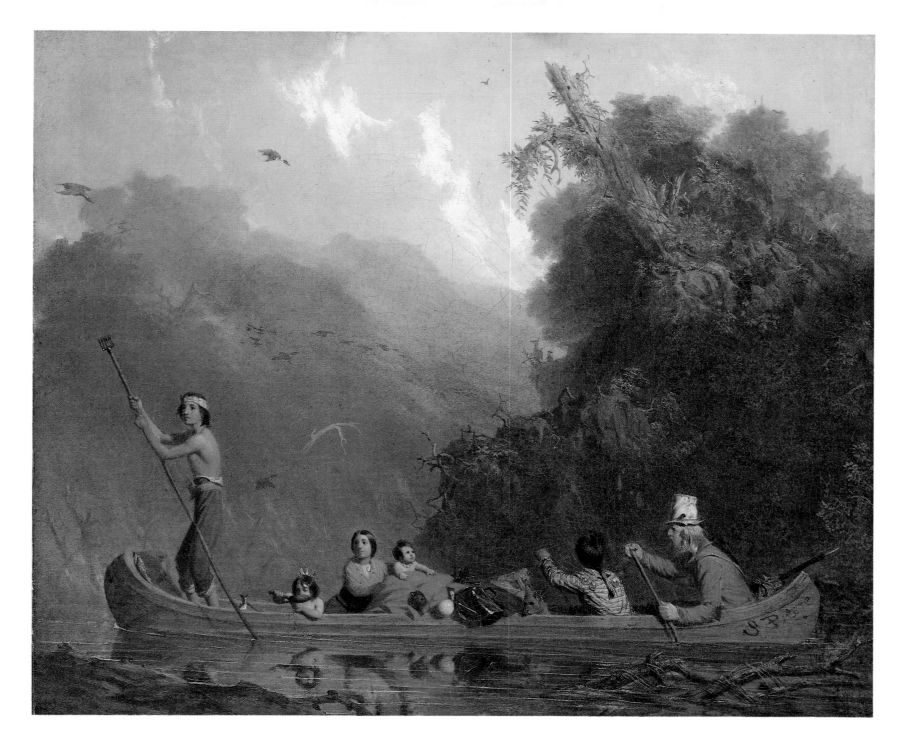

The Voyageurs

CHARLES DEAS, 1818–1867

1845. Oil on canvas, 31½ x 36 in.
The Rokeby Collection.

Among the first white men to inhabit the continental interior of North America were the fur traders of French descent, known as *voyageurs*. These enterprising adventurers did not trap beaver themselves; instead they obtained the valuable furs in trade with the Indians for manufactured goods. The *voyageurs* typically traveled in dugouts and canoes on annual journeys up and down river and often intermarried with the Native Americans. Their heyday lasted from the late 1700s well into the 1830s.

With the arrival of the steamboat and later the railroad, and the settlers who accompanied them, the *voyageurs* disappeared. But their reputation as half-civilized and half-wild inhabitants of the remote West lingered on, endearing them to artists like Charles Deas and George C. Bingham. *The Voyageurs*, painted by the St. Louis artist Charles Deas in 1845 may have inspired Bingham's more famous work, *Fur Traders Descending the Missouri* (page 26).

Unlike Bingham's picture of a fur trader and his son on a calm river at dawn, Deas' picture dramatically depicts a family traversing fast moving waters and preparing for a coming storm. While Bingham's work only implies the existence of a wife, Deas' picture presents her with her young children, one of whom is only a small child. Guiding the vessel at the stern of the dugout is the bearded head of the family, his characteristic beaver hat battered

and worn. In front of him one of his young children helps paddle while on the bow an older son poles the canoe around snags. This standing figure is the only member of the family to acknowledge the presence of a viewer. Behind him is a younger brother drinking river water from a large ladle. The dangers facing the family on its journey are suggested by the menacing, anthropomorphic trees reflected in the water and seen on the river banks and in the distance.

Many of Deas' paintings convey a sense of danger, alarm, or fright, reflections perhaps of the artist's disturbed temperament. Although he was one of the most promising and talented artists of the 1840s, Deas was forced to abandon his career in 1848 when he was not yet 30 years of age. Judged insane and committed to an asylum, he lived on for almost 20 years, but he never painted again.

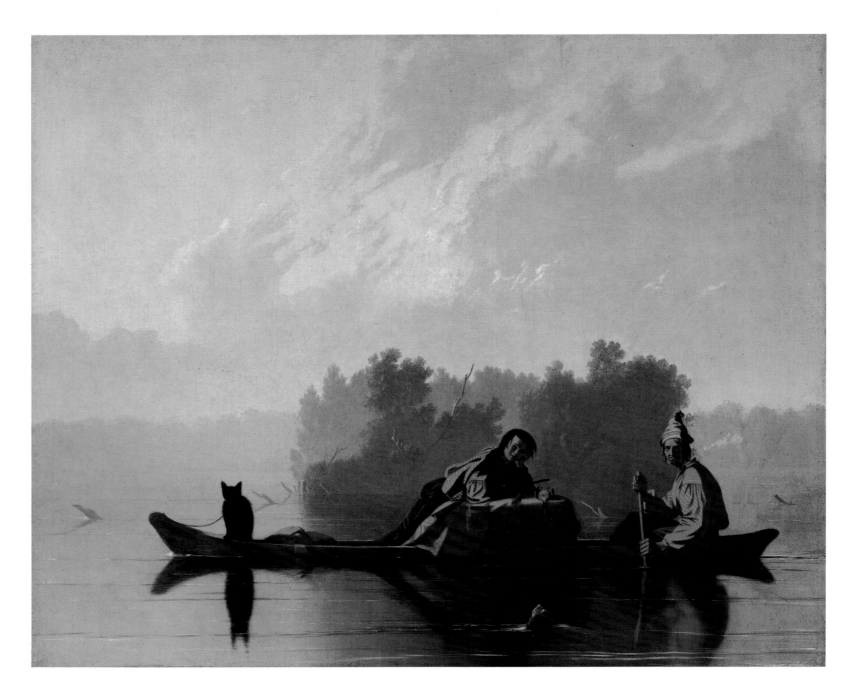

Fur Traders Descending the Missouri

GEORGE CALEB BINGHAM, 1811–1879

1845. Oil on canvas, 29 x 36½ in.
The Metropolitan Museum of Art, Morris K. Jesup Fund, 1933, New York.

Since 1933, when it was acquired by the Metropolitan Museum of Art in New York, *Fur Traders Descending the Missouri* has been considered an icon of American art, an archetypal image of frontier life, and an incarnation of emerging civilization in the western United States. This work—long considered George Caleb Bingham's greatest painting—may also be a companion, even a pendant, to another Bingham canvas of 1845, *The Concealed Enemy* (page 131). That is the view of art historian Henry Adams,

who makes a convincing case for his position. [4]

Both paintings are identical in size, yet contrast markedly in subject and meaning. Adams suggests that in its portrait of a war-painted Indian crouching above the riverbank, *The Concealed Enemy* represents the demise of savagery in the West while *Fur Traders Descending the Missouri*, which depicts a trapper and his son heading down river toward St. Louis, celebrates civilization's gradual ascent. Stylistically *The Concealed Enemy* is in the sublime mode of the 17th-century Italian artist Salvador Rosa, while *Fur Traders* is its opposite in sentiment, the beautiful mode of the 17th-century French neoclassicist Claude Lorrain. *The Concealed Enemy* is a sunset scene, while *Fur Traders* is set at dawn. There is a similarity in the crouching poses of the Indian and the fur trader's son, and both figures hold rifles, although they are intended for very different purposes. The Indian's weapon is for warfare, while the trapper's is for hunting. Adams'

intriguing thesis sheds important light on the symbolic complexity of Bingham's paintings and offers a new perspective for understanding their now obscured meanings.

While the deeper implications of Bingham's work may have been overlooked, the narrative power of *Fur Traders Descending the Missouri* has always remained accessible. In a scene that the artist could have witnessed as a youth sitting on the banks of the Missouri, an old frontiersman paddles effortlessly downstream; his pink-and-white shirt, tasseled yellow hat, and the smoke drifting from his pipe evoke nostalgic sentiments of a leisurely way of life, one that was waning even when the painting was conceived. The man's son, wearing a blue-and-white shirt and buckskin breeches, lounges on the season's bounty of furs, displaying the bird he has just shot. At the bow in near-silhouette is a bear cub which will be easily sold in St. Louis as a gourmet delicacy. Perhaps what makes the work most appealing is the calm, if bemused air with which the father and son regard the viewer.

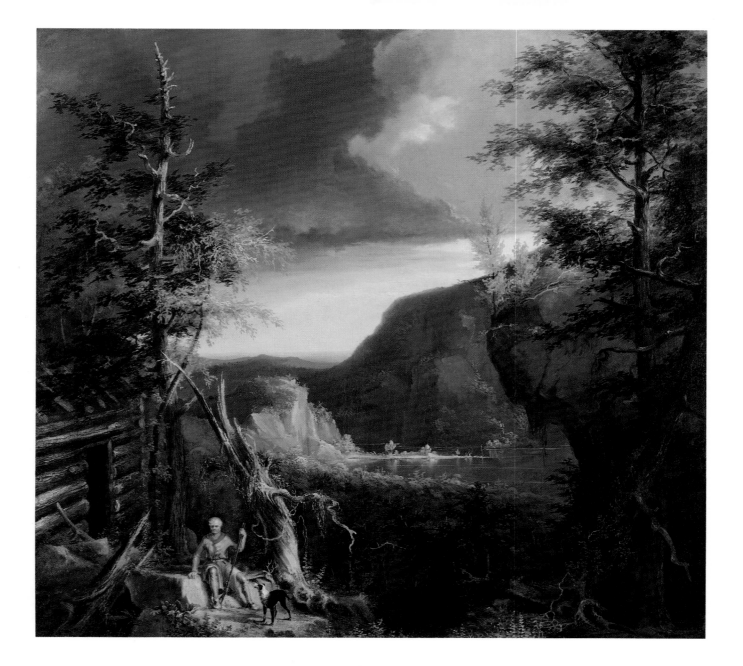

Daniel Boone Sitting at the Door of His Cabin on the Great Osage Lake, Kentucky

THOMAS COLE, 1801–1848

1826. Oil on canvas, 38 x 42½ in.
Mead Art Museum, Amherst College, Museum
Purchase, Amherst, Massachusetts.

Thanks largely to a biography of Daniel Boone published in 1784 by John Filson, a Delaware school teacher who had spent two years in Kentucky with the pathfinder, Daniel Boone became an almost mythic, international symbol of America's westward expansion. Even the English romantic poet Lord Byron included him in his epic poem *Don Juan*. Inspired by that literary work, the young English-American landscape painter

Thomas Cole created *Daniel Boone Sitting at the Door of His Cabin on the Great Osage Lake, Kentucky* in 1826.

In keeping with the poem, in which Boone was described as "An active hermit, even in age the child of Nature . . . " (stanza 62), Cole depicts the pathfinder, not as a confident hero striding through the wilderness, but rather as a hermit-like saint in buckskins. In fact, it is an aged, irascible-looking Boone who sits in front of his decrepit log cabin in an inaccessible wilderness where tangled and impenetrable growth threatens to surround him and swallow the cabin. The pathfinder is framed by trees that are joined together just above his head, suggesting the arch of a Gothic cathedral. At the right a large rock resembles a huge human head, its profile staring out protectively toward Boone and the distant landscape.

Cole, who later exerted a powerful influence on the style and sentiment of mid-19th-century western landscape painting, created *Daniel Boone* early in his career. A political conservative, he shared the ideology of his wealthy patrons, members of the Whig party who, according to scholar Alan Wallach, were apprehensive about the expansion of democracy—thanks to the populism of Andrew Jackson—into the western lands that they still owned or controlled.[5] Accordingly, Cole portrays Boone as scowling, displeased with the encroachments of civilization that threaten to disrupt his isolated refuge. His purple leggings may have been intended by the artist as a subtle tribute to his own aristocratic patrons. To be sure, this is a striking contrast to the image of the pathfinder created by George Bingham a quarter of a century later. In that painting (page 30), Boone strides confidently into the wilderness leading a column of populist settlers in their pursuit of new homesteads on the western frontier.

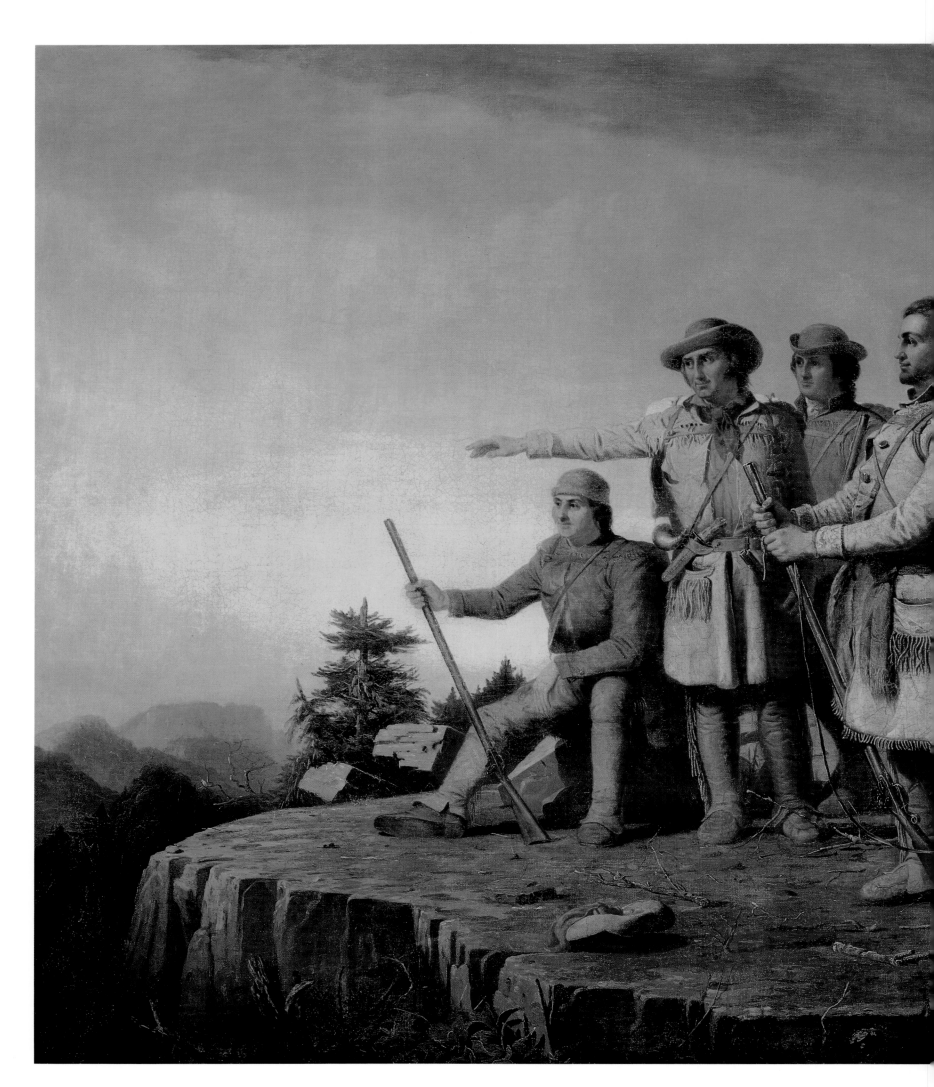

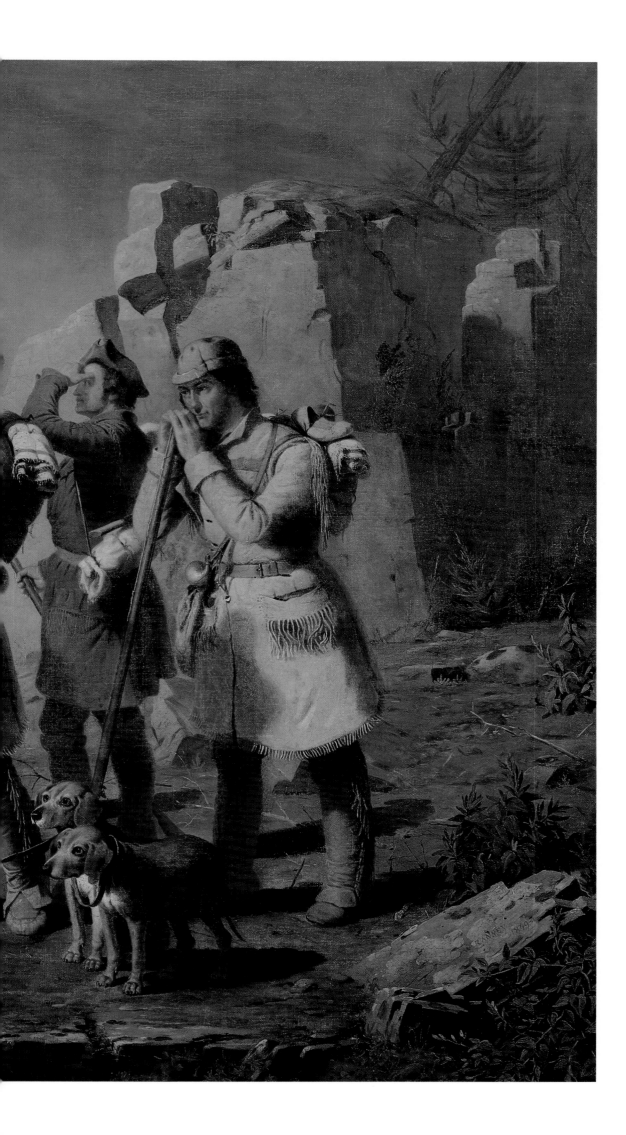

Daniel Boone's First View of the Kentucky Valley

WILLIAM RANNEY, 1813–1857

1849. Oil on canvas, 37½ x 54½ in.
The Thomas Gilcrease Institute of American Art, Tulsa.

In the 1840s, when William Ranney painted *Daniel Boone's First View of the Kentucky Valley*, America was in a period of great expansion, inspired by the popular belief in manifest destiny and fueled by the Mexican War in 1848 and the discovery of gold in California. Artists were eager to depict both contemporary and historical events related to westward migration. Even Thomas Cole, who had earlier opposed this populist movement, proposed to paint "Daniel Boone looking from the eminence over the vast forest and seeing the Ohio for the first time," although he never undertook the work. Around 1850, the popularity of depictions of the legendary pathfinder reached a peak, and Ranney's picture perfectly expressed the period's romantic fantasy of an effortless conquest of the wilderness.

The theatrical expressions and gestures of Ranney's painting were influenced by Timothy Flint's 1784 biography of Boone, which contained the following description of the pathfinder's band: "They stood on the summit of Cumberland mountain, the farthest western spur. . .What a scene opened before them! A feeling of the sublime is inspired in every bosom susceptible of it. Finley [sic] . . . exclaimed . . . This wilderness blossoms as the rose; and these desolate places are as the garden of God."[6]

In Ranney's painting Boone becomes a national hero of mythic proportion, comparable to Columbus. As Henry T. Tuckerman observed in the *Home Book of the Picturesque* in 1852, the pathfinder "is pointing out the landscape to his comrades, with an air of exultant yet calm satisfaction . . . his loose hunting shirt, his easy attitude and an ingenuous, cheerful, determined yet benign expression of countenance, proclaim the hunter and pioneer, the Columbus of the woods, the forest philosopher and brave champion."[7] Indeed, it is the serene optimism of Boone and his band as they behold the fertile new land of Kentucky that gives Ranney's painting of "the Columbus of the woods" a special distinction.

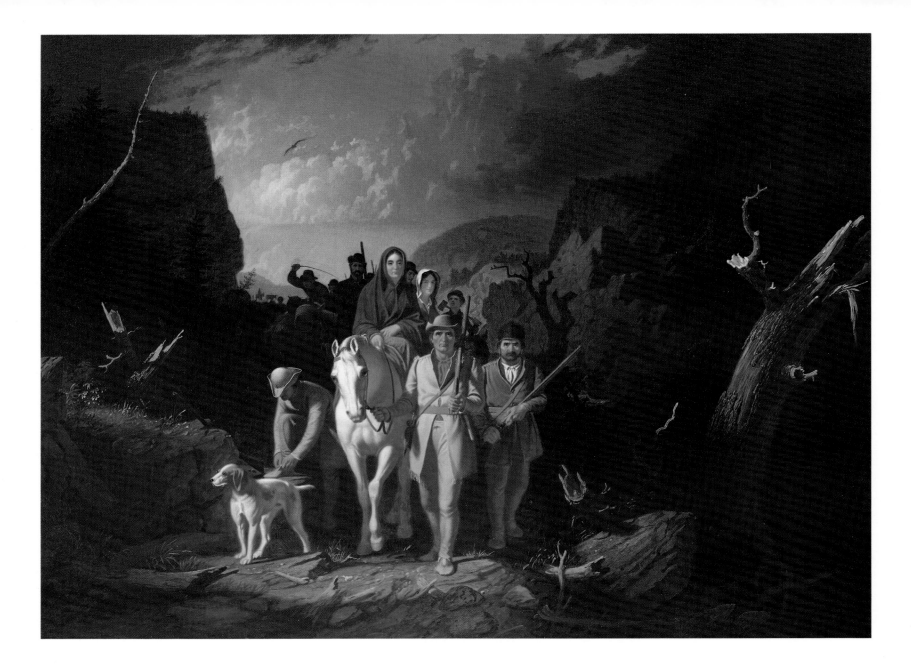

Daniel Boone Escorting Settlers Through the Cumberland Gap

**GEORGE CALEB BINGHAM,
1811–1879**

1851/1852. Oil on canvas, 36½ x 50 in.
Washington University Gallery of Art, Gift of
Nathaniel Phillips, Boston, 1890, St. Louis.

No single work of art has done more to establish the image of Daniel Boone as *the* prime visual symbol of westward expansion than George Caleb Bingham's *Daniel Boone Escorting Settlers Through the Cumberland Gap*. The picture defined for the period what moving westward meant in the *past* and what it should mean for the *future*.

For Bingham the subject was a natural one. As an aspiring young painter, he had been befriended by Chester Harding, who in

Boone's last year painted the only portrait of the pathfinder from life. In addition, Bingham created an 1830s signboard for a hotel in Booneville that depicted "old Dan'l Boone in buck skin dress with his gun at his side."[8] In 1844 Bingham proposed that the figure of Boone be used on a political banner representing the conservative Whigs of Boone County, Missouri. And, finally, when he was living in New York City almost half a decade later, he began this famous canvas. "I am now painting *The Emigration of Boone and his family to Ky*," he wrote. "The subject is a popular one in the West, and one which has never been painted."[9]

By considerably softening the physiognomy of his figures, especially those of Boone and his scout, Bingham symbolically replaces all the scoundrels, adventurers, and opportunists who went West with a representative image bespeaking the noble cause of westward expansion. From a typological perspective, Boone is depicted as a modern-day Moses leading the chosen people of America into the promised lands of the West. Rebecca, his

wife, also becomes a symbol. Sitting atop a white horse, a shawl draped around her, she is a powerful reminder of the Virgin Mary as seen in countless renderings of the Holy Family's flight into Egypt. As such, she becomes the personification of all the courageous women who went West. After the first version of his painting, Bingham issued a lithograph dedicated "To the Mothers and Daughters of the West" as a further tribute to the female pioneers.

Perhaps the best indication of the picture's progressive outlook is its perspective, which places the observer in front of the party advancing from the East, and implies, as scholar Dawn Glanz has argued, that henceforward national history will be viewed from the vantage point of the western territories.[10]

DETAIL ▶

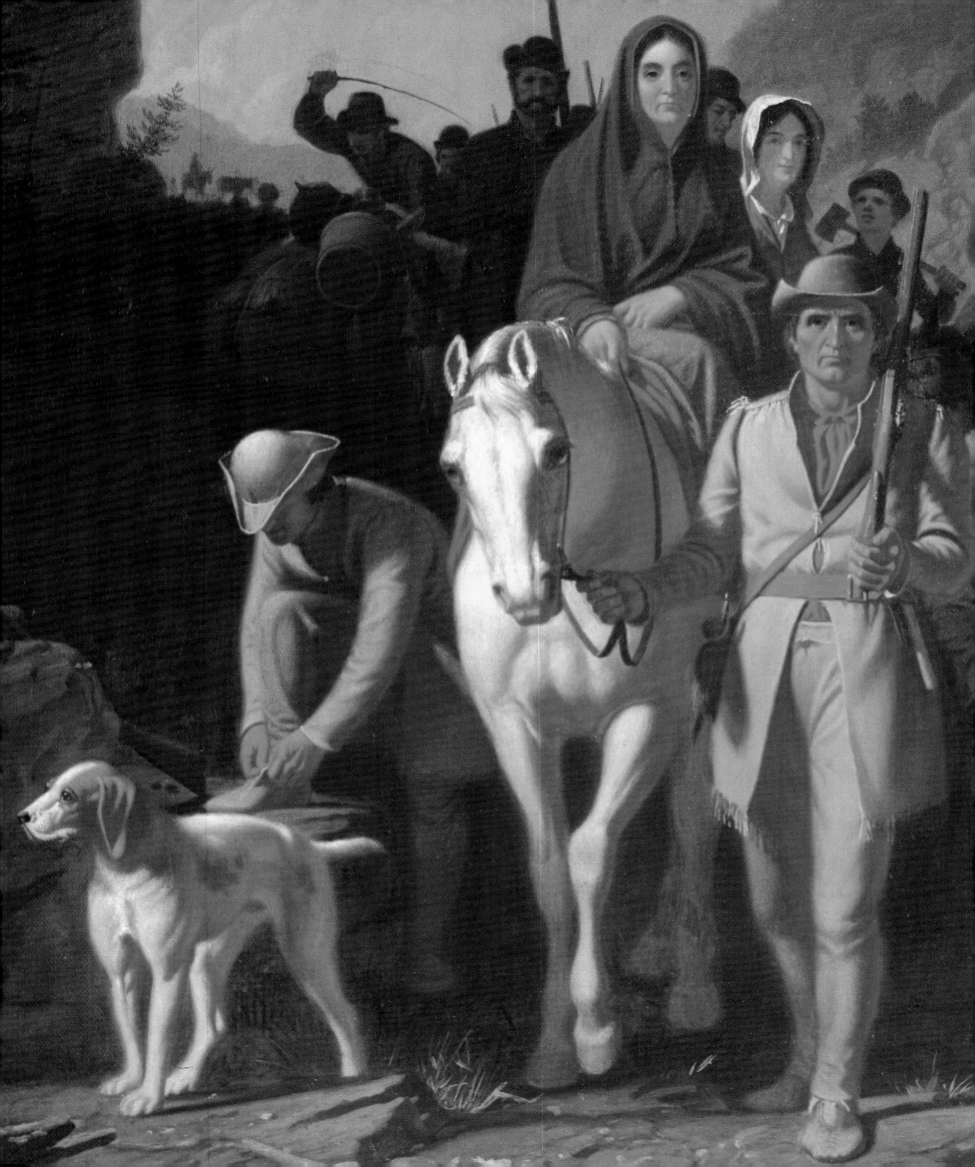

Long Jakes, The Rocky Mountain Man

CHARLES DEAS, 1818–1867

1844. Oil on canvas, 30 x 24 ⁷/₈ in.
The Manoogian Collection, Detroit.

In 1844 when Charles Deas exhibited *Long Jakes, The Rocky Mountain Man* at the American Art-Union in New York City he caused what one critic termed a "sensation among the audience." What made the work appealing was the artist's depiction of a new western hero, "a Santa Fe trader . . . wild and romantic" yet with "traits of former gentleness and refinement in his countenance."[11] According to the art historian Carol Clark, the painting can also be seen as something of a self-portrait, for Deas' exotic appearance resembled that of wild man Jakes. In fact, the artist, while retaining a manner of civilized urbanity, adopted the attire of a typical fur trapper, and earned the nickname "Rocky Mountains."

It was the trapper's untamed nature, coupled with his dangerous lifestyle, that so fascinated New Yorkers. As George Ruxton put it, "The trapper must ever be in a state of tension, and his mind ever present at his call. His eagle eye sweeps round the country, and in an instant detects any foreign appearance . . . All the wits of the subtle savage are called into play to gain an advantage over the wily woodsman; but with the natural instinct of primitive man, the white hunter has the advantages of a civilized mind, and thus provided, seldom fails to outwit, under equal advantages, the cunning savage."[12] Today's observer may detect other nuances of expression such as the reddened nose hinting at an excessive appetite for drink.

During his brief career, Deas established through his paintings the national archetypes for several western heroes. Certainly, *Long Jakes* is the quintessential fur trapper. The picture, which captures so vividly the mountain man and his perilous, lonely life, paved the way for the idealized portraits of the heroic cowboy that proliferated in the later 19th and early 20th centuries. *Long Jakes* may also be regarded as a pendant to the artist's *The Death Struggle* (page 129), in which the same fur trapper engages in mortal combat with an Indian who discovers him trespassing on the tribe's ancestral hunting grounds.

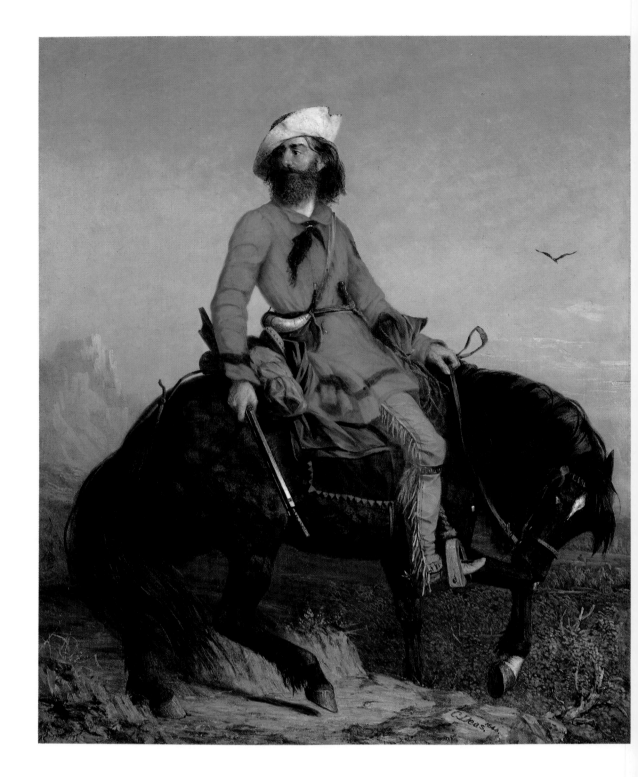

The Trapper's Bride

ALFRED J. MILLER, 1810–1874

1845. Oil on canvas, 36 x 28 in.
Eiteljorg Museum of American Indian and Western Art, Indianapolis.

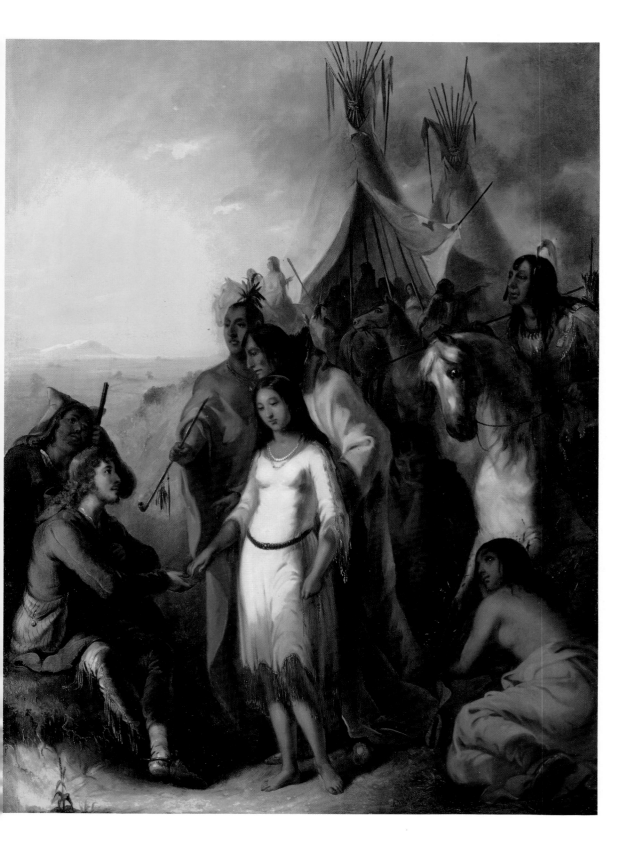

Unlike Charles Deas, who reveled in the life of a western adventurer, Alfred J. Miller did not enjoy the life of a frontiersman. His first and only expedition West came in 1837 when a wealthy Scottish nobleman, Captain William Drummond Stewart, hired him to record his party's adventures on the American frontier.

Stewart's expedition, consisting of about 100 Englishmen and Americans and 20 Indian guides, set out from near present-day Kansas City, journeying along what would become the Oregon Trail to the annual rendezvous of the mountain men in the Green River Valley. Miller made the most of the journey, compiling an extraordinary record of his experiences—some 200 watercolors and extensive notes. Upon his return to Baltimore he prepared finished drawings for his patron and executed a number of large oils that he exhibited in New York and Baltimore. Thereafter he remained in Baltimore where he developed a market for copies and variations on his work from the expedition.

Among the paintings inspired by the expedition was *The Trapper's Bride*, which was based on an incident that Miller witnessed during the rendezvous when an Indian warrior sold his daughter to a trapper for $600 worth of trade goods. Omitting any reference to the commercial nature of the transaction, Miller instead emphasizes the husband-to-be's amorous acceptance of the white-clad, virginal Indian maiden.

Miller plays to the interests of his eastern audience by providing a range of Indian types, from the mounted figure of a warrior at left—even whose horse seems excited by the union of white and Indian—to the unctuous father relinquishing his daughter in marriage and his companion who offers the peace pipe. While the incident has a certain romantic élan, Miller's painting is more than a mere celebration of marriage rites. Contemporary ideas of race and phrenology—especially popular in the South whether they pertained to African-Americans or others—held that Indians were organically inferior to whites and thus doomed to extinction unless they interbred with white men.[13] Miller's visual support for miscegenation—racial intermarriage—may explain the painting's special popularity in Baltimore, a southern city, where the artist produced several copies of the work for his patrons.

American Frontier Life (Trapper Retreating Over River)

ARTHUR F. TAIT, 1819–1905

1852. Oil on canvas, 24⅛ × 36¼ in.
Yale University Art Gallery, Whitney Collection of
Sporting Art, Given in memory of Harry Payne
Whitney and Payne Whitney by Francis P. Garvan,
New Haven, Connecticut.

During the mid-19th century, many artists attempted to capitalize on the national obsession with the West. Among these opportunists was the English-born Arthur F. Tait, who was so successful in capturing the spirit of the West during the 1850s that he virtually defined life on the plains for many of the easterners familiar with the Currier and Ives lithographs made from his paintings.

Since Tait had never ventured farther west than Chicago, which he did not visit until 1893, his popular depictions of frontier life were created from his imagination, from the images of other artists, and from the travelers' accounts that he read. According to historian Warder H. Cadbury, the artist produced these images as a means of supporting himself early in his career. After 1865, when he became established, he began to specialize in portraits of birds and farm animals.

Tait may have first become interested in the American West when George Catlin's Indian Show toured England. According to the artist's son, Tait was even employed by Catlin to impersonate a variety of Indians in the show. Tait emigrated to the United States in 1850, and shortly thereafter begin to paint western scenes because of the excitement generated by the California gold rush and overland expeditions to the Rockies. He found an early supporter in William Ranney, who lent him picturesque objects of Western gear from his own collection. Many of the costumes and props in Tait's paintings can be found in works by Ranney as well. The friendship between the two artists continued until Ranney's untimely death in 1857, when Tait played a major role in organizing an art auction to benefit Ranney's widow.

Characteristic of Tait's popular western scenes is *American Frontier Life*, which features a mounted trapper in fringed buckskin clothes, a red saddle blanket, and a longbarreled Kentucky flintlock, a weapon that evoked mid-19th century nostalgia for an earlier time. Never having actually seen a trapper or frontiersman, Tait simply borrowed the poses and gestures of the horsemen that he knew—English hunters—and, by dint of his vivid imagination, transposed them to the American frontier.

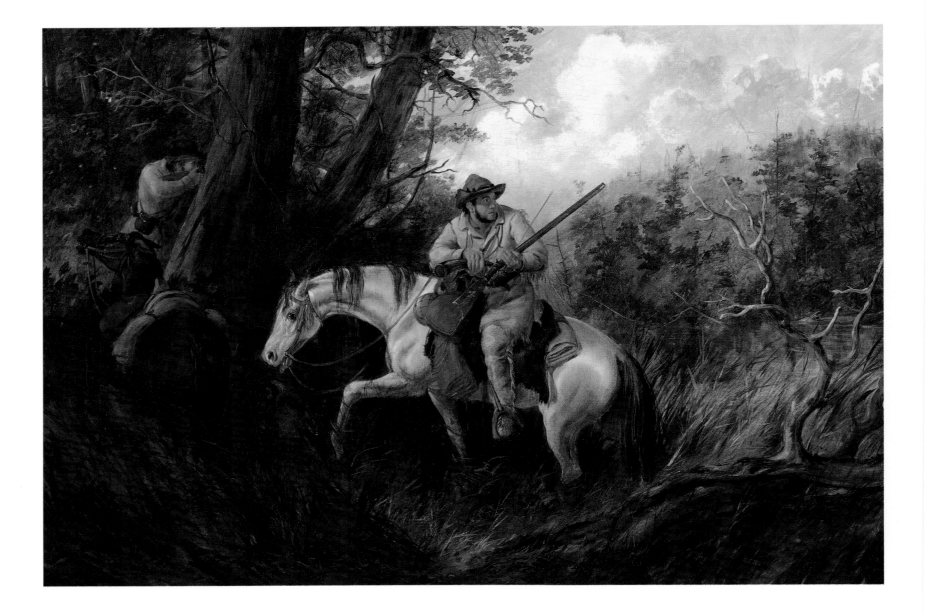

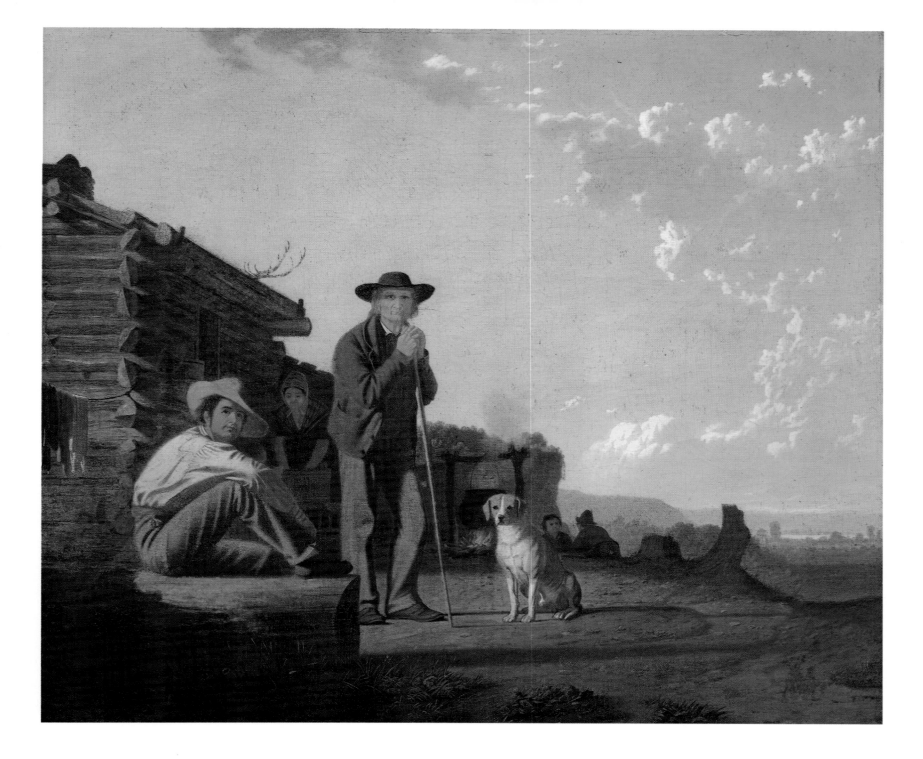

The Squatters

GEORGE CALEB BINGHAM, 1811–1879

1850. Oil on canvas, 23³⁄₈ x 28¹⁄₄ in.
Museum of Fine Arts, Boston. Bequest of Henry L. Shattuck in memory of Ralph W. Gray.

Following in the footsteps of such pathfinders as Daniel Boone were the squatters, a class of people who cleared the land, built rough log cabins, and often lived by hunting rather than farming.

George Caleb Bingham's painting *The Squatters* depicts these people. The artist had mixed feelings about them because of the transient nature of their settlements. When the painting was exhibited at the American Art-Union, Bingham was at pains to inform his New York audience of their character. "The Squatters as a class, are not fond of the toil of agriculture," he wrote, "but erect their rude cabins upon those remote portions of the national domain, when the abundant game supplies their political wants. When this source of subsistence becomes diminished in consequence of increasing settlements around, they usually sell out their slight improvement, with the '*preemption title*' to the land, and again follow the receding footsteps of the savage."14

While Bingham was critical of the squatters' way of life, he recognized their role in the acquisition of frontier lands at midcentury. And, if such settlers made minimal improvements, the next wave of pioneers—those to whom their tracts were sold—*did* create farms and encourage the growth of towns.

Bingham's painting is dominated by two squatters, an indolent-looking young man and his elderly companion. Behind the two a woman bends to wash clothes in front of the cabin. The antlers mounted on the cabin attest to the wild game that supplies the family's food, and, unlike Cole's image of a permanent settlement, *The Hunter's Return* (pages 36–37), there is no garden or any evidence of productive labor, beyond the woman's. At the right an expansive sky and river open toward the distance suggesting the vast open landscape that beckons the restless, opportunistic squatters to move still farther west.

The Hunter's Return

THOMAS COLE, 1801–1848

1845. Oil on canvas, 40⅛ × 60½ in.
Amon Carter Museum, Fort Worth.

During the 1840s the popular myth of an idyllic existence on the frontier became so powerful that even artists such as Thomas Cole, who had earlier eschewed the expansionist ideology of the Jacksonian Democrats in *Daniel Boone at His Cabin* (page 27), began to create images of the pleasant, virtuous life of the pioneer. *The Hunter's Return*, completed in 1845, is a major depiction of this myth.

The Hunter's Return is a deliberately constructed painting that operates simultaneously on several levels of meaning. As Cole historian Elwood C. Parry has suggested, it is somewhat autobiographical, with the cheery salutations of the hunters serving as a reminder of Cole's own frequent departures from and reunions with his family in the village of Catskill, an as yet unsettled region of upstate New York. On a larger, less personal level, the family members gathered at the cabin—a woman with an infant, a young child, and an older woman in the doorway—along with the youth leading the two mature men with the deer represent the various stages of life, a theme that Cole had explored in his famous series *The Voyage of Life*.

But *The Hunter's Return* is especially important at the level of stereotype, for the idyllically optimistic image of pioneer life that it represented, and against which artists like Jasper F. Cropsey and Sanford R. Gifford would later react. At the heart of the stereotype is the substantial log cabin, seen here replete with glass windowpanes, symbolizing the settler's prosperous and permanent life. It stands in striking contrast to Daniel Boone's decrepit cabin in Cole's painting of two decades earlier. The log cabin is an allusion as well to the 1840 presidential campaign in which the humble pioneer dwelling became the trademark of the victorious Whig politician, William Henry Harrison. Finally, at the level of ideology, the painting reflects Cole's coming to terms with the encroachments of civilization on nature's domain. Although he had often fulminated against the "dollar-godded utilitarians" and the "ravages of the axe," Cole concedes through the prominent placement of recently cut stumps and fallen trees in *The Hunter's Return* the need to clear the wilderness in order to establish the homestead. Even Cole's still standing trees, grouped by threes, have become cathedral arches, less protective but more inviting than their counterparts in the artist's picture of Daniel Boone, and the stony face of the large rock behind the cabin suggests that, like Cole, nature has come to accept the settlers' presence.

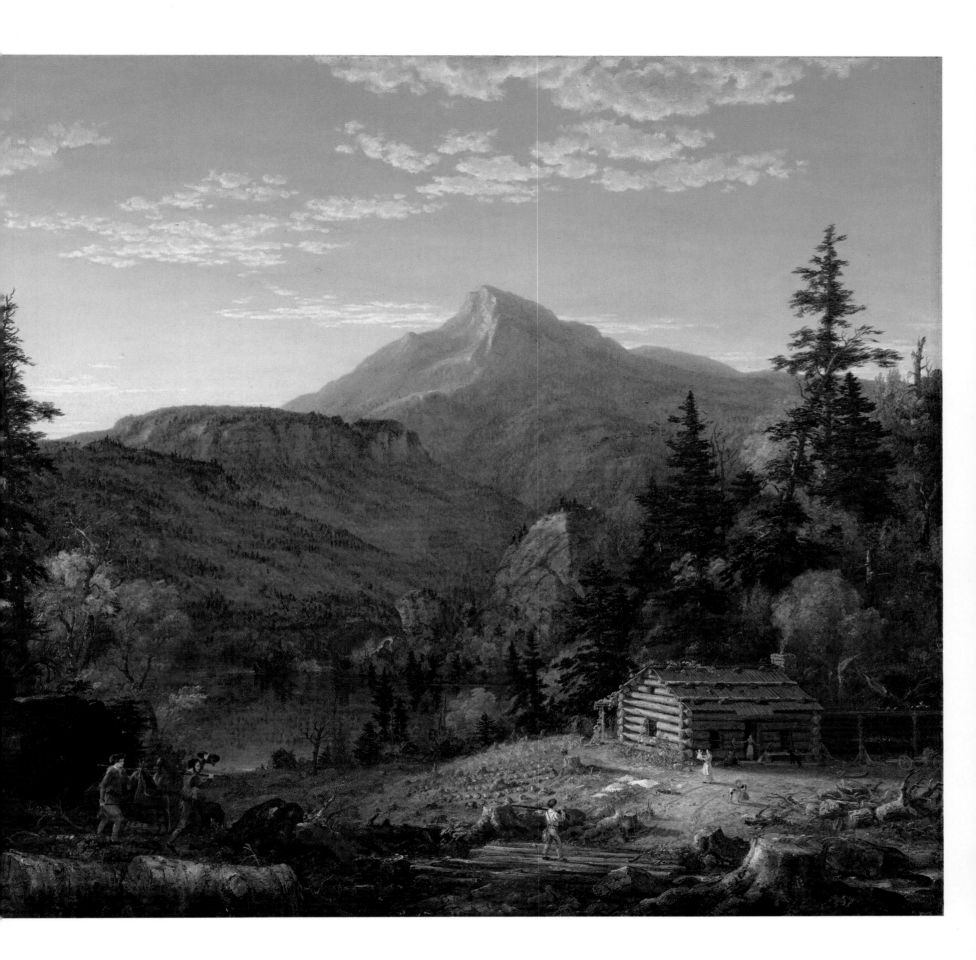

DETAIL ▶▶

37

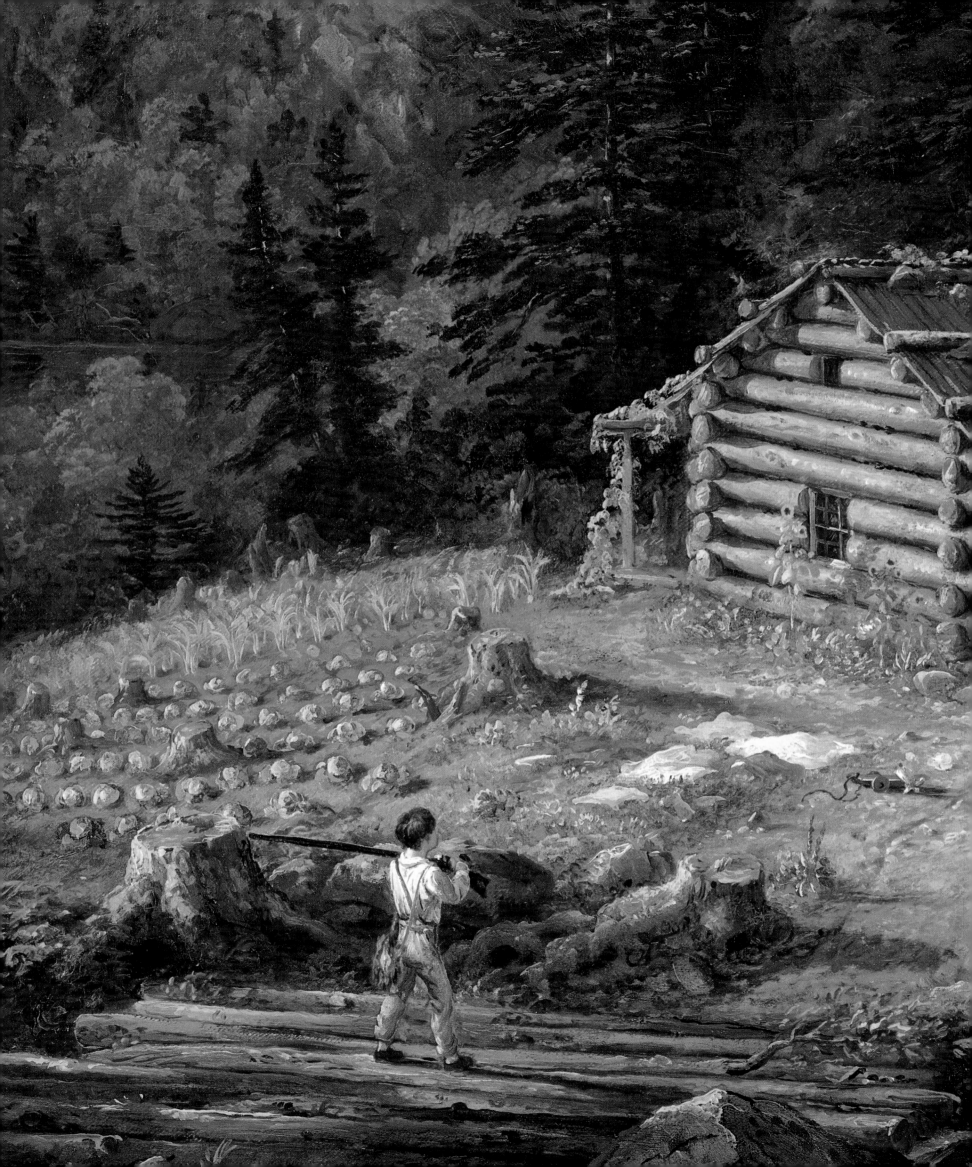

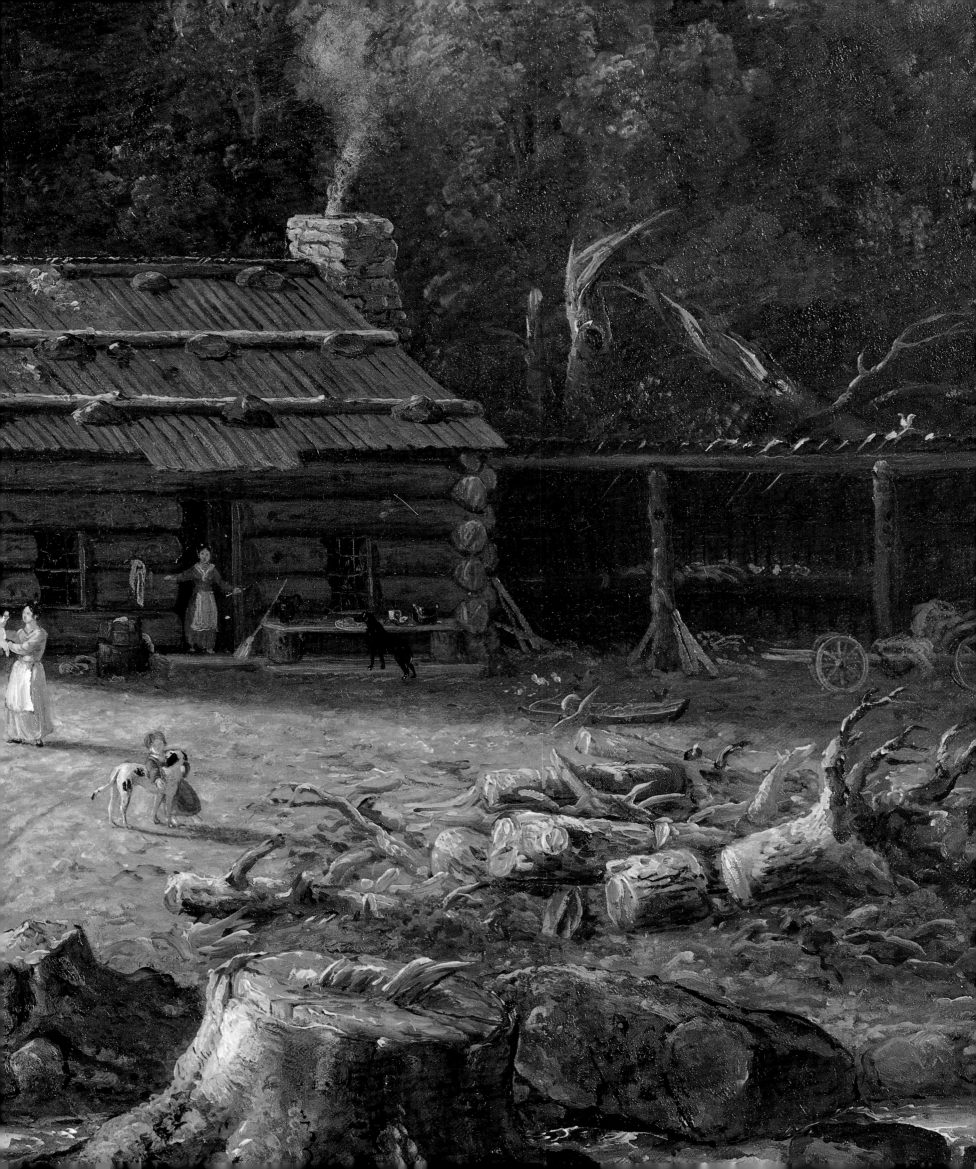

The Backwoods of America

JASPER F. CROPSEY, 1823–1900

1858. Oil on canvas, 42 x 70¼ in.
The Manoogian Collection, Detroit.

Jasper F. Cropsey's *The Backwoods of America* was completed in London on the eve of the Civil War, more than a decade after Cole's 1845 *The Hunter's Return* (pages 36–37). Although the paintings' settings are remarkably similar, Cropsey's canvas portrays a slightly more advanced state of settlement than Cole's. The many stumps that litter the foreground offer evidence of man's hand as do the two prominent dead trees that frame the cabin in a cathedral-like arch. Their leafless branches depict the common practice of "girdling," a method of killing trees by cutting the bark from a tree's base thereby denying it nutrients. To 19th-century pioneers, this practice provided a less arduous way of clearing the land than did chopping down trees with an axe. The cabin itself looks very much like the structure in *The Hunter's Return*, but in Cropsey's picture the dwelling is in poor repair. Each of the artists' works includes a family garden, but the rows of plants in Cropsey's painting are irregular, while the plot in *The Hunter's Return* is carefully tended.

Cropsey departs most significantly from Cole's idealized image of frontier life in the expression of the figures. Unlike the men in *The Hunter's Return*, who joyfully bring the bounty of nature to the family, Cropsey's yeoman is going out with his dog for a long day of felling trees. Evidence of his labors surrounds him in the ripening pumpkins and corn stalks at left and in the recently chopped stump directly ahead of him. His facial expression—determined and perhaps fatigued—is in marked contrast to the youthful happiness of Cole's pioneers. This man is not a squatter but one who knows that only with hard work can he improve his property. Given the extreme hardship and physical exertion that pioneer life demanded, even Cropsey's painting is somewhat idealized. But, in contrast to Cole's optimistic, dreamlike statement about life on the frontier, Cropsey's picture more honestly attempts to portray the demanding aspects of frontier life seldom treated by artists.

Cropsey's willingness to grapple with harsh realities may be traced to the Panic of 1857

and the deteriorating economic conditions that followed, events which caused many Americans to adopt a more sober viewpoint toward life. The artist's own ill health may also have contributed to a pessimistic outlook. He makes reference to his condition in the curious tombstonelike slab of rock in the painting's right foreground. On it he has placed his signature and the year, 1858. His fears of death proved unfounded, however; he lived until 1900, another 42 years after completing this work.

A Home in the Wilderness

SANFORD ROBINSON GIFFORD,
1823–1880

1866. Oil on canvas, 30½ x 45½ in.
The Cleveland Museum of Art. Mr. and Mrs.
William H. Marlatt Fund, the Butkin Foundation,
Dorothy Burnham Everett Memorial Collection, and
Various Donors by Exchange, 70.162.

In paintings like *Home in the Wilderness* Sanford Robinson Gifford—properly considered the most intellectual of the Hudson River School painters—created works of such startling simplicity that early efforts to assess his art understandably focused exclusively upon its topographic and stylistic aspects. Gifford's own colleagues, however, considered him to be an artist of exquisite intellectual subtlety. "His best pictures can not be merely seen but *contemplated* with entire satisfaction," wrote one critic.[15]

Gifford's *Home in the Wilderness* is an extraordinarily beautiful and seductive work in which a scene of luminous tranquility and stillness unfolds beneath a radiant golden sun. Yet even in this perfect vision of western nature there is a man-made disturbance in the log cabin at left. While the structure is similar to those found in pictures by Cole and Cropsey, Gifford—unlike his fellow Hudson River School artists—does not place his figures and cabin in the foreground. Instead he pushes them back to the middle distance, only visible across the lake. The figures are minute strokes of the brush, for the artist is intent on reducing the impact of the frontiersman's presence on the serene landscape.

By reducing the emphasis on the figures, Gifford causes the viewer to pay less attention to the human dimensions of the work and to focus instead on the imposing mountain in the distance. It is with the form of the mountain that Gifford takes special care, creating a peak of truly impressive scale, albeit one suspiciously similar to others in his art. After years of unsuccessful scholarly efforts to identify the specific setting for *Home in the Wilderness*, it has become clear that the mountain is an ideal peak, not the depiction of an actual place. In *Hunter Mountain, Twilight* (pages 44–45) a similar mass becomes a huge female figure reclining protectively over the horizon; here, on the other hand, the mountain—with its rising top peak at the picture's center and its steeply sloping

ing flanks—becomes a crouching beast about to spring to life, nothing less perhaps than the great Sphinx itself. It is a symbol of the timeless power of nature, as fully charged with vitalistic power as Georgia O'Keeffe's *Red Hills and Bones* (page 235) created almost a century later.

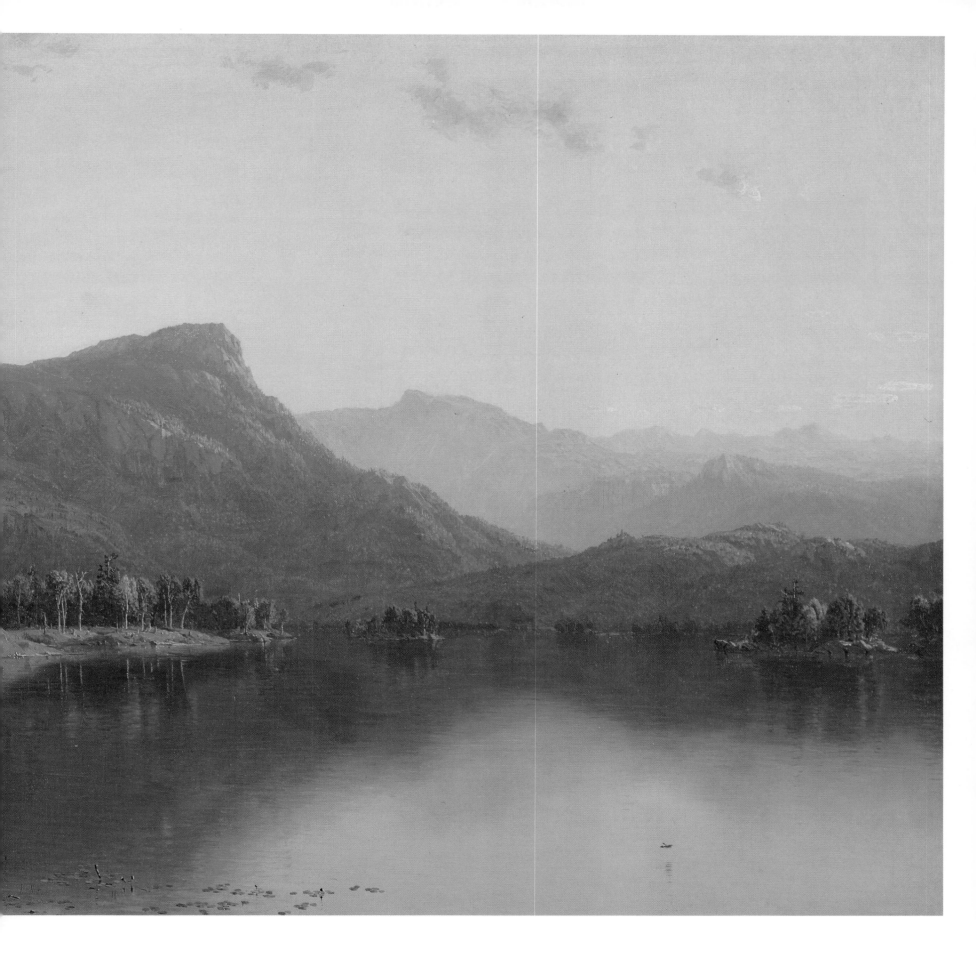

Hunter Mountain, Twilight

SANFORD ROBINSON GIFFORD, 1823–1880

1866. Oil on canvas, 30½ x 54 in.
Daniel J. Terra Collection, Terra Museum of American Art, Chicago.

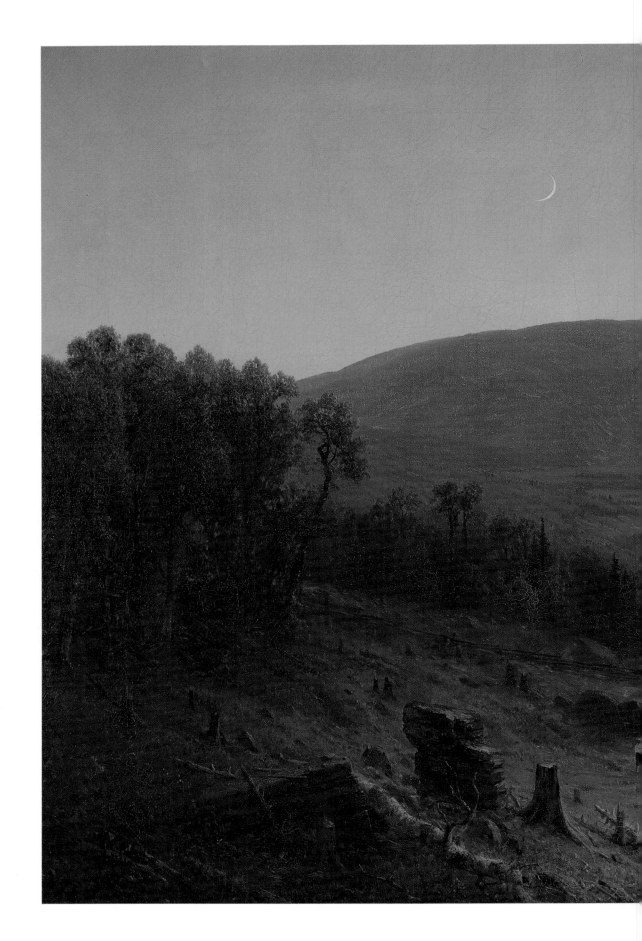

On May 7, 1866, when Sanford Gifford's *Hunter Mountain, Twilight* was first shown at the National Academy of Design in New York, the critic for the *Commercial Advertiser* provocatively noted, "We do not associate the idea of the *nude* with landscape painting and mountain forms, but we must use it in our judgment of Mr. Gifford's very beautiful 'Twilight' . . . In that picture he really has had to treat the *nude* of landscape scenery, and he has done it like an artist sure of himself."[16] As this unusual review reveals, Gifford's contemporaries understood the subtle and complex anthropomorphic symbolism that he often employed in his major paintings. Like other members of the Hudson River School, Gifford believed that through the use of such symbolism images of nature could be vitalized and spiritualized. In their paintings mountains could represent the inviolable, enduring Mother Earth, trees and rocks could become inanimate actors with waving arms or stony visages, and crimson clouds could be formed to resemble angels, even the face of God.

Gifford's introduction of anthropomorphic symbols into a depiction of a backwoods home is especially subtle in *Hunter Mountain, Twilight*, his most memorable of these works. Here the virgin wilderness is despoiled, scarred by "the ravages of the axe" and disturbed—like the landscape in *A Home in the Wilderness* (pages 42–43)—by the psychic wounds of the recently concluded Civil War. In the foreground, tree stumps stand like tombstones, memorials to the recently cleared land and the pioneer's thwarted hopes of agrarian prosperity. Ultimately, the mountain is the most arresting form in the picture. Spanning the full width of the canvas, clearly a formidable barrier to further westward expansion, it displays as well the attributes of a recumbent female nude, head and breasts rolling over the horizon. The painting is thus a profound metaphor for a living Mother Earth threatened by the intrusion of man.

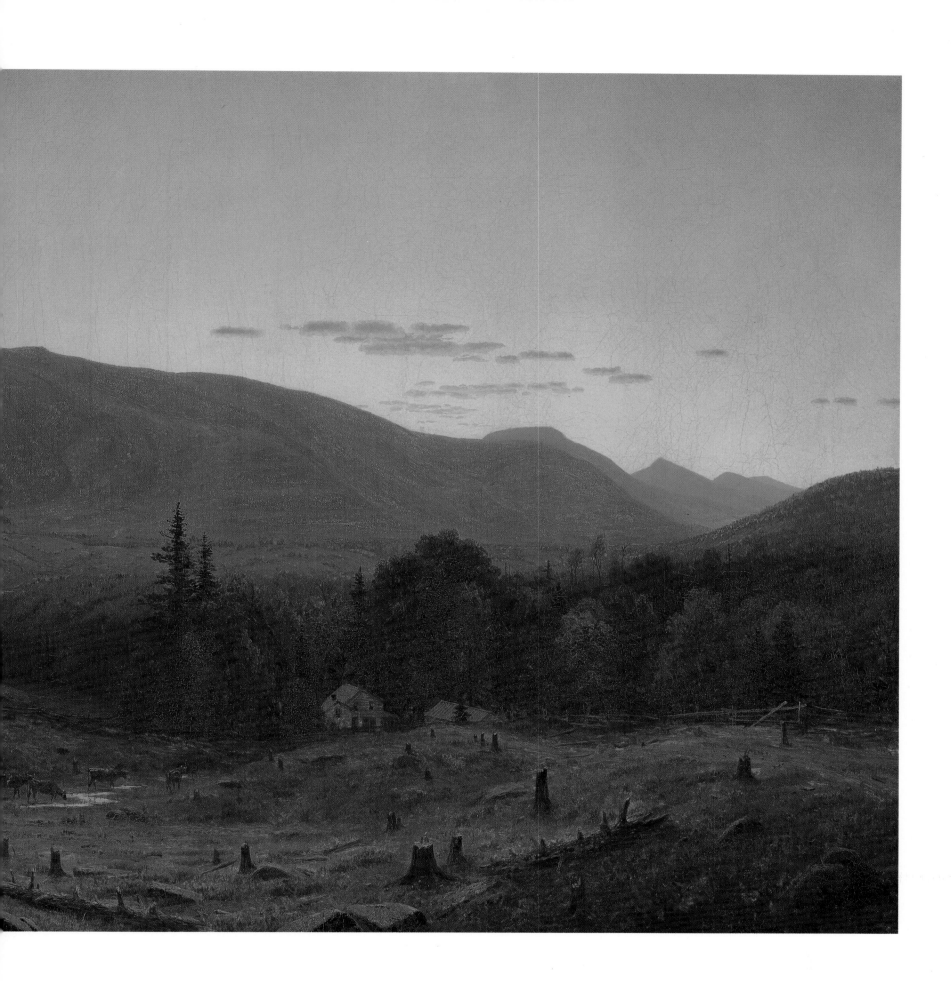

DETAIL ▶▶

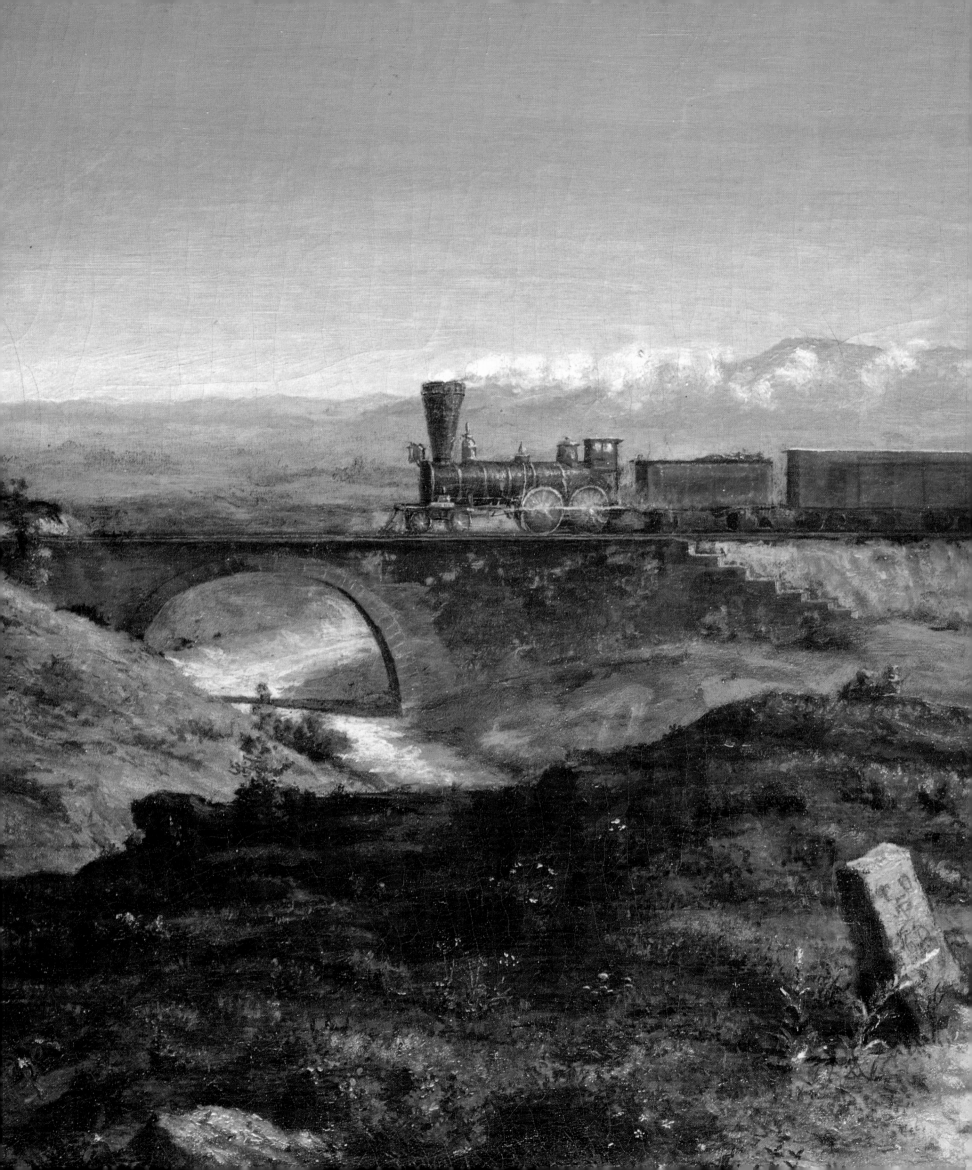

Westward the Empire

Westward the Empire

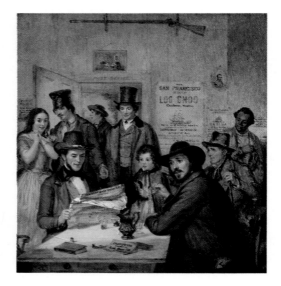

California News
WILLIAM SYDNEY MOUNT

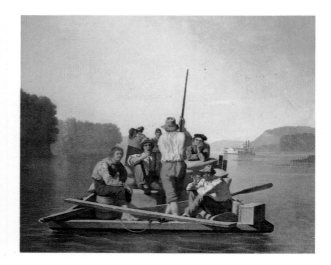

Lighter Relieving the Steamboat Aground
GEORGE CALEB BINGHAM

◄◄
On the Road (detail)
THOMAS OTTER

During the 19th century, Americans believed with absolute conviction that the new nation was destined to establish a great empire in the promised land of the West. "Westward the course of empire takes its way" was the byword of the age and it found its ultimate expression as "manifest destiny," the belief that America was destined to expand its dominion over the whole of North America and to extend its political, social, and economic influence over the indigeneous people it found there. The chief promoters of this quasi-religious doctrine were Senator Thomas Hart Benton of Missouri—grandfather of the 20th-century artist of the same name—and the writer William Gilpin. America's mission fulfilled, they believed, would realize the dreams of Columbus—a transcontinental route between Old Europe and the riches of Asia.

A degree of fanatical hyperbole characterized the claims of manifest destiny, as for example the following passage from Gilpin's book *The Mission of the North American People*: "A glance of the eye thrown across the North American continent . . . reveals an extraordinary landscape. It displays immense forces, characterized by order, activity and progress . . . Farms, cities, public works, define themselves, flash into form, accumulate, combine and harmonize . . . The American realizes that 'progress is God.' He clearly recognizes and accepts the *continental* mission of his country and his people." The ultimate economic purpose of this gigantic expansion was articulated by the patriot: "I discern . . . a new power, the *people occupied in the wilderness*, engaged at once in extracting from its recesses the omnipotent element of *gold coin*; and disbursing it immediately for the *industrial* conquest of the world."

For the painters of the era, the rapid expansion of the young nation provided exceptional opportunities to picture the great events of the day and to celebrate the heroism of a people who believed they were part of this divinely ordained mission. In retrospect, however, 19th-century Americans were not nearly so enlightened as one might have wished. From the perspective of our own growing environmental consciousness, we realize, for example, that the pioneers were seldom concerned about the headlong despoilment of nature as they went about the business of constructing their new civilization. That astute observer of the American scene, French social critic Alexis de Tocqueville, noted in 1835: "In Europe people talk a great deal of the wilds of America, but the Americans themselves never think about them; they are insensible to the wonders of inanimate nature, and they may be said not to perceive the mighty forests which surround them till they fall beneath the hatchet."

The urge to move westward and the belief that the frontier was a "safety valve" for overpopulated cities like Boston, Philadelphia, and New York, were affirmed by no less a figure than George Washington, who stated jocularly that Americans should be employed in the ". . . Agreeable amusement of fulfilling the first and great commandment—*Increase and Multiply*: as an encouragement to which we have opened the fertile plains of the Ohio to the poor, the needy and the oppressed of the Earth. . . ." Throughout the century the belief in the West as a place where people could better themselves or begin anew became increasingly popular, culminating in historian Frederic Jackson Turner's *Frontier Thesis* which maintained that "the existence of an area of free land, its continuous recession, and the advancement of American settlement westward explain American development."

The Emigrant Train Bedding Down
for the Night
BENJAMIN FRANKLIN RINEHART

Many major American painters of this period celebrated the virtue and heroism of westward expansion in their dramatic images of boatmen on the western rivers and wagon trains rolling westward over the Oregon Trail. Above all, like many of their fellow citizens, they were captivated by the prospect of a transcontinental railroad that would, as Walt Whitman proclaimed in his epic poem *Passage to India*, tie "the Eastern to the Western Sea,/The road between Europe and Asia." Scholars like Perry Miller, Lewis Mumford, and Leo Marx have stressed the degree to which Americans welcomed the mechanized aids to speed westward expansion. Welcomed may actually be too weak a verb—they rhapsodized over the new technology. Paintings in the latter section of this chapter reflect the ardor and excitement that the railroad engendered in both the popular and artistic mind.

Although our forefathers' enthusiasm for unlimited progress was pervasive, we may sift the general fervor and find a few, if very few, intellectuals of the time who questioned the extreme rhetoric of the age. That arch-skeptic, Henry David Thoreau, for example, emphatically rejected the twin ideals of progress and expansionism, writing: "The whole enterprise of this nation, which is not an upward but a westward one, toward Oregon, California, Japan, etc. is totally devoid of interest to me, whether performed on foot or by a Pacific railroad. It is not illustrated by a thought; it is not warmed by sentiment; there is nothing in it which one should lay down his life for, nor even his gloves—hardly which one should take up a newspaper for. It is perfectly heathenish—a filibustering *toward* heaven by the great western route. No; they may go their way to their Manifest Destiny which I trust is not mine." To be sure, Thoreau was out of step with the thinking of his contemporaries. Today, however, his thoughtful critique of an era marked by unchecked enthusiasm for the West seems especially relevant.

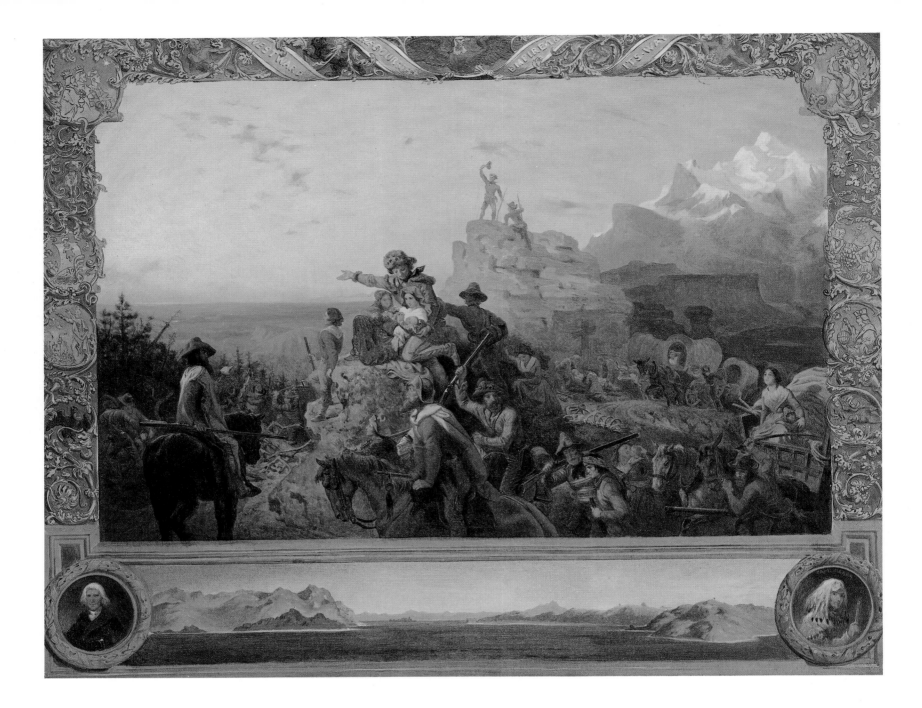

Westward the Course of Empire Takes Its Way

**EMANUEL GOTTLIEB LEUTZE,
1816–1868**

1861. Oil on canvas, 33¼ x 43⅜ in.
*National Museum of American Art, Smithsonian
Institution, Bequest of Sara Carr Upton,
Washington, D.C.*

Nowhere in 19th-century American art
was the vision of manifest destiny more
exultantly realized than in *Westward the
Course of Empire Takes Its Way*, the huge
painting that Emanuel Leutze created for the
United States House of Representatives. The
painting reproduced here is a study for that
staircase mural, which measures 20 by 30
feet. The title of Leutze's picture comes from
Bishop George Berkeley's poem "On the
Prospect of Planting Arts and Learning in
America" written between 1729 and 1731:
"Westward the course of Empire takes its
way;/The first four acts already past,/A fifth
shall close the drama with the day:/Time's
noblest offspring is the last."[1]

In this great work, a group of weary travelers
celebrates at the first view of the golden land
of California. Leutze draws upon the conven-
tions of typology so well understood in mid-
19-century America to reflect the belief that
the United States, God's chosen nation, was
on a divine mission to claim and civilize the
western wilderness. The ascending axis
formed by the figures at right culminates
with a family group in the center of the com-
position. The mother with an infant child
and her husband in the coonskin cap are pur-
posefully reminiscent of pictures of the Holy
Family on the flight into Egypt. They also
represent the new Israelites of America going
to the New Canaan in California. Behind
these lead figures are other "types"—the "suf-
fering wife," for example, and an "injured
boy" whose wounds are the result, perhaps, of
a battle with Indians on the trail. As if to
echo the triumphant gestures of the pioneers,
even the rocks in the background appear to
strain expectantly toward the golden horizon.
But death is also present on the march to
Paradise, as seen in the burial of an old
woman at center right.

The painting's elaborate foliate border con-
tains additional typological imagery, includ-
ing medallions of the new American holy
men, the explorers Daniel Boone and
William Clark, and a view of San Francisco's
Golden Gate—symbol of a mythical
promised land—which stretches across the
bottom panel like the predella of a
Renaissance altar painting.

Boatmen on the Missouri

GEORGE CALEB BINGHAM, 1811–1879

1846. Oil on canvas, 25 x 30 in.
The Fine Arts Museums of San Francisco, Gift of Mr. and Mrs. John D. Rockefeller III.

In *Boatmen on the Missouri* by George Caleb Bingham, three frontier rivermen await a steamboat, whose approach is signaled by the smoke in the distance, in order to sell their load of firewood. The composition of the painting is very tightly structured within the geometric grid of horizontal lines formed by the parallelism of the flatboat with the picture plane. The figures are arranged in a pyramidal form, a compositional device often employed by Bingham. The man at left is perhaps the most interesting of the group with his expensive, though soiled striped pants, his unkempt hair, and his battered black top hat. His friendly expression and nonchalant pose suggest an openness and freedom that seemed to typify the western character to mid-19th-century visitors to America. The two foreground figures make direct eye contact with the spectator, heightening the sense of immediacy. The third boatman is busily bailing out the bilge of the leaky flatboat to ensure that the wood will still be dry when the steamboat arrives. Good wood was essential to the operation of these vessels, which typically required a ton or more each hour to fuel their boilers.

This painting was among the earliest in a series of works portraying Missouri boatmen created by the artist between 1838 and 1857. Even as these canvases were being painted, the days of the free-and-easy rivermen were coming to an end. By the 1840s the larger steamboat lines were no longer purchasing their wood from independent suppliers, like those Bingham depicts here. Instead they had begun to arrange in advance for fuel to be supplied at the established landings along the river. In New York, where Bingham hoped to sell his paintings, western boatmen were generally considered an ill-mannered, boisterous group but, like the cowboy a half century later, these "vulgar" westerners were also considered colorful.[2] Hence in this work, the artist offers his eastern audience a vivid image of a vanishing class.

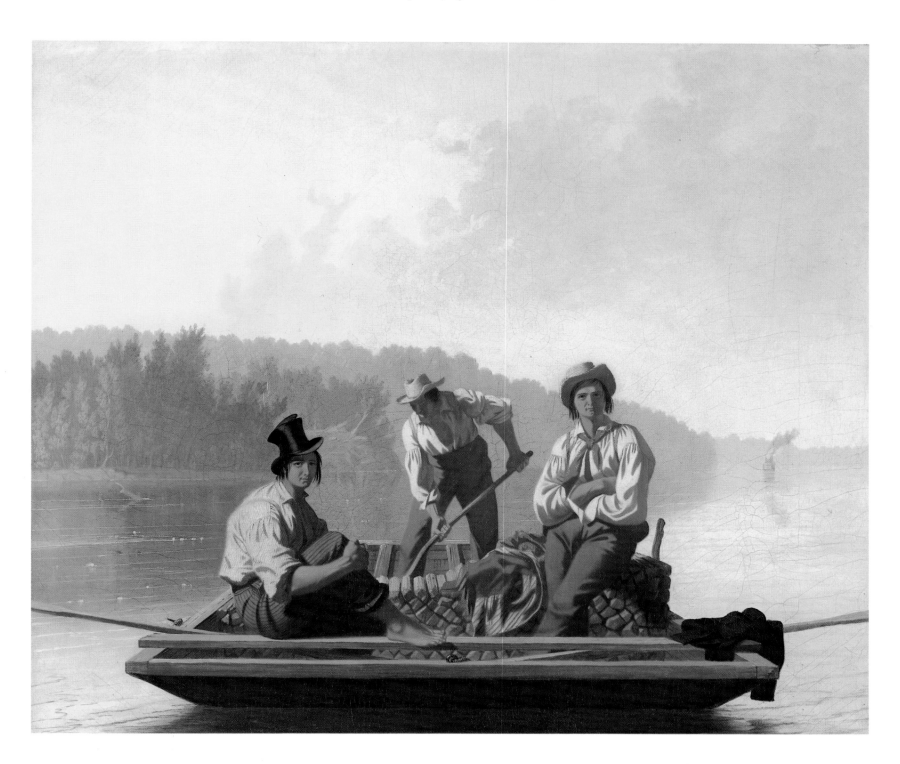

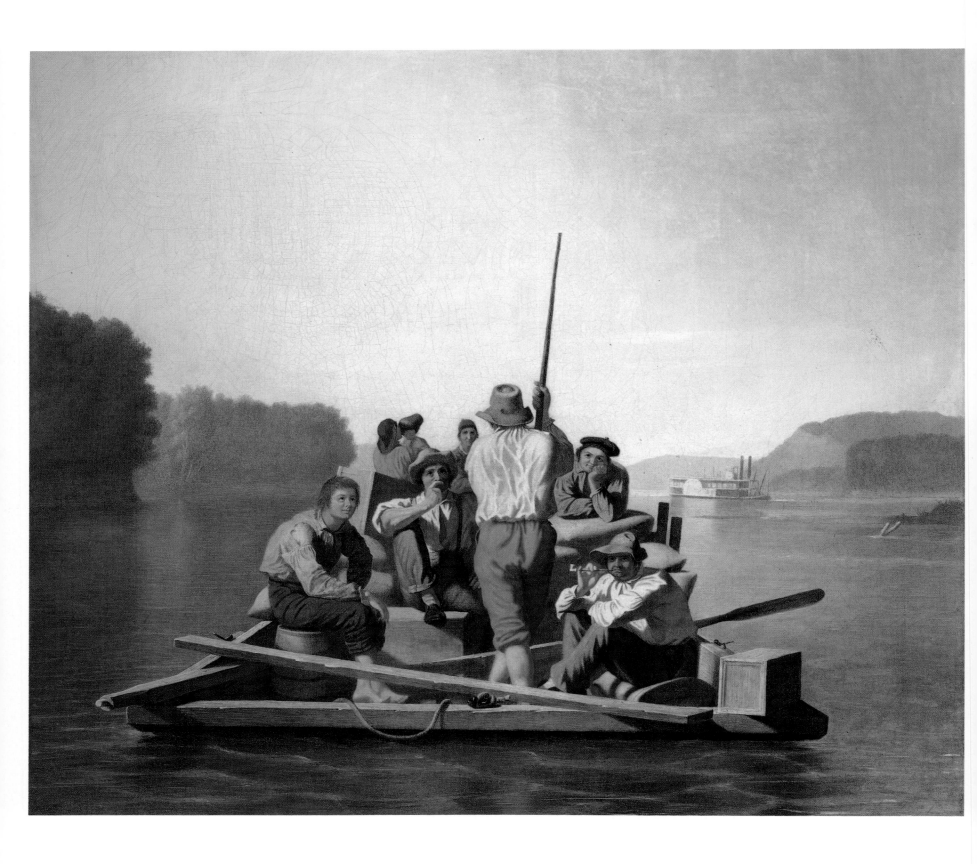

Lighter Relieving the Steamboat Aground

GEORGE CALEB BINGHAM, 1811–1879

1846–1847. Oil on canvas, 30¼ x 36 in. White House Historical Association, Washington, D. C.

A few decades ago the paintings of George Caleb Bingham seemed to be little more than native American images of a "heroic age," uncluttered by the tensions and politics of the young nation at midcentury. Recently, however, Bingham scholar Nancy Rash has demonstrated that complex intellectual and social ideas lay just beneath the surface of these "simple" Bingham works.[3] In the painting reproduced here, *Lighter Relieving the Steamboat Aground*, for example, Rash maintains that Bingham was arguing for the federal government to pay for improvements— to remove snags and to dredge channels along inland waterways. This program, which the Whigs supported, would have made commercial navigation safer, especially on the Missouri and Mississippi rivers. Viewed in this historical context, the beached steamboat in the distance becomes a key symbol. "A portion of her cargo has been put upon a lighter, a flatboat used to load or unload boats, to be conveyed to a point down the river," observed a St. Louis critic in 1847. "The moment seized upon by the artist is when the lighter floats with the current, requiring neither the use of oar nor rudder, and the hands collect together around the freight to rest from their severe toil."[4] All may not be well, however; the stranded vessel may provide an unexpected economic opportunity for the rough American types who have come to her aid. A close look at their clothes and facial expressions reveals that this crew has seen its share of rougish opportunism.

The politics of the painting may be irrelevant to people today, but they are essential to understanding the work's meaning. What *Lighter* does offer modern viewers is a wonderful formal design of horizontal and vertical shapes that lock the barge and its crew into a time-heightened moment painted in a crisp style. The artist organizes the figures in a triangular composition that moves downward from the top of the long pole held by the central standing man in red pants.

DETAIL ▶

California News

WILLIAM SYDNEY MOUNT,
1807–1868

1850. Oil on canvas, 21½ x 20¼ in.
The Museums at Stony Brook, Gift of Mr. and Mrs.
Ward Melville, 1955, Stony Brook, New York.

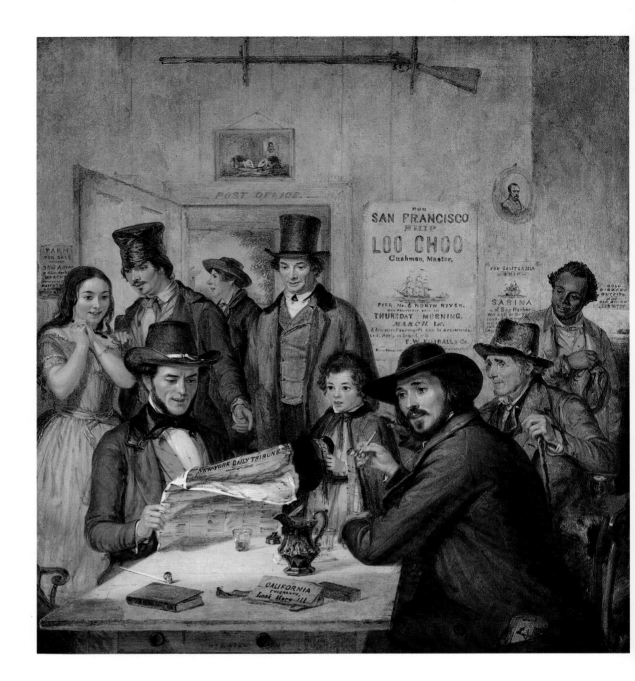

William Sidney Mount never went West, indeed he never felt the need to leave his home on Long Island, yet he painted one of the most famous images of "gold fever" in American art. Subtitled *News from the Gold Diggin's, California News* was a $300 commission from Thomas McElrath, Horace Greeley's partner at the *New York Daily Tribune*, one of the few newspapers of the period to refrain from the militant expansionism of most penny presses. Mount himself was ambivalent about the prospects for instant wealth that lured many to abruptly leave their homes and families in the wake of the great California gold rush of 1849. "I hope it may turn out [more] a blessing to the country—than a curse," he wrote in his diary. [5]

Mount's ambivalence about gold fever permeates his painting, set in the post office at Stony Brook, Long Island, a room that may have been part of Mount's house. On the walls are posters for ships to California, including one for the "Loo Choo," a nonexistent vessel whose name is an alliteration of loco. Near the top is a Kentucky long rifle, relic of an earlier age of expansion. Just below the rifle is the most telling indication of Mount's satiric intentions. A small painting over the doorway shows two pigs eating at a trough—Mount's sly comment on human greed. The most prominent figure is the artist himself, seated in the right foreground with a sketchbook protruding from his coat pocket. The other men in the painting are gathered to hear the news about the West in the *New York Daily Tribune*. The artist's brother reads the paper, while the others listen intently. Their ages and facial expressions—a reflection of the artist's gift for portraiture—and their varying stations in life provide sophisticated commentary on human nature and on the impact of gold fever among varying social and economic classes.

At the extreme right Mount places an African-American, perhaps the most interesting and problematic figure in the picture and perhaps the only one to express incredulity about grandiose claims of easy riches. This figure is Mount's most sympathetic depiction of an African-American, as the artist's view of blacks grew increasingly racist over time.

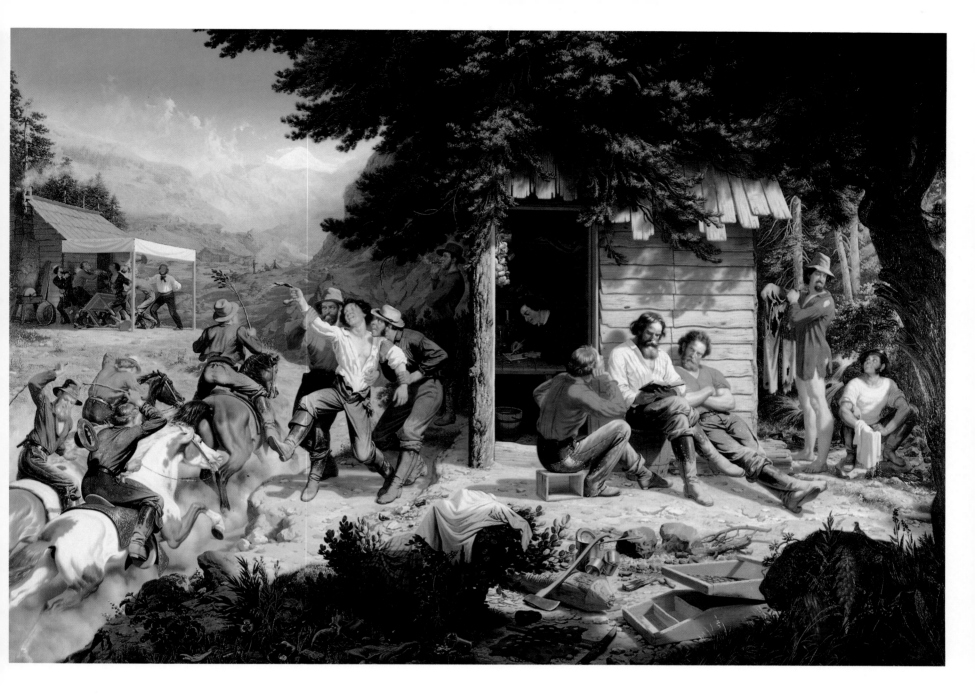

Sunday Morning in the Mines

CHARLES CHRISTIAN NAHL, 1818–1878

1872. Oil on canvas, 72 x 108 in.
E. B. Crocker Art Gallery, Sacramento.

In *Sunday Morning in the Mines* Charles Christian Nahl offers a nostalgic and moralizing recollection of the people and events that he saw and sketched during his sojourn in the mining camps during the California gold rush. He arrived in San Francisco in 1851 and proceeded to Sacramento, eventually purchasing a "salted" or bogus claim in the "Rough and Ready" mine.

Full of elaborately expressive figures painted in somewhat stiff theatrical poses, the large canvas is bisected by the log that forms the door jamb in the center of the picture. On the left vice and folly are humorously represented by a young drunken miner about to throw away his purse of gold, the racing horsemen, and the raucous figures at the cabin brawling over a card game. The discarded bottle and tin cans in the lower right bushes add to the image of immorality. At right, virtue and piety are symbolized by the man on a keg reading the Bible while two companions listen attentively. Two others, one of whom may be a sailor who has jumped ship to stake a claim in the diggings, dutifully prepare their weekly laundry. Inside the cabin a man works intently on a letter that reads, "Dear Mother, I have done well and I . . ." This figure has strong autobiographical associations, and may even be based on early self-portraits by the artist.

Nahl executed *Sunday Morning in the Mines* for his most enthusiastic patron, Edwin Bryant Crocker of Sacramento. This canvas and its pendant, *The Fandango*, a spirited scene of Spanish life in California, have traditionally hung facing each other in the Crocker Mansion in Sacramento, now the E. B. Crocker Art Gallery. The wealthy Californian and his brother Charles Crocker played leading roles in the development of the Central Pacific Railroad. As a judge, Edwin must have been pleased at the uplifting images that he acquired from Nahl which portrayed early California—although sometimes a rough-and-ready place—as an essentially moral, law-abiding society.

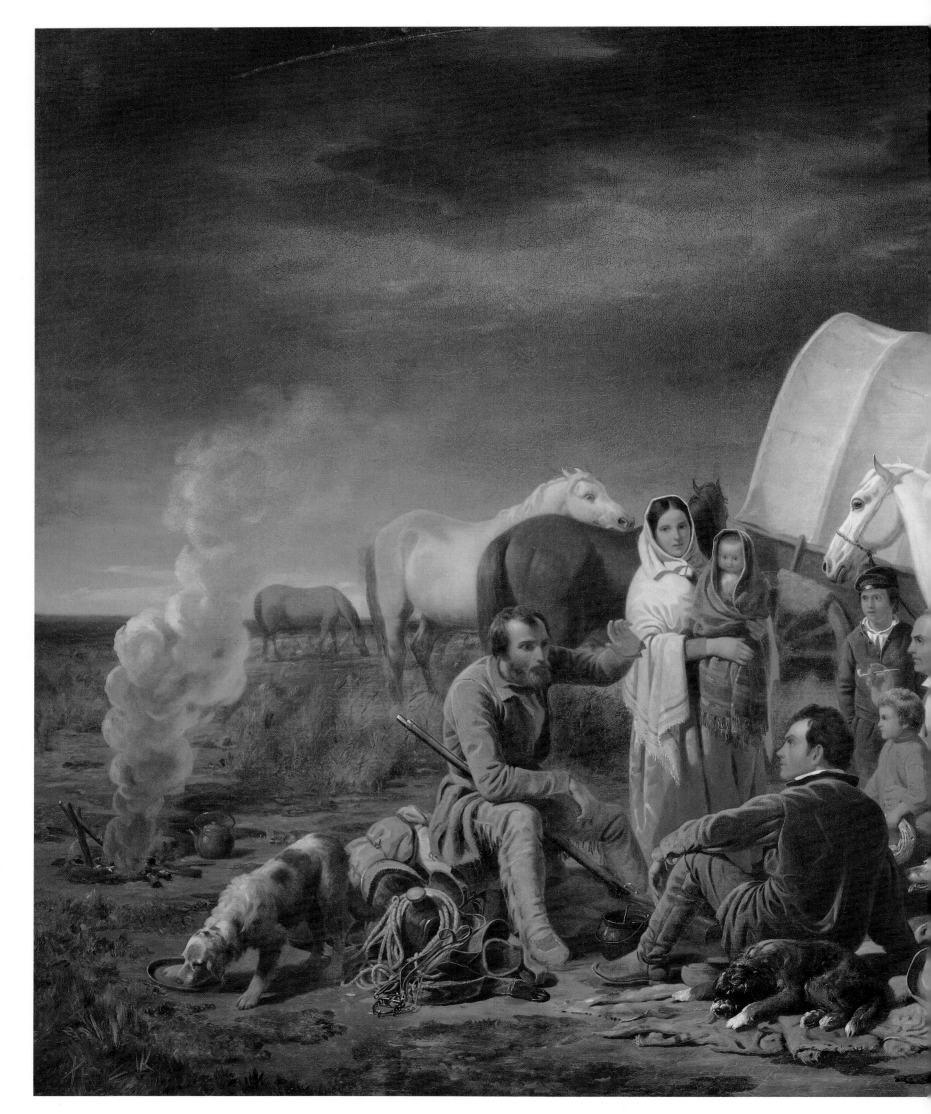

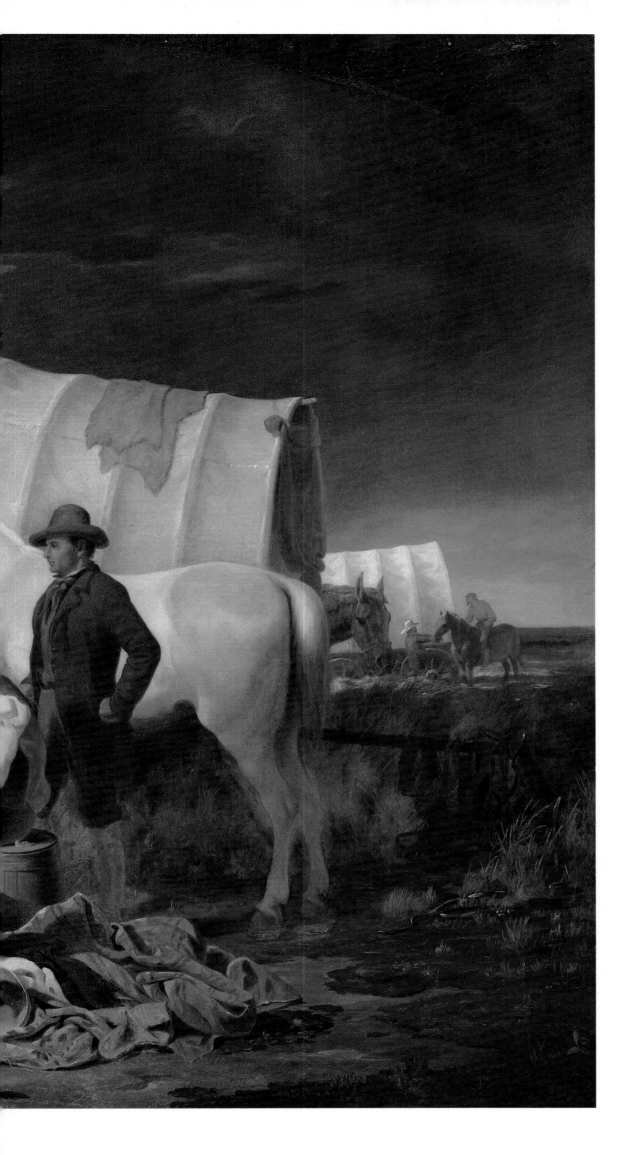

Advice on the Prairie

WILLIAM RANNEY, 1813–1857

1853. Oil on canvas, 40 x 54 in.
Private Collection

Goldseekers, farmers, merchants, and others going west overland badly needed reliable guides to show them the way and to help them survive en route. Typically scouts hired out at the most popular jumping-off points for wagon trains, notably St. Louis and St. Joseph, Missouri. Many of these guides had been fur trappers before a diminishing demand for beaverskin hats led them to seek other means of earning a living. Admired for their courage and resourcefulness and envied for their adventurous lifestyles, these colorful characters provided artists and writers with suitable subjects to offer an eastern market eager for western scenes. As Tuckerman noted, "Tales of frontier and Indian life—philosophic views of our (social) institutions—the adventures of the hunter and the emigrant—correct pictures of what is truly remarkable in our scenery, awaken instant attention in Europe. If our artists or authors, therefore, wish to earn trophies abroad, let them seize upon themes essentially American."[6]

William Ranney's *Advice on the Prairie*, also known in a smaller version as *The Old Scout's Tale*, is such a picture. Rich in anecdotal details that form an elaborate narrative about life on the trek west, the picture is dominated by the excited, buckskin-clad trapper recounting tales of frontier lore. Attending his every word are members of the prosperous, well-supplied family that he is guiding. Carefully arranged by Ranney, these emigrants represent types in the stages of life: the infant in the mother's arms, the young boy leaning on his father's knee, the seated youth in a gray coat, and finally the older man with the pipe, probably the father, whose head is on the same level as that of the trapper. The scout's excited face and animated gesture bespeak the frontiersman's skill with tall tales, while his heroic, confident presence marks him as a male role model for the youngsters clustered around him.

DETAIL ▶▶

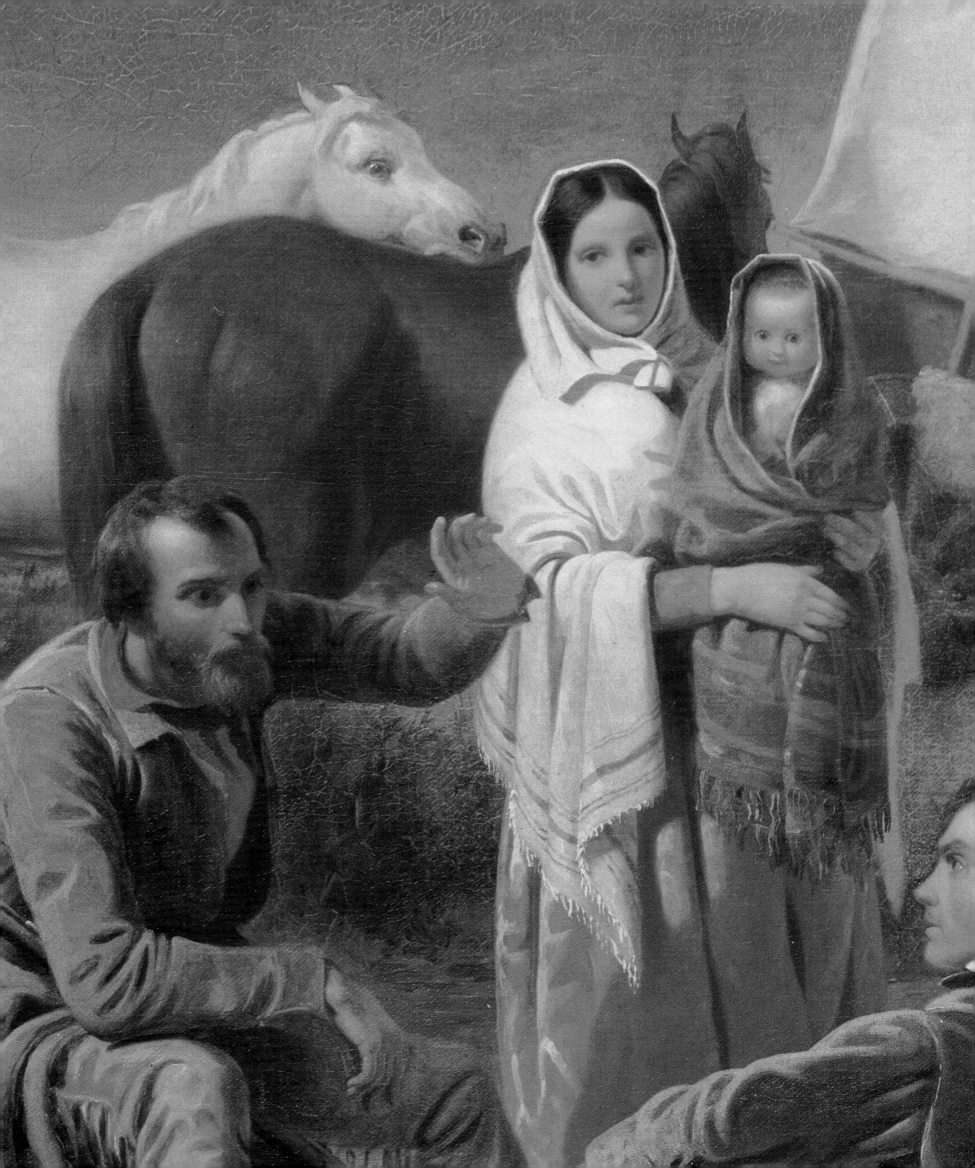

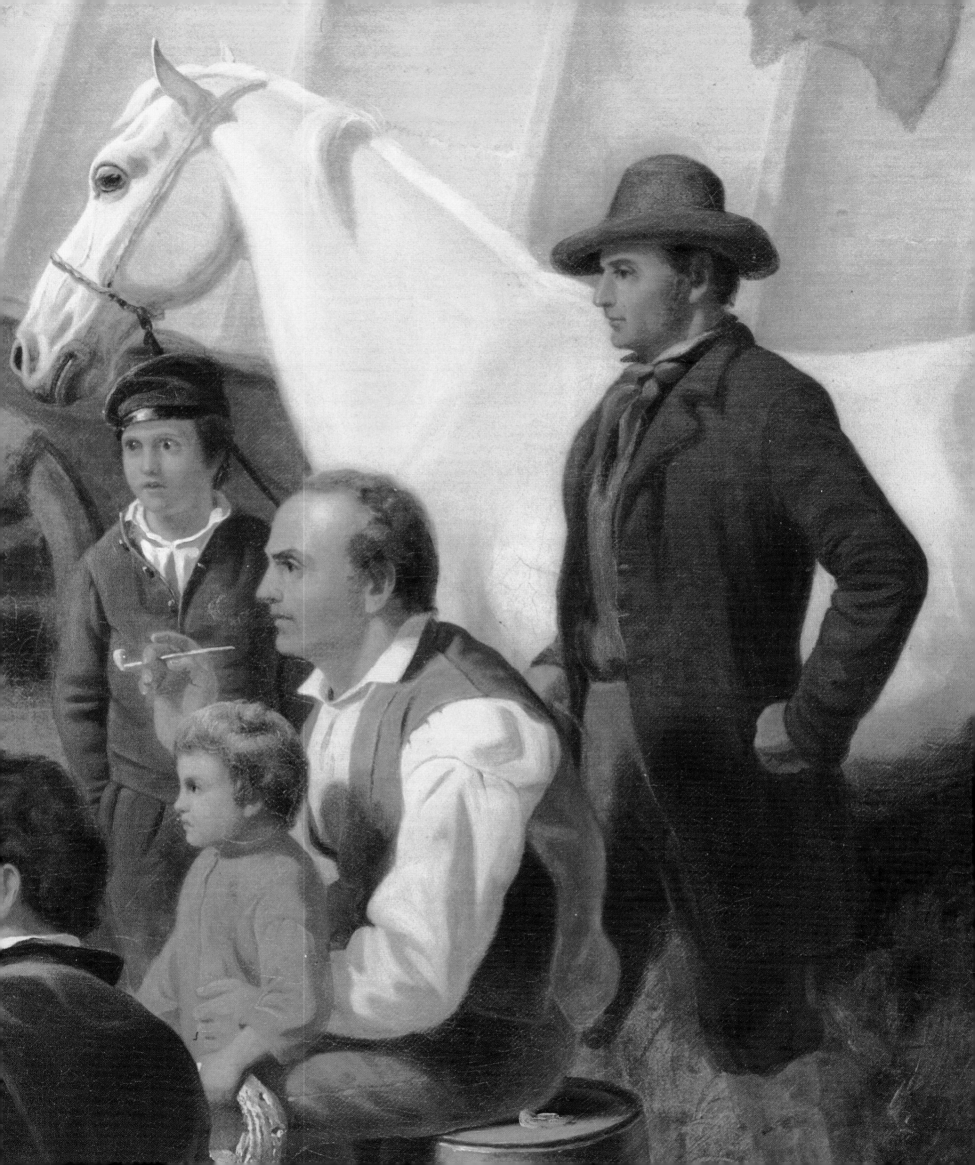

The Emigrant Train Bedding Down for the Night

**BENJAMIN FRANKLIN REINHART,
1829–1885**

1867. Oil on canvas, 40 x 70 in.
The Corcoran Gallery of Art, Gift of Mr. and Mrs.
Lansdell K. Christie, Washington, D. C.

In the late 1860s, as the transcontinental railroad was nearing completion, a number of artists looked back nostalgically to the wagon trains that had brought so many pioneers west before the railroad rendered them obsolete. Among these artists was the European Benjamin Franklin Reinhart.

Reinhart's painting *The Emigrant Train Bedding Down for the Night* offers an engaging view of a prosperous family of pioneers. Having made camp near a freshwater creek, they and their domestic animals refresh themselves and prepare for sleep. Unlike most paintings on this theme, Reinhart focuses primarily on the domestic and female side of pioneer life. The camp has been set up around a large kitchen kettle. Near the woman who is cooking, a young girl washes clothes in a tub and a bald-headed man with a rifle strokes a dog. To the left of this group a young child stands near its mother who holds an infant, and directly in front of them a young woman is accompanied by a gesturing boy. This woman, with her downcast eyes and folded arms, recalls the Virgin Mary or one of the good women of the Israelites. Pervading the scene—abetted by Reinhart's orchestration of the figures according to the stages of life—is a sense of harmony and order. The theatrical poses and gestures of the figures add to the benign and reassuring nature of the narrative.

Above the foreground group the tops of the covered wagons, which have been drawn together with their horses for the night, form a triangular composition. To be sure, Reinhart, who had never been west, exaggerates the height of the wagons' tops. At right, a supply wagon approaches, loaded with crates and casks and the other necessities for the journey. A warm yellow light envelops the scene, imparting a feeling of luminous harmony and suggesting that the emigrants have much to be grateful for this evening. The streaked clouds echo these emotions, forming grand personas that move across the sky as silent symbols of God's guidance in the pioneers' quest for the promised land. Of particular importance is the billowing cloud just to the left of the wagon top whose profile is reminiscent of George Washington.

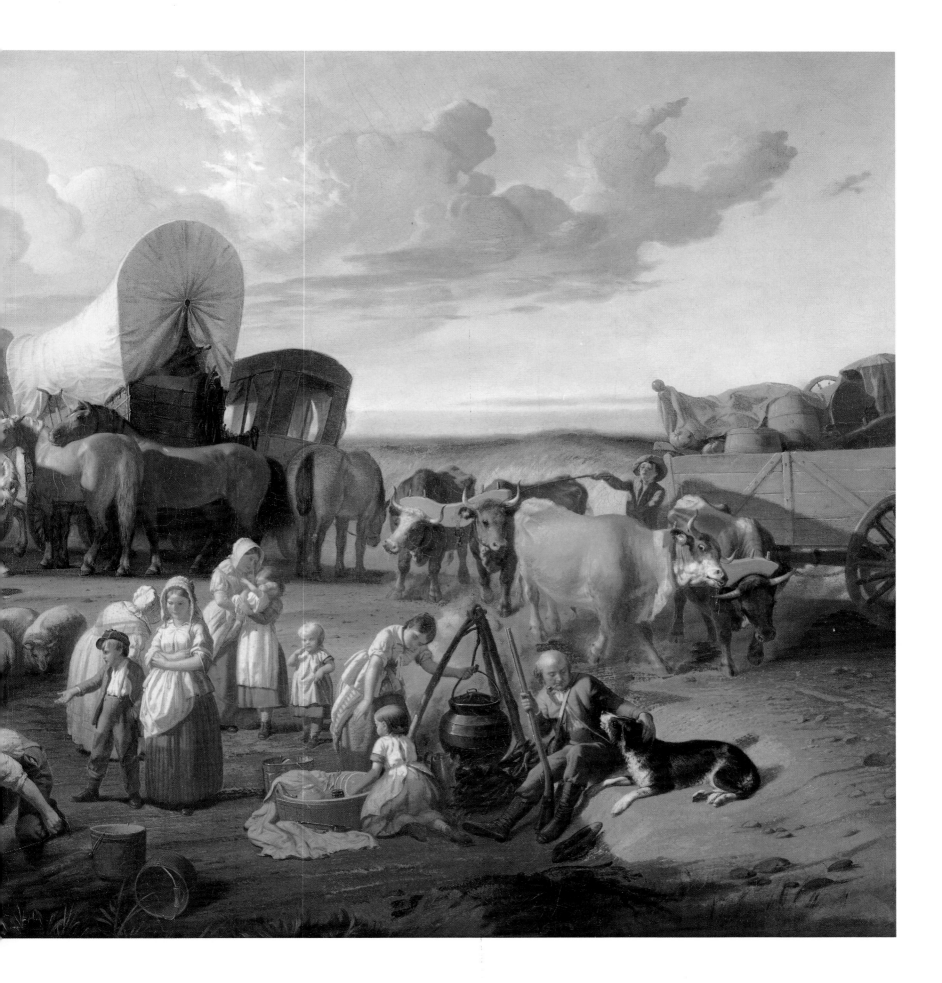

Emigrants Crossing the Plains or The Oregon Trail

ALBERT BIERSTADT, 1830–1902

1867. Oil on canvas, 60 × 90 in.
National Cowboy Hall of Fame and Western
Heritage Center, Oklahoma City.

Painted just two years before the completion of the transcontinental railroad, *Emigrants Crossing the Plains* or *The Oregon Trail* by Albert Bierstadt offers perhaps the most famous image of a wagon train making the heroic trek West in the 1850s. Like the pilgrims in Church's *Hooker and Company* (pages 18–19), Bierstadt's emigrants inhabit an idealized landscape, their expedition blessed by brilliant rays of light in a sunset sky, a symbol of the divine hand of national destiny. The rounded canvas top of the lead wagon passing beneath a cathedral-like canopy of trees is veiled in a golden halo as bright as any that ever gilded the head of a painted Renaissance madonna. Another wagon is emblazoned with the words "For Oregon."

To judge from the number and condition of the farm animals, this is a prosperous wagon train composed of people of varying economic and social classes. Fitz Hugh Ludlow, Bierstadt's traveling companion and chronicler of their 1863 journey to California, described such a band: "They had a large herd of cattle, and fifty wagons, mostly drawn by oxen, though some of the more prosperous 'outfits' were attached to horses or mules. The people themselves represented the better class of Prussian or North German peasantry. A number of strapping teamsters, in gay costumes, appeared like Westphalians. Some of them wore canary shirts and blue pantaloons; with these were intermingled blouses of claret, rich warm brown, and most vivid red. . . . I never saw so many bright and comely gems of an interior such as no Flemish ever put on canvas, and every group a genre piece" [7]

The way is marked by a freshly cut tree stump and by the still burning embers of an earlier party's campfire. At right, ox bones and a skull serve as reminders of the sacrifice made by animals in the great westward emigration. Also on the right is the wreck of a cast-iron stove. In the middle distance other settlers are encamped, in the faraway haze one can spy Indian tepees, and even further back a tower of rock, reminiscent of a medieval church spire, which completes the cathedral interior formed by the arching branches at left.

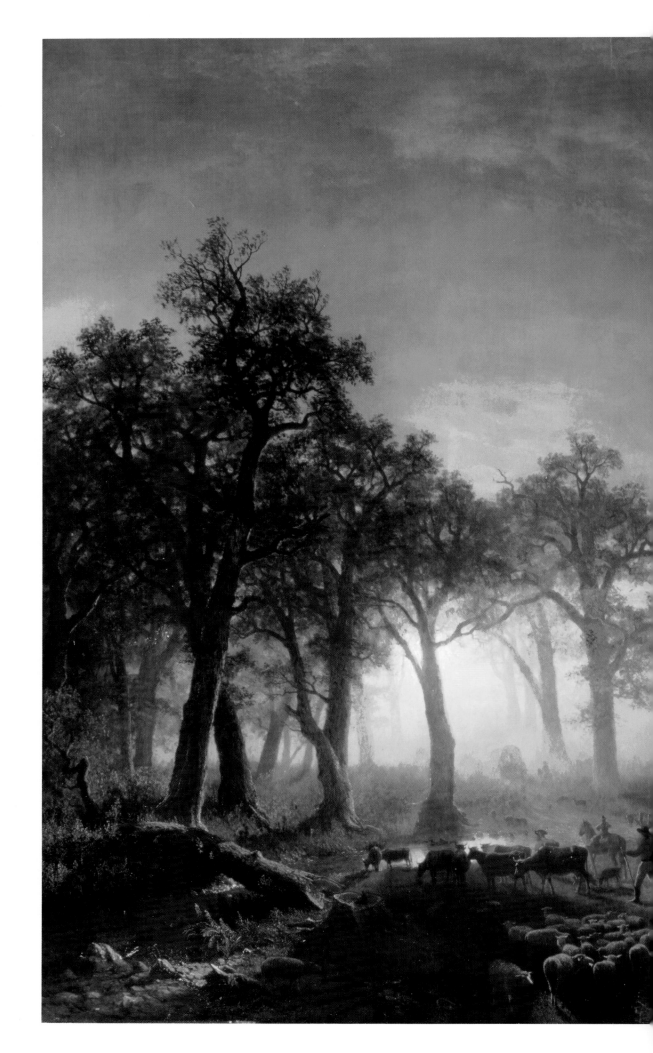

64

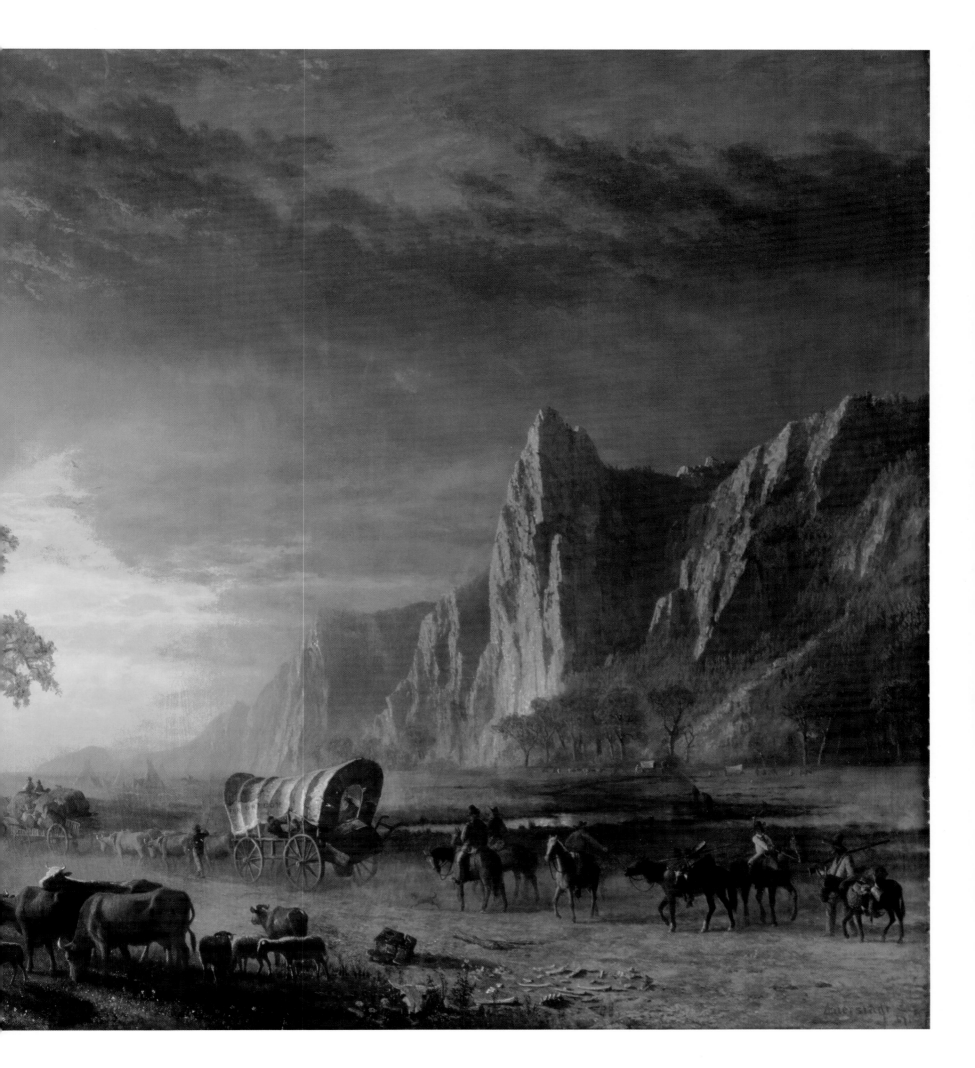

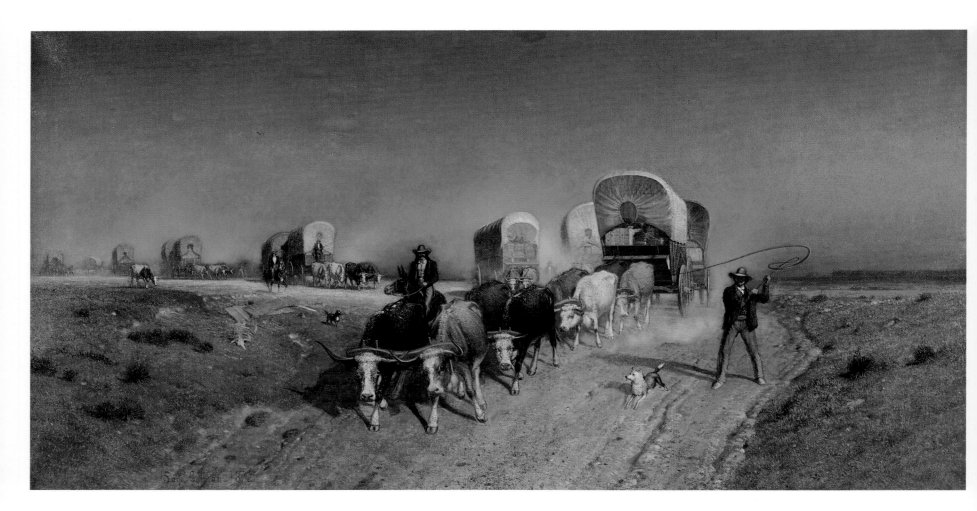

Ships of the Plains

SAMUEL COLMAN, 1832–1920

1872. Oil on canvas, 48 x 96¼ in.
The Union League Club, New York.

Samuel Colman's *Ships of the Plains*, painted more than 20 years after the great migration to Oregon and California, presents an imaginary but relatively accurate view of a covered wagon train going west. Unlike the grandiose religious and nationalistic sentiments that dominate Bierstadt's *The Oregon Trail* (pages 64–65), or the harmonious camp life in Reinhard's *Emigrant Train Bedding Down for the Night* (pages 62–63), Colman's large picture has a monumental, even stately, quality about it. There is a feeling of solidity and weightiness in its realistic depiction of a barren treeless plain punctuated by clouds of dust. In the foreground an especially large and heavy Conestoga-style supply wagon is drawn by a team of eight large oxen. Their need for constant attention and control, and the value of the wagon's contents, has the teamster at right in action: his bull whip in hand, his dog at the run, and his mounted companion guarding the beasts' other flank. Kit Carson's name adorns the wagon's top, a reference to the contributions of the famed scout in the opening of the West more than 20 years earlier.

Like Bierstadt and other artists of the period, Colman is careful to include references to the large quantities of debris and garbage scattered along the Oregon Trail. At left, the grisly skull of a dead cow and the broken sides and wheels of a wagon indicate that not all pioneers succeeded in completing the overland trek.

(FOLLOWING PAGES, TOP)

Encampment on the Plains

THOMAS WORTHINGTON WHITTREDGE, 1820–1910

1866. Oil on paper mounted on canvas, 7½ x 23 in. Gene Autry Western Heritage Museum, Los Angeles.

In 1866, Worthington Whittredge accompanied a U.S. Army expedition headed by General John Pope on a 2,000 mile trek up the Platte River from Fort Leavenworth, Kansas, to Denver and over the mountains to Santa Fe and Albuquerque. The party then returned to the western terminus of the railroad over the old Cimarron Trail. During this summer trip across present-day Colorado and New Mexico, Whittredge made perhaps a dozen on-the-spot oil studies on 8 x 22-inch paper, including sketches of the graves of travelers on the Oregon Trail.

An intriguing example of these small studies is Whittredge's *Encampment on the Plains*. A perfect antidote to the studio-created illusions of Bierstadt, Rinehart, Ranney and many others, this eyewitness rendering shows a seemingly random disposition of wagons and soldiers' tents. The sketchy handling of paint and the direct, unmediated view make the work especially attractive from a formalist and modernist perspective. Whittredge's studies were also valued as documents of actual events. Indeed, *Encampment on the Plains*, as well as *View of Santa Fe* (pages 208–209), had once been owned by Othniel Charles Marsh, professor of paleontology in the Yale Scientific School and director of the Peabody Museum.

(FOLLOWING PAGES, BOTTOM)

Graves of Travellers, Fort Kearney, Nebraska

THOMAS WORTHINGTON WHITTREDGE, 1820–1910

1866. Oil on canvas, 7¹⁵/₁₆ x 22¹³/₁₆ in. The Cleveland Museum of Art, Andrew R. and Martha Holden Jennings Fund.

The 19th-century artist's image of the national westward movement was often idealized, romanticized, and created for commercial or political advantage. Today these nostalgic and ideologically inspired paintings are of special interest to art historians since they are excellent barometers of intellectual and artistic movements of the period in which they were created. But the remarkable *plein air* oil studies created during Worthington Whittredge's first Western trip in 1866 do not fall into this category. They may be as close as one can come to a hand-painted, yet authentic, unidealized rendering of a specific time and place.

Graves of Travellers, Fort Kearney, Nebraska is especially noteworthy for its apparent compositional immediacy and its unusual subject matter. Here Whittredge allows the autonomy of the visual experience to take hold. The vast space of the treeless plain is expressed powerfully by the extreme horizontal format. Space is reduced to elongated, rigidly parallel bands, and there is a *total* absence of any picturesque accessories or framing devices.

It is the plains themselves that overlay the work with a mysterious meaning. In his autobiography, written almost four decades after his travels in the West, Whittredge described his expectations on first seeing the flat, treeless vistas: "Nothing could be more like an Arcadian landscape than was here presented to our view . . . the earth [is] covered with soft grass waving in the wind, with innumerable flowers often covering acres with a single color as if they had been planted there."[8] In this sketch direct visual perception dominates over the literary and historical associations of Arcadia and the sentiments of a romantic primitive existence, yet there remains a distant resonance of these mythic ideals.

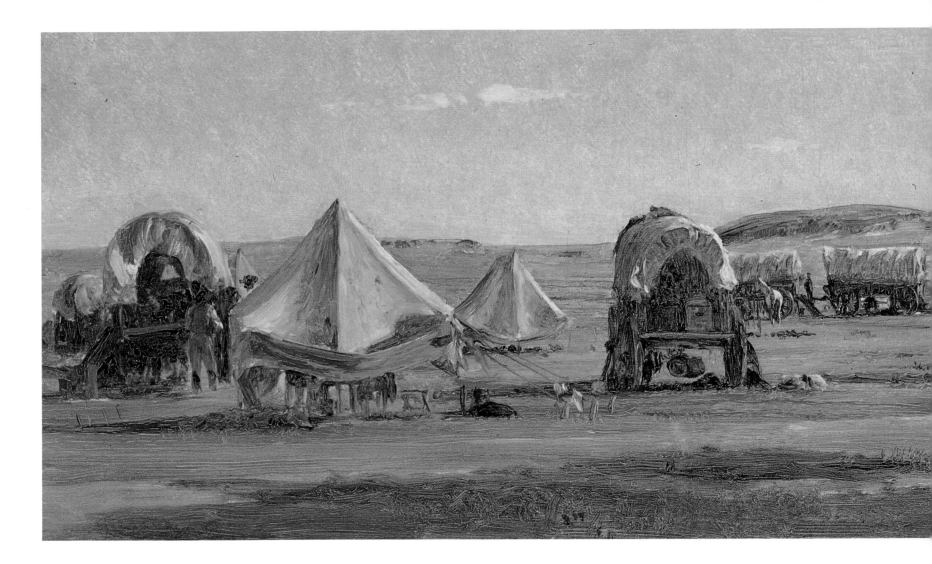

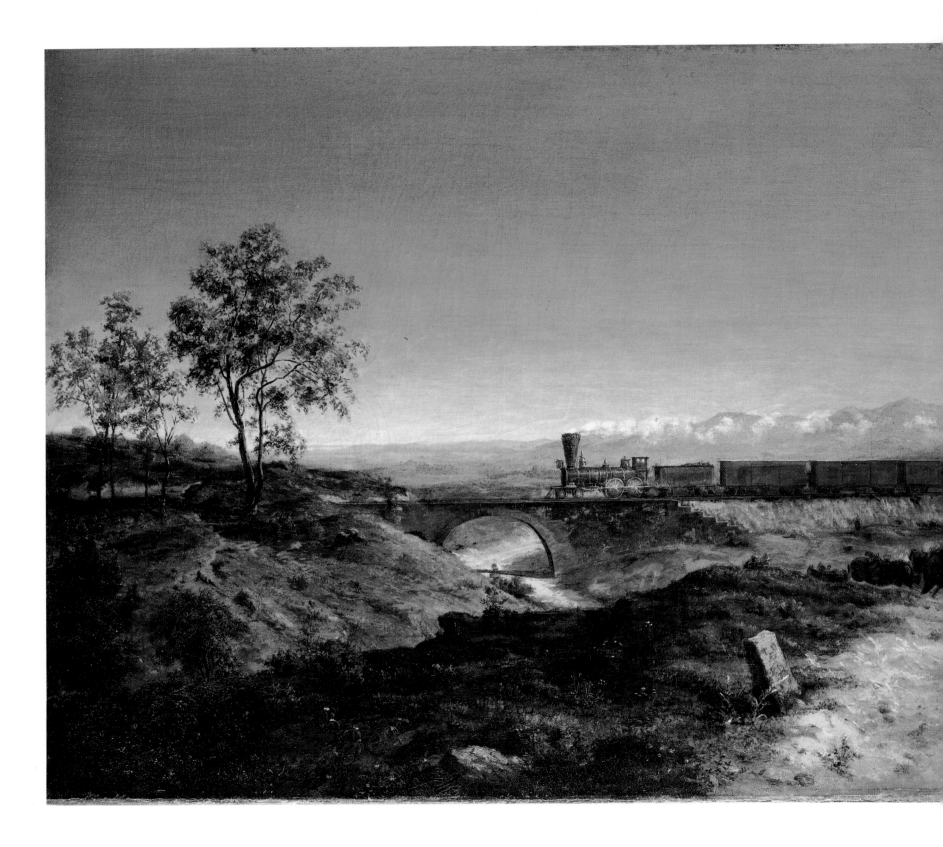

On the Road

THOMAS OTTER, 1832–1890

1860. Oil on canvas, 22½ x 45⅜ in.
The Nelson-Atkins Museum of Art, Nelson Fund,
Kansas City, Missouri.

The pleasing contrast between the new technology in transportation, the steam train, and the famed Conestoga Wagon, which had played such a key role in opening the West, is the subject of Thomas P. Otter's well-known painting *On the Road*, completed on the eve of the Civil War.

In the distance is the new technological wonder reproduced in minute detail as it runs over a fine stone bridge, reminiscent of an ancient Roman structure. Great speed is suggested by the trailing plume of smoke and steam. The railroad possessed the near magical power to annihilate space and time. Indeed, trains could travel in five or six days the same distance that it had taken the pioneers bound for Oregon and California in the 1840s and 1850s five or six months to traverse. The completion of the transcontinental railroad seemed to mid-19th-century Americans to fullfill Columbus' dream of traveling west to reach the riches of the East.

In the foreground, Otter places the lone Conestoga wagon rattling along the wheel-eroded ruts of the overland trail. By contrast to the perfectly level track created for the train, the wagon faces steep hills and valleys on its journey. Otter's simple but appealing image couples the sentiments of nostalgia for the overland wagon treks with a near veneration of the railroad's power. The prospect of crossing the continent by stream train was especially promising at the time of the painting's execution as Americans looked forward to the completion of the long-awaited transcontinental railroad, in spite of the postponement because of the Civil War.

Thomas P. Otter is one of those 19th-century American artists about whom virtually nothing is known. He exhibited at the Boston Atheneum and the Pennsylvania Academy of Fine Arts, which listed *On the Road* for sale in 1860. Few other extant works by the artist have been identified.

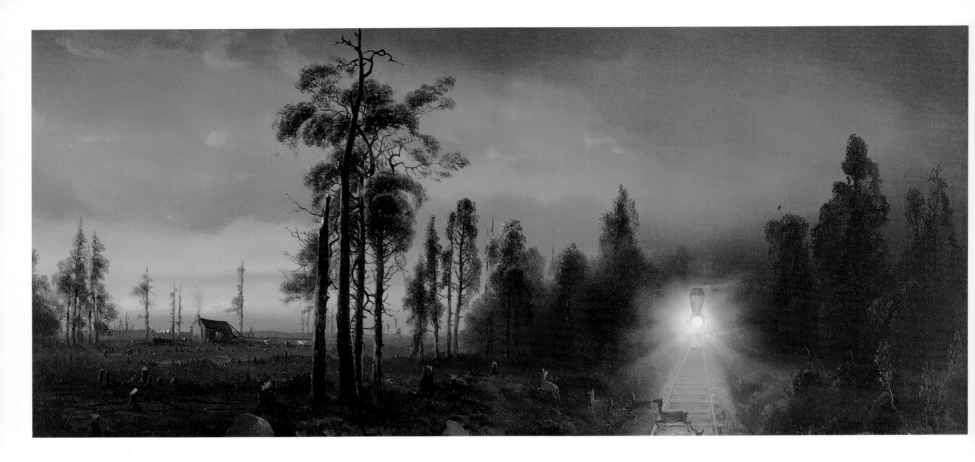

Westward the Star of Empire Takes Its Way—Near Council Bluffs, Iowa

ANDREW MELROSE, 1836–1901

circa 1865. Oil on canvas, 25¼ x 46 in.
E. W. Judson, New York.

The conclusion of the Civil War brought renewed calls for the immediate completion of the transcontinental railroad. Andrew Melrose, a New York painter who had never traveled west, responded with his impressive painting *Westward the Star of Empire Takes Its Way—Near Council Bluffs, Iowa,* dated 1865. Little is known from contemporary newspaper sources about Melrose or the reception of his picture. It is clear, however, that the image dramatically combines several key iconographic symbols to express an optimistic, confident outcome to the long-sought link between the Atlantic and the Pacific.

At right, rushing directly toward the viewer, is the brilliant headlight of a train engine, red flames issuing from its smokestack. The light catches a herd of deer crossing the track, and momentarily freezes them in motion. The deer and train are very unequal forces, the latter a product of the sublime, unstoppable force of technology, the former part of the wilderness that civilization will inevitably replace.

On the left side of the picture one can already see the impact of technology at work in the pioneer homestead situated near Council Bluffs, Iowa, then close to the western terminus of the railroad. A small log cabin is lit by the rising sun. Man's brutal destruction of the wilderness can be seen in the multitude of tree stumps, strongly resembling tombstones. Tiny figures by the cabin, laundry set out to dry, and grazing cattle tell of the settler's hopes for prosperity, now that the railroad runs through his area. In the foreground, stand a group of trees, denuded of their leaves through the technique of girdling to make room for the pioneer's home and fields. These proud sentinels, having once sheltered deer perhaps, or a band of Indians, are now shadows of their former beauty.

DETAIL ▶

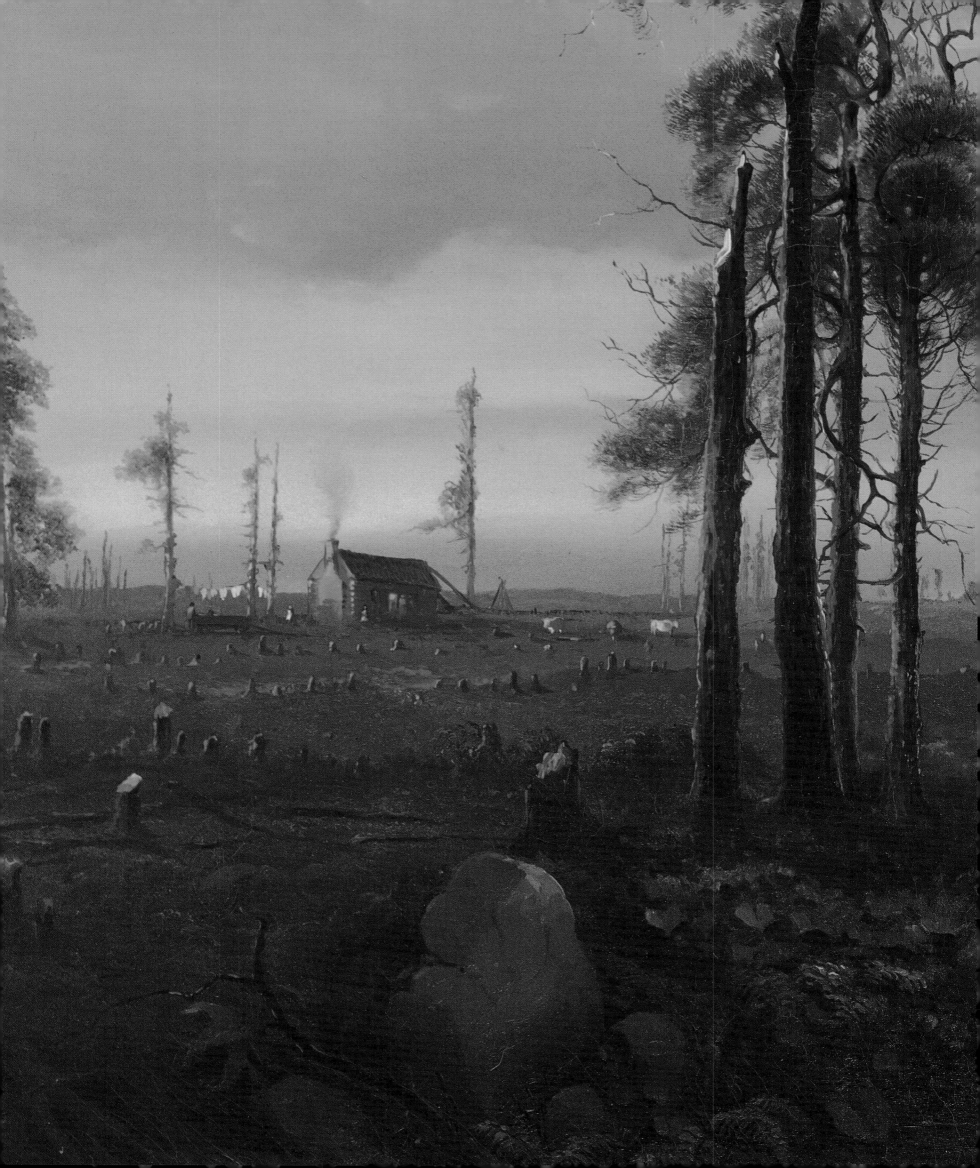

Railway Train Attacked by Indians

THEODORE KAUFMANN, 1814–AFTER 1887

1867. Oil on canvas, 36¼ x 56¼ in.
The John F. Eulich Collection, Dallas.

Numerous exaggerated accounts of Indian attacks on trains and train workers were published during the late 1860s as the railroads pushed west from Kansas and east from San Francisco to join at Promentory Point, Utah, in 1869. In *Railway Train Attacked by Indians*, Theodore Kaufmann turns from his previous interest in Civil War scenes to

depict such a confrontation. The painting draws much of its power from the striking contrast between its calm moonlit setting and the image of the train hurtling toward certain disaster. Kaufmann places the viewer directly in front of the advancing locomotive. In so doing, he creates a fascinating irony, for it is the terribly destructive act of the Indians—the removal of the steel rail that will cause the train to derail—that "saves" the imperiled viewer from collision with the oncoming locomotive.

The Indians' technological inferiority rendered them unable to compete with the whites for domination of the North American continent. This fact is made evident by the crude stone ax, hastily abandoned by the retreating figure at the left. Meanwhile, at right, a remarkable improbability is occurring as a single Indian warrior lifts an iron railroad track with one hand.

The treatment of the Native Americans in Kaufmann's polemical picture is surely among the most blatantly racist of the mid-19th century. Scholars have argued that the precise rendering of the figures' war-painted heads drew inspiration from the portrait photographs of Native Americans then just beginning to document Indian life in the West. 9

The Last Spike

THOMAS HILL, 1829–1908

1877–1881. Oil on canvas, 96½ x 240½ in.
California State Railroad Museum, Sacramento.

The railroad was enormously important to the winning of the West and the painting that did the most to memorialize that contribution is *The Last Spike* by Thomas Hill, a San Francisco artist best known for his pictures of Yosemite and the rugged California landscape.

The enormous painting represents the climactic moment that occured on May 10, 1869, when a golden spike was driven into the wooden ties at Promentory Point, Utah, to mark the meeting of the Union Pacific and the Central Pacific and the completion of the first transcontinental railroad after more than half a century of attempts to connect the Atlantic and Pacific seaboards. The gigantic canvas, originally 8 by 12 feet, contains about 400 figures, 70 of which are portraits. As president of the Central Pacific, Leland Stanford stands in the center, holding a hammer, ready for the ceremonial moment. Amid a sea of mostly white male faces, two women and an Indian are represented. The American flag, the engines about to unite the East and the West, and the Western landscape are glimpsed in the background.

According to Hill, Stanford had commissioned the painting from him in 1875, describing in great detail how the painting was to be composed, and most importantly who was to be included and with what degree of importance. Stanford even gave Hill a railroad pass, enabling him to visit the sites and make sketches. Hill recounted how "Many of his [Stanford] friends, not present on the occasion, he ordered painted into the group, which proved to me that he was arranging a picture for himself."[10] The commission seems to have been set aside in Stanford's mind when he was sued by another artist, whom he had commissioned to carve improbable allegorical sculptures showing his emergence from the clouds on a locomotive. At any rate, Stanford refused to pay for the enormous picture he had ordered. In 1884, still unable to sell the painting, the artist, in frustration and evidently some annoyance, published a pamphlet, "History Of The 'Spike Picture' And Why It Is Still In My Possession."[11]

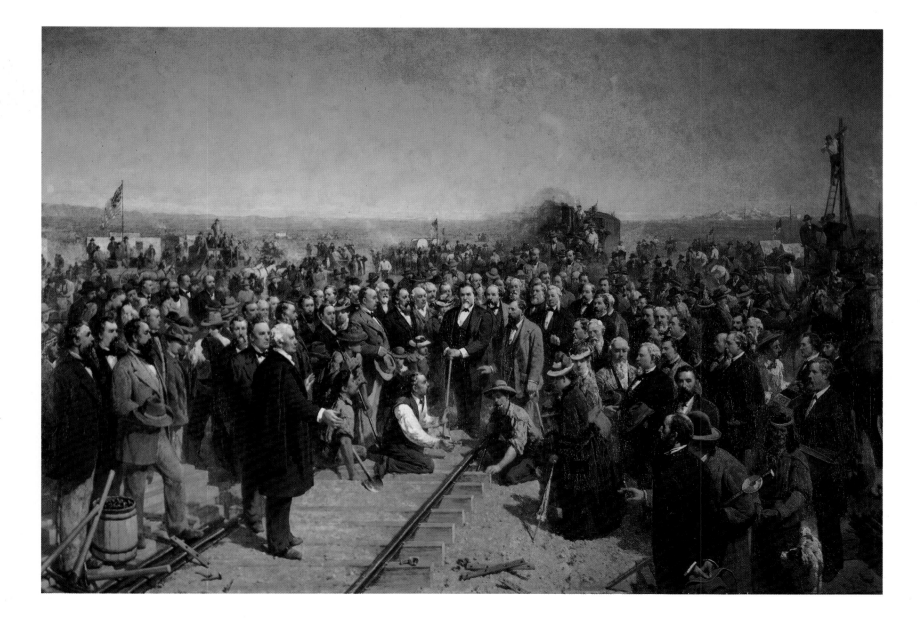

Donner Lake From The Summit

ALBERT BIERSTADT, 1830–1902

1873. Oil on canvas, 72 x 120 in.
The New-York Historical Society, New York, New York.

America's pride in the transcontinental railroad found its way into many paintings and popular prints during the late 1860s and 1870s. Among these was Albert Bierstadt's *Donner Lake From the Summit*, commissioned by Colis P. Huntington, director of the Central Pacific Railroad.

The site chosen for the painting became notorious in 1846 when the Donner party, a wagon train of settlers, was trapped in the pass at the summit of the Sierra Mountains by a snowstorm. Their terrible ordeal, which led them to resort to cannibalism to survive, was often recounted in pioneer guide books and later in railroad travel guides. To avoid the problem of heavy snowfalls in the mountain passes, particularly the Donner Lake summit, the Central Pacific had constructed miles of snowsheds. These enormous wooden structures, of which the railroad was justifiably proud, are clearly visible in the right side of Bierstadt's picture, where they stand in marked contrast to the old winding wagon road below. Although Bierstadt selected a summer scene enveloping the landscape in a warm golden light, he was still conscious of the Donner party's ordeal, indicated by the comparatively bleak foreground.

At the time of the painting's completion, one popular railroad guide book noted the associations commonly perceived in the scene: "As we look down from the beautiful (railroad) cars, with every want supplied and every wish anticipated upon that historical and picturesque spot in the summer, where those poor immigrants suffered all that humanity could suffer, and died in such a heart-sickening way, we could not release ourselves from the sad impression which this most terrible item in the history of those times made upon the mind."[12]

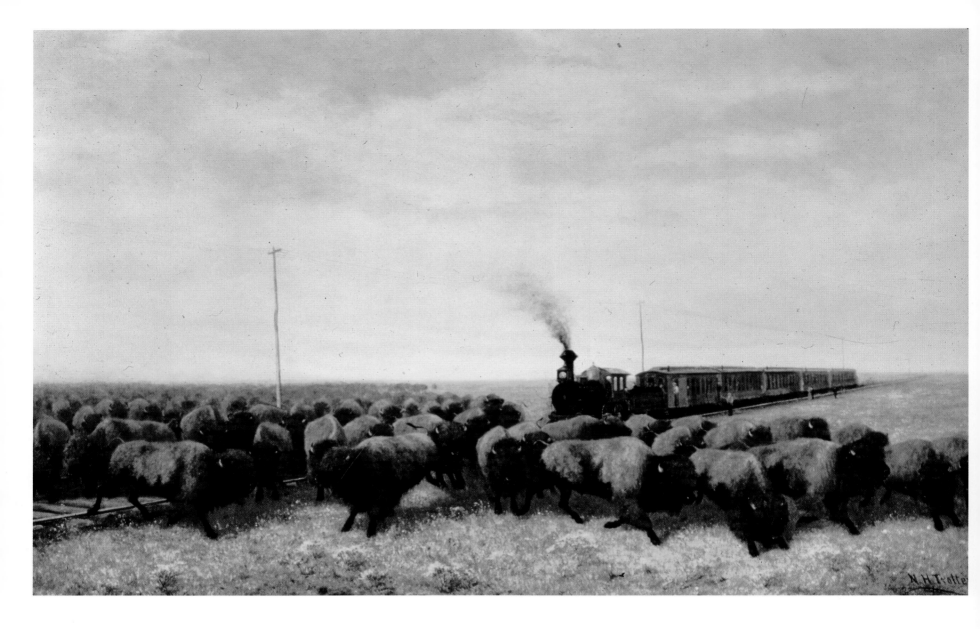

Held Up

NEWBOLD TROTTER, 1827–1898

1897. Oil on canvas, 42 x 51½ in.
National Museum of American History, Smithsonian Institution, Washington, D. C.

By the end of the 19th-century the American bison had become virtually extinct. By contrast, only 50 years earlier the beasts had been so plentiful that travelers on the prairie had been forced to wait—sometimes for several days—as giant herds went past. Such an event is depicted in *Held Up* by

Newbold Trotter. Although incidents like the one Trotter painted were exceptional, the outcomes were rarely so peaceful. In fact, the shooting of buffalo from trains was a well-established sport in the 1870s, and contributed to the rapid decimation of these splendid animals. Because of the earlier slaughters, the scene depicted in *Held Up* could not have occurred in 1897 when Trotter's painting was completed

Trotter is known primarily as an animal painter who worked around New York. He did not travel in the West and may have taken the idea for his dramatic picture from an 1868 illustration in *Frank Leslie's Illustrated Newspaper*. Entitled a "Buffalo Hunt by Steam" the illustration showed the passengers surrounded by a herd of bison

slaughtering the great beasts from the windows and roof tops of the railroad passenger cars. In Trotter's painting, however, the emigrants simply disembark to admire the passing animals. Accordingly, *Held Up* may say more about the glow of nostalgia that colored perceptions of the West at the turn of the century and a relatively minor artist's desire to capitalize on those sentiments than it does about the actual behavior of travelers in the 1860s and 1870s.

Morning of a New Day

HENRY FARNY, 1847–1916

1907. Oil on canvas, 22 x 32 in.
National Cowboy Hall of Fame and Western
Heritage Center, Oklahoma City.

For easterners who wished to go west, the railroad came as a major technological breakthrough, dramatically reducing the time of such journeys and eliminating many of the hardships along the way. To the Native Americans, across whose lands the railroads stretched, the Iron Horse also brought change, but it was unwelcome, for it spelled the beginning of the end of their ancient way of life. Henry Farny's *Morning of A New Day* offers a compelling— even a haunting—view of the impact of the railroad on the American Indian.

Like many of the titles of Farny works, *Morning of A New Day* has a sharp edge of irony. Instead of the chance for renewal and fresh opportunities, qualities usually associated with the dawning of a new day, to the Native Americans watching silently from a precipice as a locomotive chugs through the valley below, *this* morning represents not beginnings but endings, not renewal but loss. The settlers who will arrive on that train will establish homesteads, fence in lands, graze cattle in pastures, and build towns, and to do so they will occupy the lands through which the Native American used to roam freely and will destroy the game that he hunted. Moreover, the destructive impact of civilization's advance will not just affect the tribe's proud warriors. As Farny's work makes clear, there are women, children, and elderly people on that mountain and they look cold, tired, and hungry.

Representing the summation of decades of reflection on the condition of the American Indian, Farny's picture is about nothing less than the loss of a living culture. That this work was created for an urban, middle class audience whose dominant position on the American continent had been underwritten by the dispossession of this indigenous population is perhaps the ultimate irony. Of course, the painting could easily have been viewed as another nostalgic encounter between Indians and trains, and might have been read at first glance as an attempt on the part of the artist to please his patrons in Cincinnati, Ohio, with yet another idealized image of the winning of the West.

There are western artists who are known better today than Henry Farny, but there are none who more honestly depicted the impact of America's colonial expansion on the Native Americans. Born in France and trained in the French academic tradition, Farny often visited the West in the 1890s. But he *never* painted cowboys, preferring to concentrate instead on recording the people and customs of the rapidly disappearing Indians.

DETAIL ▶▶

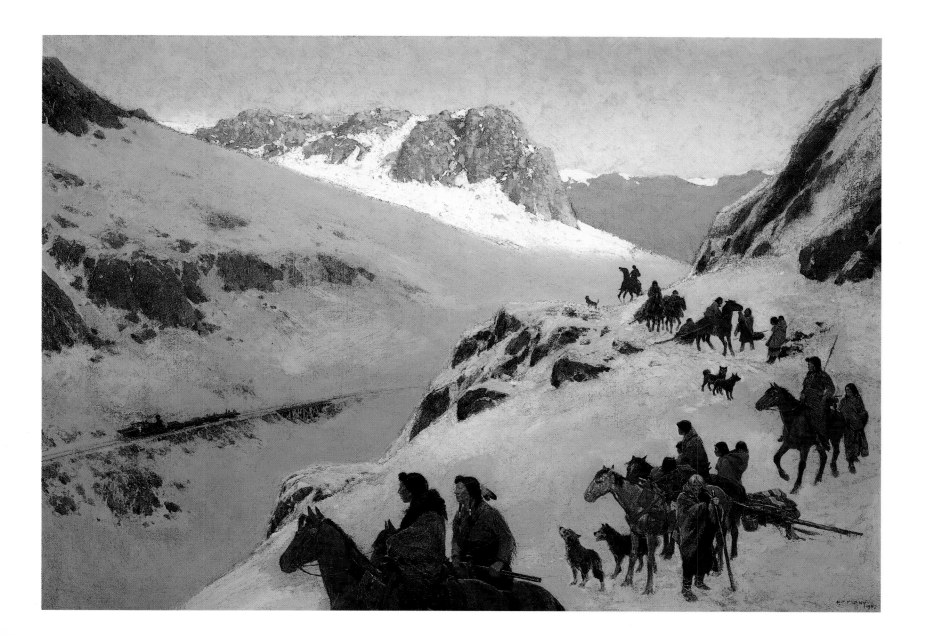

Snowstorm in the Sierra

WILLIAM HAHN, 1829–1887

1876. Oil on canvas, 21 x 33 in.
California Historical Society, San Francisco.

The principal means of transportation available to Americans headed west, the covered wagon and the stagecoach, came to represent for later generations heroic aspects of life on the frontier. *Snowstorm in the Sierra*, painted by California artist William Hahn in the centennial year, played to the nostalgic regard his countrymen felt for the stagecoach whose continued existence was threatened by the arrival of the railroad. Inspired by a winter journey that the artist took through the Sierra Mountains, the painting vividly conveys the difficulties experienced by a group of travelers during a blinding snow storm. Five horses struggle to pull a heavy coach over a snow-covered road, spurred on by an impatient coachman who wields his whip in a dramatic gesture. Only the glimpse of some trees and a hillside at the right give any sense of direction or location. It is an image of stark simplicity, without idealization. Yet a feeling of warmth pervades the painting, one that recalls the pictures of snow-covered landscapes by New England artist George Henry Durrie.

Although his work received little recognition during his lifetime, Hahn is admired today because he largely avoided the romantic and overtly sentimental subjects that dominated paintings of the 1870s and 1880s. *Snowstorm in the Sierra* is particularly memorable because it seeks to faithfully record a moment in contemporary history, albeit one that the artist and his patrons knew was fleeting in the age of railroads and the closing of the old West.

The Hold Up

CHARLES M. RUSSELL, 1864–1926

1899. Oil on canvas, 30⅜ x 48¼ in.
Amon Carter Museum, Fort Worth.

*T*he Hold Up was one of Charles M. Russell's favorites among his own works, and exemplifies the artist's love of droll story-telling. Set against a dark but colorful background of trees that create a theatrical setting, the Deadwood stage has been brought to a halt by the infamous highwayman Big Nose George. In front of the stage, their hands in the air, are a group of passengers representing "the cast of characters who people the historic West," to quote Peter Hassrick in his recent study of Russell. "The preacher, the prospector, the schoolteacher, the widow who operated the boardinghouse in Miles City, the gambler, the Chinaman,

and the New York dude recently arrived to open a men's store."[13] In front of the hold-up victims are their "treasures"—a bible, a woman's handbag, playing cards, and a liquor flask—and a little farther off the real loot, a strongbox. On the tree behind Big Nose George's horse are two ironic signs. One tells the distance to Deadwood, while the other offers a $1000 reward for George himself.

For 20th century Americans growing up on western films and TV series, The Hold Up offers an all too familiar image of the Old West. But the idea for the painting had its origins in an 1890 engraving by J. H. Smith which appeared in *Frank Leslie's Illustrated Newspaper*. Russell refined the image in several drawings and watercolors, combining reality and fantasy. There was in fact a holdup man named Big Nose George Parrott; he was arrested in Miles City and hanged by vigilantes in 1881, only a year after Russell arrived in Montana. As for the highwayman's method of operation, as one of Russell's friends explained, the highwaymen would "lie in wait at some secluded spot on

the road for a coach . . . and when near enough, [they] would spring from their cover with shotguns with the command, 'Halt! throw up your hands!' While part of the gang kept their victims covered, others would 'go through' their effects. A failure to comply with the order or any hesitancy in obeying it, was sure to cause the death of the person so disobeying." [14]

Despite the grim picture painted by Russell's friend, who incidentally owned The Hold Up, the artist chose to make Big Nose George more comic than threatening. As Russell scholar Brian Dippie observes, Russell's realism often lost out to his belief that things were always better in the past. As the artist told an interviewer in 1921, "We had outlaws, but they were big like the country they lived in."[15]

The Noble
Native American

The Noble Native American

The White Cloud, Head Chief of the Iowas
GEORGE CATLIN

Unlike Europe, 19th-century America had no ancient ruins, no monuments to symbolize its national past. Thus, artists seeking to define the identity of the young nation inevitably turned for inspiration to the vast, unexplored wilderness and to the indigenous people with their primitive, exotic customs and romantic legends. What the Native American actually was can never be known as 19th-century artists invented and reinvented the image that has come down to us today to serve the changing needs of the expanding nation.

While the Native American was a prime symbol of the New World, he also was a serious impediment to the national ambition for a transcontinental empire, and his possession of the land was an obstacle to the unfettered triumph of American progress. It became evident by as early as the end of the 18th-century that the United States and the Indian people were on a collision course. The whites had no doubt that in the struggle between what they saw as civilization and what they believed was savagery, Anglo-American virtue would triumph. It was left to the painter to record the Native American cultures before they disappeared.

In the decades preceding the Civil War, George Catlin, Charles Bird King, Karl Bodmer, and Carl Wimar among others painted romantic images of the noble Indian living in idyllic freedom beyond the frontier of advancing white civilization. Catlin wrote in the introduction to his great treatise *Letters and Notes on the Manners, Customs and Conditions of the North American Indians*, published in 1844, "I have, for many years past, contemplated the noble race of red men who are now . . . melting away at the approach of civilization . . . and I have flown to their rescue—not of their lives or of their race (for they are '*doomed*' and must perish), but to the rescue of their looks . . . [so that] phoenix-like, they may rise from the 'stain on a painter's palette,' and live again upon the canvas, and stand forth for centuries yet to come, the living monuments of a noble race." Several of Catlin's masterful "stains on a painter's palette" are reproduced in this chapter, powerful expressions of the artist's idealistic, if somewhat opportunistic commitment to preserve the appearance of the Native Americans for posterity.

Ironically, while the Indians still roamed free in the lands reserved for them, artists and writers often depicted the noble native from the safe remove of history. Thus, the living Indians of the day were ignored while famous Indians of the past were

Indians Approaching Fort Union
CARL WIMAR

◄◄
In the Foothills of the Rockies (detail)
HENRY FARNY

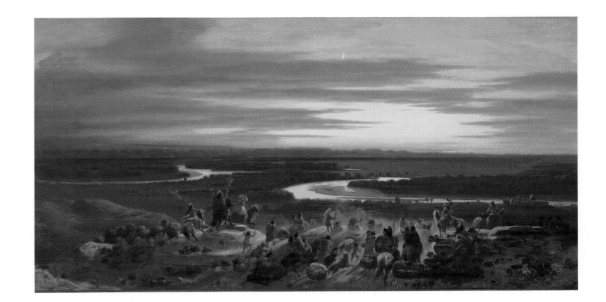

With the Eye of the Mind
FREDERIC REMINGTON

Hiawatha
THOMAS EAKINS

revived in the literature and art of the ante-bellum period. The most notable example of this was Hiawatha, immortalized in Henry Wadsworth Longfellow's epic poem *The Song of Hiawatha*, published in 1855. This story of the long-ago Indian Prometheus, his noble deeds, and his love life in the picturesque forests of the remote Lake Superior region engendered widespread popular admiration for the vanishing Native American culture. Longfellow's poem also inspired paintings by Albert Bierstadt, Thomas Moran, and even Thomas Eakins.

After the Centennial in 1876, the image of the noble Indian became cloaked in nostalgia. By the 1880s, it was apparent that what Catlin had called the "juggernaut of American progress" had succeeded in eliminating the "Indian problem" by killing off most of its remnants and removing the rest to reservations. In the moody, poetic art of Ralph Albert Blakelock the Indian became a metaphor for—even a spiritual symbol of—an introspective primitivism. Even the most famous artist of the old West, Frederic Remington, who typically painted the warlike savage, found at the end of his career a modest place for the image of the noble Indian in his evocative painting *With the Eye of the Mind*.

But it was Remington's contemporary, the French trained artist Henry Farny who uniquely saw in the plight of the Native American a powerful symbol of the tragic loss of a living culture. His *Sound of the Talking Wire* is filled with pathos as an aborigine confronts, without fully realizing its significance, the technological superiority of white civilization. Robert F. Berkhoffer, Jr., in his major study *The White Man's Indian: Images of the American Indian from Columbus to the Present*, published in 1978, astutely noted that, "Even those American [artists] who depicted the nobility of the Indian agreed with most of their fellow countrymen on the fate both good and bad Indians deserved when measured against the destiny of the United States. The quest for American cultural identity, the role of the United States in history, faith in future greatness of the nation, and the fate of the Indian and the frontier in general were all seen as connected by the White Americans of the period." Berkhoffer concluded that, regardless of whether the Indian was noble or savage, he was doomed and his place would be taken in the inexorable march of American civilization.

As explained in the final theme that this book will consider, the artists of the early 20th century became increasingly nostalgic for the Indian's vanished way of life. These transplanted easterners and midwesterners reflected the primitivist urge of an urban and industrial society to see in a vanished culture a simpler and better way of living. From that perspective, Eanger Irving Couse's haunting, dreamlike painting, *A Vision of the Past*—with its compelling vision of a captive race whose heritage has been appropriated for the profit of the motion pictures—serves as a fitting conclusion to this chapter.

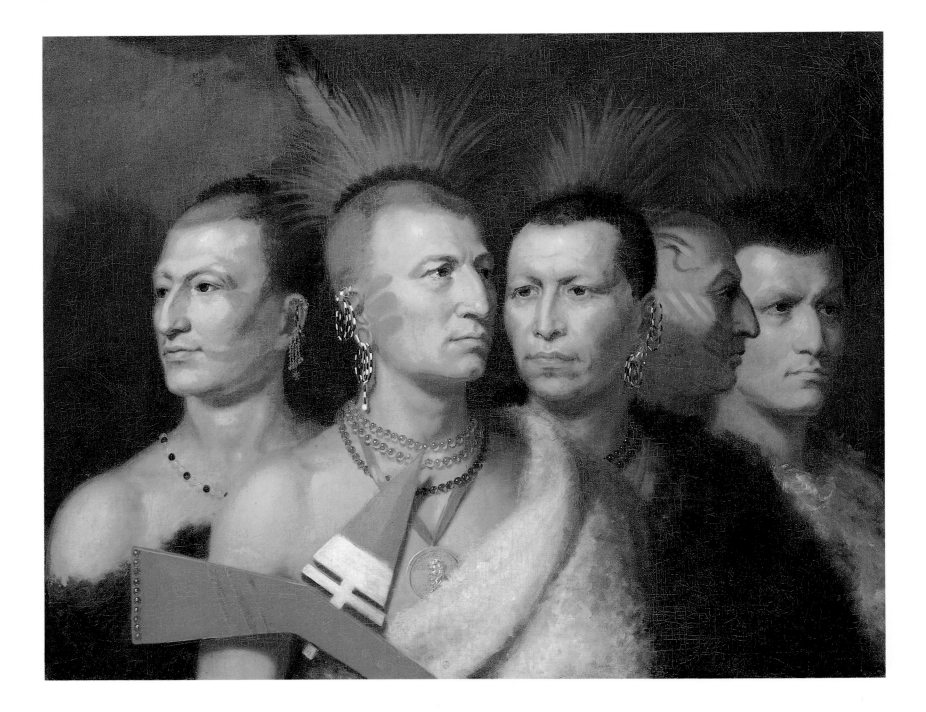

Young Omahaw, War Eagle, Little Missouri, and Pawnees

CHARLES BIRD KING, 1785–1862

1821. Oil on canvas, 36⅛ x 28 in.
National Museum of American Art, Smithsonian Institution, Gift of Helen Barlow, Washington, D.C.

Charles Bird King was the first American artist to look seriously at the Indians of the West but, unlike his near contemporary, George Catlin, he never ventured into the wilderness. Rather, he spent his entire career in a studio in Washington, D. C., creating portraits of Indian chieftains as they visited the capital to sign treaties with the "Great White Father."

King's sensitive rendering of five warriors, *Young Omahaw, War Eagle, Little Missouri, and Pawnees*, is a masterfully executed mixture of precise realism and idealization. These chiefs appear calm and eloquent and aristocratic in their bearing. At the heart of the artist's treatment of Native Americans—as this work amply illustrates—is his style of classical restraint. His figures exist in a still, undisturbed, even ideal world, far from the exploitative treatment the Indians actually received from the government. These are Indians as white men imagined them to be, exotic and fierce, but also capable of noble and civilized behavior. Consider, for example, the central figure in *Young Omahaw*. How heroic, and at the same time slightly frightening, he seems as he bears his silver "peace medal"—a profile of President Monroe suspended from a pink ribbon—while, at the same time, holding his colorful ceremonial war club close by.

In the 1820s, when King painted this work, white hatred of the Native American was already well ingrained, the result of more than half a century of bloody wars in the Old Northwest Territories and beyond the Alleghenies. Within a few years, the forcible dispossession of the indigenous population from their traditional tribal lands would begin. In a political climate dominated by the doctrine of Indian removal and an artistic milieu in which Romanticism played a leading role, King's depictions of the "noble savage," populated by classically composed and intellectual-looking figures, represented the end of an era.

Catlin Painting the Portrait of Mah-to-toh-pa— Mandan Chief

GEORGE CATLIN, 1796–1872

1861–1869. Oil on cardboard, 18 ½ x 24 in.
National Gallery of Art, Paul Mellon Collection,
Washington, D.C.

George Catlin, a modestly successful self-taught portrait painter from Washington, D.C., was among the first American artists to travel west. From his first expedition in 1830 to his fifth and final trek six years later, he sought to capture on canvas the rapidly disappearing life of the Native American, eventually producing more than 450 such oil portraits and scenes. Catlin's Indian Gallery, with its appealing veil of primitivism, not only influenced later artists, it also contributed to the very way that white civilization came to perceive Native Americans.

The undated self-portrait reproduced here shows Catlin painting the famous Mandan Indian Chief Mah-to-toh-pa. As a recent study by Kathryn S. Hight suggests, it was probably painted in London several years after the event. In this canvas, the chief and his people appear heroic, yet doomed, perfect stereotypes of American Indians living a primitive childlike existence "with minds," as Catlin wrote, ". . . unexpanded and uninfluenced by the thousand passions and ambitions of civilized life."[1] To be sure, the artist was deeply concerned about the fate of the Indians, conceiving a great park in which the native tribes could be preserved for posterity. But his concerns did not prevent him from seeking to profit from the Native Americans by exhibiting his Indian Gallery in the United States, England, and France.

Although the scene depicted in the painting may have been drawn from life, it also recalls the *tableaux vivants* (living pictures) first enacted in 1841 by Catlin and his troupe of British actors, artist William Tait among them, in their travels around England. For additional emphasis, the artist painted himself in the type of natty English-style hunting costume that he usually wore in performance.

Catlin claimed that his works showed the American Indian "in a natural state," and he did indeed gather a great deal of ethnological information, but he was an artist-entrepreneur, not a scientist. Catlin's talent lay in his ability to produce serious and believable, yet ultimately artful and idealized images. *His* Indians were like ancient Greeks or medieval knights, far from the sorry reality he experienced among the remnants of an essentially doomed race.

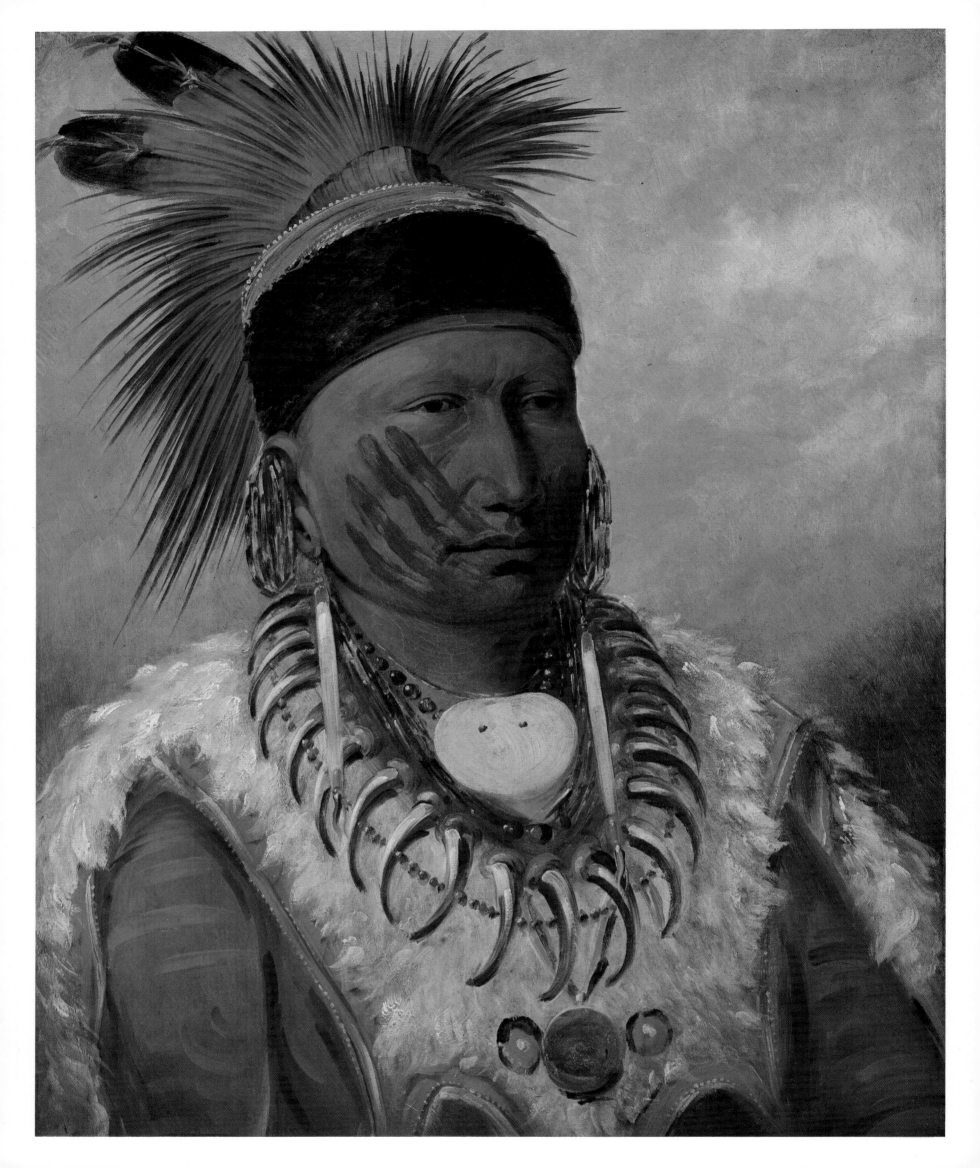

The White Cloud, Head Chief of the Iowas

GEORGE CATLIN, 1796–1872

*circa 1845. Oil on canvas, 27 ¾ x 22 ¾ in.
National Gallery of Art, Paul Mellon Collection,
Washington, D.C.*

George Catlin's wonderfully effective portrait of *The White Cloud, Head Chief of the Iowas* is an outstanding example of the artist's ability to create idealized images of the disappearing natives of America. His principal subject was a 32-year-old Iowa chief who had won the admiration of a president "who had granted him the unusual permission to make the journey to Europe . . . and [he] brought the aristocracy of the tribe." [2] White Cloud attracted considerable attention abroad because of his colorful body paint, headdress of quills and eagle feathers, great bear claw necklace, and handsome, European looking face, which the artist subtly enhanced. Posing for Catlin in London, far from his tribal lands, White Cloud lacks the expression of confidence that characterized the Indians Catlin painted on their native ground. Rather, as William H. Truettner, the foremost Catlin scholar, has pointed out, these portraits "reflect a deeper recognition of the sitters as individuals, perplexed and dismayed, perhaps, by the experience of European travel." [3]

White Cloud and his entourage of Indian aristocrats joined Catlin's touring show shortly after they arrived in London in 1844, replacing a group of Ojibwa. The following year, the troupe, having exhausted English interest, moved on to Paris, where it was received by King Louis Philippe. When some of the Indians died in the French capital, and the remainder decided to return home, Catlin dressed his nephew as a Plains Indian chief and had him stalk his Gallery to the delight of the audience.

As a firsthand observer and participant in the accounts that he relayed, Catlin and his pictorial interpretations were accorded creditability at a time when no one had better information than he. Moreover, the image of the heroic Indian that he painted and displayed in the cunningly created theater of his Indian gallery harmonized with the nation's social and political values. Perhaps most importantly, he set in motion what would become an industry, that of supplying eager urban audiences with images of a noble race that was destined to pass away with the advance of civilization.

DETAIL

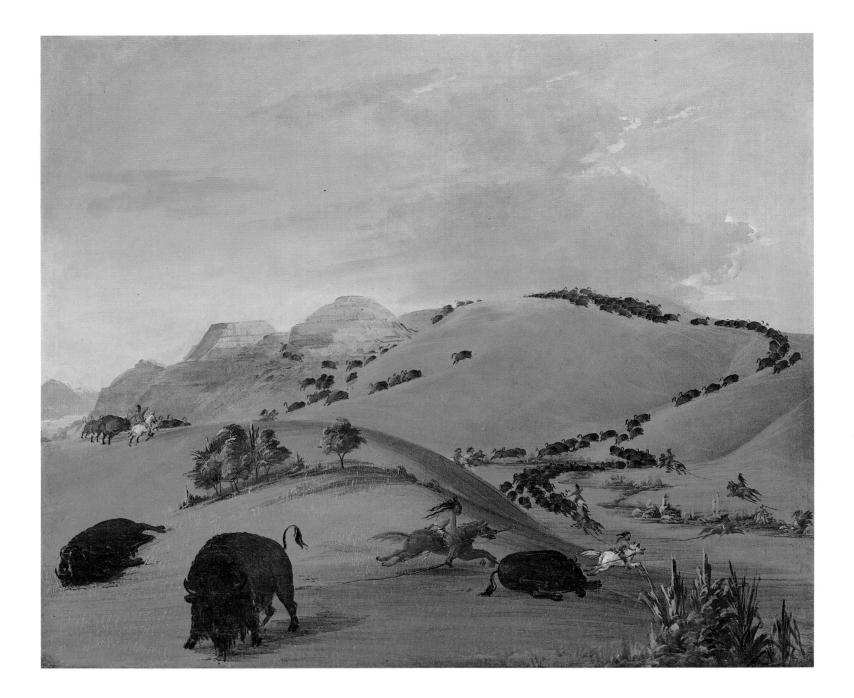

Buffalo Chase, Mouth of the Yellowstone

GEORGE CATLIN, 1796–1872

1832/1833. Oil on canvas, 24 x 29 in.
National Museum of American Art, Smithsonian Institution, Gift of Mrs. Joseph Harrison, Jr., Washington, D.C.

The image of the buffalo chase was one of Catlin's most enduring contributions to western American mythology. His many versions of this scene were superbly crafted to connect the last of the woolly beasts with the impending end of Indian life. "It is a subject of curious significance," he wrote, "like the history of the poor savage; . . . they are both wasting away at the approach of civilized man . . . in a very few years to live only in books or on canvas."[4]

The sparkle and freshness of the Catlin sketch reproduced here vividly communicates the urgency and excitement that comes as a group of mounted Indians pursue a herd of buffalo across a lush green rolling landscape. Both elements—the setting and the action—join to bring viewers into a world thousands of miles distant, a world as culturally and racially different as anything they could have imagined.

"Nature has nowhere presented more beautiful and lovely scenes, than those of the vast prairies of the West," Catlin wrote, "and of *man* and *beast*, no nobler specimens than those who inhabit them—the *Indian* and the *buffalo*—joint and original tenants of the soil, and fugitives together from the approach of civilized man; they have fled to the great plains of the West, and there, under an equal doom, they have taken up their *last abode*, where their race will expire, and their bones will bleach, together.[5]

With his references to the "equal doom" of the Indians and the buffalos and the western prairies as their "last abode," Catlin makes clear his belief in the ultimate demise of the native population thanks to the government's policy of removing them from their tribal lands and resettling them on reservations. Yet paradoxically he offered little better in his proposal for "a magnificent park, where the world could see for ages to come, the native Indian in his classic attire, galloping his wild horse . . . amid the fleeing herds of elks and buffalos."[6]

For Catlin there was no apparent contradiction in his *mission* to rescue the Indians, and in his *need* to exploit them for financial survival. In that way his art parallels the values of American culture, which held that to save the Indians it was first necessary to do away with them.

Bison Dance of the Mandan Indians

KARL BODMER, 1809–1893

1833. Aquatint, after a lost watercolor, 12 x 17 in. Joslyn Art Museum, The Internorth Foundation, Omaha.

If George Catlin's depictions of the Indians blended ethnographical documentation with showmanship and an entrepreneurial spirit, Catlin's contemporary, the Swiss-trained artist Karl Bodmer, brought a new level of scientific accuracy to imagery of the Native Americans and their lifestyle.

In 1833, the 23-year-old Bodmer and his German patron, Alexander Philipp Maximilian, Prince of Neuwied, set out to survey the savage species, documenting both appearance and environment as precisely and objectively as possible. Their mission took them from Boston to Pennsylvania and the Ohio Valley and from there down the Mississippi River and far up the Missouri. The prince, who had been greatly influenced by the famous Prussian explorer and geographer Alexander Von Humboldt, took his mission seriously. But it was Bodmer's extraordinarily beautiful and accurate watercolors that truly distinguished the expedition. Later, on his return to Germany, the prince arranged for the reproduction of his companion's pictures in a volume of aquatint illustrations.

Like Catlin and Prince Maximilian, Bodmer saw the Indians as exotic beings who evoked an earlier, primitive existence but who were somehow living a grand and noble life just in advance of civilization's rapid approach. Bodmer could not have known it, but most of the Mandan Indians that he painted in 1833/34 would be dead within a few years, victims of a terrible epidemic of smallpox, which was carried to their lands by white traders.

One of Bodmer's most powerful and expressive images is the one reproduced here, *Bison Dance of the Mandan Indians*. In this aquatint, after a lost watercolor, the artist captured with detailed, scientific precision the elaborate costumes of the Mandans and their ritual to call the buffalo to them for easier hunting. In this ceremony, the principal male warriors wore buffalo masks over their heads with long strips of skin hanging down their backs. When a dancer became tired, he would bend forward and sink toward the earth, as two figures in the center of Bodmer's aquatint are doing. He would then "become" the buffalo, his fellow dancers striking him with blunt arrows, dragging him out of the ring by the heels, and symbolically skinning him. This ritual was continued day and night until the magical effect was deemed to have been achieved. As William H. Goetzmann, the leading historian of Bodmer's art observed, one can almost hear the drums, the howls, and the chants of the dancers in this image.

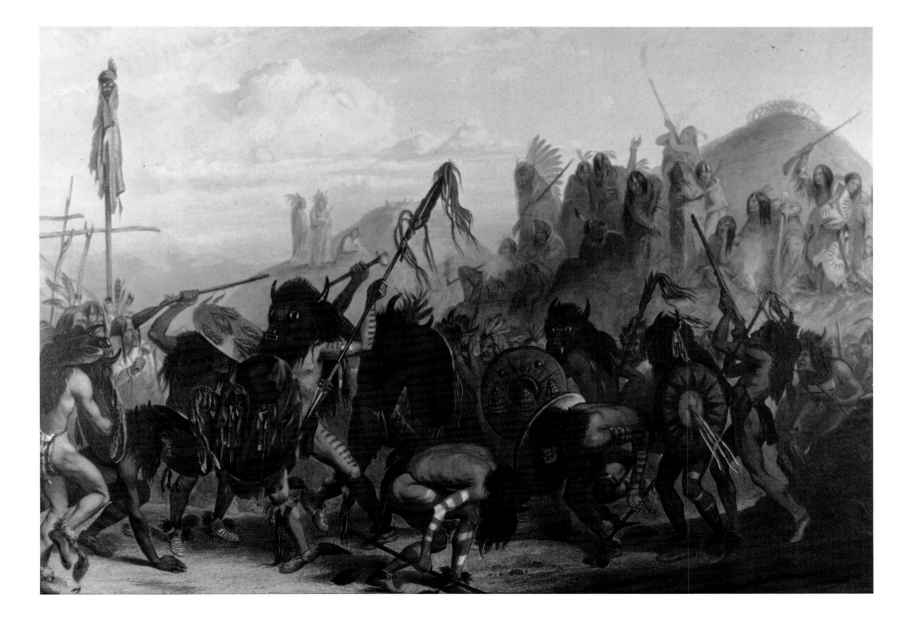

Fort Laramie
(Fort William on
the Laramie)

ALFRED J. MILLER, 1810–1874

1851. Oil on canvas, 18 x 27 in.
Thomas Gilcrease Institute of American History and Art, Tulsa.

The romantic image of western life found full expression in the art of Alfred J. Miller, who portrayed the Indian and the mountain man in what seemed an unending pastoral adventure.

Miller's painting of Fort Laramie, along the route of what became the Oregon Trail, is perhaps the most impressive and complete image of a stockaded trading post. The scene was sketched first in 1837, during the artist's travels with his patron, Scottish nobleman Captain William Drummond Stewart, but over the ensuing years Miller painted the subject many times. In this later version of 1851, he depicts the fort surrounded by Indian braves who have come with their ponies to sell furs and trade for the white man's goods and whiskey. Some are engaged in sports, others are resting after their long trek.

Unlike Bodmer's scientific, ethnographic paintings, Miller's views tended to portray Native Americans as free-spirited children of nature. Ironically, Miller's Indian figures are, for the most part, faceless. He relied more on excited gestures and spirited emotional energy than on portraiture to convey the attitudes and behavior of his subjects. It was an approach that not only suited the tastes of his adventurous patron, it also accorded well with the prevailing idea of the noble, if childlike, savage living a free-and-easy existence beyond the frontier.

DETAIL ▶▶

Lacrosse Playing Among the Sioux Indians

SETH EASTMAN, 1808–1875

1851. Oil on canvas, 28³/₁₆ x 40³/₄ in.
Corcoran Gallery of Art, Gift of William Wilson
Corcoran, 1869, Washington, D.C .

Emphasizing the commonplace, everyday aspect of Native American life, Seth Eastman created images that were methodical and seldom inspired, striking departures from the romantic and entertaining works of Catlin and Miller. His perspective was different too, for, as William H. Goetzmann has perceptively observed, his art was not about the "vanished Indian," but rather that of the

"virtually domesticated Indian with whom the white man could live side by side."[7] Eastman could be aptly characterized as the midcentury sociologist of Native American life, typically depicting Indian women at work and men gathered in quiet groups or playing checkers.

Eastman began depicting Indians as the illustrator for Henry Rowe Schoolcraft's five-volume study of Native Americans published by the government. In this role, which lasted five years, and as an up-and-coming military officer on the frontier with all the right connections in Washington, Eastman brought to his art the official attitude toward Native Americans, a view that held them to be intelligent and possessed of a significant culture, which should be studied and preserved as a curious relic. But the "official consensus" also maintained that, in the end, Indians were best left undisturbed. With effort and education they were capable of improve-

ment, but they could never be integrated into white American culture.

Lacrosse Playing Among the Sioux Indians is an unusual, even exceptional painting in Eastman's career, reflecting the artist's fascination with the Indians' games. Like many observers of Native American life, he found the participants wild and unrelenting at play, but recognized that their sports also demonstrated a high degree of structure and cultural development. In creating this canvas, the artist was influenced by his wife, Mary, who contributed a serious study of Indian folklore and customs, entitled *Dakota: Life and Legends of the Sioux* . This work was also one of the sources for Longfellow's epic poem about Indian life, *The Song of Hiawatha*.

Indians Approaching Fort Union

CARL WIMAR, 1828–1862

1859. Oil on canvas, 24⅛ x 48½ in.
Washington University Gallery of Art, Gift of Dr.
William Van Zandt, 1886, St. Louis.

Carl Wimar's dramatic painting, *Indians Approaching Fort Union*, was clearly intended to excite the popular imagination. The broad sunset sky filled with colors that range from brilliant crimson through lemon yellow and the number and variety of figures make this one of the artist's most impressive works.

The view is from the steep bluffs north of the confluence of the Missouri and Yellowstone rivers in Montana. At the far right, on the near side of the Missouri, stand the stockade walls of the American Fur Company's famous outpost, Fort Union, along with the tepees of an Indian encampment. On the far left there is a glimpse of the walls of Fort William, owned by a rival fur company. In the foreground is a large, picturesque group of Indian men, women, and children who have arrived at Fort Union to trade goods, buy whiskey,

and collect their annual annuities from the government for the sale of the ancestral lands from which they had been forcibly removed. The scene is dramatic, filled with exotic, primitive characters, such as the warriors in the center vignette who rear their horses as they discharge their guns in the air.

Wimar's picture served to confirm the prevailing belief that once the Indian had been removed to his final place in the far West, he would be free from the contaminating influence of civilization that threatened to destroy his way of life. Episodes like the annual tribal gatherings at forts beyond the frontier were exhilarating to Anglo-Americans for they were evidence of the submission of the Indians and, hence, the preservation of their savage lifestyle, thanks to an "enlightened" government in Washington. Such rendezvous were already disappearing, however. A year later after Wimar painted this work, the fur company abandoned Fort Union, bringing to an end a significant era in early western history—the fur trade.

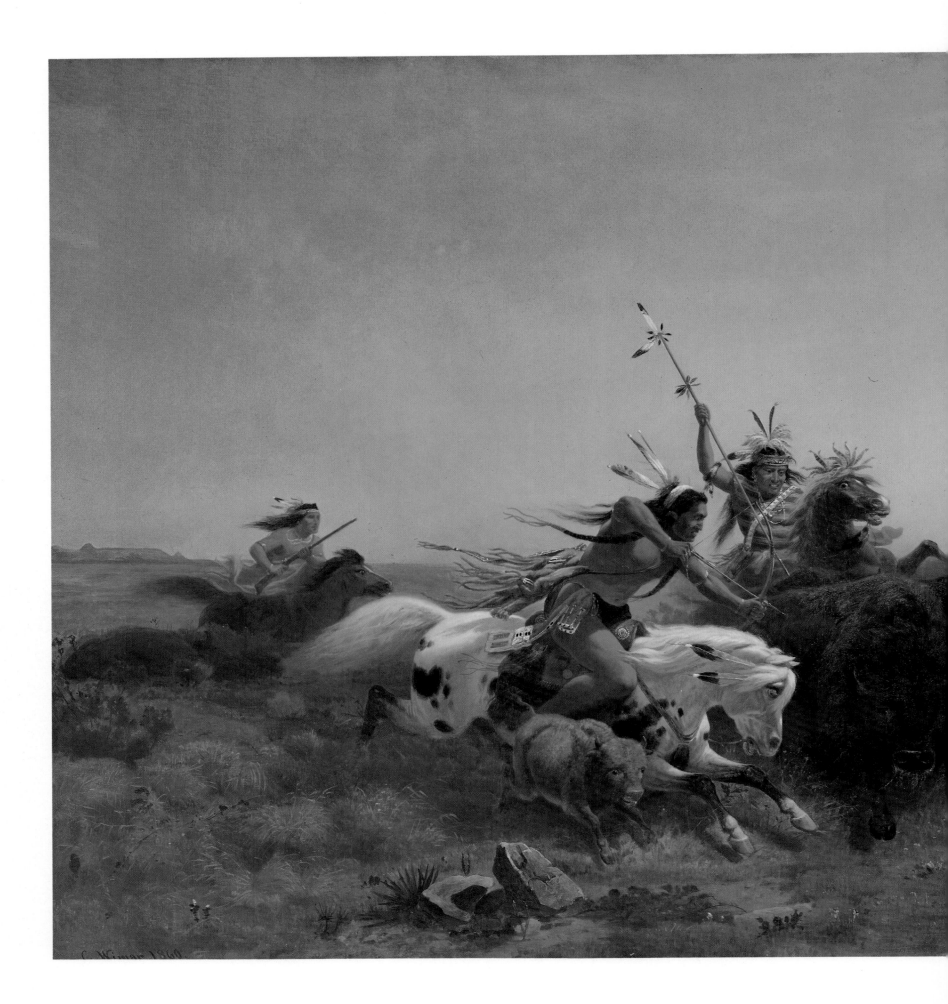

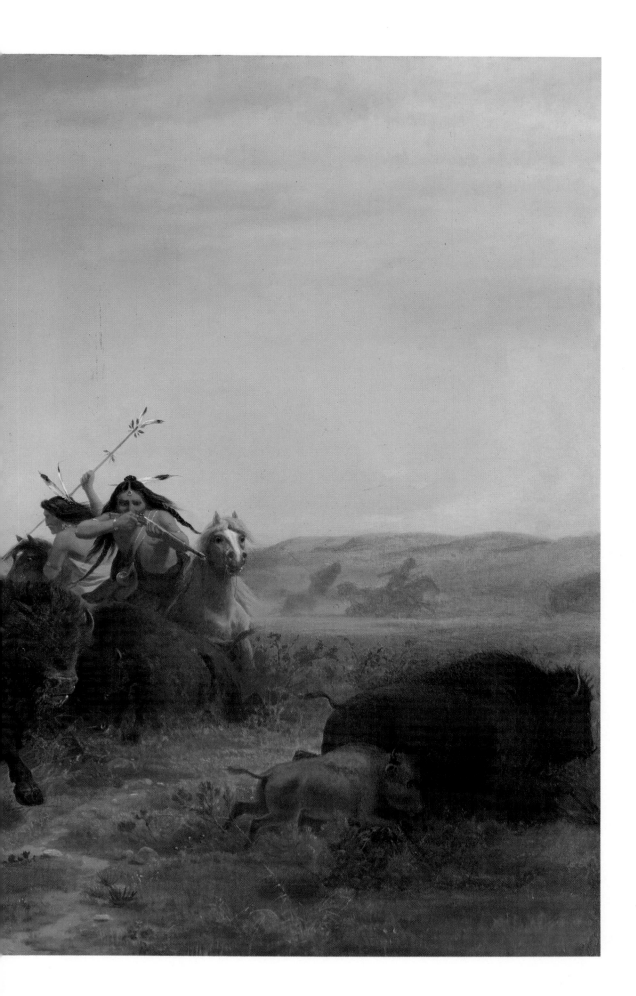

The Buffalo Hunt
CARL WIMAR, 1828–1862

1860. Oil on canvas, 35¼ x 60 in.
Washington University Gallery of Art, Gift of Dr.
William Van Zandt, 1886, St. Louis.

Historians have generally praised the accurate depictions of Indian life that Carl Wimar produced in the wake of his extensive trip up the Missouri River in 1858. Of these works, perhaps the most important and influential was *The Buffalo Hunt* of 1860. To be sure, the artist's rendering of Indian clothing and horses and the appearance of the ferocious buffalo were more specific than the romantic impressions of Catlin or Miller. Like his predecessors, however, Wimar used his artistic talents, which had been honed during his years of study in the academy at Dusseldorf with Emanuel Leutze, to idealize the Native American and his disappearing ways.

The Buffalo Hunt was created expressly for the opening of the galleries of the Western Academy of Art in St. Louis, the first art institution west of the Mississippi. Received enthusiastically in its initial showing, Wimar's picture grew to become the standard image of the buffalo hunt by the 1880s, with, as scholar Rena N. Coen has observed, his iconography serving to influence many later renderings of the popular theme by other artists, Charles M. Russell for one. Russell, who was also from St. Louis, used Wimar's picture as the inspiration for a number of works depicting buffalo hunts (page 203).

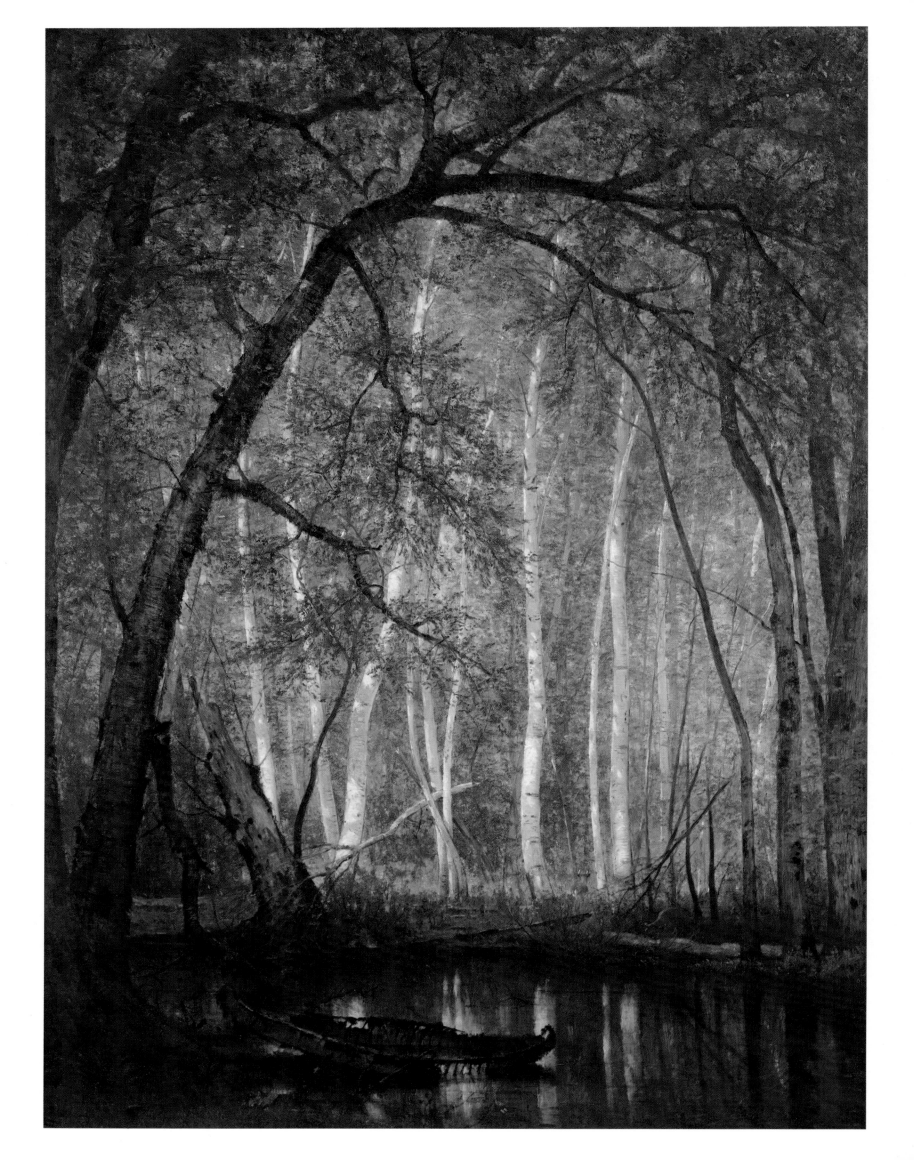

The Old Hunting Grounds

THOMAS WORTHINGTON WHITTREDGE, 1820–1910

1864. Oil on canvas, 36 x 27 in.
Reynolda House, Museum of American Art,
Winston-Salem, North Carolina.

*T*he Old Hunting Ground is a poignant attempt by Worthington Whittredge to dramatize the decimation of the Native American population and the demise of its culture. Painted in 1864 during the Civil War, the work was readily recognized as a major statement at the time of its completion by the artist's contemporaries.

A reverential, almost spiritual mood prevails, as Whittredge's tree branches form a cathedral arch above the tranquil, if forlorn, forest pool. Perhaps this idea was inspired by the poetry of William Cullen Bryant, whose *A Forest Hymn* proclaimed that "the groves were God's first temples." Art historian Henry T. Tuckerman was particularly drawn to Whittredge's trees, which he called "melancholy silvery birches that bend under the weight of years, and lean toward each other as though breathing of the light of other days ere the red man sought other grounds, and left them to sough and sigh in solitude."[8]

In the midst of this serene environment lies the wreckage of an old Indian birch-bark canoe, its charred skeletal frame seeming to bear the marks of a violent end. This is all that remains of a tribe that once hunted in the woods. Near this relic two deer approach the water to drink. No longer need they fear the arrows that used to fell their kind.

Directly behind the canoe in the area of brilliant sunlight, three birch trees intersect to create a cruciform. By this motif, Whittredge establishes white civilization's appropriation of the woods in the wake of the Indian's dispossession. As Bryant put it in *A Walk at Sunset*, "The warrior generations came and passed,/And glory was laid up for many an age to last."

Indian Telegraph

JOHN MIX STANLEY, 1814–1872

1860. Oil on canvas, 20 x 15½ in.
The Detroit Institute of Arts, Purchase, Popular
Subscription Fund.

Like Catlin, Eastman, and Wimar, John Mix Stanley was eager to document and profit from an interest in the Native Americans. Like Catlin, Stanley also tried to sell his collection of Indian paintings to the government and was disappointed when Congress and the Smithsonian Institution refused to purchase his gallery. But, where Catlin was an incorrigible romantic seeking to save the indigenous population, Stanley was somewhat more pedestrian, concerned largely with ethnographic description. He traveled widely in the far West, searching for subjects and images that could be added to his expanding collection of Indian portraits and scenes. Ironically, like Catlin, he realized little financial benefit from this enterprise. Although Americans in the 1850s and 1860s were obsessed with Indians, there were many powerful interests that had little to gain from idealized depictions that seemed to threaten civilization's advance.

One of Stanley's most popular images, *Indian Telegraph*, was painted in at least four versions during the 1860s and issued as a chromolithograph. The version reproduced here is the first, painted in 1860. The subject— Indian means of communication—fascinated white audiences through the 19th century. Moreover, Stanley's image inspired many later artists who found in its depiction of pre-technological simplicity and its titled reference to the invention of Samuel Morse, a subtle reaffirmation of white superiority. Another, very different look at the relationship between Native Americans and the telegraph would surface at the turn of the century in Henry Farny's powerful image, *The Song of the Talking Wire* (page 118).

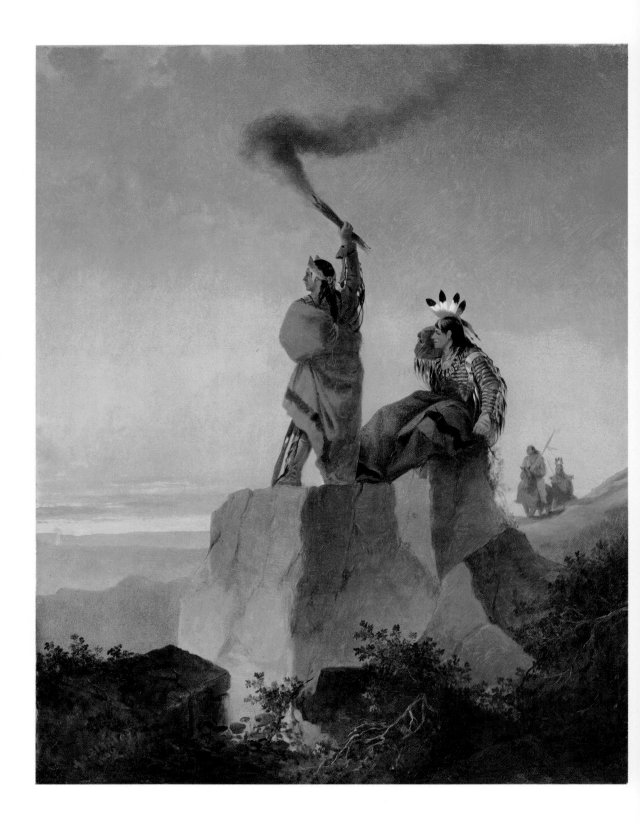

The Departure of Hiawatha

ALBERT BIERSTADT, 1830–1902

circa 1868. Oil on paper, 6⅞ x 8⅛ in.
The Longfellow National Historic Site, Cambridge,
Massachusetts.

The most famous memorial to the Hiawatha legend is Albert Bierstadt's 1868 *The Departure of Hiawatha*, a cabinet-sized picture that was presented to the poet Henry Wadsworth Longfellow by the artist at a prestigious dinner party in London. The elaborate three-hour affair, which was attended by future Prime Minister Edward Gladstone and such literary and artistic luminaries as Robert Browning, Sir Edwin Landseer, Samuel Carter Hall, and the Duke of Argyll, included tributes to the poet and the artist. A menu of the dinner inscribed in gold was affixed to the back of the picture along with the appropriate verses of Longfellow's poem.

The image of an American Indian sailing off into the oblivion of a "fiery sunset . . . the purple vapors . . . the dusk of evening" would have been especially meaningful to the English capitalists and land developers gathered there that evening. Many of them had land holdings in America or investments in such ventures as the transcontinental railroad, which the British often hailed as the greatest enterprise of the age. They understood quite well that the destruction of the Native American population would inevitably result from the progress that they sought to foster, and no doubt the poetic evocations of Longfellow's poem, with its elegiac mood of the loss of a noble culture, helped to justify their actions. Although these investors and aristocrats may not have fully realized it, they were being served, along with the food and the speeches and the art, yet another installment in the investment potential of the American West. Thus, the affair, in its own way, added not only to the artistic but also the financial bonding of the two nations.

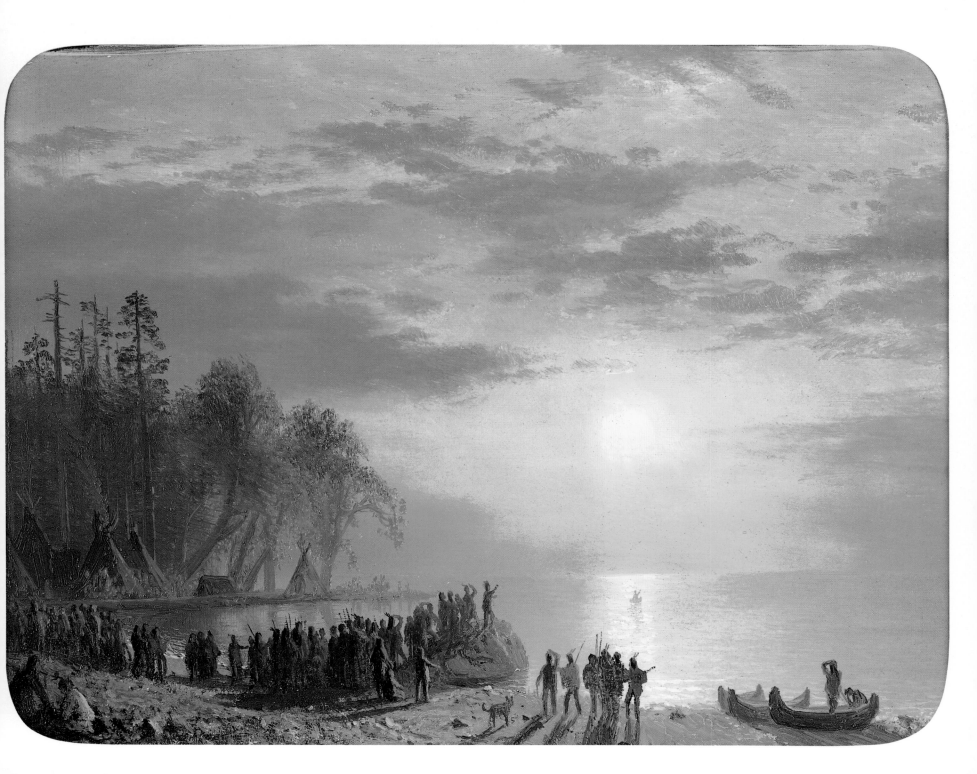

The Spirit of the Indian

THOMAS MORAN, 1837–1926

1869. Oil on canvas, 32 x 48 in.
The Philbrook Museum, Tulsa.

In 1860, 23-year-old Thomas Moran visited the wilderness areas on the remote shores of Lake Superior along Michigan's upper peninsula, a region that seemed open to tourism—or so Moran had heard in a discussion about commercial developments in the area. As a young artist, still in search of his identity, he was excited at the thought of the region with its pictureque scenery richly attractive to potential patrons. He was also captivated by its sublime wilderness landscapes and their powerful association with Henry Wadsworth Longfellow's 1860 poem, *The Song of Hiawatha.* The result in 1867 was an allegorical painting entitled *Hiawatha and the Serpent of the Kenneback.*

In 1869, with the impending completion of the transcontinental railroad, Moran was even more eager to treat subjects that identified him with the West. *The Spirit of the Indian,* with its heavy symbolic freight, is such a work. In it Hiawatha, who appears as a tiny figure in the foreground, becomes an American type of Hercules, or even the Greek hero Ulysses deriding the giant Polyphemus, subjects that Moran had seen in paintings by J. M. W. Turner during his visit to England. Here, however, the protagonist is engaged in a heroic, if unequal, confrontation with the Indian god Manito, seen as a giant being embedded in the silvery mountain at upper right.

In Longfellow's story, Hiawatha had to kill the god by shooting a lock of his hair. The idea that the Indian was forever killing off his own race, which both Longfellow and his source, Henry Rowe Schoolcraft, propounded, offered more potent ammunition to the forces seeking the Native American's extermination. While Moran, in his painting, was not advocating, even indirectly, the destruction of the Indian, he did underscore the widely held belief that even without white intervention the Indians would exterminate themselves because of their warlike ways. It is ironic that after Moran became established as the painter of the Yellowstone and Grand Canyon regions, he "killed off" the Indians in his own way, including them infrequently in his mature works.

Fiercely the Red Sun Descending Burned His Way Across the Heavens

THOMAS MORAN, 1837–1926

1875–76. Oil on canvas, 33⅜ x 50¹/₁₆ in.
The North Carolina Museum of Art, Raleigh.

Six years after *The Spirit of the Indian* was completed (pages 106–107), Thomas Moran again returned to the Hiawatha story. This time, however, the figure of the Indian was completely eliminated. Instead, *Fiercely the Red Sun Descending Burned His Way Across the Heavens* depicts Hiawatha's point of view as he looks out from his canoe over a surging and boiling sea to a wild and rocky coastline. The spectacular sunset is derived from J. M. W. Turner's masterpiece *The Slave Ship*, which had been acquired by the Museum of Fine Arts, Boston in 1872.

Like the lugubrious sentiments of death and dying that the English romanticist's work possessed, there is a dark side to Moran's picture, but, where Turner's subject was overt and terrifying—the human carnage of slaves being thrown alive to the sharks, the sea red with their blood—Moran's picture appears at first glance to be almost serene. Moran reverses Turner's composition, placing the sun at left and introducing a foreboding mass of rocks at left where Turner's ghostly slave ship had been. Imbedded in the broken forms of these outcroppings are veiled personifica-

tions and at the center rises a great cave, shaped like a huge sinister head emerging from the turbulent waters. The entrance to this ephemeral hell suggests a gaping mouth, with eyes etched in the rock above.

Seeing Longfellow's Indian hero find his end in a glorious apocalyptic vision of light and atmosphere was no doubt satisfying to Moran's audience anxious about future relations between the Indians and the whites. Their worst fears were realized in 1876, the centennial year and the year of this painting's completion, when General George Armstrong Custer and the 7th Cavalry went down to stunning defeat at the battle of the Little Big Horn.

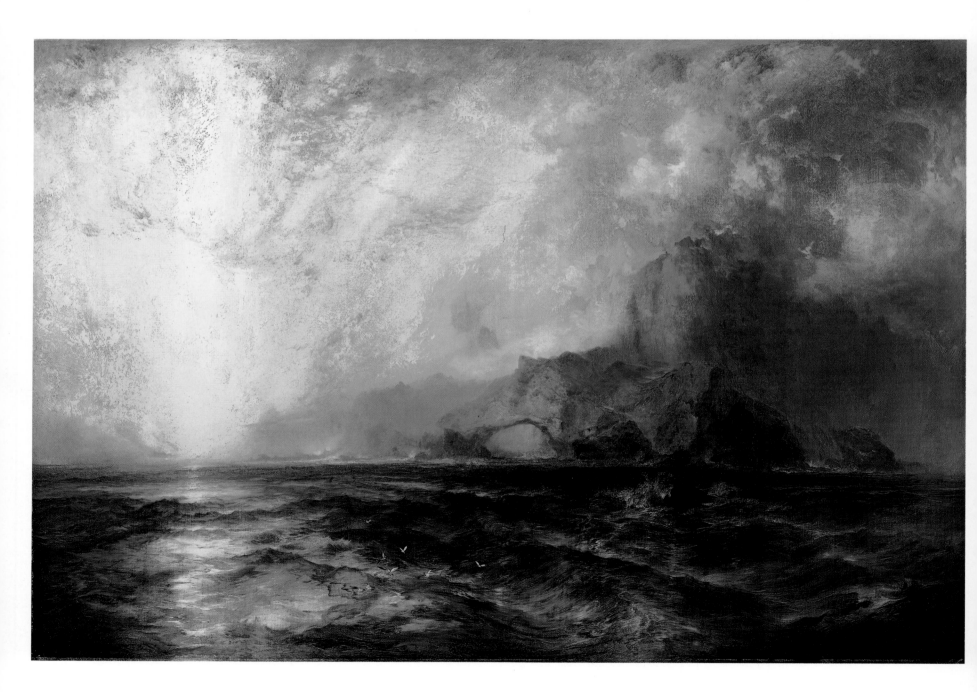

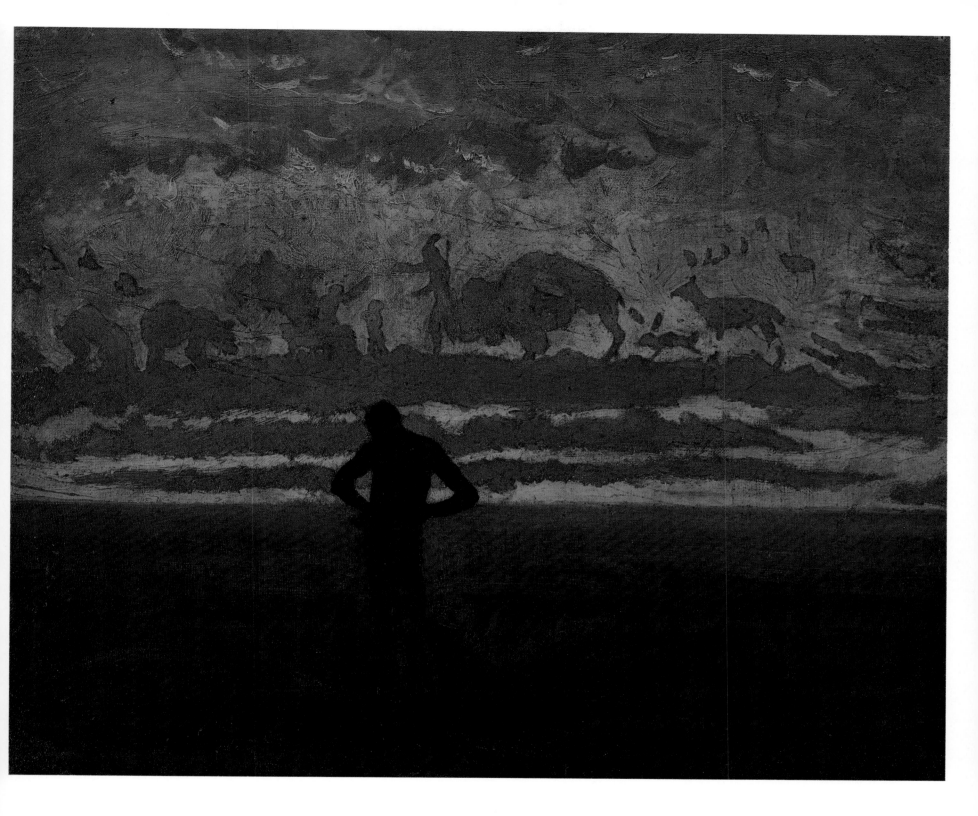

Hiawatha

THOMAS EAKINS, 1844–1916

*1874. Oil on canvas, 13³⁄₄ x 17³⁄₈ in.
Hirshhorn Museum and Sculpture Garden,
Smithsonian Institution, Washington, D.C.*

Like Thomas Moran, Thomas Eakins was
also intrigued by the story of Hiawatha.
In an important study for a never realized
larger painting, the Philadelphia master of
psychological realism created a fantasy image
of the "dreams and visions many" that came

to Hiawatha during his fast. This episode was
graphically described by Henry Wadsworth
Longfellow in the following manner: "Gazing
with half-open eyelids, / Full of shadowy
dreams and visions / On the dizzy, swimming
landscape, / On the gleaming of the water, /
On the splendor of the sunset."

Eakins carefully followed the sense of
Longfellow's passage. Hiawatha, having
defeated Mondamin, the benevolent Corn-
Spirit, in order to gain knowledge of the
planting and harvesting of corn, wanders in a
trance through a forest beside a lake. In the
sky he sees a passing procession of deer, rab-
bits, pheasants, and squirrels. He also sees

several figures not mentioned in Longfellow's
verses—an Indian in the clouds and to his
rear a bison and a bear.

Eakins' procession of visionary beasts and
anthropomorphic forms bears some resem-
blance to the romantic visions of Moran,
Frederic Remington, and E. Irving Couse,
but Eakins—a master at capturing the hero-
ism in modern, everyday life—selects a
moment of quiet introspection for his foray
into the idyll of another time.

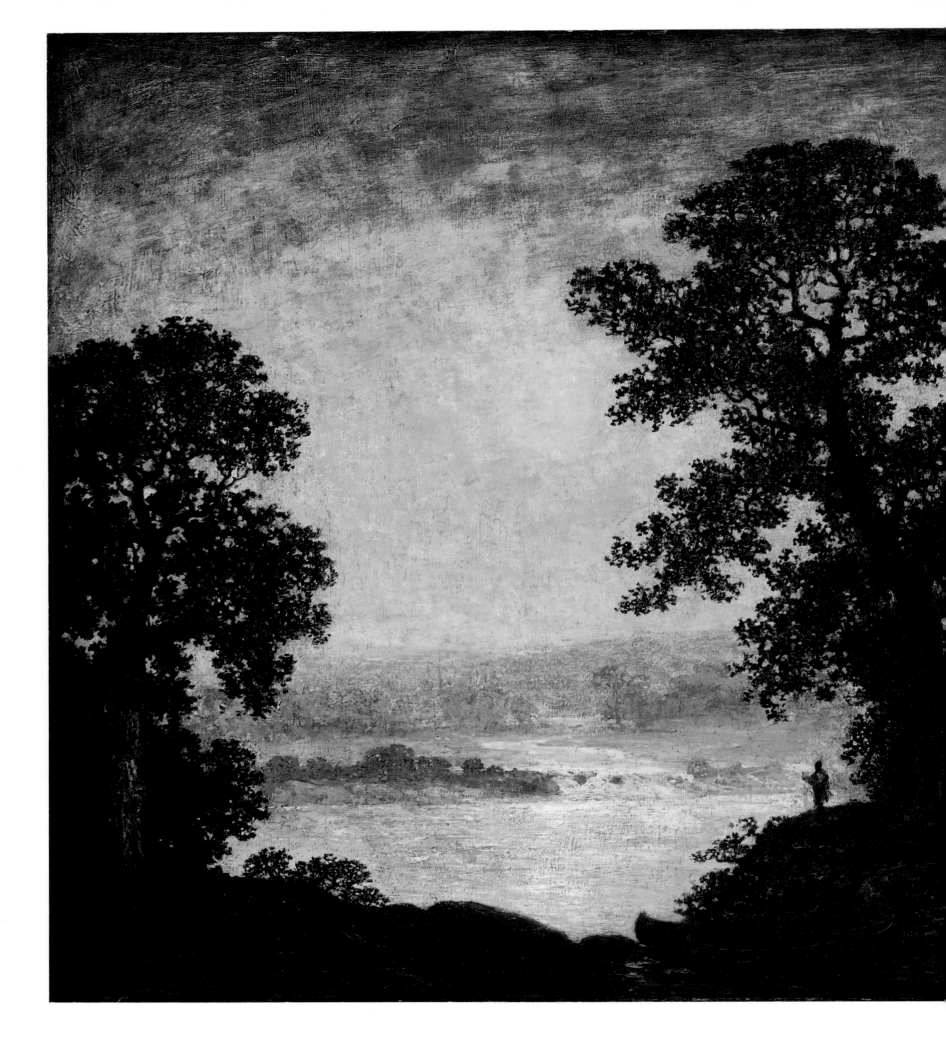

Moonlight, Indian Encampment

RALPH ALBERT BLAKELOCK, 1847–1919

1885-89. Oil on canvas, 27⅛ x 34⅛ in.
National Museum of American Art, Smithsonian
Institution, Gift of John Gellatly, Washington,
D. C.

In 1869, Ralph Albert Blakelock traveled west on the newly opened transcontinental railroad in search of scenes of Indian life. Like Catlin earlier in the century, he spent considerable time with several western tribes. An itinerary shows that he traveled through Nebraska, Kansas, Colorado, Wyoming, Utah, Nevada, and California. So powerful was the impression left by this first trip that he ventured west again in 1872. The extensive drawings made on that journey became the source of Blakelock's subsequent Indian paintings.

Blakelock's conception of the Indians and their environment was very different from the tight style of academic realism that characterized most of his contemporaries. *Moonlight, Indian Encampment*, painted between 1885–1889, is full of mystery and poetry, with the Indian figures emerging out of the dark foreground as if in a dream. At the right, under a canopy of *cloisonné* trees stands an enigmatic encampment with two wigwams, four figures, a horse, and a campfire. To the left, under the tall tree, a solitary figure is silhouetted against the distant river, bathed in an ethereal lunar light. The surface of the painting is worked densely in a painterly impasto, and in places the artist's brushwork is applied in conflicting directions, the wet paint seemingly incised with a stylus so that as the eye moves across the scumbled surface it encounters a world of obscure and indecipherable markings.

In this glowing, diaphanous landscape only the figures of the Indians seem to possess warmth and human certainty, but even they are enveloped in a gossamer film of unreality. When we view this work, "we are no longer in the Museum looking at pictures," wrote Elliott Dangerfield, Blakelock's first biographer, "but somewhere the great woods have opened and let us in—in upon a clearing where the sound is weird and the color wild—the song of birds is hushed, and civilization silenced—aboriginal man performs his rites, and the watchful spirit of the artist seizes and gives to us the tragic mystery."[9]

In the late 1880s, when Blakelock created this picture, the poetic, idealizing veil of primitivism that some 20th-century artists would use in their images was just beginning to make its appearance. Blakelock pioneered this conception of the Native Americans to great effect, but, at the same time, the "tragic mystery," as Dangerfield put it, drove him deeper and deeper into insanity. Finally he had to be institutionalized. His monogram—the outline of an Indian arrowhead—thus became the emblem of his haunted personality.

DETAIL ▶▶

The Orphan

GRACE CARPENTER HUDSON, 1865–1937

circa 1898. Oil on canvas, 30 x 25 in.
California Historical Society, San Francisco.

By the end of the 19th century the stereotype of the noble Indian warrior was permanently enshrined in the popular imagination. It required the sensitive perceptions of a female artist, Grace Carpenter Hudson, to show that there was another side to Native American life and culture, namely, the world of Indian women and children.

Largely underappreciated today, Grace Hudson helped to record on canvas the vanishing culture of the Pomo Indians of Northern California, a tribe that had been decimated by the advance of white civilization and its incorporation of their valuable lands. The daughter of a newspaperman and photographer, Hudson was educated in Ukiah, California. Upon the completion of her studies with Virgil Williams at San Francisco's California School of Design, she returned to Ukiah, about 100 miles north of the Golden Gate city, and remained there until her death in 1937. In Ukiah, she opened a studio and undertook numerous portraits of Indian infants and children, not an easy task since Native Americans believed that the visual capturing of a person's image could bring bad luck. The portraits were popular at the turn of the century because Hudson often resorted to sentimental, cloying images of innocent children in order to make her work more salable.

One of Hudson's more unusual, poignant paintings is *The Orphan*, painted around 1898. It is a simple but effective image of an old Pomo Indian woman with a young girl, perhaps an orphan of the tribe. The two figures appear in a barren, sketchily painted landscape, which highlights their pathetic, impoverished existence. The old woman is a character study of the first order, with Hudson's deeply touching rendering of a wrinkled, weathered face clearly reflecting much suffering. For the young girl beside her it seems that life will be not be much better. Her torn shirt and forlorn expression are powerful, if subtle, testimony to the tragic wasting of Native American culture.

With the Eye of the Mind

FREDERIC REMINGTON, 1861–1909

1908. Oil on canvas, 27 x 40 in.
Thomas Gilcrease Institute of American History and Art, Tulsa.

Frederic Remington's *With the Eye of the Mind* is one of the most imaginative paintings in the artist's oeuvre, and is frequently acknowledged as one of his most impressive late works. Painted in 1908 as Remington reached a remarkable maturing of his art intellectually as well as technically, *With the Eye of the Mind* shows three Plains Indian riders at twilight, gesturing excitedly toward a group of charging spirit figures in the clouds. In his use of a symbolic device with wide currency at the time, Remington seems to suggest that ghostly images are all that remain of the once proud and heroic Native Americans of the West.

That such a painting would come from the hand of Frederic Remington seems remarkable for it represents a turning away from the macho, all too frequently racist treatment of America's native population that colored much of the artist's art and writings. Perhaps with this work he needed to acknowledge— out of a sense of nostalgia, perhaps even with a sense of guilt—that something vital had been lost with the near passing of the Native Americans.

During the last decade of his life—he died in 1909—Remington began a profound artistic transformation. Not only did his work undergo a stylistic change, strongly influenced by Impressionism, but even more remarkably, he displayed profound conceptual and intellectual growth. Perhaps under the influence of his new friends in the New York artistic community, Willard L. Metcalf, John Alden Weir, and Childe Hassam—all leading figures in American Impressionism— Remington was stimulated to rethink some of the basic attitudes that had made him the most successful illustrator of western American life. *With the Eye of the Mind* is one vivid indication of this development, which was cut short by the artist's untimely death at age 48.

In the Foothills of the Rockies

HENRY FARNY, 1847–1916

1898. Oil on canvas, 22 x 40¼ in.
Manoogian Collection, Detroit.

When Henry Farny first visited the West in 1881 it had already been spanned by railroads and increasingly occupied by settlers. Nevertheless, during the two-and-a-half decades that he painted the frontier from his studio in Cincinnati, Ohio, the artist never wavered in his desire to portray a way of native life that had for all practicable purposes disappeared. The apparent authenticity of his paintings stemmed, in part, from his careful study of the many Indian artifacts and ethnographical materials that he brought back from his western travels. Furthermore his highly refined artistic sensibility combined the influences of Impressionism, Japanese art, and photography. Most importantly, he had a deep respect and appreciation for the Native American way of life, a culture whose destruction he deeply regretted.

Unlike his younger contemporaries— Remington, Russell, and Schreyvogel— Farny, who was deeply influenced by his years of study in Europe, never painted the cowboy, the pioneer, or the cavalry man, the vaunted protagonists of American progress. The Native American at home in the full splendor of his ancestral landscape was the subject that completely preoccupied his imagination. Nicolai Cikovsky, Jr. has noted that although Farny's landscapes were, like his figures, painted from memory in the studio, they reveal the natural environment, the light, and, above all, the vast spaces of the American West with a remarkable visual truth and expressive feeling.[10]

The apparent freedom and spontaneous life of the Indians depicted in *In the Foothills of the Rockies* was of course an elaborate fantasy, as Farny well understood. During his trips west in 1883, 1884, and 1894, he had seen firsthand the Indian's degradation and his economic dependence on the government's reservations. As he wrote in 1910, "It breaks my heart, to see the prairies cut up with barbed wire, and to see the once noble Red Man debauching himself with firewater on reservations. The golden West isn't what it used to be."[11]

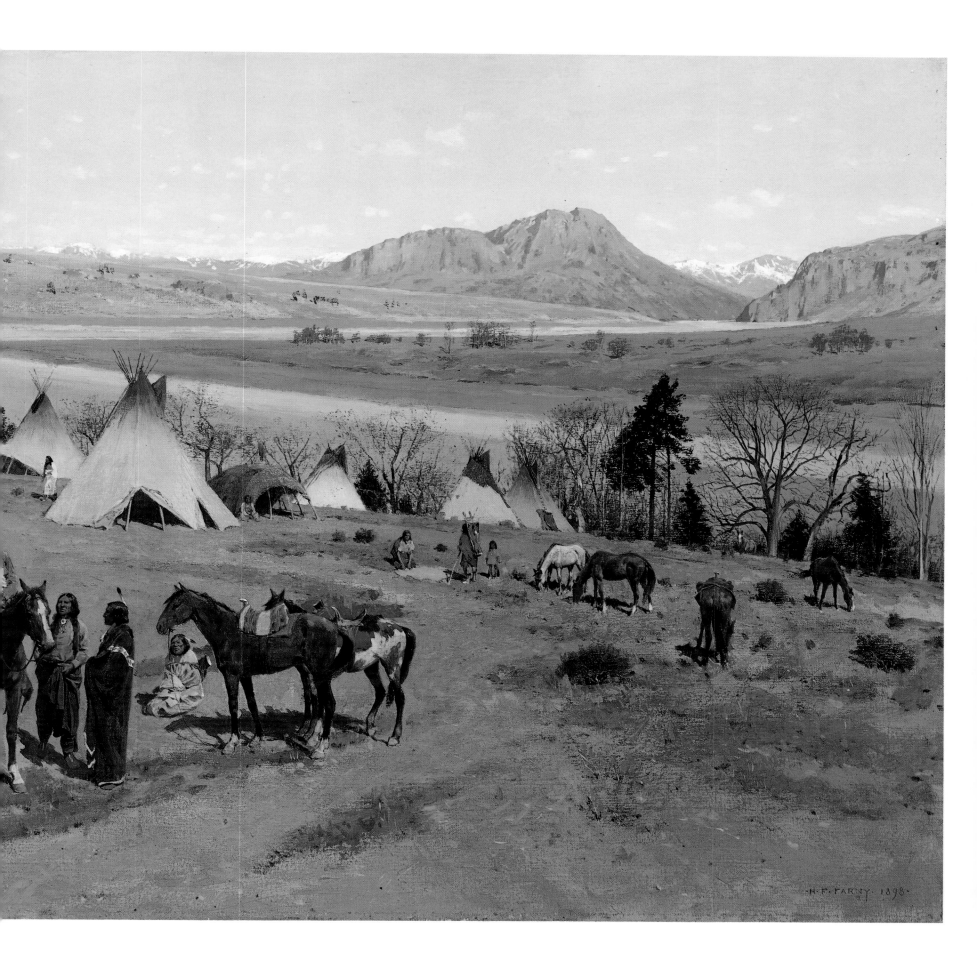

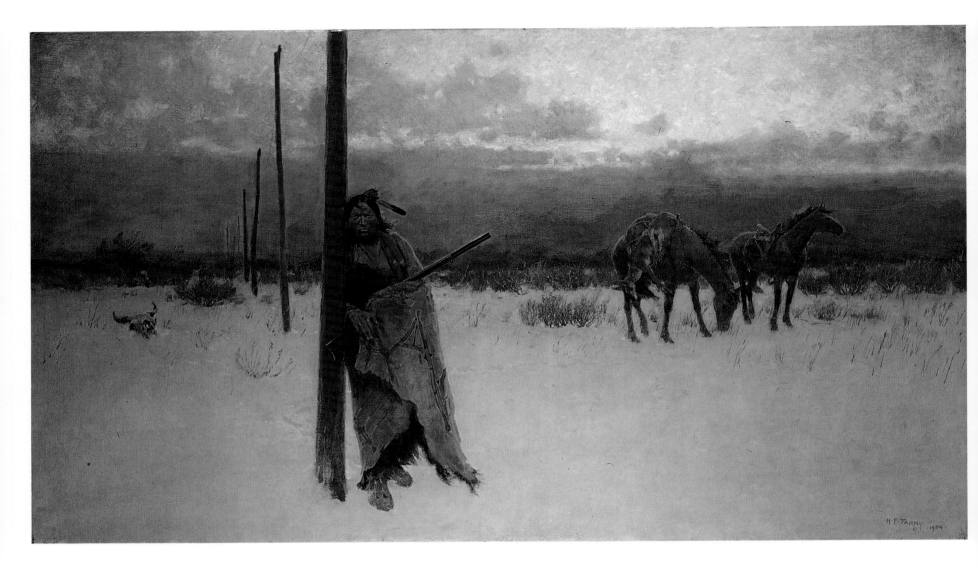

The Song of the Talking Wire

HENRY FARNY, 1847–1916

1904. Oil on canvas, 22⅛ x 40 in.
The Taft Museum, Bequest of Mr. and Mrs. Charles Phelps Taft, Cincinnati.

By the turn of the century the Indian, despite his oppressed circumstances—or, ironically, perhaps *because* of them—had become even more of a mythic figure. This new-found status emerged in views of heroic but fallen warriors. It also found expression in images that showed Indians clinging to the remnants of an unconstrained existence in the face of the relentless advance of white civilization. Henry Farny painted this theme on occasion, and it found masterful expression in the artist's pathos-filled work, *The Song of the Talking Wire*.

The Song of the Talking Wire portrays an Indian brave returning to his camp with provisions. He has stopped to place his ear against a pole where he hears the buzzing and clicking of Samuel Morse's technological wonder, the telegraph. Although his brow is furrowed, he does not seem to comprehend what this curious device may mean to or for him. To his uneducated mind it is merely a "talking wire." A wintry landscape and the dying light provide the simple but expressive backdrop for the scene. At the left, Farny places a bleached buffalo skull as if to highlight the Indian's own mortality.

By 1904, when the picture was completed, the telephone had already come into relatively widespread use, and the sight of telegraph poles stretching across the western landscape had long since grown familiar. Thus, even in Farny's day, this picture had a nostalgic quality about it.

Through unauthorized reproductions, *The Song of the Talking Wire* soon became one of Farny's most famous paintings. As a newspaper reviewer of 1893 observed, it was created "with the eye of the artist, tempered with the mind of the poet, and verified with the fidelity of an illustrator." [12] Even Kaiser Wilhelm wanted to purchase the picture when he saw it in Berlin. The German monarch had never visited the American West but he shared the white Americans' feelings of cultural superiority toward "primitive" peoples.

A Vision of the Past

EANGER IRVING COUSE, 1866–1936

1913. Oil on canvas, 59 x 59 in.
Butler Institute of American Art, Youngstown,
Ohio.

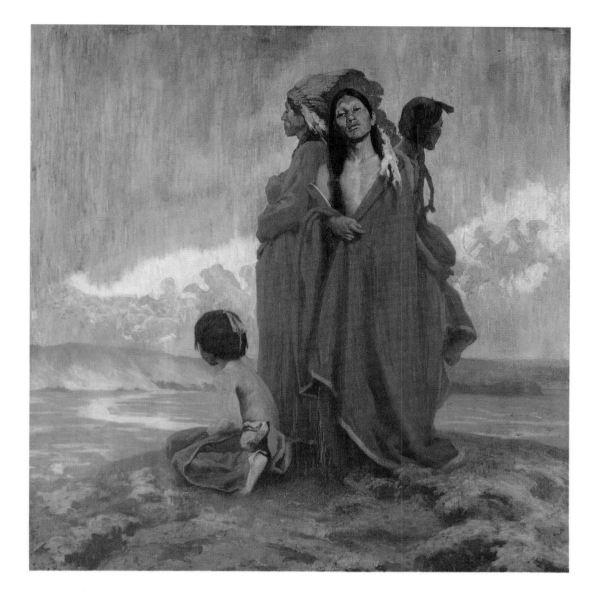

Although he was raised in Michigan and trained in the French Academy, E. Irving Couse is remembered today as one of the leading figures of the Santa Fe artists' colony. His prizewinning *A Vision of the Past*, reproduced here, depicts three Indian braves standing back to back to back as if held together by unseen bonds as they share a remembrance of their former greatness. They are symbols of a captive race that has been stripped of its independence but not of its nobility nor its spiritual unity and strength, which are reflected in the sculptural mass formed by the three figures and by the pyramidal composition. As with Eakins' painting of Hiawatha's vision (page 109), the three braves do not stare directly at the sky, for theirs is an inner vision of a heroic, but lost past. A young child sits at their feet, surveying the verdant valley before him, and although he is a part of the group, he is also separate, a symbol of the new generation. Perhaps the green valley suggests he will become a farmer—as the white culture would have him be—rather than follow the nomadic life of his ancestors, commemorated in the celestial buffalo hunt.

By placing his figures on a high point of ground with a low horizon, Couse was able to silhouette them against the sky and thereby endow them with a more immediate and monumental presence. His decision to link his protagonists with the heavens rather than the earth enhances their roles as symbols of a lost race. And by shifting their gaze away from the vision, he establishes—as Virginia Couse Leavitt, the artist's granddaughter, has observed—a poignant mood of introspection.

The inspiration for this painting may well have come from a meeting that Couse had with Hamlin Garland to discuss the well-known writer's interest in seeing one of his stories about Indians and the cavalry turned into a motion picture. Couse was invited to contribute ideas for scenes and Indian costumes. According to the artist, one of the subjects under consideration was a depiction of, in his words, "Dreams of Captive Race, a group on a hilltop seeing visions of an ancient Buffalo Hunt in the sky—empty plains intervening." Couse liked the idea of the project, which he saw as an "attempt to remove the misconception and contempt in which the Indian has been held, and to show that they are human beings worthy of consideration and a place in the sun."[13]

Cultures in Conflict

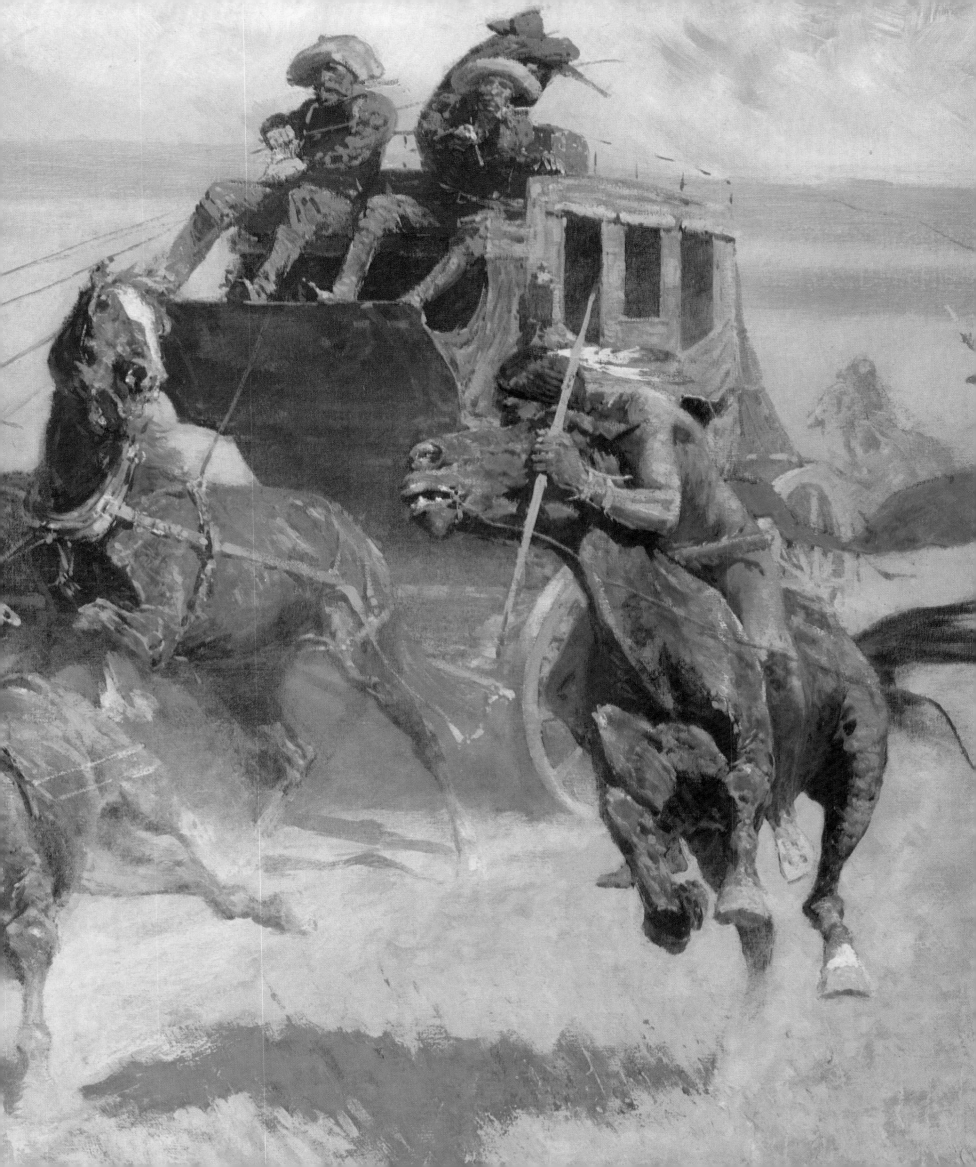

Cultures in Conflict

Even in the earliest days of American colonial history, European settlers in the New World found the Indian a fascinating figure, not so much for what he was in and of himself, but rather, as Roy Harvy Pearce noted in his classic study *Savagism and Civilization*, published in 1953, "for what he showed civilized men they were not and must not be." White fascination with the indigenous people swiftly turned to hostility, however, creating what Richard Slotkin termed "the fatal environment" for the Native Americans. White bias against Indians became so strong, in fact, that it ultimately fostered the near extermination of the entire native population. In his monumental study entitled *The Fatal Environment: The Myth of the Frontier in the Age of Industrialization*, published in 1985, Slotkin showed that these deeply ingrained feelings of cultural and racial hostility dominated popular attitudes and government policies toward Native Americans throughout the 19th century.

As loyal retainers of the ruling elite, American artists, with only a few exceptions—Catlin in the 1840s and Farny in the 1890s—reinforced, and so perpetuated the prevailing stereotype of the Native American as a blood-thirsty savage. As Pearce noted, a remarkable exception to the literature of the period was Herman Melville's *Confidence Man*. Published in 1857 this novel featured a chapter entitled "The Metaphysics of Indian-Hating," which held up Indian savagery for what it was—"hatred justified by piety, piety rationalized by hatred, civilization cultivating and then feeding upon its discontents."

On the following pages are some of the remarkable visual images that reflect white animosity toward Native Americans. They document the pervasive racism that ultimately brought about the virtual genocide of the indigenous people.

One of the dominant concerns of the period was the chilling prospect of white women and children falling into the hands of the savage foe and suffering sexual abuse. As early as 1804, with John Vanderlyn's neoclassical painting depicting *The Murder of Jane McCrea*, and 1827, with Thomas Cole's *Last of the Mohicans* based on James Fenimore Cooper's novel, the popular and commercially viable nature of this theme became apparent. Later, around the middle of the century, the belief in the Indian's sexual promiscuity and his alleged propensity for violence found expression in works by John Mix Stanley, George Caleb Bingham, Asher B. Durand, and Carl Wimar. The images created by these artists combined with popular "captivity narratives" found in literature to offer powerful evidence of the Indian's uncivilized and immoral ways. This "evidence," in turn, helped convince many Americans that the only viable solutions to the Indian problem were removal to areas beyond the frontier, better yet, confinement to reservations, and best of all, elimination.

Around the turn of the 20th century, depictions of the savage Indian reached a peak in the paintings of Frederic Remington and Charles Schreyvogel, who had created, as had other artists, a number of visual formulas to bolster the attitude ruthlessly expressed in the popular slogan, "the only good Indian is a dead Indian." Among these was the motif of the savage slinking up on his foe to attack, his features not even worth the artist's effort to flesh out. This motif found early expression in Bingham's *The Concealed Enemy* and was repeated countless times not only in art but in dime novels and later in motion pictures.

Ironically, as these powerful images proliferated, the actual power of the Indian tribes—and with it their claim to the land—was passing into history. By 1900,

The Death Struggle
CHARLES DEAS

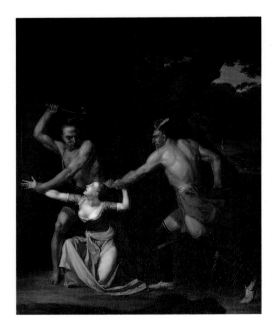

The Murder of Jane McCrea
JOHN VANDERLYN

◄◄
Downing the Nigh Leader (detail)
FREDERIC REMINGTON

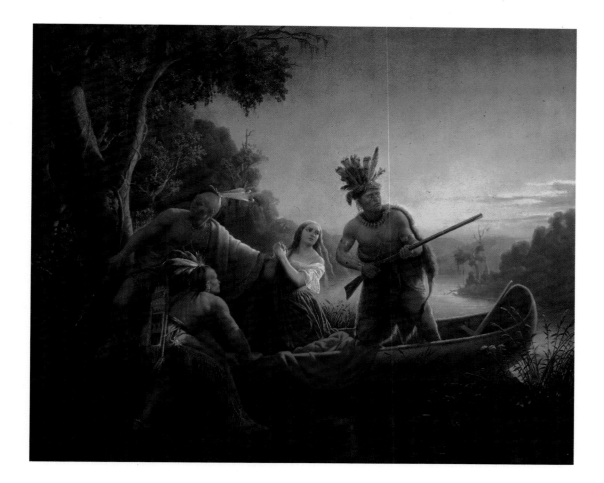

The Abduction of Daniel Boone's Daughter by the Indians
CARL WIMAR

How Kola!
CHARLES SCHREYVOGEL

when the Native American had been all but eliminated as a serious threat to white expansion, he had become even more warlike and dangerous in paintings, in the Wild West Shows of Buffalo Bill Cody, and in the popular imagination.

In 1881, Helen Hunt Jackson in her great book, *A Century of Dishonor*, issued a call for the protection of the Indians from the abuses of the federal government, but it was not until 1924 that Native Americans were finally granted U.S. citizenship. Even today, one must struggle to break free of cultural prejudice and racial stereotyping. A sensitive view of Indian life and culture, such as Kevin Costner's 1990 film *Dances with Wolves*, is rare.

As we consider the power of the painted images in this and the preceding chapter with their heavy baggage of obsolete cultural values concerning Native Americans—Catlin's "stains on the painter's palette"—it is worth remembering that stereotypes are destructive to all parties. For as Slotin, Pearce, and Berkhoffer have argued, the value of an entire race was denied in art, in literature, through governmental policy, and through acts of brutal violence, and the very act of this negation degraded civilization. Herman Melville put it well more than a century ago. "We are all of us—Anglo-Saxon, Dyaks, and Indians—sprung from one head, and made in one image," he said. "And if we regret this brotherhood now, we shall be forced to join hands hereafter. . . . The savage is born a savage; and the civilized being but inherits his civilization, nothing more." Perhaps it is well to heed the advice of Pearce who enjoined us in the conclusion of his profound study to recall the words of Queequeg, the savage Indian in Melville's great moral fable *Moby-Dick*: "It's a mutual, joint-stock world, in all meridians. We cannibals must help these Christians."

The Murder of Jane McCrea

JOHN VANDERLYN, 1775–1852

1804. Oil on canvas, 32 x 26½ in.
Wadsworth Atheneum, Purchased by Subscription,
Hartford, Connecticut.

Among the first artists to show Native Americans as murderous savages was the neoclassical painter John Vanderlyn, whose dramatic picture, *The Murder of Jane McCrea* is reproduced here.

Vanderlyn's painting was inspired by an event that occurred in 1777, during the Revolutionary War. Jane McCrea was a young Tory engaged to a soldier in the British army. During her journey to meet her intended, she was mistakenly killed by Indian allies of the British. Rumor held that her captors "tore off her scalp" and presented it for reward to their British paymasters. This event was a great propaganda coup for the Americans since McCrea's death caused many of those who sympathized with the Tories to turn against the British.

Vanderlyn's painting was created in Paris more than a quarter of a century after the event, when the French and English were at war. Consequently, the painting was lauded for its anti-British sentiment when the artist exhibited it at the annual Salon in 1804. The treatment of the figures is strongly reminiscent of Hellenistic sculpture, especially that of McCrea which may be based on works depicting Niobe (whose children, according to mythology, were killed by the gods). Such classical associations would have been more readily grasped by Vanderlyn's audience in France than in America. However, his American audience would have focused on the fact that a white woman was in the grasp of Indians, a situation with racial and sexual overtones abhorrent in the period. As if to underscore the horrific aspects of the story and the sado-sexual undercurrents as well, Vanderlyn places a tiny figure of McCrea's British fiance in the background rushing—too late—to her rescue.

Vanderlyn's painting was commissioned by Joel Barlow, President Jefferson's ambassador to France and the author of the *Columbiad*, a ten-volume epic poem tracing the history of

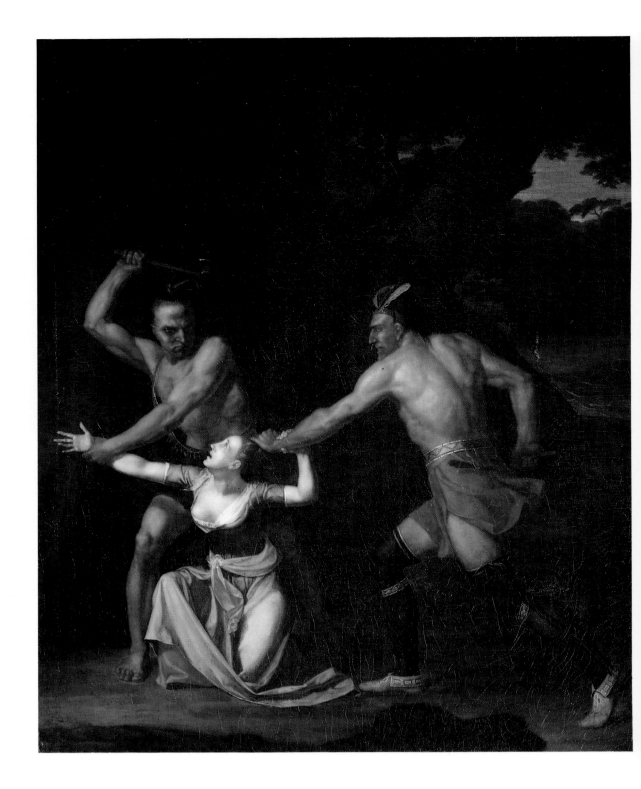

the Americas. Vanderlyn's work was to have illustrated this poem, but the artist became so engrossed with the subject that eventually Barlow had to engage someone else. Meanwhile, *The Murder of Jane McCrea* soon found its way back to America where it was exhibited in New York City for several decades. Vanderlyn's powerful image influenced many later artists, providing an archetypal representation of an Indian atrocity that would endure through the 19th century. [1]

Scene from "The Last of the Mohicans," Cora Kneeling at the Feet of Tamenund

THOMAS COLE, 1801–1848

1827. Oil on canvas, 25³⁄₈ x 35¹⁄₁₆ in.
Wadsworth Atheneum, Bequest of Alfred Smith,
Hartford, Connecticut.

The possibility of a white woman submitting sexually to an Indian was a tantalizing if traumatic idea to 19th-century Americans. It was a subject that Thomas Cole explored early in the century in several canvases based on James Fenimore Cooper's popular novel, *The Last of the Mohicans*. In the 1820s, when Cole created these works, the Iroquois and Mohicans were still considered a threat to white expansion into the western territories, then known as the Old Northwest. The artist and the novelist Cooper saw in the stories of Indian atrocities an opportunity to use their respective skills for political—and personal—ends. Surely their fellow citizens would not feel guilt over wresting land from such savages, they must have thought, and would, at the same time, pay good money for works designed to excite anti-Indian emotions.

That Cole relied on Cooper for inspiration is clear from the inscription on the back of the canvas that reads "Scene from the Last of the Mohicans 2 Vol., Chap. 12." Moreover, early exhibitions of the painting featured the line from the novel that found the savage Tamenund offering Cora, the white heroine, a choice between "the wigwam or the knife!" Other lines were often reproduced in early catalogs as well: "Cora regarded him not; but dropped on her knees, with a rich glow suffusing itself over her features, she raised her eyes and stretched her arms toward heaven, saying in a meek and yet confiding voice, 'I am thine! Do with me as thou seest best!'"

Although Cole's figures are small, Cora can be seen kneeling in supplication before Tamenund who is in the center of the encircled Indians. The sexual overtones of the image are reinforced by a huge phallic column of rock capped by a rocking stone just behind the figures and by the cliff to the right of it, with its grimacing Indian-like profile.

DETAIL ▶▶

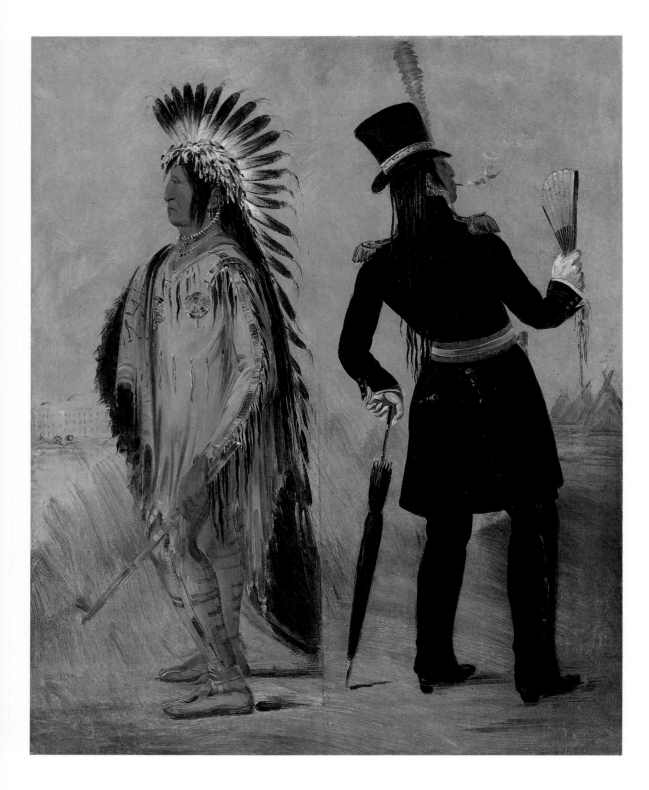

Pigeon's Egg Head (The Light) Going to and Returning from Washington

GEORGE CATLIN, 1796–1872

1837–1839. Oil on canvas, 29 x 24 in.
National Museum of American Art, Gift of Mrs.
Joseph Harrison, Jr., Smithsonian Institution,
Washington, D. C.

In 1831, Pigeon's Egg Head, a handsome young Assiniboine warrior, was the leader of a delegation of Indians invited to Washington to visit the president. George Catlin first met him in St. Louis and painted his portrait "in his native costume, which was classic and exceedingly beautiful." Pigeon's Egg Head wintered in the nation's capital, where he discovered the ways of the white man. "He traveled the giddy maze," Catlin wrote, "and beheld, amid the buzzing din of civil life, their tricks of art, their handiworks, and their finery; he visited their principal cities, he saw their forts, their ships, their great guns, steamboats, balloons, &c. &c. . . ."[2] In the spring he returned to St. Louis where Catlin joined him and his companions for the journey back to their country.

In Catlin's painting the Indian warrior appears at the left in his splendid native regalia, a glimpse of the White House to his right. On the opposite side, he has returned from Washington, having exchanged his Indian garb for a military tunic with gold lace and epaulets and high-heeled boots that made him "step like a yoked hog." He holds the accouterments of gentility—a fan and an umbrella—while he smokes a cigarette; from his pocket protrudes a liquor bottle. When Catlin saw him thus attired he was vainly swaggering on the deck of a steamboat ascending the Missouri River, whistling "Yankee Doodle."

Pigeon's Egg Head returned home, where he told his fellow tribesman all that he had seen and done, but they found his tales impossible to believe. He was labeled a liar and an imposter, and, according to Catlin, "he sank rapidly into disgrace in his tribe; his high claims to political eminence all vanished; he was reputed worthless—the greatest liar of the nation."[3] After three years of listening to his stories, the Assiniboine assassinated him as a menace to the tribe.

The Death Struggle

CHARLES DEAS, 1818–1867

circa 1845. Oil on canvas, 30 x 25 in.
The Shelburne Museum, Shelburne, Vermont.

When *The Death Struggle* by Charles Deas was exhibited in New York in 1845, it attracted considerable attention because of the horrible, unrestrained battle that it depicted between a tenacious Indian and the white trapper who is trespassing on his hunting ground. During the fight, the foes and their horses become wounded and all four, the men and their mounts, topple over the edge of the cliff on which they are struggling. "On, on, speed the horses," described the *Broadway Journal* in the florid rhetoric of the period, "wilder and wilder they grow in their flight—the height is gained—without let or pause over they go! Man and beast food for the Buzzards! But no! their downward progress is arrested by a boldly jutting rock." [4]

Deas' mastery of expression and gesture is evident in the terror-stricken eyes of the trapper and his futile reach for an insubstantial branch above his head. With his other hand he still holds the contested beaver that bites the Indian's arm. The horrific scene is observed from above by the Indian's companion who strains forward in disbelief. Blood-red colors in the trapper's shirt, the Indian's painted face, and the streaming blood on the men and horses—even the snorts from the nostrils of the Indian's horse—emphasize the fatal savagery of the moment. A dark, stormy sky, with the appearance of black birds below the figures, heightens the portent of certain death. Subtle indications of ethnic preference are communicated by the white horse of the trapper, contrasting with the black mount of the Indian. The faces of both horses are contorted in expressions of stark terror. Although wildly improbable as an actual event, Deas' *Death Struggle* is nonetheless a superbly crafted piece of theater, a "horse opera" long before the days of movie Westerns.

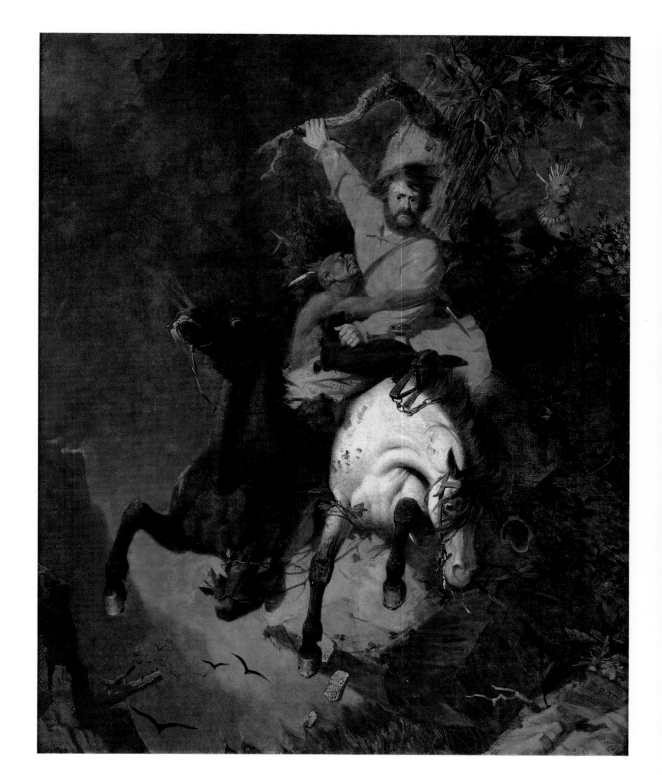

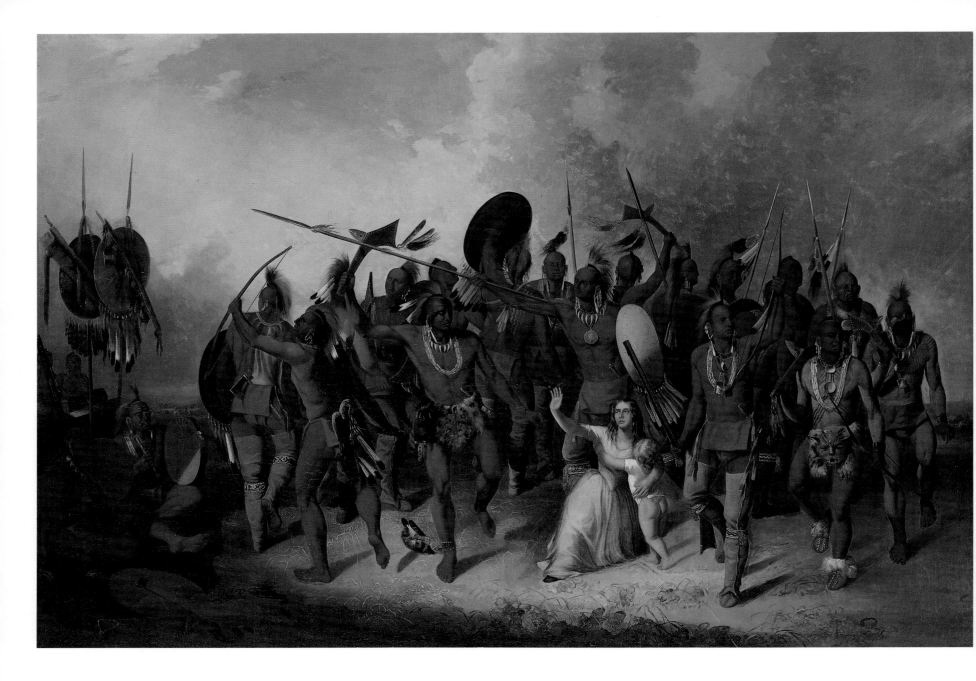

Osage Scalp Dance

JOHN MIX STANLEY, 1814–1872

1845. Oil on canvas, 40¾ × 60½ in.
National Museum of American Art, Smithsonian
Institution, Gift of the Misses Henry, 1908,
Washington, D. C.

In *Osage Scalp Dance* John Mix Stanley dramatically portrays a group of wildly gesturing Indians who are threatening to do unspeakable harm to a helpless white woman and her child. The work is clearly a studio composition, designed to arouse feelings of outrage at the Native American, whose barbaric practices and savage appearance are stereotyped by the artist's contrived rendering of the event. The scalping of white women was, in fact, a far rarer occurrence

than the wanton murder of Indian women and children by whites, although sensational pictures such as Stanley's would lead one to believe otherwise.

While *Osage Scalp Dance* reveals the artist's knowledge of Indian costumes, weapons, and customs, his careful ethnographical descriptions are overshadowed by the work's central melodrama and the disturbing cultural values expressed in it. The woman's gesture, suspiciously familiar from both Vanderlyn's painting of Jane McCrea (page 124) and the many derivative prints made after it, is directed toward the figure at left brandishing the war club. His threatening gesture is parried by the central figure who ironically wears a presidential peace medal. The poses of the woman and child suggest typological associations with the traditional theme of the slaughter of the Innocents, the gospel story in which Herod ordered the death of every male child two years and under in the land of Judea.

The poses and gestures of Stanley's figures show his awareness of both classical sculpture and European academic drawing manuals for representing the human figure.

Osage Scalp Dance was one of the few works by Stanley to escape the disastrous fire at the Smithsonian Castle in 1865. Unfortunately about 150 other works from the artist's Indian and Western Gallery were destroyed. They had been on deposit at the Smithsonian awaiting purchase by the government.

The Concealed Enemy

GEORGE CALEB BINGHAM, 1811–1879

1845. Oil on canvas, 29½ x 36½ in.
Stark Museum of Art, Orange, Texas.

George Caleb Bingham painted *The Concealed Enemy* in 1845, the year that a New York newspaper editor coined the term "manifest destiny." Perhaps it was not coincidence that Bingham's depiction of a hostile savage waiting in concealment in the western wilderness came at almost the same time as this powerful expression of America's territorial ambitions entered the language.

In Bingham's painting a lone warrior tightly grasps his rifle with a menacing expression on his face as he crouches behind a rock. The intended victim of his ambush is unseen, but was doubtless understood by Bingham's audience to be a white settler taking his rightful place in the West. As Henry Adams has argued, the events of the picture occur as the sun is setting—thus evoking the end of Indian civilization. By contrast a radiant dawn celebrates the ascent of white civilization in the picture's pendant, *Fur Traders Descending the Missouri* (page 26).

Relying on the compositional devices that he had learned by studying the prints of 17th-century Italian artist Salvator Rosa, Bingham contrives an image that is as unsettling as that in *Fur Traders Descending the Missouri* is restful and inviting. Perhaps most disturbing of all is the introduction of the precipice on the left side of the painting which places the viewer in a nearly eye-to-eye confrontation with the Indian. The sense of impending doom is further accentuated by the stormy sky and by the jagged dead trees that project from the rocks. These forms, influenced by precedents in the art of Thomas Cole, serve to complete the effect of a landscape containing imminent dangers.

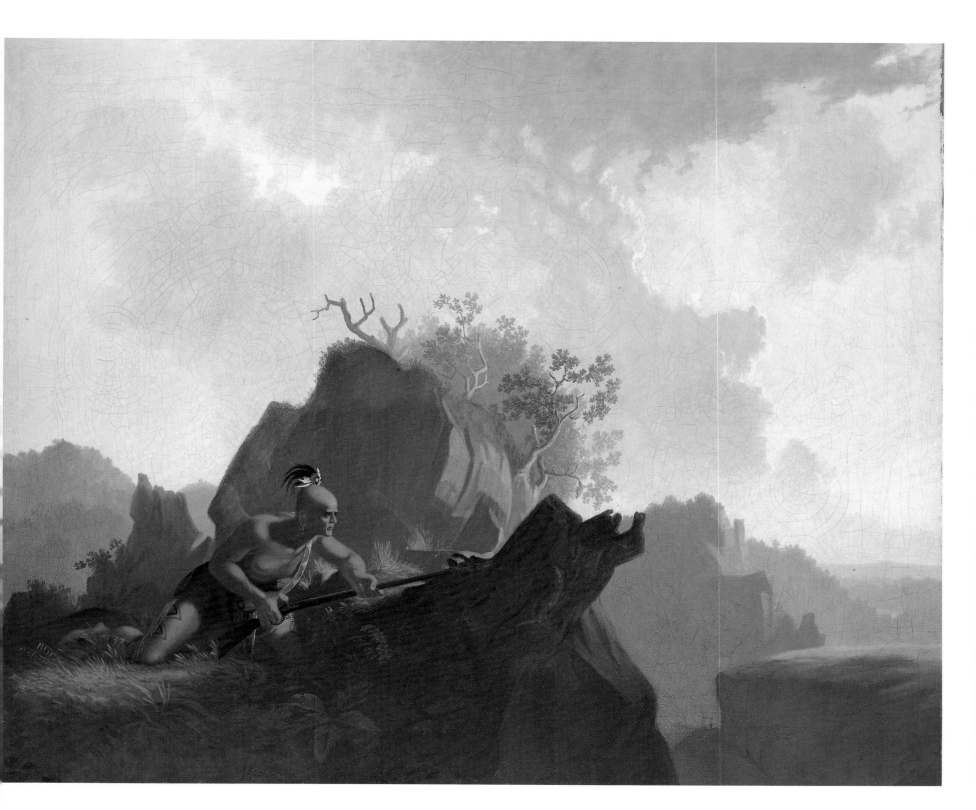

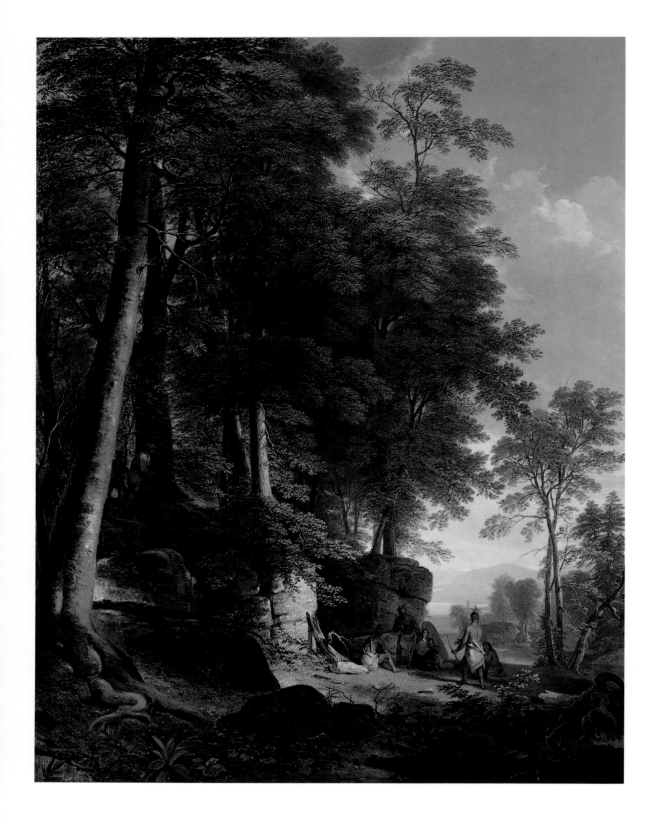

Indian Rescue

ASHER B. DURAND, 1796–1886

1846. Oil on canvas, 45 x 36 in.
The Anschutz Collection, Denver.

During the 18th and much of the 19th century a unique genre of American literature, called captivity narratives, sensationalized Indian attacks on whites. These popular stories contributed to the climate of hatred that ultimately led to the near extermination of the Native Americans. Asher B. Durand's painting, *Indian Rescue*, is one of several visual counterparts to these popular horror stories. In this instance, a white woman with a child is held captive by several Indians. One "savage," standing just behind the woman, raises a threatening tomahawk, while another, armed with a bow, gestures toward an Indian woman seated nearby as if to ask, why not kill the whites. This foreground drama, calculated to arouse the anger of white spectators and make Durand's painting more salable, is balanced by the band of rescuers cautiously advancing at left through the forest. Ironically, they move stealthily, a posture normally reserved for Indians.

An established landscape painter of mid-19th-century America, Durand uses his artistic ability effectively in *Indian Rescue* to create an ambience that underscores the drama of the captivity. The figures are posed against a cluster of rocks in a sunlit clearing that offers a vista down to a river. Several broken tree branches and tree roots, particularly those just to the left of the Indians and in the extreme right foreground, evoke menacing, serpentine forms. Clearly, this serene, inviting landscape merely needs to be rid of the Native Americans in order to flourish—or at least that is how the eastern audience for whom this painting was intended would have seen it. Lest there be any doubt, the artist creates a group of three small trees just to the right of the central figures, emblems of the three crosses on Calvary, thus signifying a divine—explicitly Christian—promise of salvation even in the wilderness.

DETAIL ▶

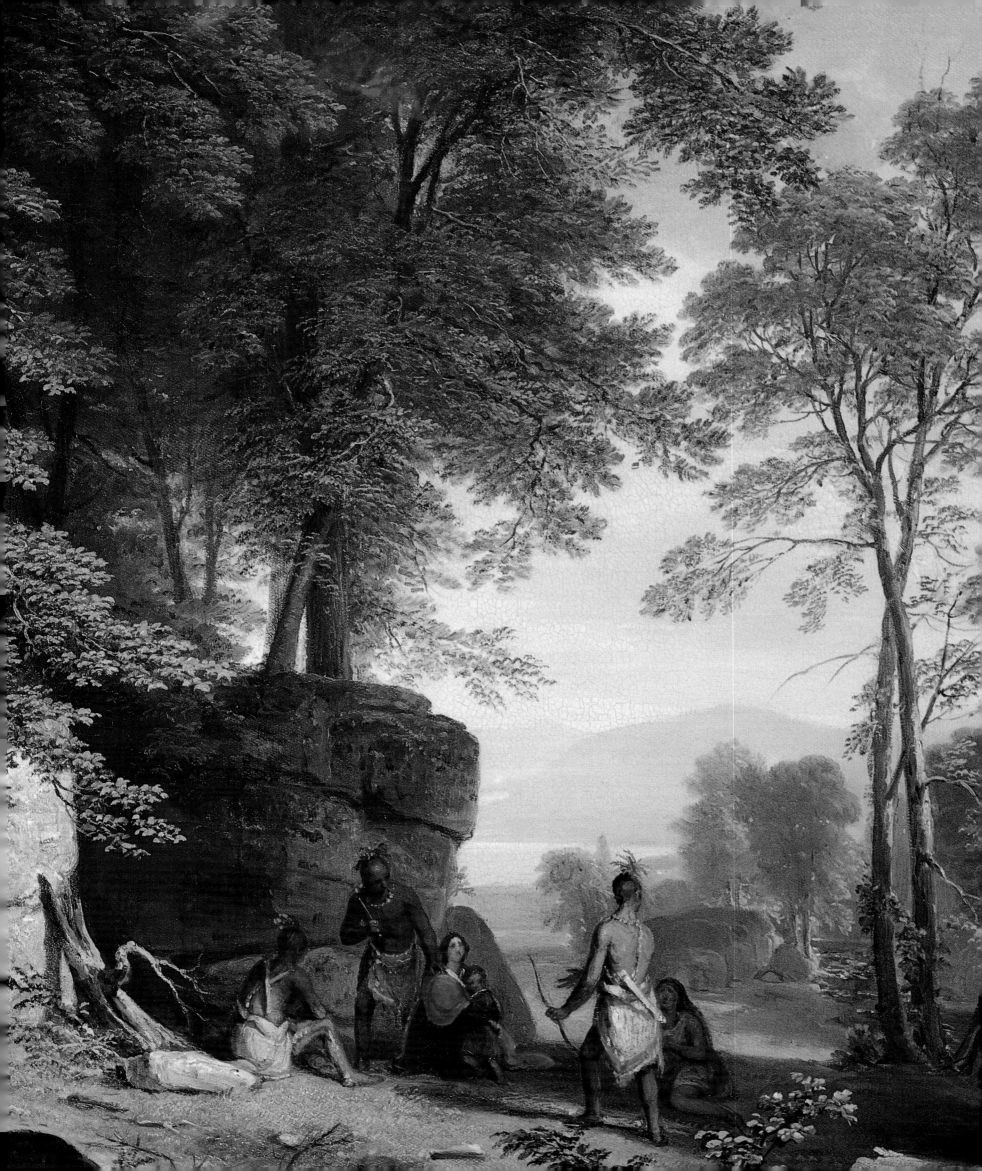

Captured by the Indians

**GEORGE CALEB BINGHAM,
1811–1879**

1848. Oil on canvas, 25 x 30 in.
*The St. Louis Art Museum. Bequest of Arthur C.
Hoskins.*

One of the most ambiguous examples of
the captivity theme can be found in
George Caleb Bingham's *Captured by the
Indians*, in which a woman and child are
guarded at gunpoint by three Indians. It is a
dark, menacing night, the illumination from
the fire casting an eerie glow on the figures.
The Indians, armed with rifles, their heads
shaved to scalplocks, their bodies bedecked
in colorful blankets, are certifiably savage.
Yet, as Elizabeth Johns has perceptively

observed, there are ambiguous details in the
work. Two of the captors are asleep, while
the third on guard at left appears less savage
than firm. The woman and child, placed at
the exact center of the composition, are rem-
iniscent of the Madonna and Child, the
"Mary" figure in this case looking upward as
if in prayer while her child sleeps. Recent
interpretations have suggested that the child
may be of mixed blood, further blurring the
meaning of their captivity.

It is curious that Bingham would have
painted such a scene, because in the 1840s,
when the work was executed, the threat of
Indian raids in the artist's Missouri had long
since ceased. If the painting was intended—
like so many other captivity paintings—to
inflame white hatred against the Indians and
hence justify the taking of tribal lands, then
Bingham seems to make a relatively weak
case. There is no sense of immediate danger

to the woman and child. In fact, the lack of
threat seems to confirm that such emotions
were incompatible with Bingham's own artis-
tic temperament, despite his treatment of the
hostile savage a few years earlier in *The
Concealed Enemy* (page 131). Bingham could
neither perpetuate the myth of the savage
Indian, nor fully deny the stereotype of the
helpless woman. In its treatment of these
troubling cultural issues, the work may ulti-
mately be unresolved.

The Abduction of Daniel Boone's Daughter by the Indians

CARL WIMAR, 1828–1862

1853. Oil on canvas, 40 x 50 in.
Washington University Gallery of Art, Gift of Mrs.
John T. Davis, Jr., St. Louis.

If there is ambiguity in Bingham's treatment of the captivity motif (page 134), *The Abduction of Daniel Boone's Daughter by the Indians* leaves no doubt about Carl Wimar's position. For this artist, the sexual molestation of white women by Indians alone qualified them for conquest, if not annihilation.

The work was painted in Düsseldorf, Germany, where Wimar learned his melodramatic style of history painting from Emanuel Leutze.

According to legend, Boone's daughter had been gathering flowers when she was carried off by Indians. Where Bingham had evoked the Madonna and Child to portray a captured woman and her son, it is Mary Magdalene that Wimar chooses as the model for his "high-soul'd Jemima" Boone.

Viewing this work on its simplest terms, Jemima is pleading for mercy from her captors. But, as Joseph Ketner has astutely observed in a recent study, perhaps she is really praying for divine redemption from any sexual violation that she may suffer in captivity.[5] Hints of her impending violation can be found in the dress that has provocatively fallen from her shoulder, revealing her breast, and the red blanket at her feet, which alludes to the bloody prospect of her violation. The leering gaze of the Indian about to enter the boat at left further emphasizes the young woman's sexual appeal.

Wimar's overtly sexual treatment of the captivity theme reveals prevailing 19th-century ideas about the Indians' sexual habits. Common myths held that, in general, the men were promiscuous and that they raped their female captives, a view reinforced repeatedly in sensationalistic captivity narratives. To self-righteous Christians such immoral and uncivilized behavior—for which there was little basis in fact—supported the belief that, to solve the Indian "problem," the entire race had to be removed, confined, or eliminated.

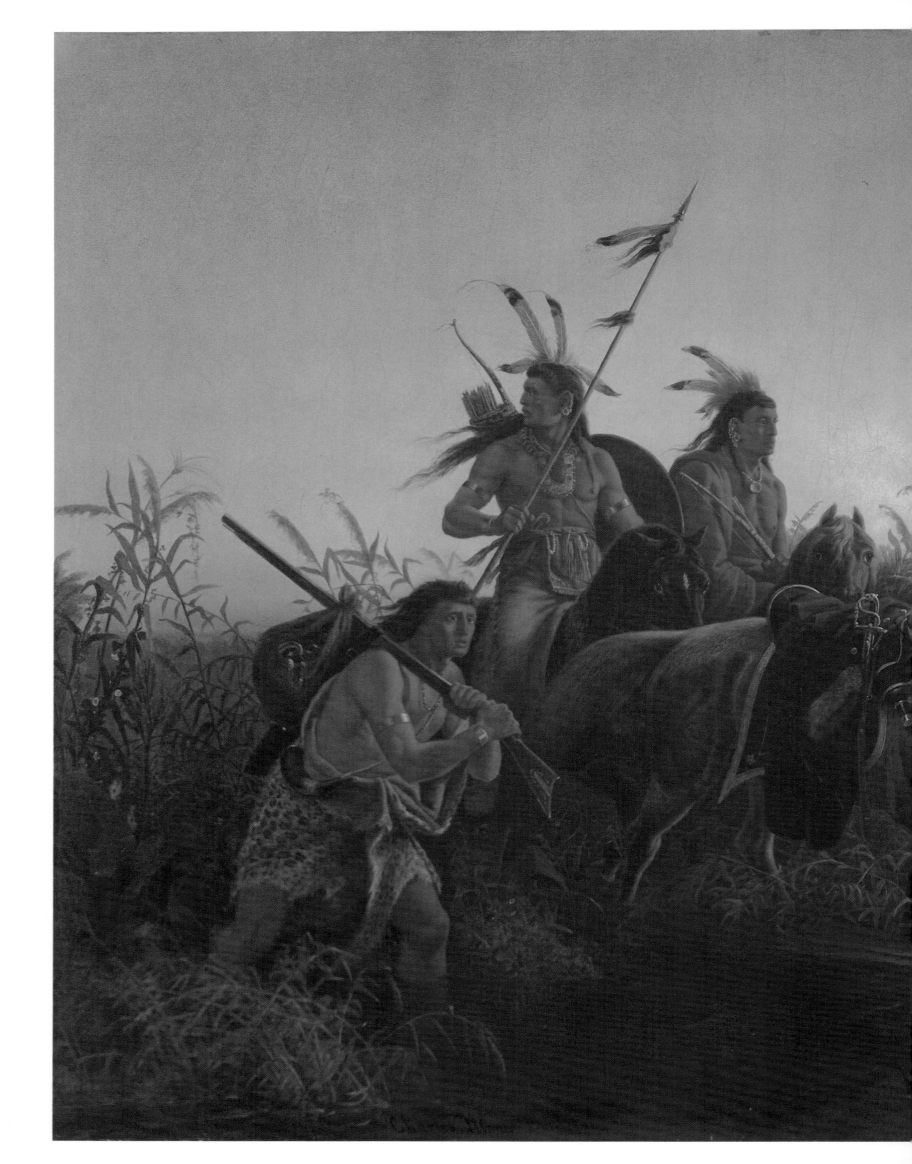

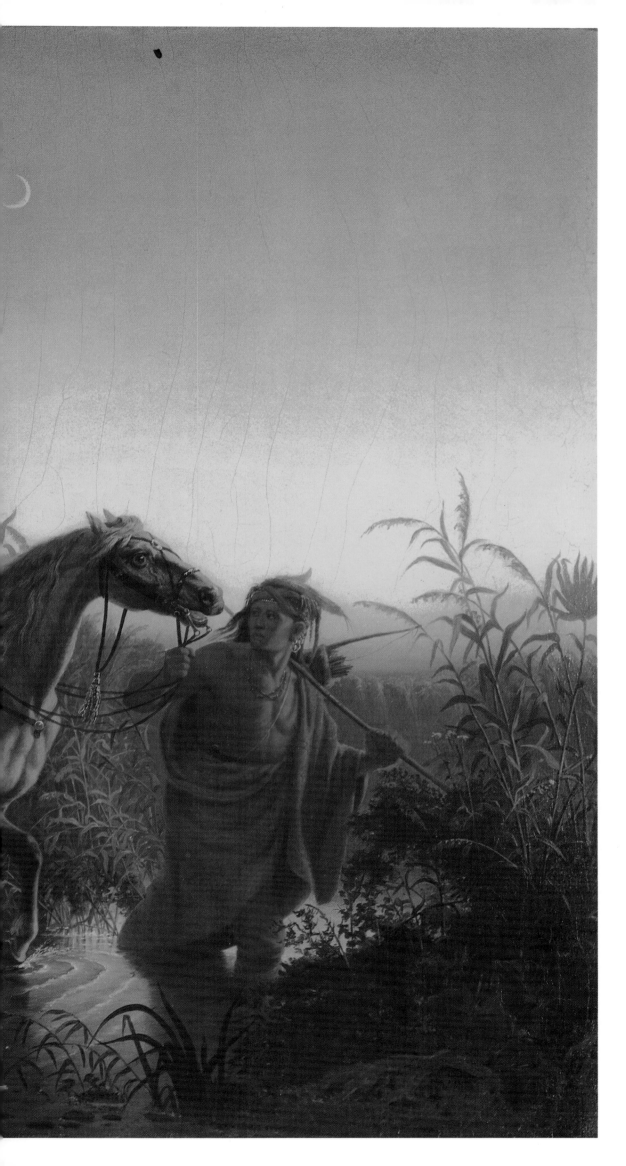

The Captive Charger

CARL WIMAR, 1828–1862

1854. Oil on canvas, 30 x 41 in.
The St. Louis Art Museum. Gift of Miss Lillie B.
Randell.

It was Carl Wimar, German born and trained, who gave fullest expression to the prevailing notions of the savage Indian, establishing motifs of Native American cruelty that would have currency well into the 20th century. In the work reproduced here, *The Captive Charger*, for example and in another painting, *Indians Pursued by American Dragoons*, he created the archetypical images of conflict between the Indians and the United States Cavalry.

Painted in Düsseldorf, Germany, under the direction of Wimar's teacher, Emanuel Leutze, the work, originally called "Indians as Horse Thieves," depicts a group of Indians stealing an American cavalry officer's white horse in the waning light of sunset. The furtive glance of the mounted figure at left with a spear, and the sack of booty carried by his companion in an improbable leopardskin skirt indicate that they have ambushed an army scouting party. Although this act is an attempt to deflect what Catlin aptly called the "juggernaut" of American progress, it is a futile gesture. These braves are lost culturally, having abandoned their tribe's code of honor. Their anxious, stealthy looks and their evident haste to escape with the stolen loot under the waning moon and evening star underscore the fate that awaits them for their petty theft. This and other acts of defiance will only bring down the wrath of America's military might upon them.

The Attack on an Emigrant Train

CARL WIMAR, 1828–1862

1856. Oil on canvas, 55⅛ x 79⅛ in.
The University of Michigan Museum of Art, Bequest
of Henry C. Lewis, Ann Arbor.

While Carl Wimar was completing *The Abduction of Daniel Boone s Daughter* (page 135), he was developing ideas for what would become one of his most important and influential paintings, *The Attack on an Emigrant Train*. He completed the work just before he left Düsseldorf to return to St. Louis in 1856. This picture was based on his reading of Gabriel Ferry, a French author of western stories, whose 1851 *Impressions de Voyages et Adventures dans le Mexique, La Haute Californie et les Regions de l'Or* described "a caravan of gold seekers in camp, on the prairie . . . defending themselves against the attack of a band of Indians."[6] As Joseph Ketner has observed, Wimar's rendering of the scene was entirely novel in its conception, establishing the stereotype for all future images of Indian attacks on wagon trains.

The painting shows a group of settlers attempting to defend themselves against a furious attack by a band of Indians on horseback. Several vignettes contribute to the dramatic action of the narrative. At left, two savages, looking suspiciously like pieces of classical sculpture, appear to rise from the prairie grass to attack the lead wagon, their war clubs and tomahawks at the ready. Nearby, the settler on the lead horse points a pistol directly at the head of one of his attackers, just as the horses pulling the wagon rear up. At the same time the settler at the rear of the wagon shoots another brave, who falls backward. At right, other warriors ride past the train shooting arrows and wielding tomahawks. One savage is wounded and falls backward, clutching his chest.

In 1860, Wimar's *Attack* was lithographed by Louis Grozelier as *On the Prairie* and given nationwide distribution. It became enormously influential, inspiring, among others, turn-of-the century paintings by Remington and Russell. Later, film director John Ford relied on Wimar's painting for cinematic formulations of Indian attacks on wagon trains.

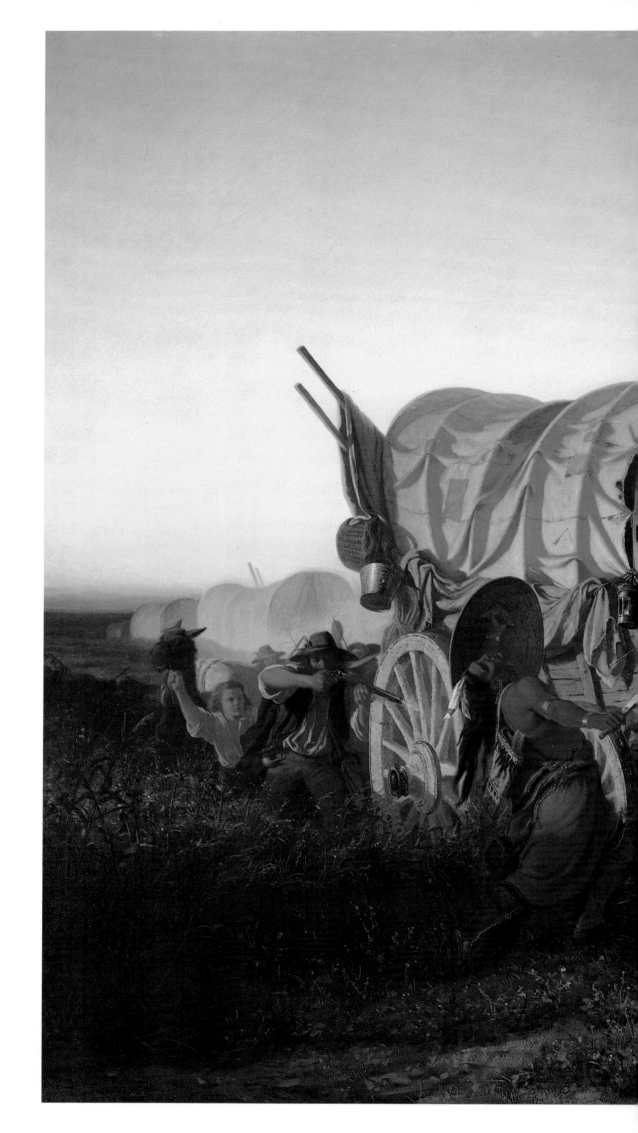

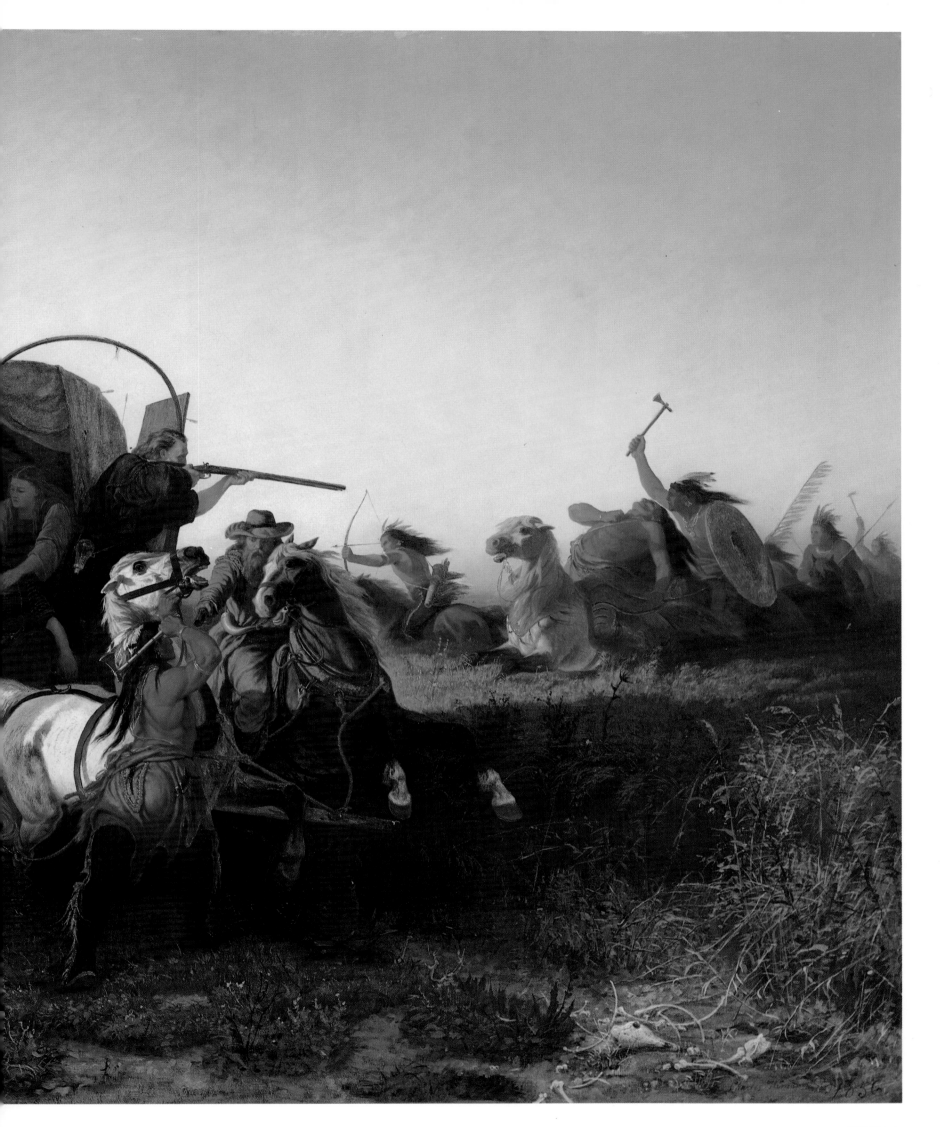

DETAIL ▶▶

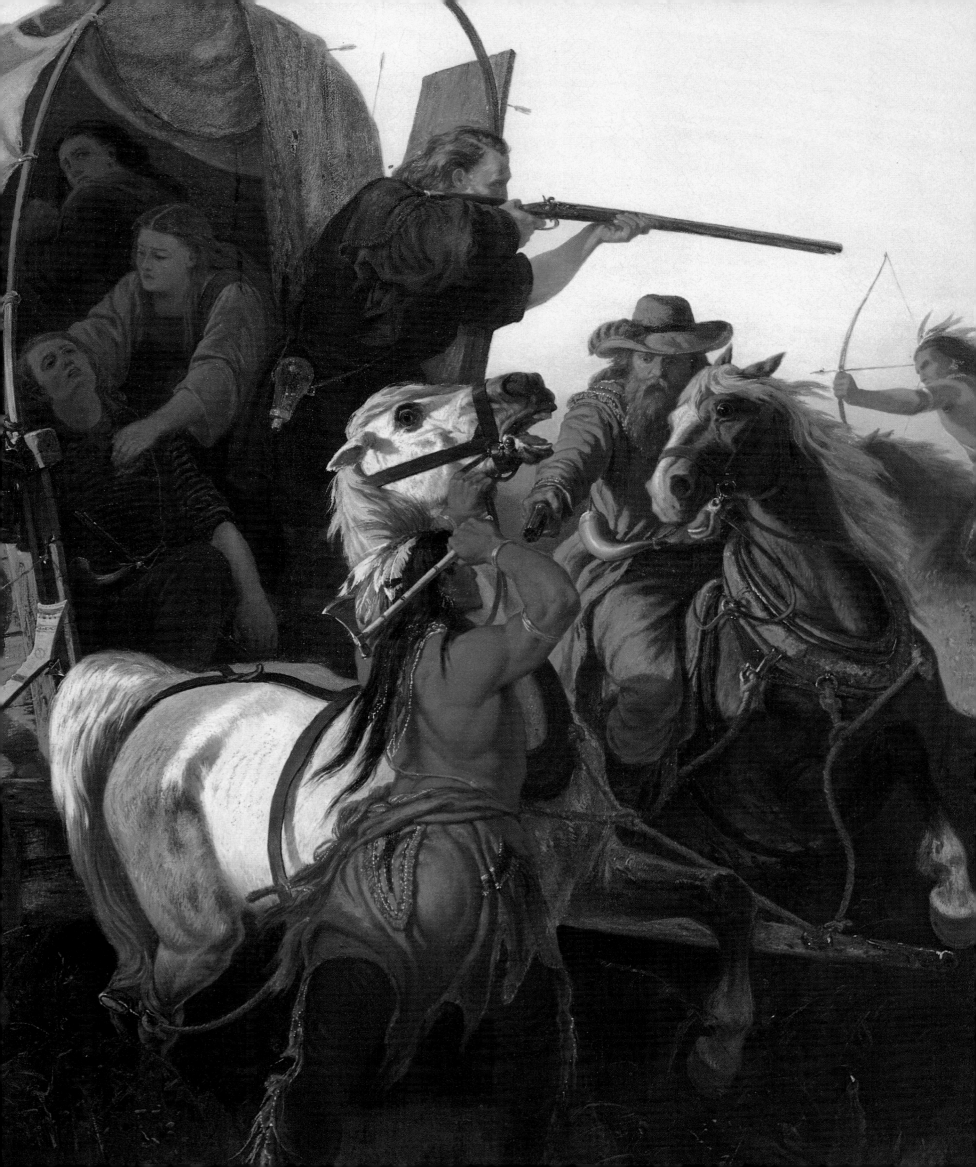

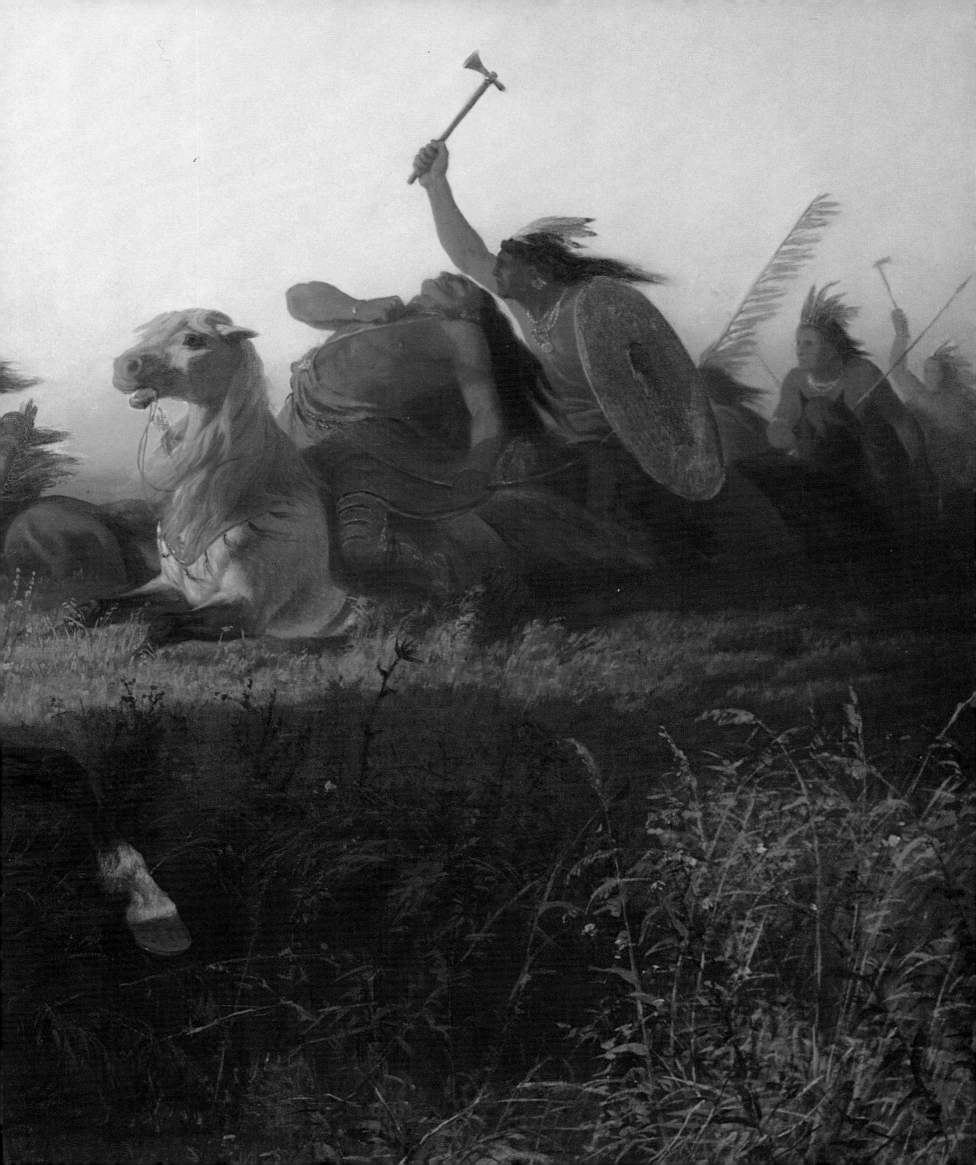

The Revenge

GEORGE DE FOREST BRUSH, 1855–1941

1882. Oil on canvas, 15½ x 19½ in.
Philadelphia Museum of Art. Alex Simpson Collection.

George De Forest Brush has never ranked with Remington, Russell, Farny, or Schreyvogel as one of the leading painters of the American Indian. Rather, he is known best as an artist of the American Renaissance who painted a few remarkable western images like *The Revenge*.

Brush was a student at the National Academy of Design in New York and at the French Academy, where his master was Jean-Leon Gerome. Upon his return to America in 1881, he accompanied his brother to Wyoming to establish a ranch. Camping for a summer with the Shoshones, the Arapahoes, and later the Crow in Montana, Brush developed a deep appreciation for the Native Americans and their way of life.

Shortly after his return to New York in 1882, he painted *The Revenge*. In this horrific image, a mounted warrior gallops directly toward the viewer, triumphantly displaying his trophy, a bloody, freshly cut scalp. The warrior's hairstyle identifies him as a Crow, and the feather in the horse's mane marks the mount as one of the tribe's best. In the background, an enemy war party is in pursuit. The simplicity of this terrifying image set against a white, snow-covered landscape, and the radical, almost photograph-like immediacy of the asymmetrical composition marked this as one of the most important works of the artist's oeuvre. It also represented a sig-nificant departure from Brush's typically idealized and romanticized images of Native Americans engaged in quiet activities such as weaving or acts of poetic meditation.

Curiously, Brush was not successful in his attempt to enter the long tradition of American Indian painters, and by 1890 he had abandoned the subject in favor of sentimental images of American women and children. Brush's daughter later said that her father stopped painting Indians because the government's treatment of the decent peoples he had met left him heartbroken. Brush believed they had been cheated of their lands, customs, and lives and had become drunkards as a consequence.[7]

A Taint in the Wind

FREDERIC REMINGTON, 1861–1909

1906. Oil on canvas, 27⅛ x 40 in.
The Sid Richardson Collection of Western Art,
Fort Worth.

For years Frederic Remington was dismissed by art historians as a mere illustrator, but today his reputation is being rehabilitated under the guise of Post-modernist formalism. Recent publications have attempted to place him in the mainstream of American art by showing that his late works, especially those created after 1900, reflected a strong association with the aesthetics of American Impressionism. An excellent example of Remington's mature style is *A Taint in the Wind*, which drew praise from no less an Impressionist than Childe Hassam. "The only thing to say in criticism," he wrote, "is your stars look 'stuck on' and perhaps your foreground shadows are too black. Too much paint for stars, perhaps—too much pigment I mean" [8] Hassam's comment may have been tongue in cheek, as he was noted for loading his canvases far more heavily with pigment than Remington does here.

In the process of re-evaluating Remington's art on the basis of stylistic grounds, it should not be forgotten that the artist carried rather extreme racial prejudices and these too were often expressed in his work. "I've got some Winchesters, and when the massacring begins . . . I can get my share of 'em and what's more I will," Remington once wrote. "Jews—Injuns—Chinamen—Italians—Huns, the rubbish of the earth I hate." [9]

While *A Taint in the Wind* exemplifies Remington's maturing technical skill, it also reflects his bigotry. As the title suggests, the horses in the painting rear up in fear because they detect the unfamiliar odor of the Indians and their mounts lurking nearby, waiting to ambush the stagecoach. If one chooses to overlook this disturbing point of view by emphasizing the artist's tonalist treatment of moonlight and his Impressionist handling of pigment, one ignores the kind of racial bias that contributed to the virtual decimation of a people, made worse in this case by the very skill of the work's creator.

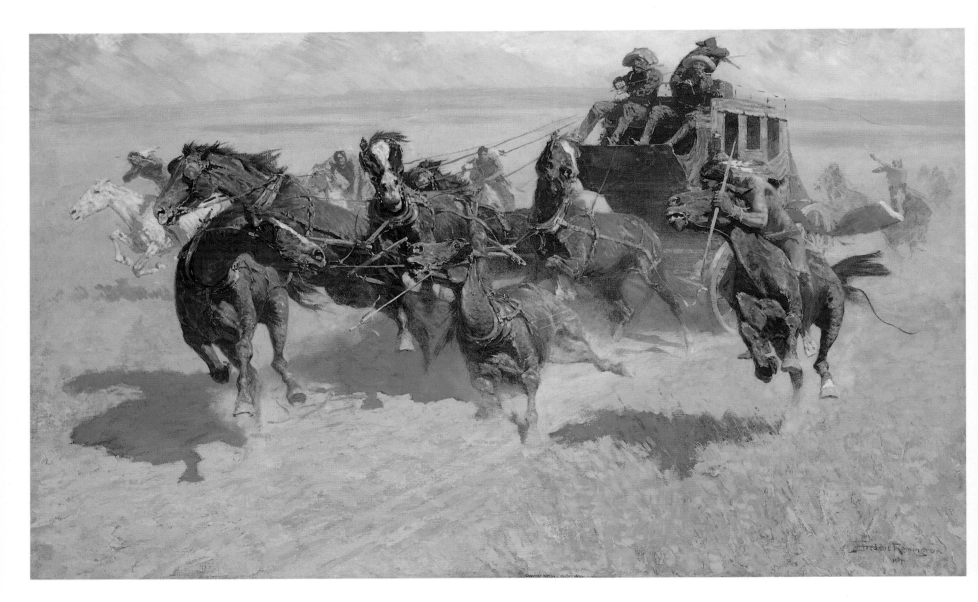

Downing the Nigh Leader

FREDERIC REMINGTON, 1861–1909

circa 1907. Oil on canvas, 30 x 50 in.
Museum of Western Art, Denver.

In *Downing the Nigh Leader*, Frederic Remington depicts a stagecoach that has been waylaid by a group of mostly faceless braves. They have killed the front left horse— the "nigh leader"—in order to bring the coach to a stop.

According to Remington scholar James K. Ballinger, *Downing the Nigh Leader* is a daytime version of *A Taint in the Wind* (page 143). Created as an illustration for *Collier's*, its depiction of a savage Indian attack is a perfect sequel to the braves' implied presence in the earlier picture. Perhaps the work was based on an actual incident. That was the

opinion of Harold McCracken, the doyen of Remington students, although he provided no evidence to support this contention. [10]

Throughout his career, but especially in his late work, Remington displayed a conflicted attitude toward Native Americans. In meditation paintings such as *With the Eye of the Mind* (page 115), he revealed a sympathetic point of view, while in works like *Downing the Nigh Leader* his Indians appear as fierce animalistic creatures, scarcely distinguishable from the horses they ride. Moreover, if Remington became absorbed with Impressionism in his maturity, *Downing the Nigh Leader* confirms that even at the apex of his career he still retained his strong interest in storytelling. As he wrote during this period, "I sometimes feel that I am trying to do the impossible in my pictures in not having a chance to work direct, but as there are no people such as I paint, it's 'studio' or nothing . . . Yet these transcript from nature fellows [the Impressionists] who are so clever cannot compare with the imaginative men in [the] long run."[11]

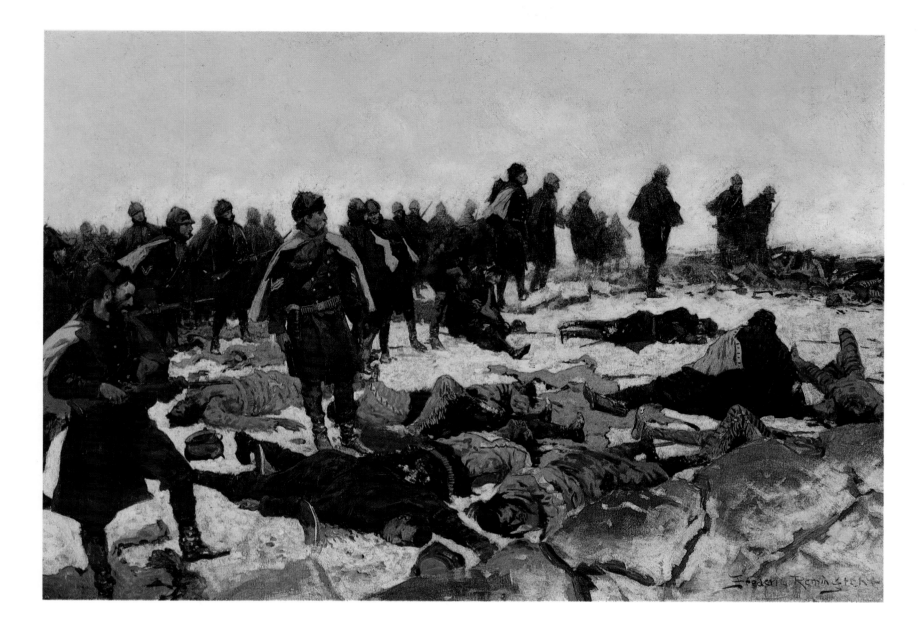

The Battle of War Bonnet Creek

FREDERIC REMINGTON, 1861–1909

not dated. Oil on canvas, 27 x 40 in.
Thomas Gilcrease Institute of American History and Art, Tulsa.

In Frederic Remington's many paintings depicting the conflict between Native Americans and the U.S. Army, the cavalry was invariably shown as the force representing good, the power of advancing civilization riding heroically to the rescue.

The artist's most disturbing image of the conflict between the "horse soldiers" and the Indians is *The Battle of War Bonnet Creek*, a seldom reproduced painting that focuses on an engagement that took place in Nebraska just three weeks after Custer's defeat at the Little Big Horn. The battle ensued when 200

soldiers of the 5th Cavalry were stationed inside what appeared to be a group of unescorted wagons. A force of Cheyenne warriors charged into the ambush where they were massacred. Highlighting the battle was a knife fight between Army scout Buffalo Bill Cody and the Indian Chief Yellow Hand; Cody killed the chief in what whites proudly called "the first scalp for Custer."

Remington's painting, based on accounts of the battle and the artist's fertile imagination, was created to memorialize the Army's victory. The scene is filled with the grim litter of Indian corpses over which stand the blue-coated soldiers, oblivious to the death and suffering of their foes. Like the battle itself, Remington's painting would no doubt have been comforting to the artist's eastern audience, which remained sensitive to Custer's defeat at the hands of Sioux for many years after the 1876 battle.

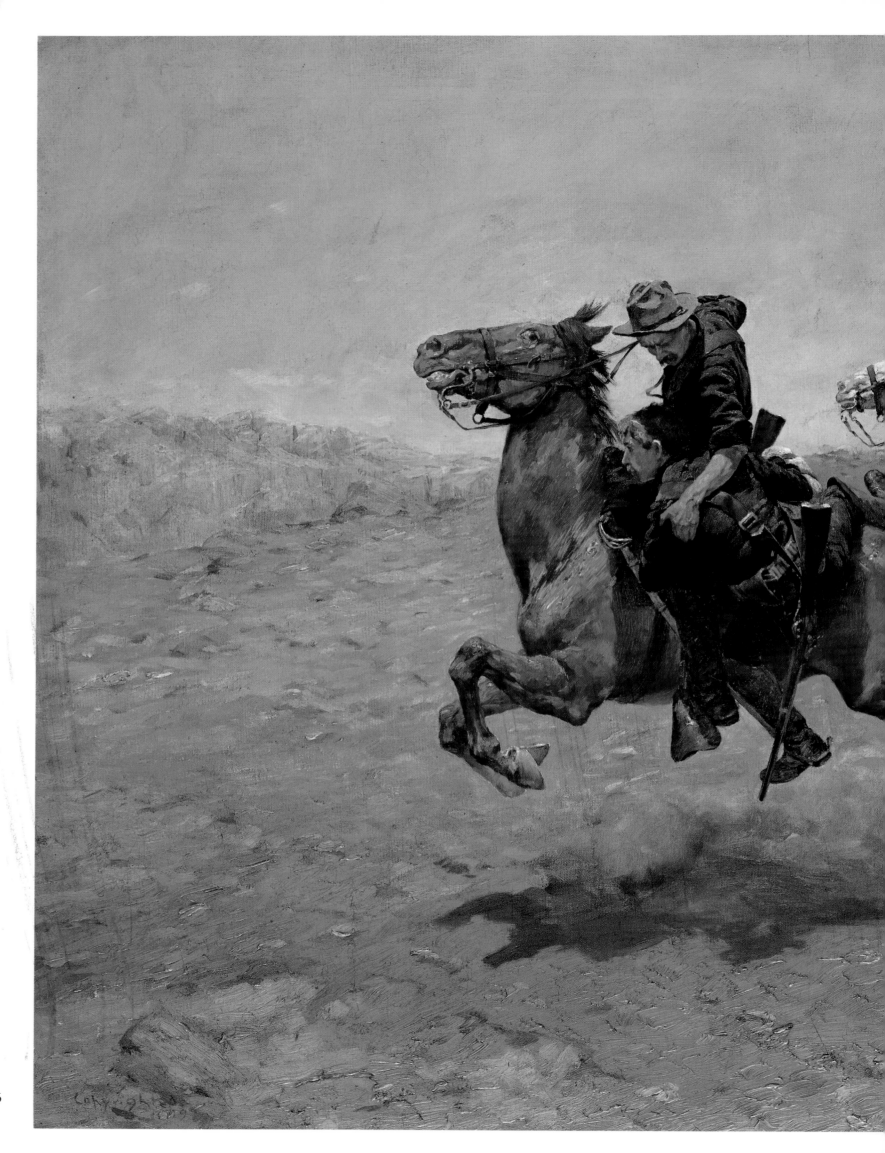

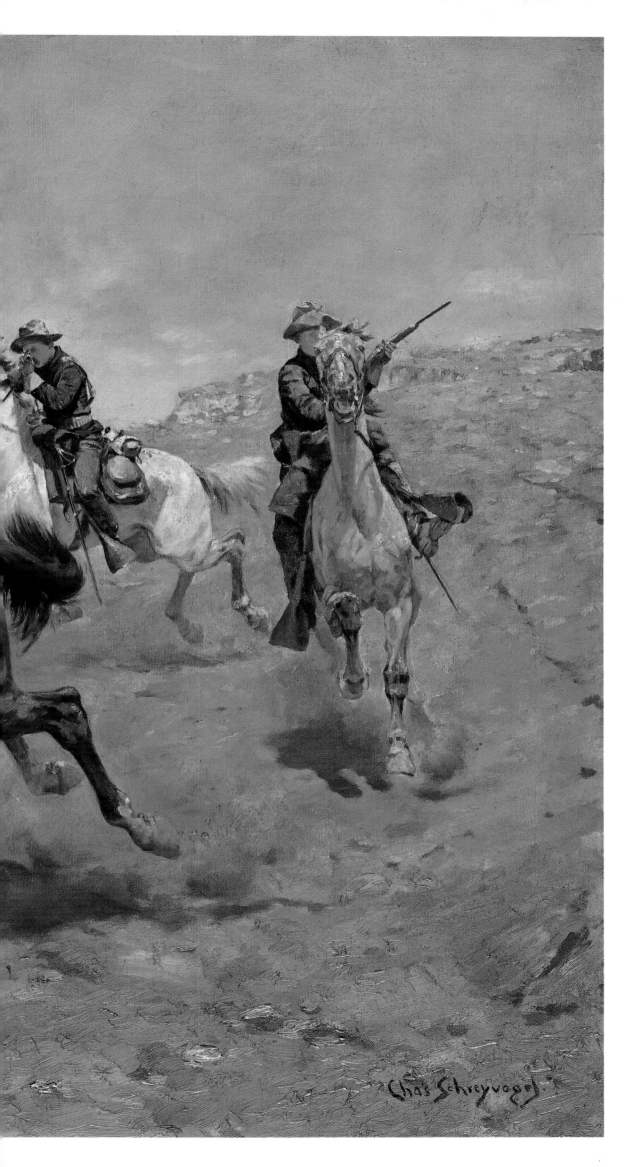

My Bunkie

CHARLES SCHREYVOGEL, 1861–1912

1899. Oil on canvas, 25³/₁₆ x 34 in.
The Metropolitan Museum of Art, Gift of friends of the artist, New York.

In 1893 the young German-American artist Charles Schreyvogel was so taken by Buffalo Bill's Wild West Show, which he saw in New York City, that he decided to make his career painting scenes of the Indian Wars. He traveled west several times to sketch and collect Native American artifacts, but his paintings were executed in his studio in Hoboken, New Jersey. Unlike his contemporaries—the prolific Remington and Russell—to whom he is often compared, Schreyvogel was a slow, methodical worker who painted only two or three pictures each year. For models, he employed local athletes who posed on the tin roof of his apartment building overlooking New York.

Unlike Remington, Schreyvogel did not produce illustrations for popular magazines. His works possessed a similar anecdotal quality, but they were more limited in their imaginative scope and subject than those of his celebrated contemporary. But when it came to the accurate depiction of cavalry uniforms and equipment, Schreyvogel had no betters. Of course, it wasn't the cavalry of *his* day that he captured on canvas but the troopers of several decades earlier. These dashing men in blue battled a truly warlike, animalistic band of savages. For him, it seems there was only one type of Indian—the red-skinned villain.

My Bunkie, one of Schreyvogel's first military paintings, was entered in the annual competition at the National Academy of Design in 1900, where it won the prestigious Clarke Prize, making the artist an almost overnight celebrity. Soon he rivaled the better known Remington, who until then virtually monopolized the market for western pictures. The work depicts a galloping trooper lifting to safety a fallen comrade—a barracks bunkmate—whose horse has been shot from under him. It was, as William H. Goetzmann has noted, a perfect emblem of macho heroism in a period when American nationalism was at its height, following the nation's victory in the Spanish-American War. That the Indian had been reduced to living in poverty on the reservation by then was an irony that few noted. Rather, as one critic of the day put it, Schreyvogel was seen as "giving us an invaluable record of those parlous days of the Western frontier when a handful of brave [white] men blazed the path for civilization and extended the boundaries of empire for a growing nation."[12]

147

How Kola!

CHARLES SCHREYVOGEL, 1861–1912

1901. Oil on canvas, 25 x 34 in.
Buffalo Bill Historical Center, Cody, Wyoming.

Like Remington, Charles Schreyvogel particularly enjoyed painting the galloping horse, and many of his best works depict animals in furious action. *How Kola!* is such a picture whose sentimental story line and inherent drama could have provided the basis for many of the dime novels that were popular around the turn of the century.

It is said that *How Kola!* was inspired by a story that Schreyvogel heard from a soldier who had served in General Crooks' army during the Indian Wars of the 1870s and 1880s. According to the account, a trooper

fell behind the main company of soldiers during a winter march and became lost on the freezing, snow-covered prairie. He was rescued by an Indian. Later, the same trooper was leading a cavalry charge in the battle of the Rosebud, when he found himself about to kill a "redskin." Suddenly the Indian called out, "How, kola," or "Hello, friend." Recognizing the brave as the man who had saved him from freezing, the soldier spared his life in return.

Schreyvogel depicts this dramatic story in an equally dramatic fashion, placing the moment of recognition just as the Indian's horse falls and the trooper is about to ride over him, Winchester in hand. However improbable this story may be, it illustrates the sense of a man owning up to his obligations that became part of the code of the West. This blend of macho heroism and

rugged independence became part of the American character during the progressive era of the first cowboy president, Theodore Roosevelt. Not surprisingly, Roosevelt was a strong admirer of Schreyvogel's work.

Summit Springs Rescue—1869

CHARLES SCHREYVOGEL, 1861–1912

1908. Oil on canvas, 48 × 66 in.
Buffalo Bill Historical Center, Bequest in memory of
Houx and Newell Families, Cody, Wyoming.

Summit Springs Rescue—1869, Charles
Schreyvogel's painting of 1908, seems like
a moment frozen in time from one of Buffalo
Bill's Wild West shows. Not coincidentally,
the celebrated scout-turned-entrepeneur,
William Frederick Cody, is the subject of the
work, which recalls the battle of Summit
Springs, a skirmish that took place in 1869,

more than three decades before the paint-
ing's execution. Buffalo Bill's heroic role in
the battle is depicted just as Cody himself
described it to the artist. Thus, he is seen in
very dramatic fashion, shooting a savage
Indian in the back at point-blank range as
the brave is about to scalp a white woman.

Schreyvogel's improbable melee of violent
action coupled with the heroic figure of
Cody galloping on a white horse to save a
sobbing white woman certainly captures the
theatricality of the scout's Wild West show.
Part rodeo, part circus, and part melodrama,
it too featured damsels in distress and last-
minute rescues. Ironically, in the distance of
Schreyvogel's painting an Indian woman and
child run for cover before the onslaught of
the troopers. Inadvertently perhaps, the
artist, who was hardly an Indian sympathizer,
reveals that white women and children were

not the only victims of the Indian Wars.
Although he includes them, this pair of
Native Americans and the fate that awaits
them were of no concern to the artist and his
turn-of-the-century audience. At right,
another soldier prepares to shoot an Indian
in the back at close range. Such images of
the white man's revenge on the Indian must
have seemed just, contributing to the perva-
sive attitude that justified the horrible but
common phrase, "the only good Indian is a
dead Indian."

When Shadows Hint Death

CHARLES M. RUSSELL, 1864–1926

1915. Oil on canvas, 30 x 40 in.
The Duquesne Club, Pittsburgh.

Unlike his contemporaries, Remington and Schreyvogel, Charles M. Russell was not hostile toward Native Americans. Indeed, as Russell scholar Brian W. Dippie has observed, the Montana cowboy-turned-artist considered the Indian "the onley [sic] real American" [13] and spoke out publicly in support of the native population's rights at a time when such a position was unpopular.

One of the artist's best-known paintings is *When Shadows Hint Death*, executed in 1915. Despite Russell's professed sympathies for Native Americans, this work depicts the war-like side of Indian life. His protagonists, two trapper-cowboy types, are attempting to silence their horses and draw them under the cover of a rock ledge. In the distance they see the improbably magnified silhouettes of a band of marauding Indians, their ceremonial war-bonnets proceeding as shadows across the opposite canyon walls. It is a simple yet dramatic effect showing the artist at his best from a formalist perspective. It also reveals Russell's willingness on occasion to show Indians that were hostile and dangerous. While it could be argued that the artist, despite his respect for Native Americans, was after all a product of his times and that paintings such as *When Shadows Hint Death* betrayed his repressed negative attitudes toward Indians, one could also maintain that Native Americans were neither noble heroic pacifists nor brutal unfeeling savages. Russell, by his willingness to paint both sides of the Native American character—the warlike side as well as that which was noble—exhibited a realitistic, balanced viewpoint.

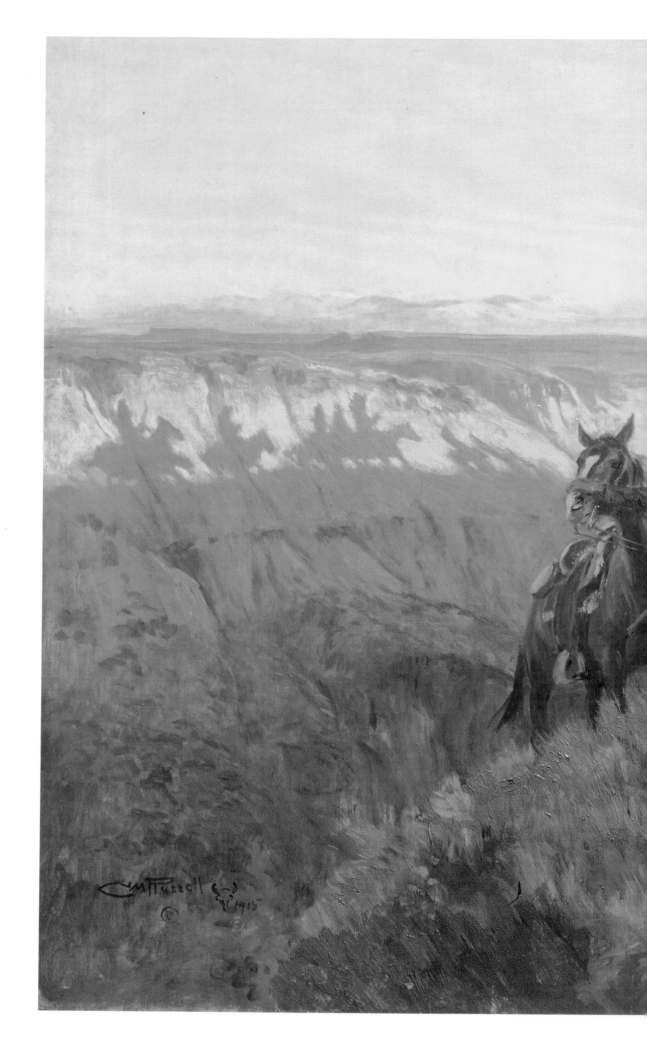

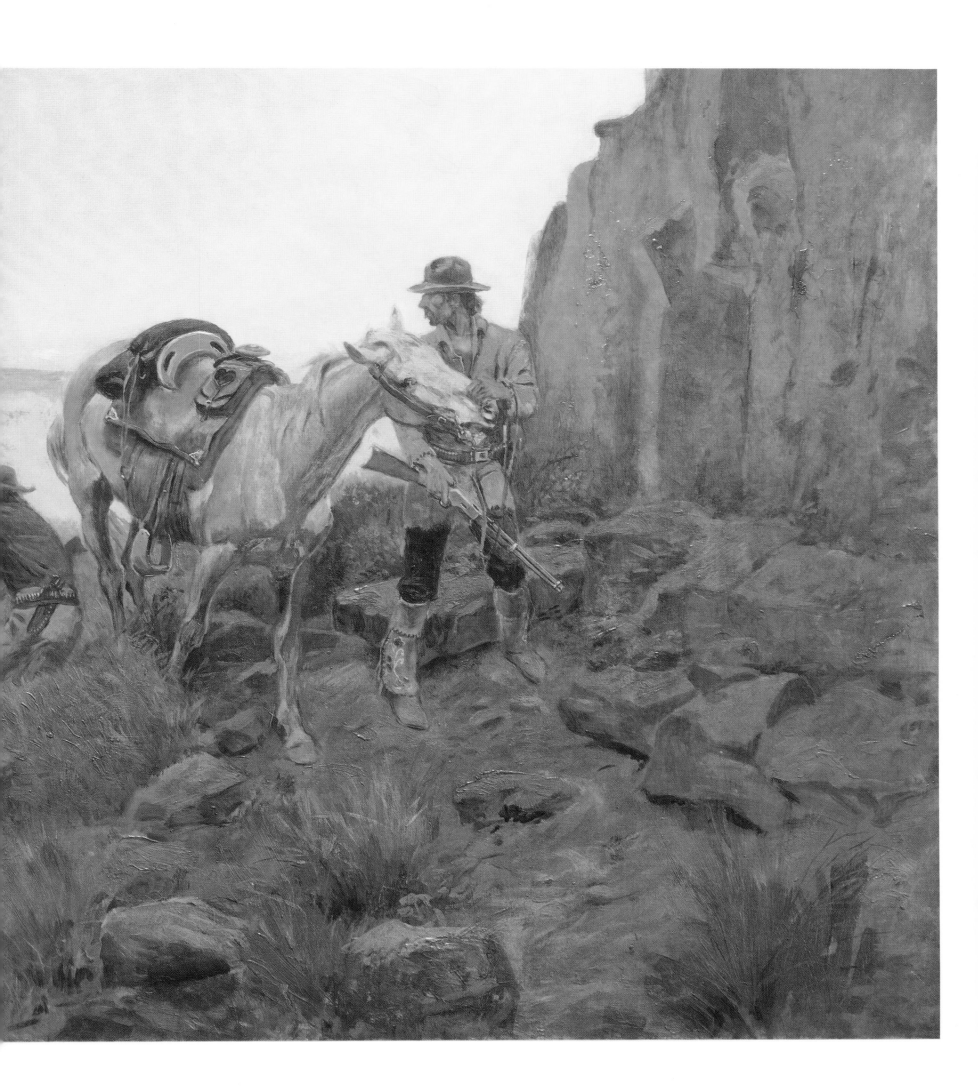

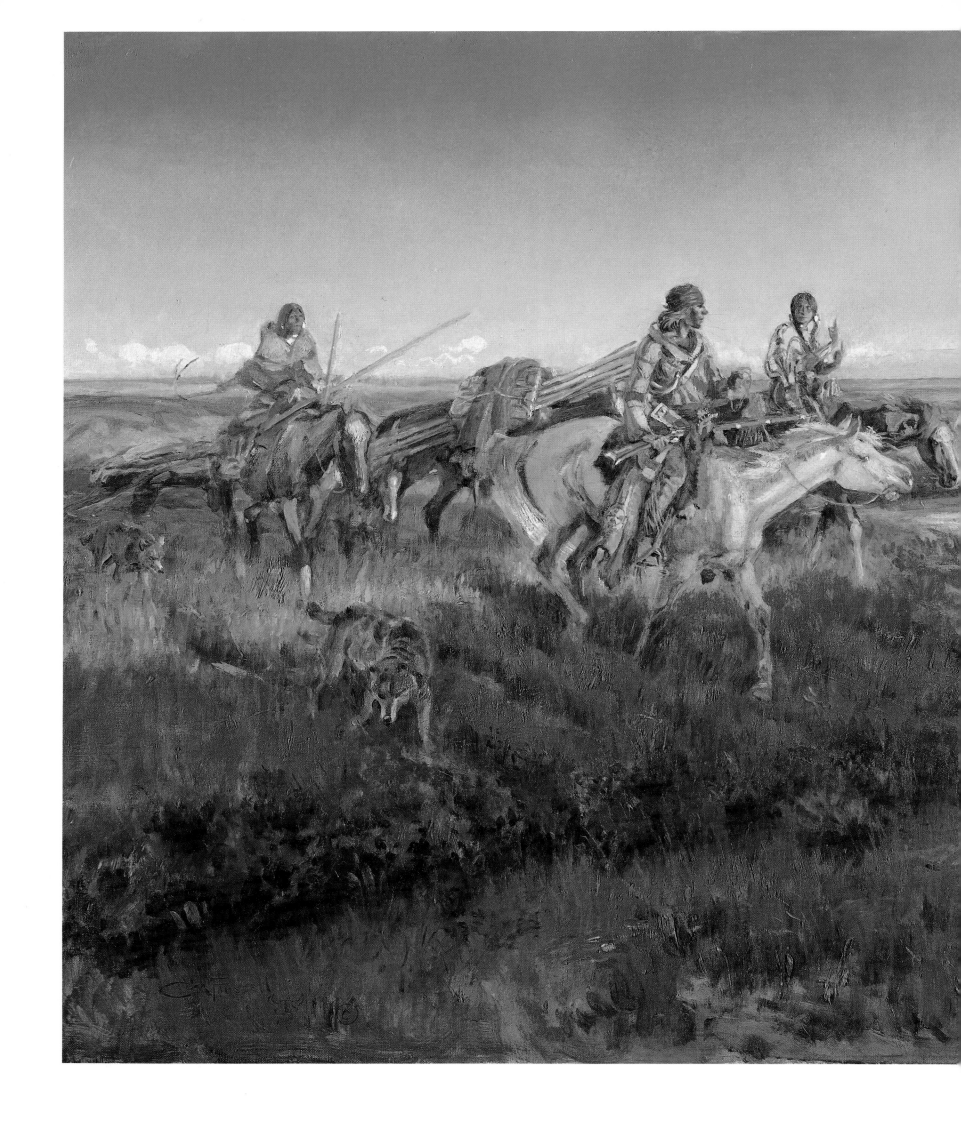

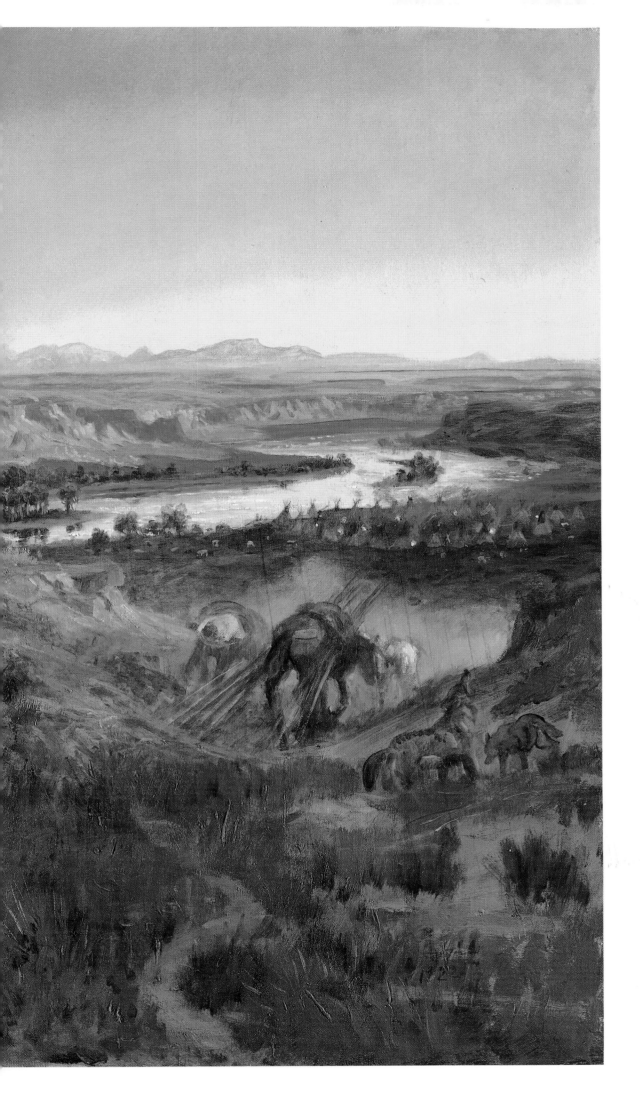

When White Men Turn Red

CHARLES M. RUSSELL, 1864–1926

1922. Oil on canvas, 24 x 36¼ in.
The Sid Richardson Collection of Western Art,
Fort Worth.

"In early times when white men mixed with Injuns away from their own kind, these wild women in their paint an' beads looked mighty enticin', but to stand with a squaw you had to turn Injun," wrote Charles M. Russell in his short story "How Lindsay Turned Indian," the tale of a trapper who married a Native American. [14]

Russell also explored the relationship between a white man and an Indian woman in *When White Men Turn Red*, a painting created in 1922 as his long career was coming to an end. In this canvas, a long-haired, blond trapper and his Indian wives are moving down from the hills to camp with the women's tribesmen whose tepees are glimpsed in the valley below.

As Russell scholar Brian W. Dippie has observed, the predicament of white men— the so-called squaw men who had "gone Indian"— may have interested Russell because of his own proclivity for Native American life. At any rate, he was one of the few artists to examine the sexual and social relations between a white man and an Indian woman. As such, *When White Men Turn Red* stands virtually alone among the many works that explicitly or implicitly depict the reverse—relations between Indian men and white women. This was a subject of great concern to 19th-century Americans, touching upon sexual taboos and the typical 19th-century view of women as helpless and dependent upon men, as a number of works reproduced in this chapter have shown.

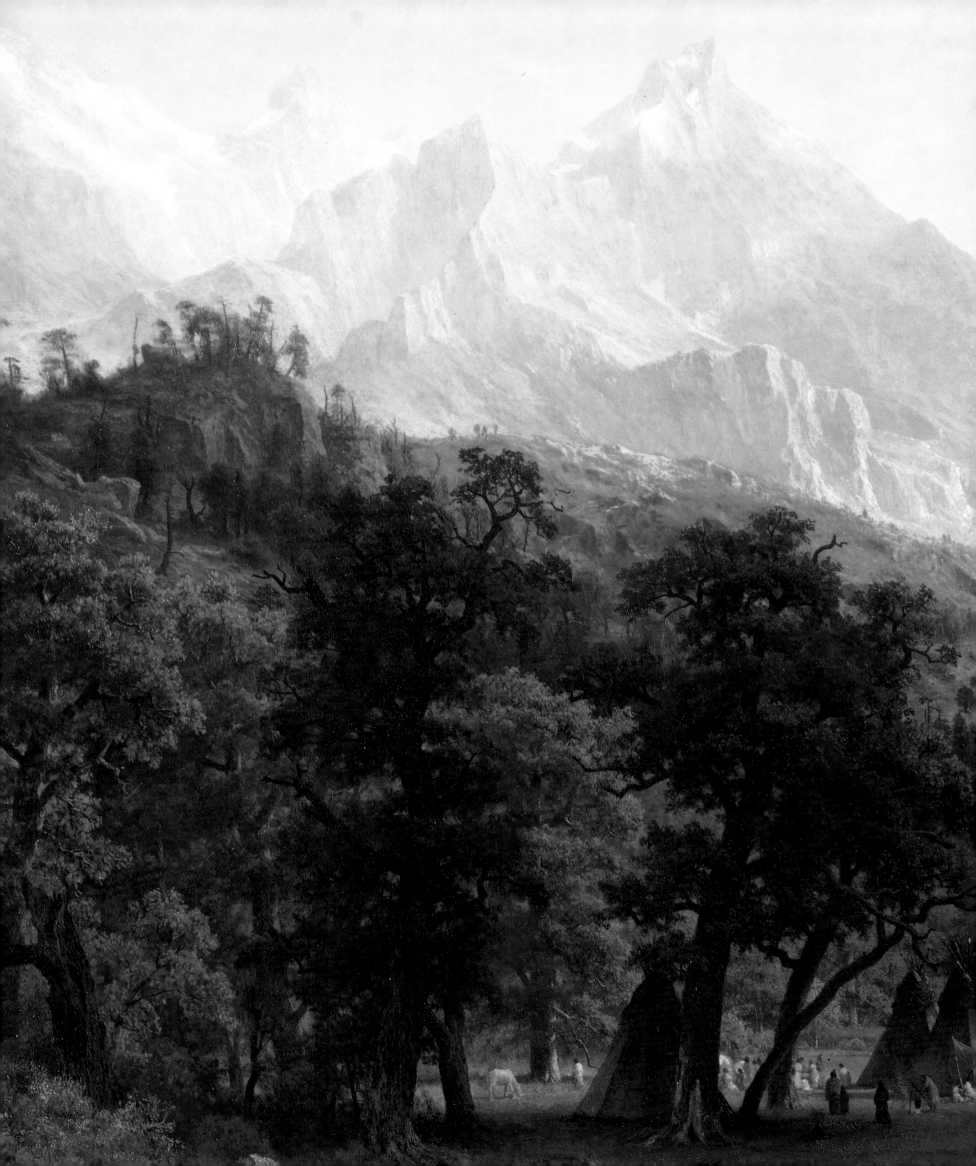

Natural Cathedrals
of Sublimity

Natural Cathedrals of Sublimity

The West's natural grandeur and seemingly limitless potential generated enormous interest in the East. Dreams of a transcontinental empire and the dictates of manifest destiny made the landscape painter a national hero. Landscape painting was, in fact, the preeminent art in America at the time of the Civil War, spurred on by the belief in the divinity of the natural world, as taught by the transcendentalists, and the idea of America as what historian Perry Miller called "nature's nation." As the late art historian David C. Huntington put it, "Nature in the era of manifest destiny was prophecy."

"Our country is a wilderness, or at least only half reclaimed," declared the nation's leading art magazine, the *Crayon* in 1855. "Untamed nature everywhere asserts her claim upon us, and the recognition of this claim constitutes an essential part of our art." European landscape painters had picturesque ruins, ancient temples, and Gothic cathedrals; American painters had none of these. Instead they had towering mountains, giant trees, and sublime wildernesss landscapes that had never been painted before. Thus, for them the landscape itself became a proud symbol of the new nation.

Yet, paradoxically, the conquest of nature was so rapid and its conversion into farms, towns, and cities so swift that artistic wonder often occasioned a deep sense of loss. Thomas Cole, for example, in his 1836 *Essay on American Scenery* wrote, "I cannot but express my sorrow that the beauty of such [American] landscapes are quickly passing away—the ravages of the axe are daily increasing—the most noble scenes are made desolate, and often times with a wantonness and barbarism scarcely creditable in a civilized nation."

America's leading landscape painters at midcentury were Frederic Edwin Church and his arch-rival Albert Bierstadt. Church, who greatly influenced Bierstadt, never went west. Instead he pursued his vision of natural divinity and national destiny by creating sublime images of Niagara Falls, the Andes of South America, and mammoth icebergs. His art was internationally acclaimed. Even the British art critic, John Ruskin, acknowledged in 1859 that on "this American [Church] more than any other . . . does the mantle of our greatest painter [J. M. W. Turner] appear to have fallen. Westward the sun of Art still seems rolling." With his celebrity status and his travels to exotic lands, Church, one of the greatest artist-explorers of the age, felt no need to paint the West. Indeed, in 1888, he lauded the "Great East—the greatest—for was it not the enterprise, energy, brain, and cash of the East that made the West as we know it?"

Church vied for the title "monarch of landscape painting" with Albert Bierstadt and later Thomas Moran. These artists built their reputations on theater-sized paintings of western scenery inspired by Church's own grandiose expressions of sublimity and nationalism. As a critic wrote of one of Bierstadt's views of Yosemite Valley in 1865, "it looks as if it was painted in an Eldorado, in a distant land of gold; heard of in a song and story; dreamed of but never seen. Yet it is real. Why should our artists make their pilgrimages to the Alps . . . when we have the mountains and skies of California."

Ironically, Bierstadt's great success sowed the seeds of its own failure, for as scientists like Clarence King began to view nature with materialistic and scientific detachment they saw sites like Yosemite not as symbols of the divinity of nature but

*Storm in the Rocky Mountains—
Mount Rosalie*
ALBERT BIERSTADT

◄◄
*The Rocky Mountains—
Lander's Peak* (detail)
ALBERT BIERSTADT

158

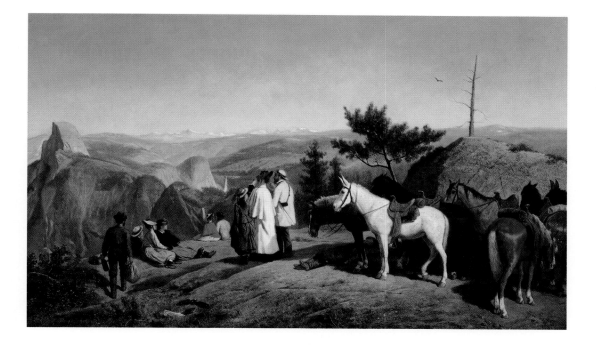

Yosemite Valley from Glacier Point
WILLIAM HAHN

The Mountain of the Holy Cross
THOMAS MORAN

simply as the product of geological forces. King, in particular, was scornful of Bierstadt's artistic manipulations of geologic reality. "It's all Bierstadt and Bierstadt and Bierstadt nowadays!" he wrote. "What has he done but twist and skew and distort and discolor and belittle and bepretty this doggoned country? Why, his mountains are too high and slim; they'd blow over in one of our fall winds."

With the completion of the transcontinental railroad in 1869, a new chapter in the history of western landscape painting began. Worthington Whittredge, himself an artist-explorer, recalled the excitement of the 1860s and 1870s: "It must be some great display on a big canvas to suit the taste of the times. Great railroads were opened through the most magnificent *scenery* the world ever saw, and the brush of the landscape painter was needed immediately. Bierstadt and Church answered the need." With the railroad came people. Some planned to settle in the West. Others were tourists who came to see the majestic western landscapes. William Hahn's *Yosemite Valley From Glacier Point* humorously depicts just such a group of tourists enjoying the breathtaking western scenery.

Just as Bierstadt had rivaled Church in the 1860s, Moran became something of a competitor to Bierstadt a decade later. Moran's greatest contribution, not only to art history but also to the preservation of America's natural wonders, was his series of pictures depicting the Yellowstone region, images that helped persuade Congress to preserve that remote area as a national park. A few years later, he also created notable depictions of the Grand Canyon of the Colorado and the Mountain of the Holy Cross.

With Moran's grand canvases American art's relationship with the natural cathedrals of sublimity came to a close. Newer styles, notably Impressionism and Tonalism, and a more poetic and intimate approach to nature came into vogue around the end of the 19th century, and the paintings of Church, Bierstadt, and Moran were forgotten, only to be appreciated once again in our own time.

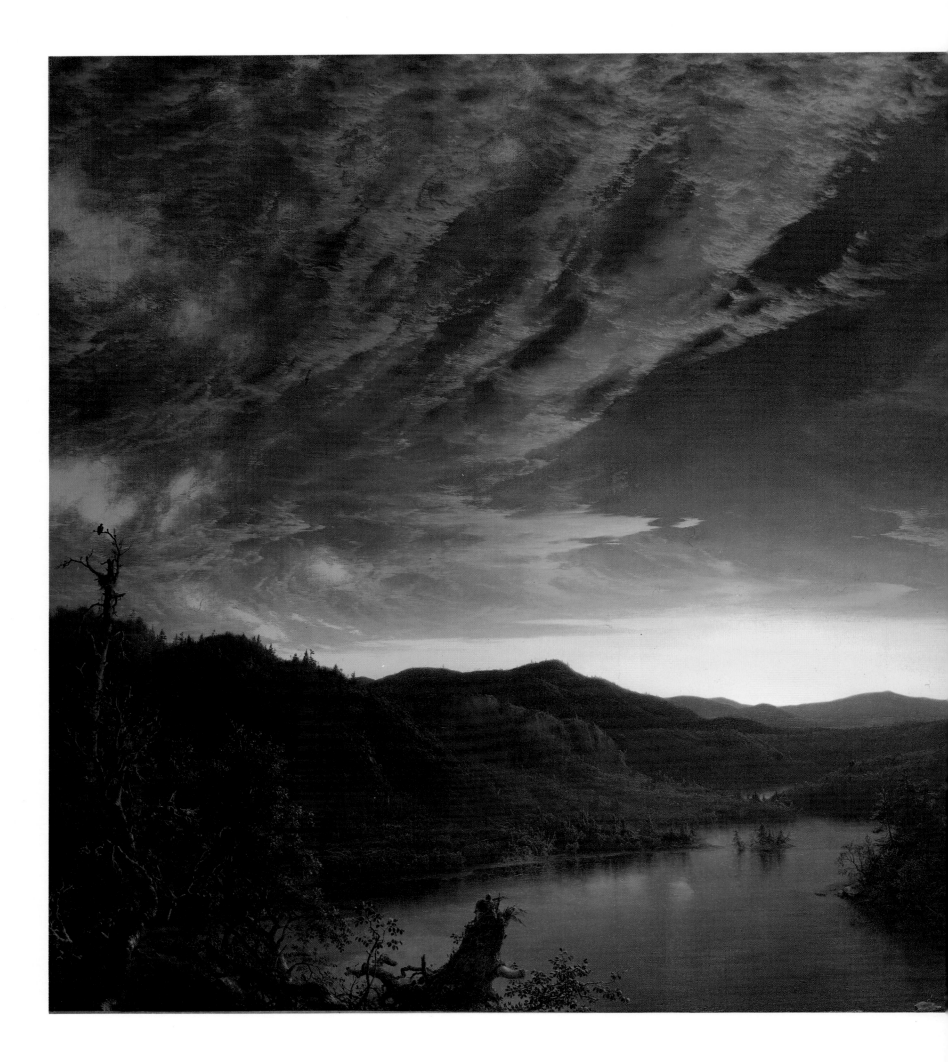

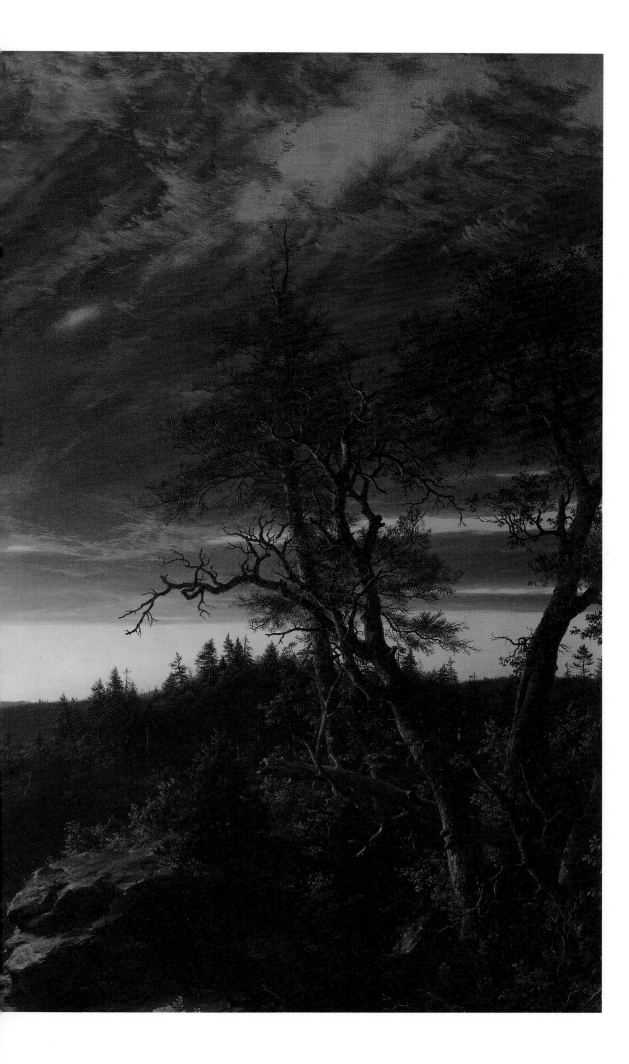

Twilight in the Wilderness

**FREDERIC EDWIN CHURCH,
1826–1900**

*1860. Oil on canvas, 40 x 64 in.
The Cleveland Museum of Art, Mr. and Mrs.
William H. Marlatt Fund.*

Frederic Edwin Church's *Twilight in the Wilderness* was the seminal painting of the wilderness to the West during the 1860s. Completed on the eve of the Civil War, the picture is a sublime view of an apocalyptic sunset over a landscape completely devoid of human presence. When the painting was rediscovered scholars surmised that it represented a particular place, perhaps the woods of Maine or the Catskills, but now, increasingly it is understood as a picture created in Church's imagination to expresses the period's ideal vision of the West as the place where America's future would be manifest. In 1860, however, this national destiny was about to be interrupted by war.

In the opinion of his contemporaries, Church's exact handling of details in *Twilight in the Wilderness* and his brilliant use of color, derived from the English romanticist J. M. W. Turner, marked this as one of Church's "Great Pictures." One critic thought it "disposed the spectator to dreamy and contemplative [thoughts]; it is Nature with folded hands, kneeling at her evening prayer." [1]

To a viewer thus inclined, religious symbolism informs even the smallest detail. The tree stump in the left foreground, for example, represents a wilderness altar, complete with a cross made of tiny wood splinters. But it is the sky that is the most expressive aspect of the painting. In the radiant heavens, on a compositional line that ascends diagonally from the stump in the left foreground, there is a small cloudlet that the scholar David Huntington identified as "the Dove of the Holy Spirit." Above it, and slightly to the right is a cluster of clouds pierced by three holes that extend below the curtain line of flaming sunset vapor. This formation is the anthropomorphic representation of the face of the God, the Creator, "Father of Lights," as one critic in Church's day called Him.

For Church's age *Twilight in the Wilderness* represented the ultimate manifestation of nature as God's church, and holy book. It was a profound expression of the nation's belief in natural cathedrals of sublimity in the western wilderness.

The Rocky Mountains— Lander's Peak

ALBERT BIERSTADT, 1830–1902

1863. Oil on canvas, 73½ x 120¾ in.
The Metropolitan Museum of Art, Rogers Fund,
1907, New York, photograph by Geoffrey Clements.

By the 1860s Americans had long since turned scenic sites such as Niagara Falls and the Catskill Mountains into popular tourist attractions, but it was not until the 1863 exhibition of Albert Bierstadt's *The Rocky Mountains* that the West's potential for tourism became firmly established. Of course, easterners had long been fascinated by the remote landscapes beyond the Mississippi River and this persisted despite the interruption the Civil War. They looked to Bierstadt's large picture for what was purported to be an eyewitness account of the vastness of the West and its exotic inhabitants and for visual escape from the depressing war news that was engulfing them.

In actuality, Bierstadt's picture consisted of two compositions rather uneasily joined. The lower portion of the foreground was an idealized depiction of a Shoshone Indian village, while the upper half of the painting was an Americanized version of the Swiss Alps that Bierstadt had visited as a student in Europe. The tallest mountain peak in the painting was named Lander's Peak by the artist, in honor of the recently martyred war hero and western explorer, Frederick Lander, whose exploring party Bierstadt had joined during his first journey west in 1859. Ironically, during this trip the artist did not actually see the Rockies that he supposedly painted. Consequently his "Lander's Peak" lacked actual geographic authenticity.

Americans could not help but take pride in their vast, scenic land as Bierstadt showed it to them. As one reviewer in 1863 saw it, this was "purely an American scene . . . It is the curtained continent with its sublime natural forms and its rude savage human life . . . so stimulating [to] the imagination and satisfying curiosity . . . it depicts and the imagination contemplates it as the possible seat of [a] supreme civilization."[2] Not only did Bierstadt's pictures satisfy the natural desire for information about the landscapes of the far West and dramatically convey the region's potential as a tourist mecca, they also portrayed an area ripe for settlement, a place where "a city populated by our descendants may rise."[3]

DETAIL ▶▶

Storm in the Rocky Mountains—Mount Rosalie

ALBERT BIERSTADT, 1830–1902

1866. Oil on canvas, 84⅜ x 144⅛ in.

Brooklyn Museum, Dick S. Ramsay Fund, A. Augustus Healy Fund B, Frank L. Babbott Fund, A. Augustus Healy Fund, Ella C. Woodward Memorial Funds, Gift of Daniel M. Kelly, Gift of Charles Simon, Charles Smith Memorial Fund, Caroline Pratt Fund, Frederick Loeser Fund, Augustus Graham School of Design Fund, Bequest of Mrs. William T. Brewster, Gift of Mrs. W. Woodward Phelps, Gift of Seymour Barnard, Charles Stuart Smith Fund, Bequest of Laura L. Barnes, Gift of J.A.H. Bell, John B. Woodward Memorial Fund, Bequest of Mark Finley, Brooklyn, New York.

After a second trip west to California in 1863, during which Albert Bierstadt finally saw the Rocky Mountains, he returned to his New York studio to begin work on a grand new western landscape. The result was the work reproduced here, *Storm in the Rocky Mountains—Mount Rosalie.*

Storm in the Rocky Mountains—Mount Rosalie is filled with turbulent movement and lurid, sensational effects of dramatic light. Its composition is dominated by an inward and upward swirling motion that carries the viewer's eye from the fleeing Indians in the right foreground up toward the sublime peak floating above the clouds at left. This is "Mount Rosalie"—named by the artist for his wife— a mountain that existed only in his imagination. In this painting Bierstadt is still bound to the exaggerated aesthetics of the Düsseldorf Academy, where he studied. The influence of Hudson River School artist Frederic Church is also apparent in several passages, particularly in the rocky monolith with an anthropomorphic visage just behind the Indians fleeing the approaching thunderstorm.

Storm in the Rocky Mountains—Mount Rosalie drew considerable acclaim when it was exhibited in 1866. But it was also harshly criticized by those who were becoming increasingly uncomfortable with Bierstadt's outright manipulations of topography and geology. "The truth is, we fear, Mr. Bierstadt has undertaken a subject much beyond his powers," one reviewer noted. "To suggest God's nature on canvas required a depth of feeling which not every artist possesses . . . The whole science of geology cries out against him . . . The law of gravitation leagues itself with geological law against the artist . . . what is the height of Mount Rosalie? Answer: approximately, ten thousand miles or so. Impossible."[4] Another critic declared that by pandering to the popular love for excitement, Bierstadt had succumbed to the hyperbole of his own press notices. For years *Storm in the Rocky Mountains—Mount Rosalie* was thought to be lost. In 1978 it was rediscovered in England, and acquired by the Brooklyn Museum.

On the Mariposa Trail

VIRGIL WILLIAMS, 1830–1886

1863. Oil on canvas, 41½ x 35½ in.
California Historical Society, San Francisco.

In late July 1863 Albert Bierstadt, the writer Fitz Hugh Ludlow, and the San Francisco painters Virgil Williams and Enoch Perry made the journey to California's Yosemite Valley. Their expectations were high, and Ludlow wrote, "If reports were true we were going to the original site of the Garden of Eden, into a region which . . . surpassed the Alps in its waterfalls, and the Himmal-yeh [sic] in its precipices"[5] Their visit to Yosemite was documented in Ludlow's florid accounts and in newspaper reports of their journey. In one passage, Ludlow described his companions' working methods. "Sitting in their divine workshop, by a little after sunrise our artists began labor in that only method which can ever make a true painter or a living landscape, color-studies on the spot"[6]

There are no images recording the artists at their work, but *On the Mariposa Trail* by Virgil Williams does provide a vivid glimpse of the party en route. Traveling on the famed trail for which the painting was named, the four companions have paused beside the Merced River; in the background the lofty towers of the Yosemite rise like cathedral spires above them. Only Bierstadt is positively identified. He is the standing, red-shirted, bearded figure with a sketchbook. The man seated on the ground, smoking a pipe, holding a book, and gesturing excitedly may be Ludlow. He had gained some notoriety for his habit of smoking hashish. He had even written an infamous book on the subject, *The Hashish Eater*, in 1857.

Surrounding these artist-explorers is the verdant Eden-like Yosemite Valley. Bierstadt would become strongly identified with this locale in subsequent years, just as Thomas Moran would later be identified with the Yellowstone and Grand Canyon regions of Wyoming and Arizona. On journeys like the one pictured in *On the Mariposa Trail*,

Bierstadt amassed many studies providing him with material for some of his most important paintings. *The Daily Alta California* noted this in September, 1863: "Mr. Bierstadt has been very industrious and has taken a multitude of sketches, which though made in six or eight hours each, have an excellence that would entitle them to take rank with finished pictures. Indeed, several of them are great works of art."[7]

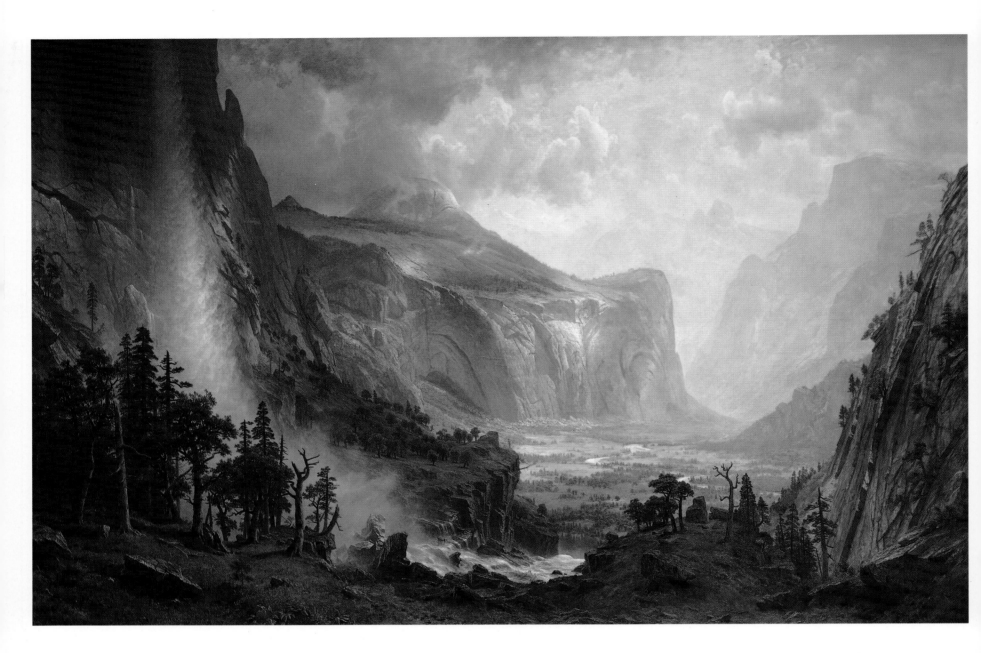

The Domes of the Yosemite

ALBERT BIERSTADT, 1830–1902

1867. Oil on canvas, 116 x 180 in.
St. Johnsbury Athenaeum, St. Johnsbury, Vermont.

On his return to New York from California in 1863, Albert Bierstadt began to produce a series of paintings of the Yosemite Valley that would continue over the next two decades. His largest painting was the theater-sized *Domes of the Yosemite*, which New York financier Legrand Lockwood claimed to have commissioned for $25,000. The canvas was so large that Bierstadt was said to have needed scaffolding to paint the sky. The painting went on exhi-

bition in New York to a great fanfare and an ensuing critical battle about its artistic merits.

Bierstadt's great painting presented a view of the valley looking east from the base of the Upper Yosemite Falls. In the middle distance the Merced River flows toward the renowned peak, Half Dome, at right. While the topography of the painting is generally accurate, the foreground has been freely manipulated. Groups of trees are combined for expressive effects, including one specimen in the left foreground that seems contrived, as if it were waving at the sublime scene.

The critics were divided in their opinions of the picture. Some reviewers thought it was devoid of proper sentiment, although most admired its nationalist feeling. Expressing the latter, one writer observed, "There is now no

question but we have in this country the grandest scenery on earth, one is lost in amazement, and impressed . . . with the sublime works of the Almighty. It is worth a week's hard travel to see this great picture . . . The picture will advance Mr. Bierstadt's reputation still more. He is ascending the throne, and [in] a few more strides, he will seat himself as the monarch of all landscape painters . . . We recommend our readers go at once to see the works. They will feel the world is progressing and the Americans are a great people."[8]

Sunset in Yosemite Valley

ALBERT BIERSTADT, 1830–1902

1868. Oil on canvas, 35½ x 51½ in.
The Haggen Museum, Stockton, California.

In striking contrast to the luminosity of Bierstadt's *Domes of the Yosemite* is the radiant sublimity of his *Sunset in Yosemite Valley*, executed a year later while the artist was traveling in Europe. The work derives its expressive power from the astonishing contrasts of light and darkness. At the left, tall cathedral-like towers lift pointed spires, their bases warmed by the awesome sunset light filling the valley. The artist greatly exaggerates the forms of these rocks, playing to the widespread view of the Yosemite as a veritable cathedral of nature. In the valley, the shadow cast from the gigantic monolith El Capitan at right intersects the reflection of the river, forming a spectacular cross of light on the valley floor. The artist again takes subtle but perceptible liberties with topography and geology to widen the valley, emphasizing this calculated visual effect. Hovering above El Capitan are clouds that appear to resemble the wings and face of an angelic being. In the foreground, following the accepted conventions of the picturesque, Bierstadt arranges trees in groups with ecstatic anthropomorphized gestures. The final effect of the picture is to give eastern audiences, who had never seen the Yosemite, a view of paradise where they could celebrate America's grandeur.

The dramatic use of light and darkness in *Sunset in Yosemite Valley* was inspired in part by the brilliant colorist effects of J. M. W. Turner, the English romantic artist. Bierstadt would have had the opportunity to study Turner's paintings in London when he visited the British capital to present his *Departure of Hiawatha* to the poet Longfellow (page 105). *Sunset in Yosemite Valley* was also influenced by the work of Hudson River School artist Frederic Church, particularly by Church's well-known masterpiece of 1860, *Twilight in the Wilderness* (pages 160–161). Church and Bierstadt were artistic rivals in New York City around this time, as each man aspired to be known as "the monarch of landscape painters."

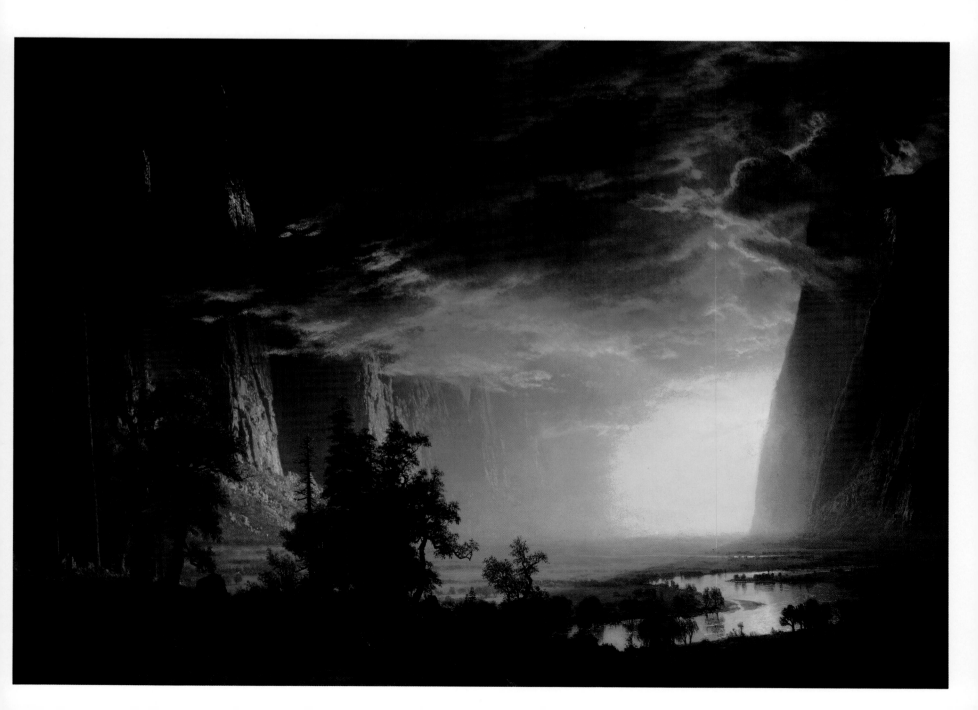

Yosemite Valley, Glacier Point Trail

ALBERT BIERSTADT, 1830–1902

*circa 1873–74. Oil on canvas, 54 × 84¾ in.
Yale University Art Gallery, Gift of Mrs. Vincenzo
Ardenghi, New Haven, Connecticut.*

In 1863, Frederic Law Olmsted—who later gained recognition as the architect of New York's Central Park—arrived in Yosemite to become superintendent of the nearby Mariposa Estates. Struck by the beauty and grandeur of the region, he urged the United States Congress to preserve the valley's pristine state before it was lost to settlers. In 1864, during the Lincoln administration, Congress responded, setting aside the valley and the nearby giant sequoia trees for "public use, resort and recreation." By the early 1870s the once-remote wilderness of the Yosemite had become accessible to tourists thanks to the completion of the transcontinental railroad and the creation of a spur track that gave entrance to the valley.

With the act of Congress, the Yosemite became in effect the first national park, and its establishment, like that of Yellowstone National Park in 1872, owed a great debt to landscape painters like Bierstadt. Olmstead noted the role that Bierstadt's paintings had played in awakening interest in the area. "It was during one of the darkest years [of the Civil War] when the paintings of Bierstadt . . . had given the people of the Atlantic some idea of the sublimity of the Yosemite . . . that consideration was first given to danger that such scenes might become private property . . . and their value to posterity injured."[9]

In a few of Bierstadt's later paintings, such as *Yosemite Valley from Glacier Point*, the artist acknowledged the presence of tourists in the valley. In foreground of this work three visitors have stopped to admire the view. One of them sits in rapt meditation while nearby, at the edge of the famed point, his companion raises his hand in salute. In an echo of that gesture, a tree just above the saluting figure seems to gracefully wave its branch. The scene that unfolds before these visitors is serene, filled with an inviting, golden light that expresses the artist's nationalist pride in the incomparably beautiful land of the American West.

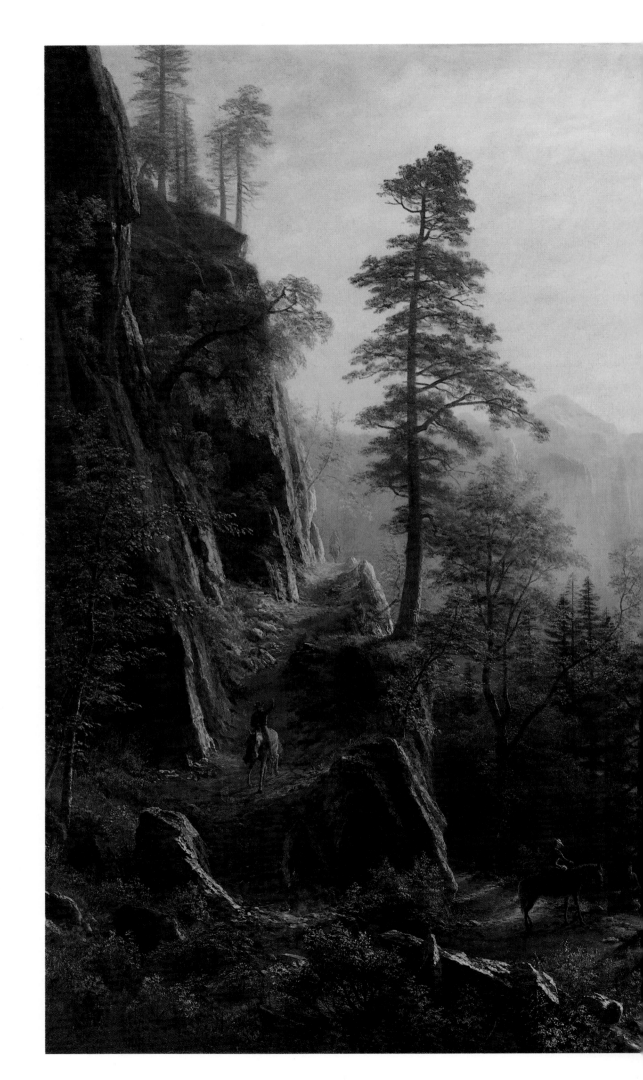

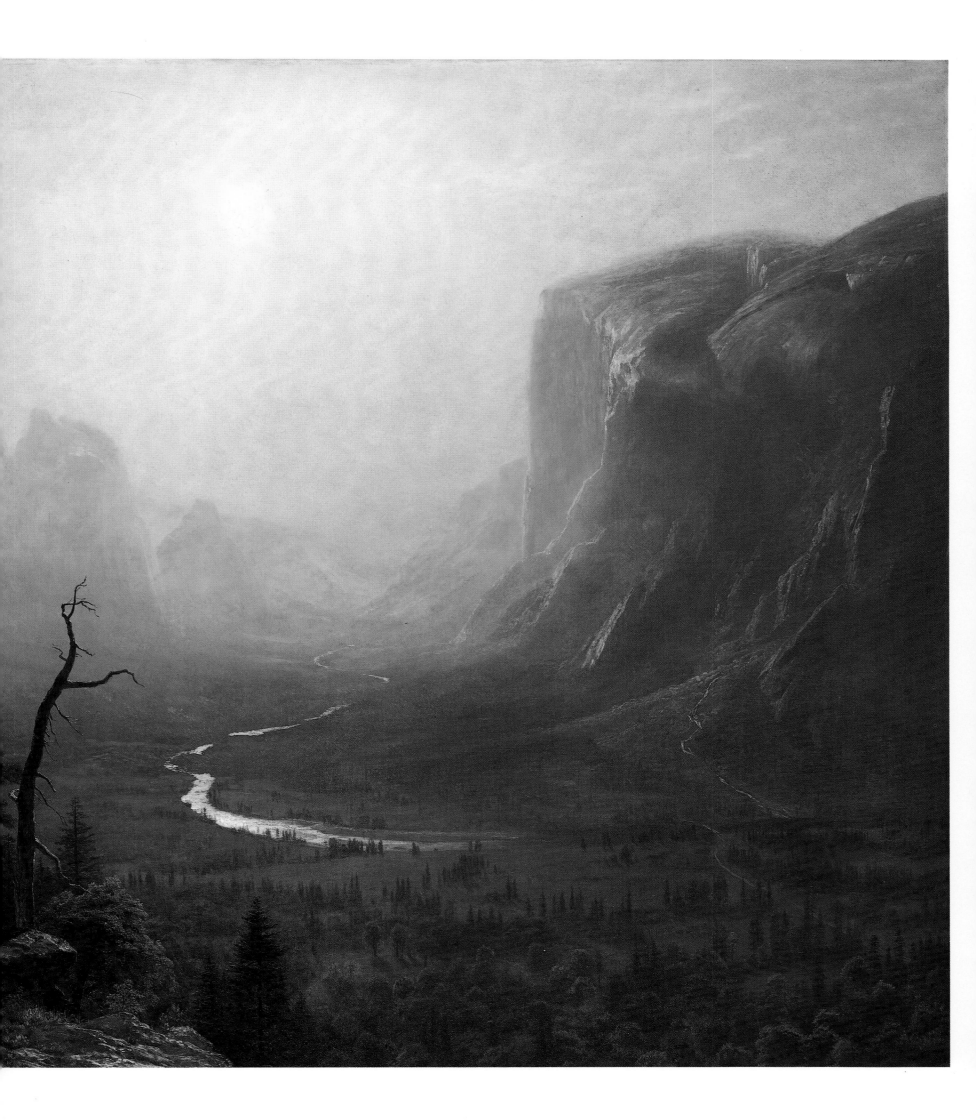

Giant Redwoods of California

ALBERT BIERSTADT, 1830–1902

circa 1874. Oil on canvas, 52½ x 43 in.
The Berkshire Museum, Pittsfield, Massachusetts.

Among California's most impressive natural marvels are the groves of giant sequoia trees in the Yosemite region. As visitors do today, travelers who saw them in the 19th century were apt to rhapsodize over their size and great antiquity. Among these was Reverend Thomas Starr King, a minister and well-known writer, who first described them during his 1860 tour of the Yosemite Valley region. He marveled that one tree "was a giant in the time of the first Crusade," and that its origins antedated "the foundations some of the oldest Gothic Spires in Europe."[10]

Albert Bierstadt first saw these ancient wonders during his 1863 visit to California. But it was not until his second trip in 1871–1873 that he undertook a leisurely survey of the sequoias. From that experience came a number of paintings including *Giant Redwoods of California*. Painted in Bierstadt's New York studio, *Giant Redwoods of California* emphasized not the great height of the trees, which was said to be unpaintable, but the cathedral-like environment surrounding their enormous trunks. Camped inside their massive burned-out hollows are a band of Indians. While their presence gave Bierstadt the opportunity to portray the Indians' primitive and exotic nature, the tribes native to the area had in fact been killed long before the artist visited the grove. Bierstadt introduced a stream and pool of water where none actually existed. This device made the picture more comprehensible to an eastern audience accustomed to seeing small ponds or brooks in forest scenes. To emphasize further the mighty size of the sequoias, the artist placed smaller redwoods near them and, in the background, one deciduous tree that seems to bend over backward in a gesture of arboreal humility toward its stupendous relative rising above it. A calm golden light filters down, completing the artist's carefully contrived attempt to depict the forest as a sublime natural cathedral, echoing sentiments similar to those expressed in *The Old Hunting Grounds* by Whittredge (page 103).

Yosemite Valley
from Glacier Point

WILLIAM HAHN, 1829–1887

1874. Oil on canvas, 27¼ x 46¼ in.
California Historical Society, San Franciso.

Bierstadt's restrained enthusiasm for western tourism becomes more apparent when *Yosemite Valley, Glacier Point Trail* (pages 170–171) is compared with William Hahn's painting of the same sublime viewpoint. Hahn's picture is the direct opposite of Bierstadt's. Where the latter focuses on the landscape, the former, while providing views of Yosemite Falls and Half Dome in the distance, fills the foreground with a fascinating genre scene of colorfully dressed tourists who have come to take in the view. After a long and difficult trip on horseback from the valley below, the group has reached the summit and the overlook. The horses have been tethered by the young guide who is now lying down asleep in the mounts' shadows, bored

from having seen the view so many times before. The most prominent of the tourists is the family group attired in fashionable riding garments. The mother holds the prescribed field glasses, the father points, and the young girl in bloomers turns to look, not at the valley, but at her parents. To the left, a couple of lovers sit distracted from the scenery by their romance, while another guide brings up the picnic lunch and wine bottle. Discarded bottles and tins from previous tourists litter the foreground.

With a degree of tongue-in-cheek humor Hahn's painting suggests the posture of typical tourists in search of the conventionally approved view. Their conduct was denounced by Clarence King, the famed natural scientist and friend of Bierstadt, who wrote, "I always go swiftly by this famous point of view now, feeling that somehow that I don't belong to that army of literary travelers who have here planted themselves and burst into rhetoric. Here all who make California books, down to the last and most sentimental specimen . . . dismount and inflate."[11]

Yosemite Valley

THOMAS HILL, 1829–1908

1876. Oil on canvas, 72 x 120 in.
The Oakland Museum, Kahn Foundation.

Thomas Hill, the most successful painter of the Yosemite after Bierstadt's near monopoly of the subject in the 1860s and early 1870s, had gone west for the first time in 1861. He settled in San Francisco and around 1866/67 began to paint landscapes. He first painted the Yosemite around 1870, several years after Bierstadt's visit there. By the end of the decade he had even eclipsed Bierstadt, becoming known popularly as the "artist-in-waiting to the Yosemite." He operated a summer studio at Wawona, in

Yosemite Park, and a winter studio/residence at nearby Raymond, the gateway to the grove of giant sequoia trees in Mariposa County. From these locations he was ideally situated to produce numerous landscapes for the tourists, who came in ever growing numbers to take in the sights. During his long career he painted hundreds of Yosemite views.

One of his largest and most celebrated paintings of the region was executed for Leland Stanford in the centennial year of 1876. *Yosemite Valley* presents an encompassing, panoramic view of the valley with a characteristic group of tourists riding up to take in the sights. Hill developed a formula for his paintings of the valley, regularly varying the foreground figures according to the taste of his patrons and the sentiment that he wanted to express. In addition to tourists, his favorite types were sportsmen and Indians. At first his style followed that of Bierstadt, since the German-born Hill, like his more

famous contemporary, had also studied at Düsseldorf. Gradually in the late 1870s and early 1880s, however, Hill's handling of paint relaxed, to resemble superficially the work of his friend William Keith and the French Barbizon and Impressionist schools.

The Grand Canyon of the Yellowstone

THOMAS MORAN, 1837–1926

1872. Oil on canvas, 84 x 144¼ in.
National Museum of American Art, Smithsonian Institution, Washington, D. C. Lent by the U. S. Department of the Interior, National Park Service.

The completion of the transcontinental railroad in 1869 marked the beginning of the end of the old West as a vast, unknown, unsettled frontier. One of the region's last uncharted territories lay in Wyoming; to explore it the government organized a major expedition in 1871. Among the participants was the 34-year-old landscape painter, Thomas Moran, whose presence was due largely to the influence of the Northern Pacific Railroad, which hoped that the pictures resulting from the journey would promote tourism in the region. By midsummer the exploring party had reached the fabled Yellowstone area. Moran was awestruck by the strange and colorful landscapes he found there, so much so that he declared the scene beyond the reach of human art.

Nevertheless, after his return to the East, Moran began work on his great painting *The Grand Canyon of the Yellowstone*. In this picture, Moran, like Bierstadt with Yosemite, created an ideal composition, subtly rearranging the topography for maximum expressive effect. After its completion in 1872, *The Grand Canyon of the Yellowstone* was sold to the government to hang in the Capitol building, a proud symbol of the nation's conquest of one of the last remnants of the unexplored West.

Moran's picture sought to capture the fantastic color and bizarre rock formations of the Yellowstone River's Grand Canyon. Because of his familiarity with the English romanticist J. M. W. Turner, Moran was well suited to the task of painting the riotous colors of this natural wonder. His treatment of the rocky towers and pinnacles of the canyon walls exaggerated their size and appearance to enhance their resemblance to architectural forms. Perhaps the most remarkable feature of Moran's picture is the painter's introduction of a huge totemic figure of an Indian in the craggy rock formation in the extreme right foreground.

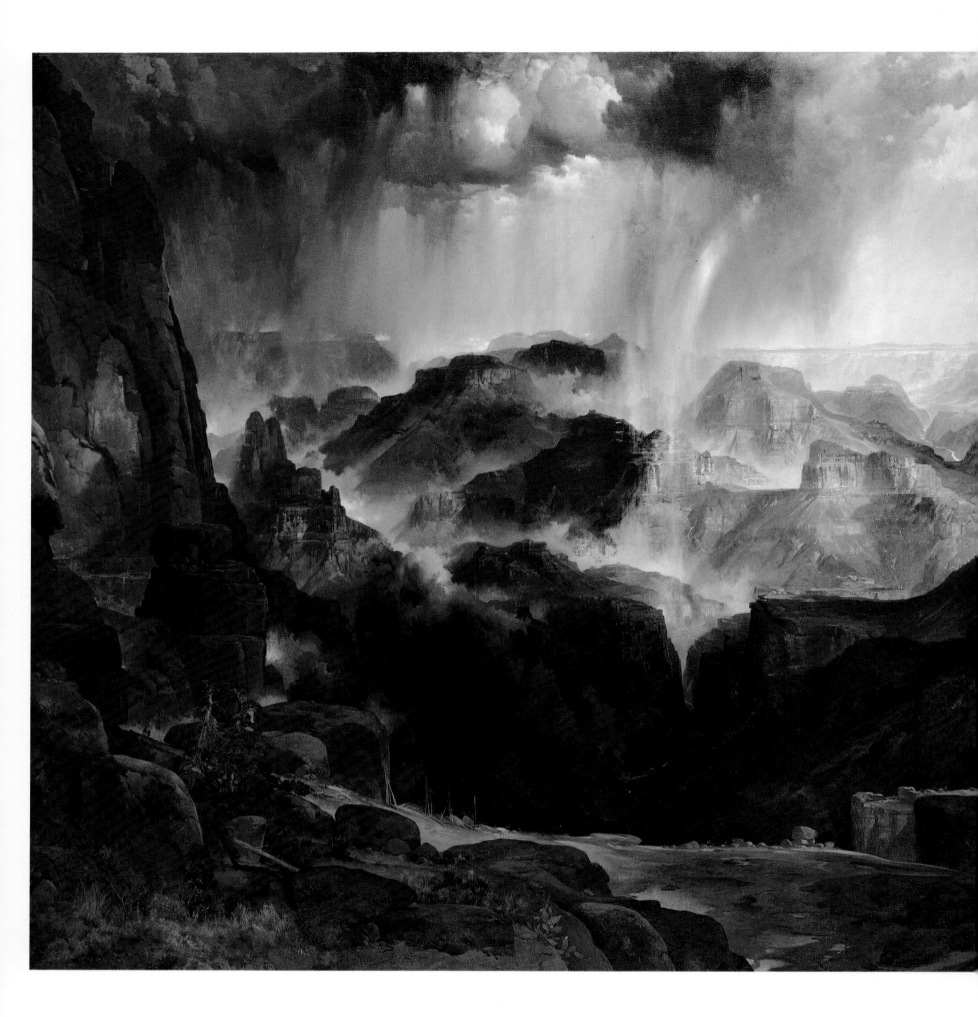

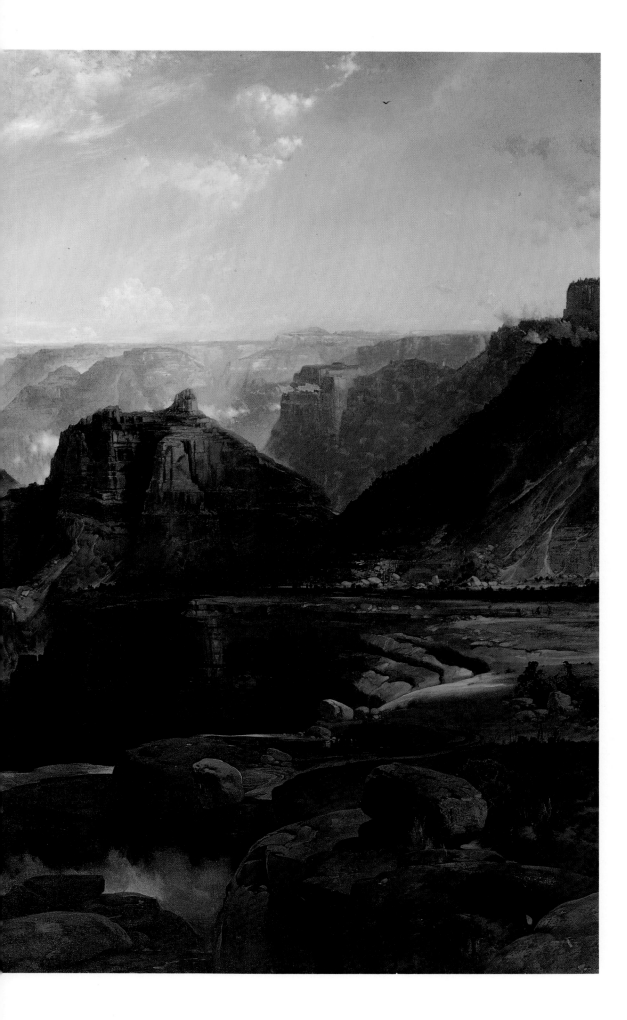

Chasm of the Colorado

THOMAS MORAN, 1837–1926

1873–74. Oil on canvas, 84¾ x 144¾ in. National Museum of American Art, Smithsonian Institution, Washington, D. C. Lent by the U. S. Department of the Interior, Office of the Secretary.

In 1873, Thomas Moran traveled to the Southwest to accompany Major John Wesley Powell on an expedition to the Grand Canyon of the Colorado. During his journey, Moran studied the canyon's vast, strangely eroded landscape and found it worthy of a second 7-by-12-foot painting to serve as the companion to his *Grand Canyon of the Yellowstone* (page 175). The scene he chose for this large painting is entitled *Chasm of the Colorado.*

As with the 1872 painting of the Yellowstone, the gigantic scale and vastness of the Grand Canyon necessitated a rearrangement of topography and geology to suit the artist's expressive purposes. The painting is not so much a view of the canyon as Moran's impressions of the whole fantastic landscape through which the Colorado River twisted. Where in the Yellowstone painting Moran had relied on a V-shaped triangular composition, in *Chasm of the Colorado* he chooses a broad U-shaped arc that curves down from the towering Kaibab abutment at left into the gallery of a huge "amphitheater" in the center, and thence to a cut-off portion of the buttes at right. In order to provide the conventional and expected note of the sublime, Moran adds a thunderstorm, a touch that some critics found distracting. In general, however, the painting was well received. The writer for the *Atlantic Monthly* even found it superior to the works of Bierstadt. "As there is no claptrap about Mr. Moran . . . the faults we discover in this latest work are the result of trying to do too much . . . the subject . . . is one that never should have been attempted—partly because it is impossible to do justice to it, and again because art is not concerned with it, if it were possible . . . It was said by one who looked at it 'There is no use in trying to paint all out-of-doors.'"[12] Congress did purchase *Chasm of the Colorado* and it hung for many years in the Senate lobby next to Moran's *Grand Canyon of the Yellowstone.*

DETAIL ▶▶

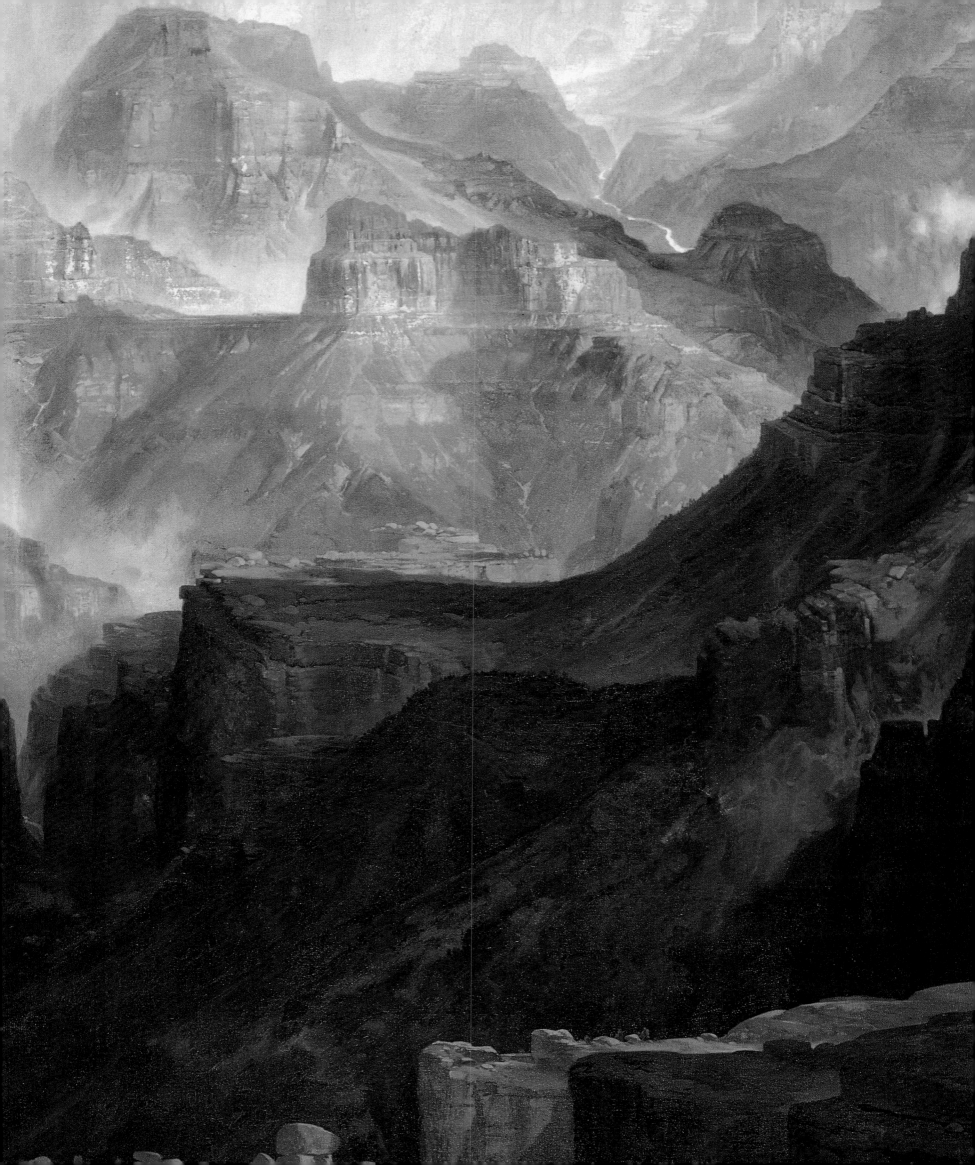

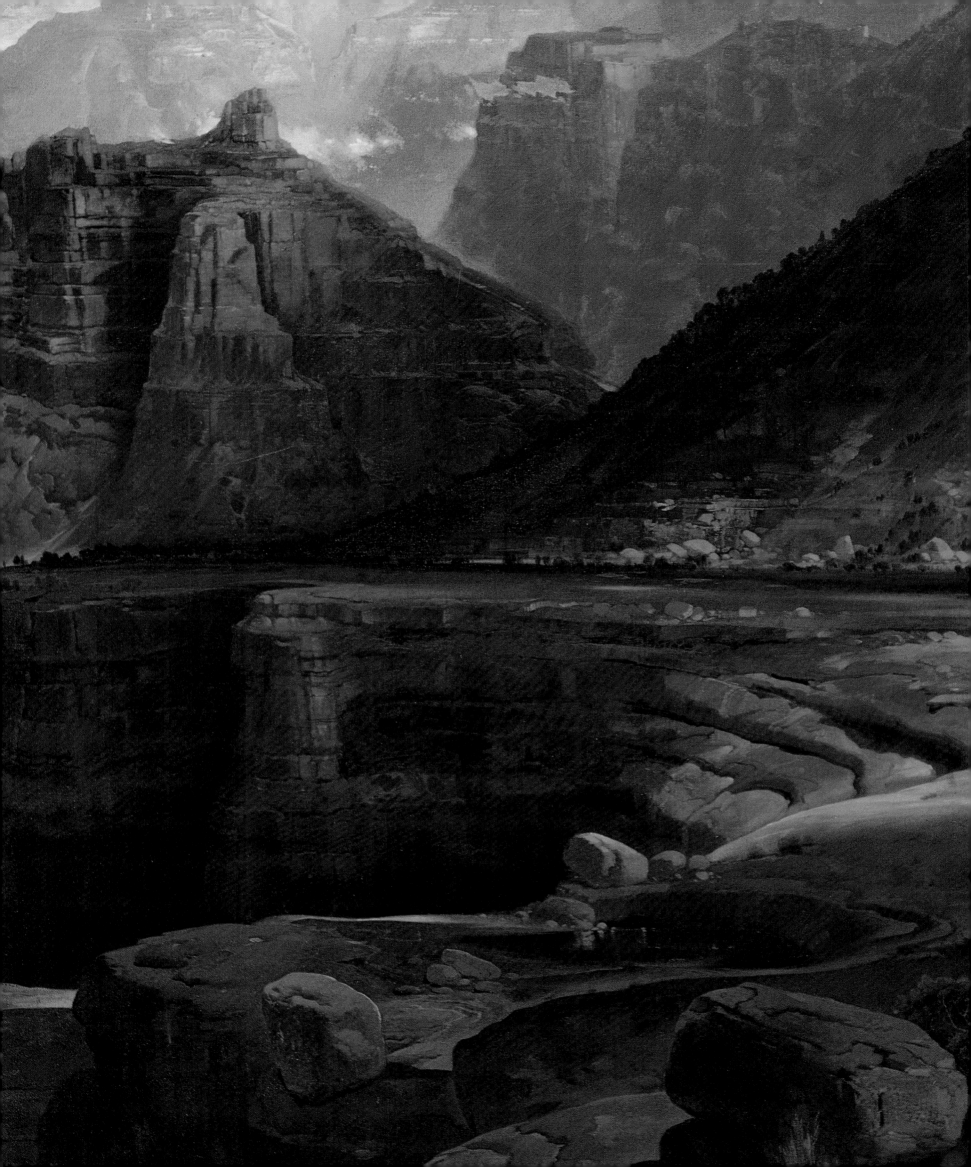

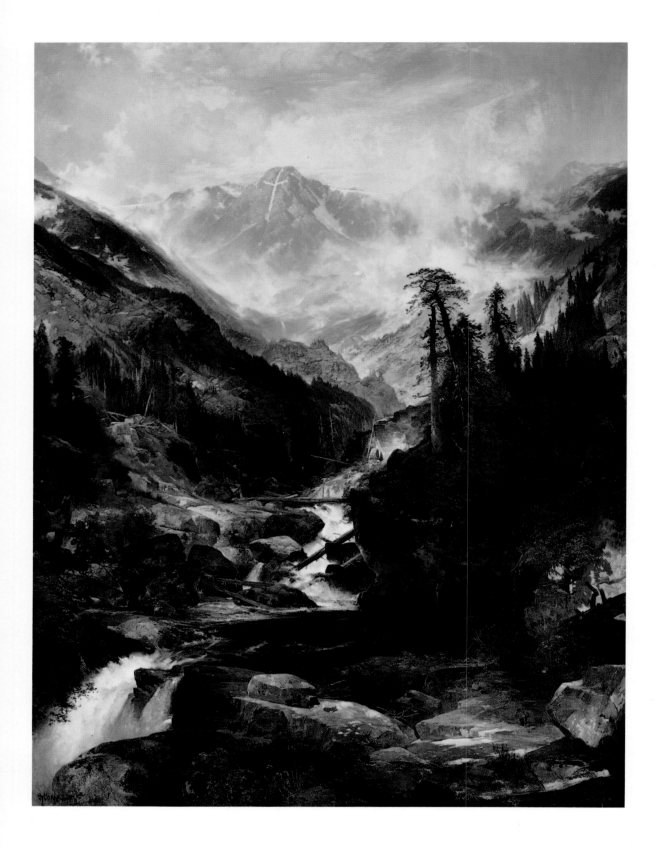

Mountain of the Holy Cross

THOMAS MORAN, 1837–1926

1875. Oil on canvas, 83½ x 64½ in.
The Gene Autry Western Heritage Center, Los Angeles.

The Mountain of the Holy Cross in Colorado, a huge peak with a strangely formed cross of snow on its flank, had been largely the stuff of Spanish legend until it was discovered by a government exploring party in the summer of 1873. Shortly thereafter, Thomas Moran traveled to Colorado to prepare a painting of this natural wonder, which he exhibited to considerable fanfare at the Centennial Exhibition in Philadelphia. In a recent study, scholar Joni L. Kinsey has shown how the mountain and Moran's painting of it were hailed as literal manifestations of Christianity, whose ideology underlay much of American thought and politics through the mid-19th century. Even as late as the 1870s, when the secular science of geology and Darwin's theories of evolution had begun to undermine older theological ideas, the image of the great mountain with its cross of snow seemed to offer in the remote landscapes of the West a final confirmation and sanction of the notions of manifest destiny.

In *Mountain of the Holy Cross* Moran stresses the vast space of the Colorado landscape by creating a dark foreground of tangled vegetation and rocks which contrasts with the ethereal atmospheric distance, where the cross on the mountainside appears remote and inaccessible. It was impossible to mistake the symbolism of Holy Cross Mountain. As one member of the exploring party described it, "Suddenly the artist glances upward, and beholds a vision exceedingly dramatic and beautiful. He is amazed, he is transfixed. There, set in the dark rock, held high among the floating clouds, he beholds the long straight cross, perfect, spotless, white, grand in dimensions, at once the sublimest thing in nature and the emblem of heaven."[13]

Moran had hoped that William Wilson Corcoran would purchase *Mountain of the Holy Cross* for his Washington art gallery, but he did not. Eventually the painting was sold to the Colorado railroad financier William A. Bell, who hung it in his mansion. There the painting was used to promote the railroad's role in developing the region and as a visual symbol of the healing powers of Bell's homeopathic resort hotel at Manitou Springs, Colorado.

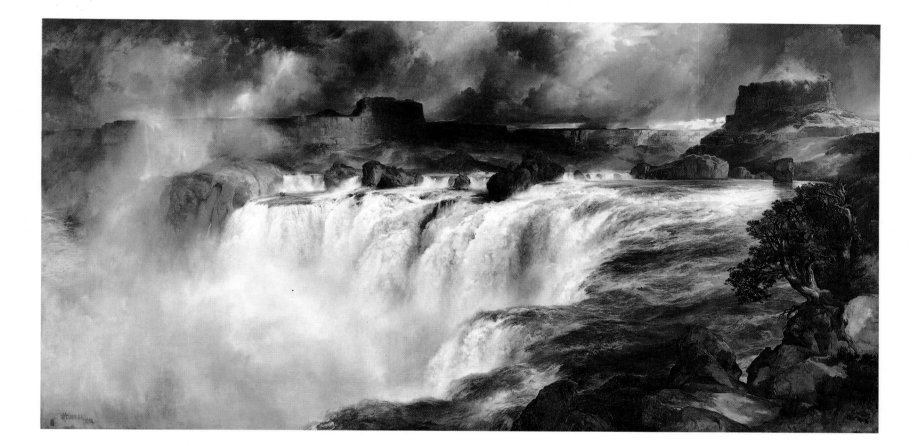

Shoshone Falls on the Snake River

THOMAS MORAN, 1837–1926

1900. Oil on canvas, 71 x 132 in.
Thomas Gilcrease Institute of American History and Art, Tulsa.

Shoshone Falls on the Snake River by Thomas Moran was one of the last large canvases to depict the western wilderness, a subject that had preoccupied American landscape painters for nearly a century. Like the great works of Moran's predecessors, Cole, Church, and Bierstadt, the painting celebrated the pristine state of nature represented by the American wilderness and, at the same time, expressed a nationalistic pride in the western

landscape. But, as scholar Linda C. Hults has argued in a recent article, Moran was also using the painting to inspire his countrymen to care for the sublime wilderness they had conquered. [14]

By the turn of the century, when Moran painted Shoshone Falls, Niagara Falls had attracted so many tourists, with such attendant commercial exploitation, that the surrounding area had fallen into a degraded state. By deliberately basing his composition on Frederic Edwin Church's renowned 1857 painting *Niagara*, a sublime image of the breathtaking wonder on the New York–Canada border, Moran expressed the hope that America would do better by its precious natural resource in Idaho. The turbulent water of Shoshone Falls and the surrounding jagged rocks—so brilliantly captured by the artist—offered compelling reasons for

Moran's audience to turn its attention from the tainted East to the still-pristine wilderness of the West. If further persuasion were needed, Moran included a rainbow at the left side of the canvas—an echo of that which appeared in Church's picture of Niagara. This colorful phenomenon can be seen as a call by the artist for a new covenant between God and the American people. Faithful to the convention of turning scenic elements into anthropomorphic forms, Moran includes two rocky profiles at the bottom left. They seem to be engaged in a silent conversation about the future of the grand scene unfolding before them.

The Cowboy
and the Buffalo

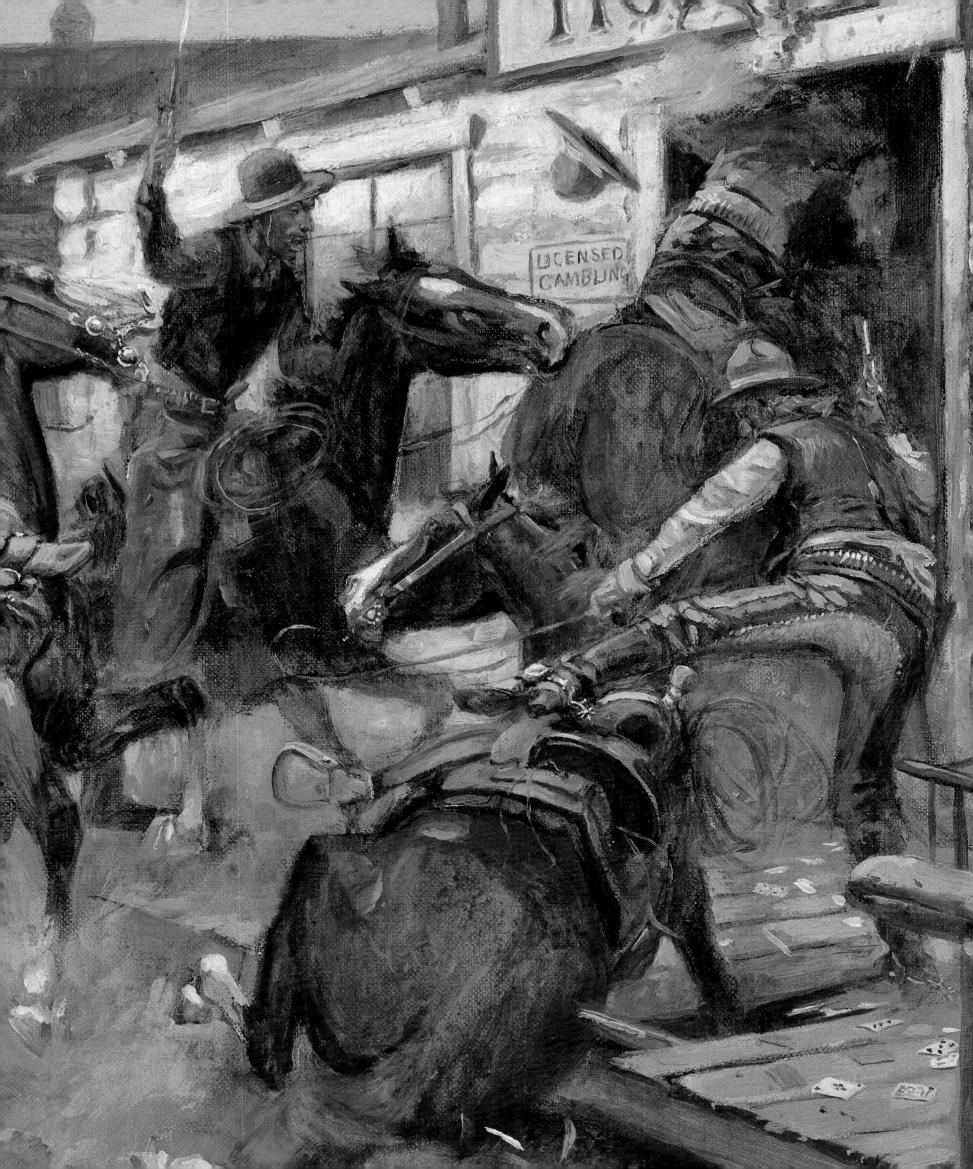

The Cowboy
and the Buffalo

The Fall of the Cowboy
FREDERIC REMINGTON

A Tight Dally and Loose Latigo
CHARLES M. RUSSELL

◄◄
In Without Knocking (detail)
CHARLES M. RUSSELL

For much of the 20th century, the lone cowboy has been virtually synonymous with the old West, but in recent years a new generation of cultural and art historians has been taking a fresh look at this legendary figure and finding, as the Montana historian K. Ross Toole put it, "an enormous feast on little food." Revisionist scholars like Richard Slotkin, Patricia N. Limerick, and Donald Worster have concluded that the *real* protagonists of the old West were not the cowboys, but less memorable individuals like the land surveyor and the real estate agent, even the banker or entrepreneur who provided the capital to finance the opening of the western territories. For these new historians, the West was won not so much by rugged individualism as by social enterprise. They credit the federal government and its corporate allies with opening the lands beyond the Mississippi in response to the needs of the railroads, the farmers working irrigated land in the arid regions beyond the 100th meridian, and other powerful commercial interests.

Despite these new and intriguing scholarly viewpoints, the American love affair with the cowboy shows no sign of diminishing. The "Marlboro Man" still maintains his grip on the imagination, and Ronald Reagan, America's second cowboy president, masterfully exploited western symbolis—as did his predecessor, Teddy Roosevelt—to achieve political objectives.

In 1983, the Library of Congress mounted a comprehensive scholarly investigation of the myth of the cowboy in a major exhibition entitled *The American Cowboy*. For the catalog, Lonn Taylor wrote a seminal essay called "The Open-Range Cowboy of the Nineteenth Century" in which he drew an astute distinction between the actual cowboy of the 1880s, who was simply a hired hand on horseback, and the mythic cowboy who has become an unforgettable protagonist in what he called a "national morality play."

The cowboy at the source of the legend first came to national prominence in the years following the Civil War. Early in the 19th-century, the herdsman, as the cowboy was first called, occupied a lowly place in the economic and social hierarchy of agricultural labor—cow herding was an ancient occupation, usually practiced without fanfare or celebration. His stature increased dramatically during the 1870s, when the railroads opened public lands through the Great Plains, lands that could be exploited cheaply for grazing cattle. There was something admirable about a man willing to drive hundreds of cantankerous creatures across miles of difficult terrain, risking exposure to the elements, rustlers, and unfriendly Indians. His mistique was further enhanced by the accouterments that he adapted from the Hispanic *vaquero*—the broad-brimmed hat to protect him from the sun, the chaps that guarded his trousers from high grasses and brush, and the spurs that he used to engage his horse. Still the cowhand's workday on the open range was long and difficult, his financial rewards minimal, and his life expectancy brief.

The heyday of the cowboy lasted until the 1890s. Then, as the railroads reached cow country, the need for long cattle drives was eliminated, and the cowboy's job became largely obsolete. At that point, Taylor noted, the cowboy should by all rights have passed into history, as had the Kentucky frontiersman, the fur trader, and the western flatboatman before him. In their day, these figures had also been popular in song and on the stage but had since been forgotten. Instead of disappearing, however, the cowboy flourished, living on as a national icon in art, literature, film, and television.

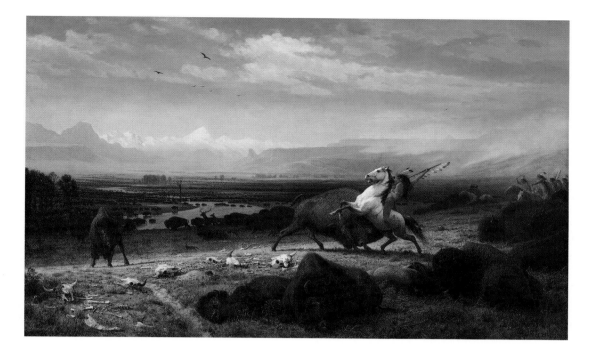

Last of the Buffalo
ALBERT BIERSTADT

A hint of what was to come can be found in the penny presses of the late 1860s, when journalists began writing about the cattle drives from Texas. Their reports, as Taylor observed, ascribed to the cowboy the characteristics of earlier national heroes. He was seen as a skilled and daring individualist with a love of the outdoors and an innate sense of fair play, qualities hidden beneath a rough and ready exterior. Newspaper accounts were followed in the 1870s by stage melodramas in which the cowboy figured as a protagonist. By the 1880s and 1890s, he had become an indispensable figure in Buffalo Bill Cody's famous Wild West Shows, his rising stature even noted by an English visitor, who wrote in 1887 that the "cowboy has at the present time become a personage: nay, more, he is rapidly becoming a mythical one. Distance is doing for him what lapse of time did for the heroes of antiquity. His admirers are investing him with all manner of romantic qualities; they descant upon his magnifold virtues and his pardonable weaknesses as if he were a demigod . . . Meantime, the true character of the cowboy has been obscured, his genuine qualities are lost in fantastic tales of impossible daring and skill, of daring equitations and unexampled endurance."

It was around the same time that Frederic Remington in New York and James Walker in San Francisco began to make the cowboy or *vaquero* the subject of their paintings. Their idealized images of these free-ranging individualists perfectly suited the emotional needs of a nation moving inexorably from a rural, agricultural society to one largely urban and industrial. Turn-of-the-century America was torn by class warfare, riddled with strife between labor and management, dominated by giant monopolies, and flooded with immigrants from places unheard of before the Civil War. The cowboy was the perfect antidote to the changing times. He was seen as everything that society in fact was not: free and independent, self-reliant, virtuous, and competitive. Stereotyped as 100% Anglo-Saxon, he seemed to embody attributes of the Progressive Movement spearheaded by no less than that cowboy president himself, Theodore Roosevelt (who had operated a ranch in the Dakota Badlands in the 1880s). "Once established in this manner," Taylor wrote, "the mythical cowboy hero became the medium through which America's own changing social values were displayed."

Vaqueros at the Round-up

JAMES WALKER, 1819–1889

1877. Oil on canvas, 30¼ x 50 in.
The Elisabeth Waldo-Dentzel Collection, Northridge, California.

It is ironic that James Walker, an English-born painter whose studio was in New York City, was the artist largely responsible for recording the character of the *vaquero*, the Hispanic cattleman of California who became the precursor of the American cowboy. When Walker first visited California in 1877, the once-prosperous ranches of these cattlemen of Spanish descent were already in decline. The image of the dashing, picturesque *vaquero*, however, immediately captured the imagination of American emigrants to the state.

What Walker chose to paint was not the sorry *vaquero* that the he actually saw, but the heroic, idealized figure who in earlier times had taught the cattle culture to the Anglos and provided much of the equipment, techniques, and terminology used by the American settlers.

In *Vaqueros at the Round-up*, Walker shows these colorful *Californios* in large flat brimmed sombreros and heeled with taloned spurs. Their *chaparojos* are of leather, in some cases studded with silver buttons, and *saltillos*, or colorful Mexican blankets, are rolled up behind their saddles. As the picture shows, this unusual type of saddle with its large pommel was particularly useful when it came to roping half-wild longhorn cattle. The Anglos quickly adopted this feature in their own saddles, and soon it became a standard part of the cowboys' gear. Walker's painting also shows the *vaqueros'* braided rawhide rope, called a *reata*, whose innovative slipknot gave the lariat its name.

Walker was largely self-taught, and his unsophisticated style sometimes suggests the handling of the folk artist or amateur. This is especially the case in his treatment of the exaggerated facial expressions of the animals in *Vaqueros at the Round-up*.

Walker's paintings reflected the artist's realization that the rich Spanish colonial way of life in California was passing away even as he was depicting it. In his idealized treatment of this dying culture, Walker served as a precursor to later cowboy artists like Remington and Russell, who painted the vanishing old West with a more sophisticated style but with essentially the same nostalgic spirit.

El Rodeo, Santa Margarita, California

JULES TAVERNIER, 1844–1889

1884. Oil on canvas, 36 x 60 in.
Arthur J. Phelan Collection, Chevy Chase,
Maryland.

The matter-of-fact realism of *El Rodeo, Santa Margarita, California* by Jules Tavernier provides a striking contrast to Walker's idealized *Vaqueros at the Round-up* (page 186). Tavernier's painting, which depicts an event that the artist actually witnessed, was executed while Tavernier was a guest at the ranch of millionaire cattleman General Patrick Washington Murphy and was given in payment to Murphy's brother, Dr. Gerald Murphy, in return for medical treatment. In fact, the most prominent mounted figure in the left foreground is the rancher himself. The smaller man behind him is probably the patron, Dr. Murphy, accompanied by his wife. Behind him other members of the Murphy family are seated in a carriage, viewing the action-filled drama of the roundup.

Tavernier's painting is not only a beautifully rendered work in the atmospheric style for which the artist was noted, it also provides a fascinating record of life in California during the heyday of the early Anglo-American cattle barons. By the 1880s, the Murphys, who had played a significant role in the early American emigration to California, were among the state's richest families. In the grand European tradition of landed gentry they commissioned Tavernier to paint the family portrait as a memento of their proprietorship and prosperity.

Jules Tavernier was as improbable an artist for this commission as one could imagine. He was born in France in 1844 and active in Parisian art circles as early as 1865. He came to America in 1871 and traveled overland until he reached San Francisco in 1874, where within a few years he had established himself as a leading member of the city's renowned Bohemian Society. Tavernier quickly fell deep in debt as a result of his eccentric habits and his alcoholism. His fellow artists raised funds that enabled him to escape his creditors and the sheriff by fleeing to Hawaii. There he painted evocative landscapes of the islands, but he was soon back in financial straits. He died in Honolulu in the spring of 1889.

The Fall of the Cowboy

FREDERIC REMINGTON, 1861–1909

1895. Oil on canvas, 25 x 35⅛ in.
Amon Carter Museum, Fort Worth.

As early as the mid–1890s the cowboy's way of life was coming to an end. The expansion of the railroads into cattle country had eliminated the need for the long trail drives that had carried the herds to the railheads of Kansas and Missouri, and the great expanses of public grazing lands had been opened to homesteaders who had enclosed them with barbed-wire fences. After more than a decade of painting the cowboy as a symbol of unfettered western life, Frederic Remington had begun to realize that the West he had idealized in his art was vanishing. Out of this awareness he produced one of his most memorable pictures, *The Fall of the Cowboy*.

Inspired by a visit to a New Mexico ranch and by a collaboration with the writer Owen Wister for an article entitled "The Evolution of the CowPuncher" that appeared in *Harper's*, the painter created a compelling image of two cowboys returning to the ranch after a long day's work. Both are evidently fatigued and so are their horses. The day is cold and snowy with a dull gray overcast sky. In a simple yet eloquent action one cowpuncher dismounts in order to open the gate through a barbed-wire fence, a prime symbol of the end of the open range.

The pathos that Remington empathetically expressed in *The Fall of the Cowboy* can be better understood in the context of the illustrations that the artist created for Wister's article. One of these, *The Last Cavalier*, sought to establish the cowboy as the last and greatest in a long tradition of horsemen by depicting him in a proud procession that also included medieval knights, French chevaliers, and an assortment of other historical figures who have left their tracks on western civilization. Remington's picture was so powerful that Wister wrote in a passage that also applies to *The Fall of the Cowboy*, "The Last Cavalier will haunt me forever. He inhabits a Past into which I withdraw and mourn. In a measure there is compensation, for the lime-light glares no longer, nor the noon sun—But makes the figures tender as they move across the hills."[1]

Frederic Remington

His First Lesson

FREDERIC REMINGTON, 1861–1909

1903. Oil on canvas, 27¼ × 40 in.
Amon Carter Museum, Fort Worth.

By 1903 Frederic Remington, whose near monopoly in the field of western painting had earned him a national reputation, had begun to tire of the constant demand for illustrations from Harper's and Collier's. Yet he did not want to give up the steady source of income that these publishers provided. In April, 1903, a solution to his dilemma presented itself when Collier's offered him a four-year contract, according to which he would be paid the large sum of $1,000 per

picture and given the freedom to select his own subjects. The pictures, no fewer than 12 a year, were to be reproduced in color and would be independent of any story or text, thereby eliminating the stigma of "illustration."

His First Lesson, reproduced here, was the first picture to appear under Remington's new arrangement with *Collier's*. The scene, which conveys the Hispanic flavor of the old Southwest, is set in a shallow, stage-like corral in front of an adobe building. Two cowboys are about to attempt to break in a hobbled pony unaccustomed to the saddle on his back. The wrangler at right gingerly reaches out to tighten the cinch, clearly fearful of the skittish animal, while his companion at left holds the reins with similar apprehension. Characteristically for Remington it is the expression of the animal and not the man

that is the focal point of the picture, leading one to ask whose first lesson is it?

Remington's late-career use of a more painterly technique and the coloristic effects of the Impressionists can be seen in the painting's tonal harmonies and in the purple shadows in the foreground. These shadows are also an important part of the work's compositional structure. They create a half-circle, drawing the viewer's eye inward from the foreground toward the apprehensive animal, while their form subtly emphasizes the drama of breaking the horse and, perhaps, the cowboy's first ride on a raw bronco.

On the Southern Plains

FREDERIC REMINGTON, 1861–1909

1907–1908. Oil on canvas, 30⅛ x 51⅛ in.
The Metropolitan Museum of Art, Gift of Several
Gentlemen, 1911, New York.

Remington once told a drinking companion that if he could have a single epitaph written on his tombstone it would be "He Knew the Horse."[2] Contrary to popular belief, however, Remington had never been a cowboy, although he did possess extensive firsthand experience with western customs and horses. As he once told a reporter, "What success I have had has been because I have a horseman's knowledge of a horse. No one can draw equestrian subjects unless he is an equestrian himself."[3]

Given the cavalry's close association with the horse, it is not surprising that Remington frequently turned to troopers for subject matter, just as he did cowboys. Among these works is *On the Southern Plains*, one of Remington's most powerful images of a hard-riding calvary unit moving confidently on horseback through the landscape.

Painted in the last years of Remington's career and at the height of his artistic powers, *On the Southern Plains* reflects the subtle contradictions between subject and style in Remington's art created after 1905. The artist draws on his mastery of Impressionist technique and painterly brushwork but places these refined technical skills at the service of a subject that is rather brutal and as idealized as any the artist ever painted.

For early 20th-century audiences looking longingly back at an earlier and less complex time, this image of the U.S. Cavalry sweeping majestically across the plains in a disciplined advance, the troopers with their pistols and sabers at the ready for a sudden Indian attack, would have held considerable appeal. To be sure, it offered a dramatic contrast to the dreary problems confronting the nation at the time: urbanization, industrialization, and an influx of emigrants, and it called to mind ideals of the frontier that seemed to have been lost in the nation's rush to maturity. For the artist, perhaps, this image also represented an attempt to reestablish his command over subjects depicting soldiers in action in the wake of rival Charles Schreyvogel's growing recognition in the field, a reputation that is known to have annoyed Remington. The pageantry of mounted cavalrymen and Indians in Buffalo Bill Cody's immensely popular Wild West Show was also a stimulus.

The Tenderfoot

CHARLES M. RUSSELL, 1864–1926

1900. Oil on canvas, 14⅛ x 20⅛ in.
The Sid Richardson Collection of Western Art, Fort Worth.

Unlike Remington, Charles M. Russell was a genuine westerner. His early works were exhibited in saloons and store windows, and around the turn of the century he became a local celebrity in Great Falls, Montana, when one newspaper described him as "the cowboy artist." Because of Russell's close connection with the old West, his art was more realistic on the whole than Remington's. Where Remington painted heroic scenes from history, Russell, possess-

ing the down-to-earth sensibility of a raconteur who enjoyed a good joke, often filled his pictures with humorous action and comic figures.

The Tenderfoot is one of Russell's most delightful depictions of "cowboy fun," presenting in an amusing context the conflict between the rough-and-ready West and the effete civilization of the East that the artist often derided.

According to Russell's friend, Patrick T. Tucker, with whom the artist had ridden the range in the early 1880s, *The Tenderfoot*, was based on an actual event witnessed by the artist. In the painting, a dude, possibly an Englishman, has arrived at a saloon around sundown. Having purchased several rounds of drinks, he and some cowboys stagger outside to inspect horses, and it is then that the fun begins. "Bill Bullard [the bully firing the

gun] is trailing the dude, pulling his shooting iron as he goes," Tucker wrote long after the painting's execution. "They are both walking crooked. A lone Indian buck is standing by the log shack. He can't move—too much firewater. . . . The [dude] is traveling slow. Bullard is making eyes at the boys, and walking tiptoe. His legs are shaky but his aim is still good. He takes a crack at Johnny Bull's feet with his six-gun. That raises a dust. The [dude] crowhops. Bill makes him dance the cancan while he shoots at his feet. [Russell] told me afterward that this was the first time he had ever seen a man dance to the music of a six-gun."[4]

In Without Knocking

CHARLES M. RUSSELL, 1864–1926

1909. Oil on canvas, 20⅛ x 29⅞ in.
Amon Carter Museum, Fort Worth.

The titles of Charles M. Russell's paintings often reflected the artist's rough and occasionally raucous western sense of humor. An example is *In Without Knocking* in which a group of drunken cowboys in a moment of carefree hell-raising enter Hoffman's Saloon through the front door without dismounting from their horses. The scene depicts an actual event that occurred in Stanford, Montana, in 1881 when a group of cowboys rode into town for a celebration before embarking on a long cattle drive. Russell was not among them because he was employed as the night watchman to guard the herd, but those who *were* there later said that the artist had captured the incident exactly as they described it to him. The image of a muddy street strewn with playing cards and discarded liquor bottles with the boozy cowpunchers firing their guns randomly into the air and into the ground and falling over one another to ride into the crude log cabin bar shows Russell at his most boisterous.

Depicting the cowboy as a reckless, lawless fellow was a favorite theme of dime novelists and sensational magazines like the *National Police Gazette* and *Frank Leslie's Illustrated Weekly*. During the 1870s and through the 1890s, virtually every issue carried woodcut illustrations showing the cowboys' drunken behavior. In a passage that offers striking parallels to Russell's painting, the January 14, 1882, issue of *Frank Leslie's* informed its readers that "when off duty cowboys are a terror in the way they manifest their exuberance of spirits. Two or three will dash through a town, and before the people know what is going on will have robbed every store. . . and made their escape. They practice a kind of guerilla warfare during their brief and infrequent holidays in the towns Two have defied successfully a dozen constables, and a score could circumvent an entire company of militia."[5]

A Tight Dally and Loose Latigo

CHARLES M. RUSSELL, 1864–1926

1920. Oil on canvas, 30 x 48 in.
Amon Carter Museum, Fort Worth.

Charles M. Russell's direct experience as a cowboy provided him with subjects for many pictures that possess an authenticity unrivaled in the work of Remington or any of the other so-called cowboy artists who later imitated him. *A Tight Dally and Loose Latigo* is the kind of picture that only someone who had actually participated in a cattle drive or roundup could have painted.

In this action-filled work, three Montana cowhands are driving a small herd along a dry wash and one of the men has gotten himself into difficulty. After attempting to lasso a cow, he finds that the latigo—the strap connecting the cinch with the "riggin'" that holds the saddle on his horse—has loosened, while the dally—the half-hitch that the cowboy throws around the saddle horn to pull in the animal he has roped—holds tight. A cowboy with a tight dally and a loose latigo would have been in serious trouble because as the cow pulled away, the cowhand's saddle would have been jerked from beneath him and he might have been thrown from his horse. He would then have been in great danger of falling under the feet of the frightened animal. Recognizing their companion's distress, the other cowboys in the picture ride to his rescue, lariats at the ready, while he struggles to maintain his mount.

The stop-action image that Russell employs in this and other paintings from the last decade of his career indicate a remarkable maturing of his skills as a self-taught painter. According to Russell scholar Frederic G. Renner, the details of the horses, including the Bar Triangle brand on the bucking animal, identify the cowboys as part of the Greely Grum outfit ranging south of Judith Gap, Montana. Russell pays close attention to the specifics of cowboy clothes, and the topography of the background landscape identifies it as the famous Judith Basin that the artist painted so often. Despite the realistic details that pervade this work, however, *A Tight Dally and Loose Latigo* is ultimately a romanticized image of a rapidly disappearing way of life.

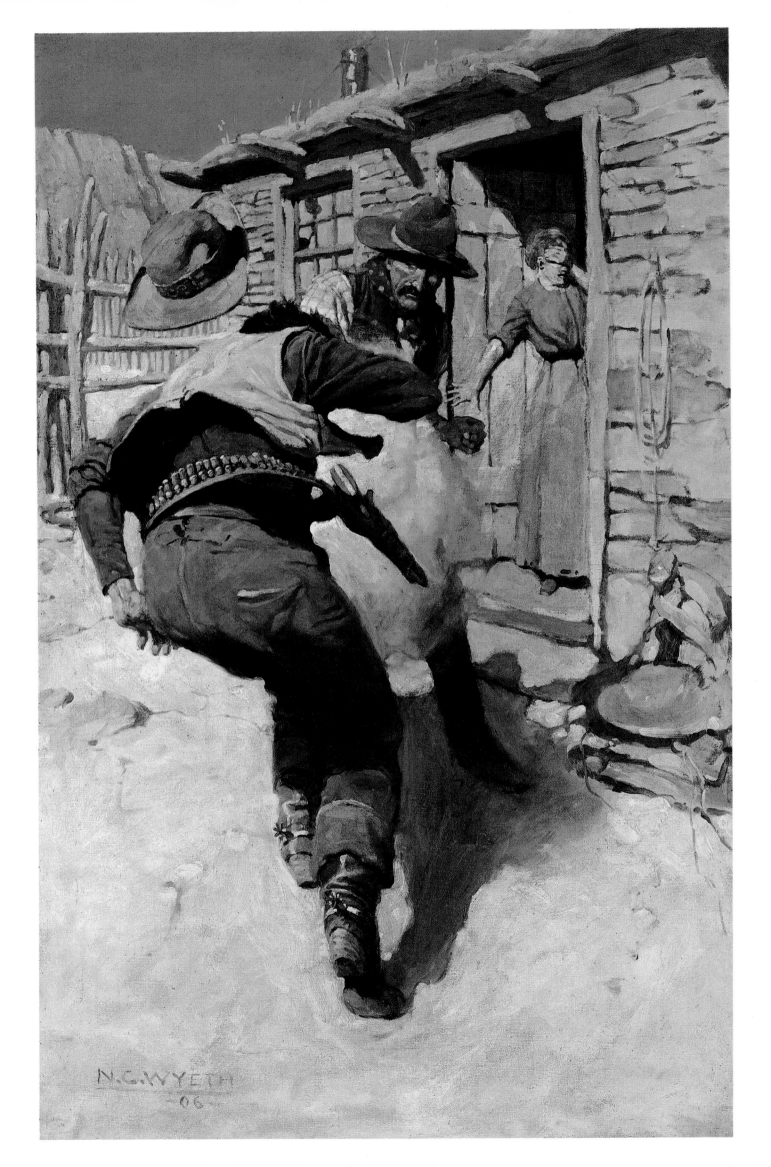

Hahn Pulled His Gun and Shot Him Through the Middle

NEWELL CONVERS WYETH, 1882–1945

1906. Oil on canvas, 37 7/8 x 23 7/8 in.
The Stark Museum of Art, Orange, Texas.

Novelists and illustrators at the outset of the 20th century frequently turned to the violent, lawless ways of the old West for subject matter. Among them was N. C. Wyeth, who painted the West long before he ever saw it. In fact, shortly after he arrived in Wilmington, Delaware, to work at the school of famed illustrator Howard Pyle, he sold a painting of a bronco buster, which was reproduced on the cover of *The Saturday Evening Post*. Wyeth formed his initial impressions of western life from the kind of popular western novels and short stories that he came to illustrate and from pictures by Remington, Farny, and others. In 1904 he made his first trip to Colorado and New Mexico to gather material for illustrations. On his return, Pyle praised his work, although he found too much Remington in several sketches.

In 1906 *McClure's Magazine* asked Wyeth to produce seven illustrations for Stewart Edward White's collection of short stories, *Arizona Nights*. Perhaps the most dramatic of these works was *Hahn Pulled His Gun and Shot Him Through the Middle*. The picture illustrated "The Ranch Foreman's Yarn: The Cattle Rustlers' Story," a grisly tale set in New Mexico that concerned two cowhands who discover, much to their disbelief, that a family of indigent cattle rustlers have been stealing their "dogies." They track the culprits to their remote ranch where they confront the thieves. In the cabin, Hahn, the leader of the rustlers, unexpectedly pulled his gun and shot one of the cowboys in the stomach. The episode provoked the narrator to observe: "There's a great deal of romance been written about the bad man, and there's about the same amount of nonsense. The bad man is just a plain murderer, neither more nor less. He never does get into a real, good, plain, stand-up gun fight if he can possibly help it. His killin's are done from behind a door, or when he's got his man dead to rights"[6]

Last of the Buffalo

ALBERT BIERSTADT, 1830–1902

1888. Oil on canvas, 71¼ x 119¼ in.
The Corcoran Gallery of Art, Gift of Mrs. Albert
Bierstadt, Washington, D. C.

In the late 1880s, paintings that lamented the disappearance of the old West reached a climax. No image better marked the frontier's passing than Albert Bierstadt's *The Last of the Buffalo*, although the use of the American bison to symbolize the vanishing western way of life was not new. Earlier artists like Catlin and Wimar had also employed the great beasts to presage the Indian's impending doom.

Bierstadt's work is carefully constructed for maximum allegorical effect. Set in an expansive prairie landscape stretching back to snow-covered mountains in the distance, the drama of the hunt takes place in the foreground. Near the center of the composition a wounded bull buffalo attacks a mounted, yet faceless and nearly naked, Indian on a rearing horse. Despite their adversarial roles, the Indian and buffalo form a compact visual unit, reflective of their symbiotic relationship. At left, a lone bull stands at bay, its fate foretold by the dead and dying animals at right.

The close relationship between the Native American and the bison is recognized again in the immediate foreground where the body of an Indian brave lies almost concealed among the dying forms of the animals. Next to the figure is the grey-white form of an albino calf. In Indian mythology to kill or capture an albino had special significance. It was a sign of favor from the Great Spirit, and rituals reenacting such events represented the rebirth of the Indian race. In the symbolic context of Bierstadt's painting, however, the albino and the brave represent not the renewal of life, but rather life's end, and the linkage of the animal and the man foretell the demise of both species. In a newspaper article, Bierstadt stated that his purpose in painting the picture was "to show the buffalo in all his aspects and depict the cruel slaughter of a noble animal now almost extinct."[7] By "cruel slaughter" the artist did not mean the Indian buffalo hunt. He was referring to the senseless extermination of the once vast herds by whites beginning in the 1870s. Reflective of the devastating expansion of American civilization across the western landscape, an intrusion that doomed the bison and the Indian, is the wagon-wheel rut that runs through the pile of skulls in *Last of the Buffalo*.

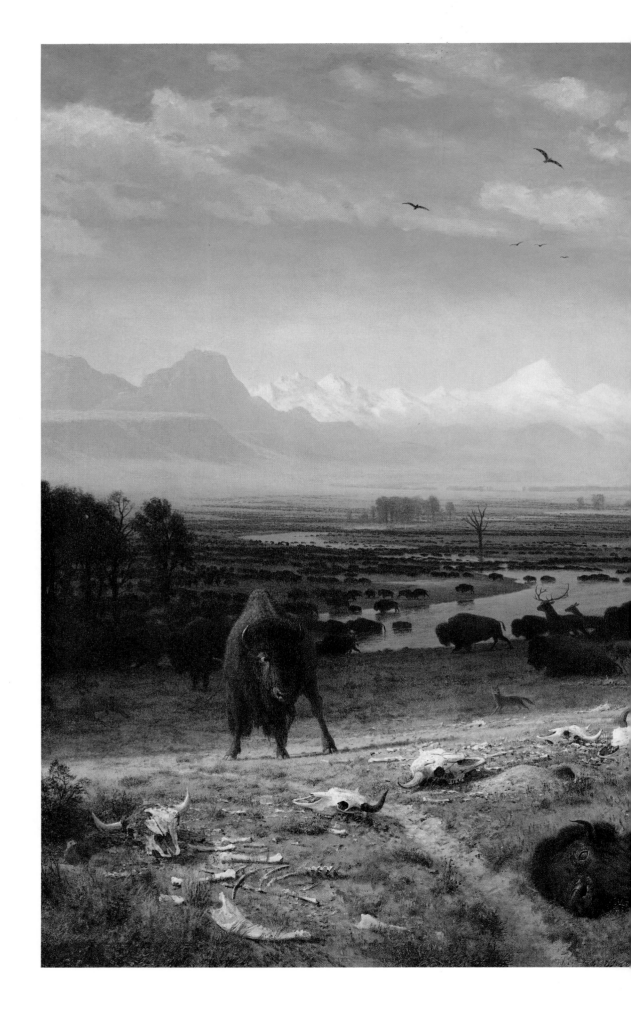

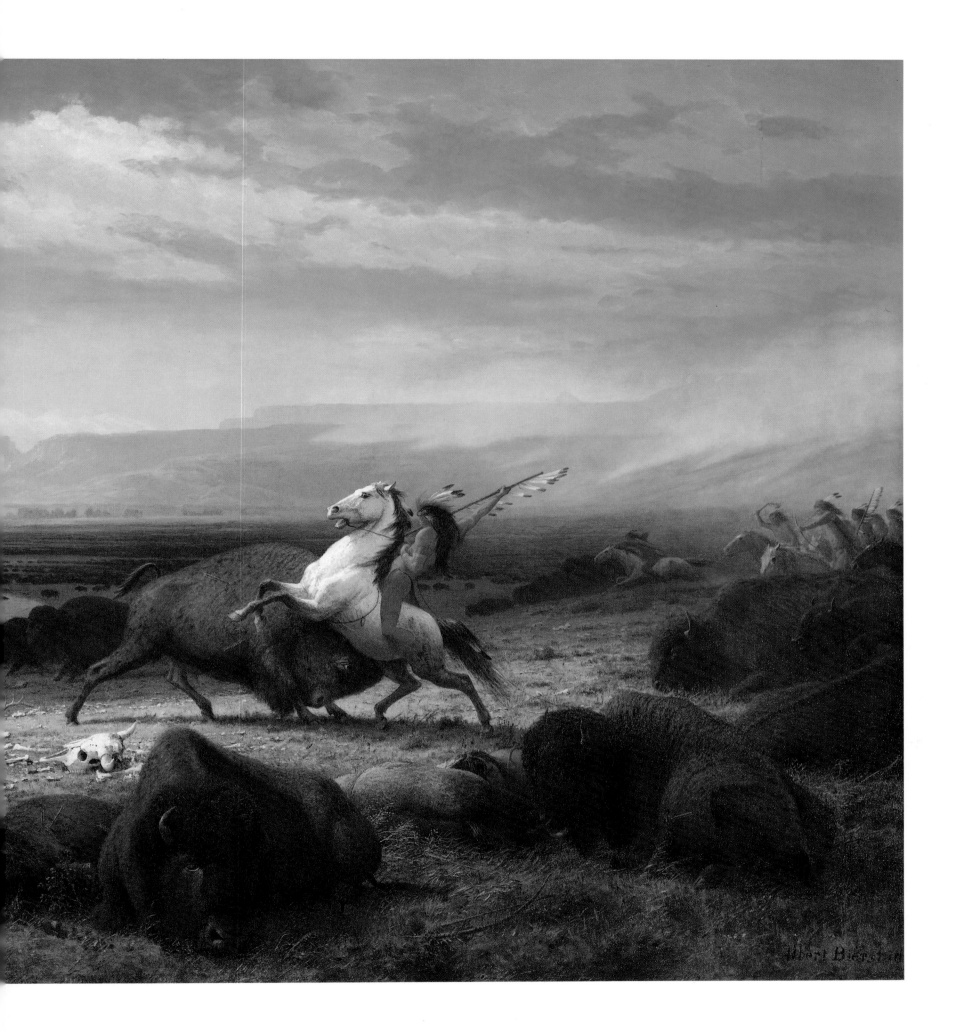

DETAIL ▶▶

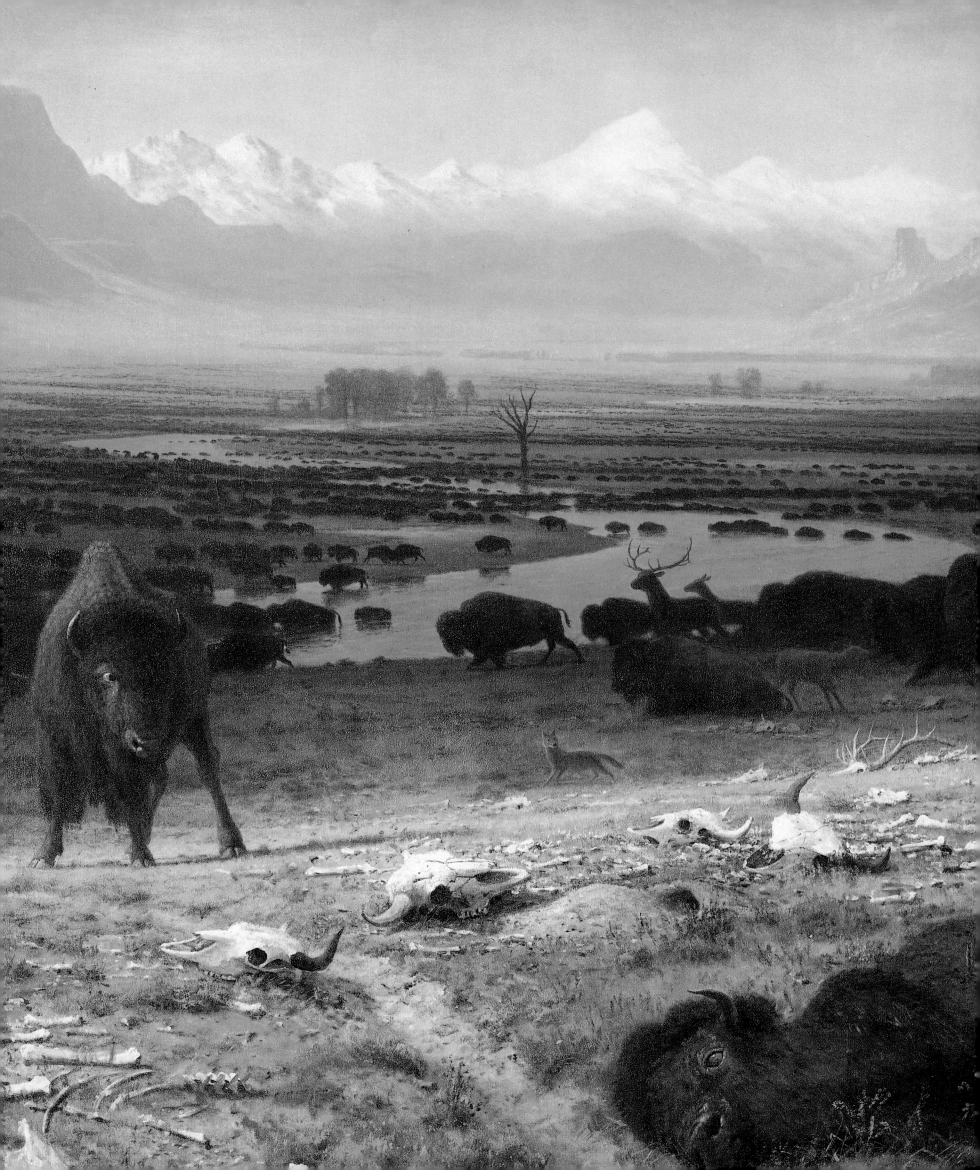

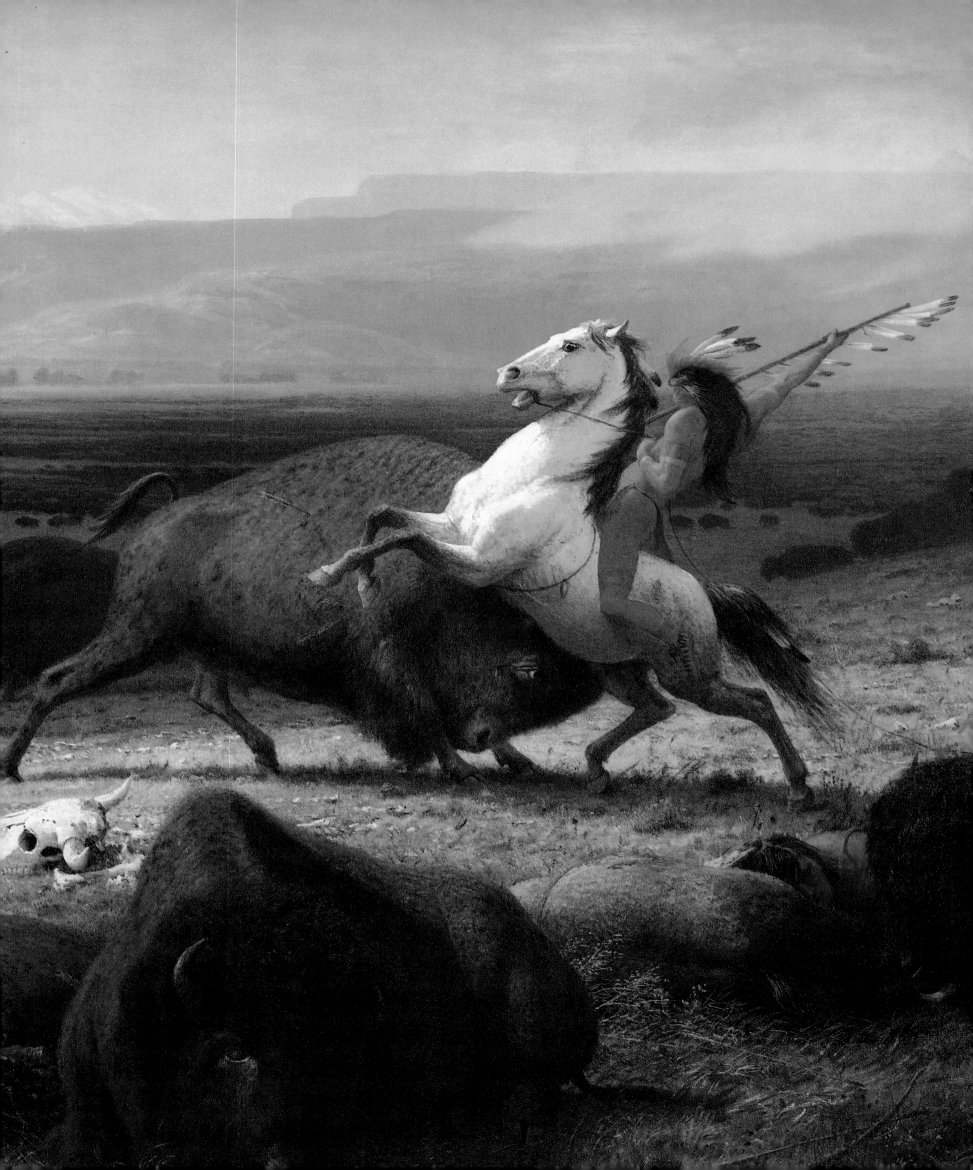

Buffalo Hunt

WALTER SHIRLAW, 1838–1909

circa 1890–1894. Oil on canvas, 9⅜ x 14 in.
The C. R. Smith Collection, Archer M. Huntington
Art Gallery, University of Texas, Austin.

By the 1890s the free-ranging herds of buffalo had long since disappeared, but public nostalgia for them had never been greater. At the same time, people realized that the buffalo's demise meant that the final solution to the Indian problem was inevitable and that great new tracts of western land would presumably become available for settlement. Walter Shirlaw harkens back to an earlier day, however, with *Buffalo Hunt*, reproduced here.

With his flickering brushwork, Shirlaw

envelops his subjects in a misty veil of light that turns them into apparitions from a distant past. It is surprising that Shirlaw, a Munich trained academician, a professor at the Art Students' League in New York, and a member of the conservative National Academy of Design, would elect to paint this romantic, evocative image. He almost certainly never witnessed such a scene and probably based his image on a bank note engraving by the midcentury illustrator Felix O. C. Darley entitled *Indian Hunting Buffalo*, whose key figures bear a strong resemblance to their counterparts in the right foreground of Shirlaw's painting.

It is highly probable that Shirlaw's trip west in 1890 inspired him to paint *Buffalo Hunt*. He traveled as a special agent for the U. S. government to Montana to prepare paintings and written reports on the conditions at sev-

eral Indian agencies. His findings were published in the extensive document *Report on Indians Taxed and Not Taxed*, which contained two of his paintings created in a dramatic style similar to that of *Buffalo Hunt*. But where the paintings in the government report possess an on-the-spot documentary quality, the painting reproduced here is a product of the artist's studio and is rooted in Shirlaw's imagination. Its moody evocation of a bygone era when Indian and bison roamed freely is as compelling as the grandiose allegory of Bierstadt's *Last of the Buffalo* (pages 198–199), but it works its magic on an intimate, cabinet-sized scale.

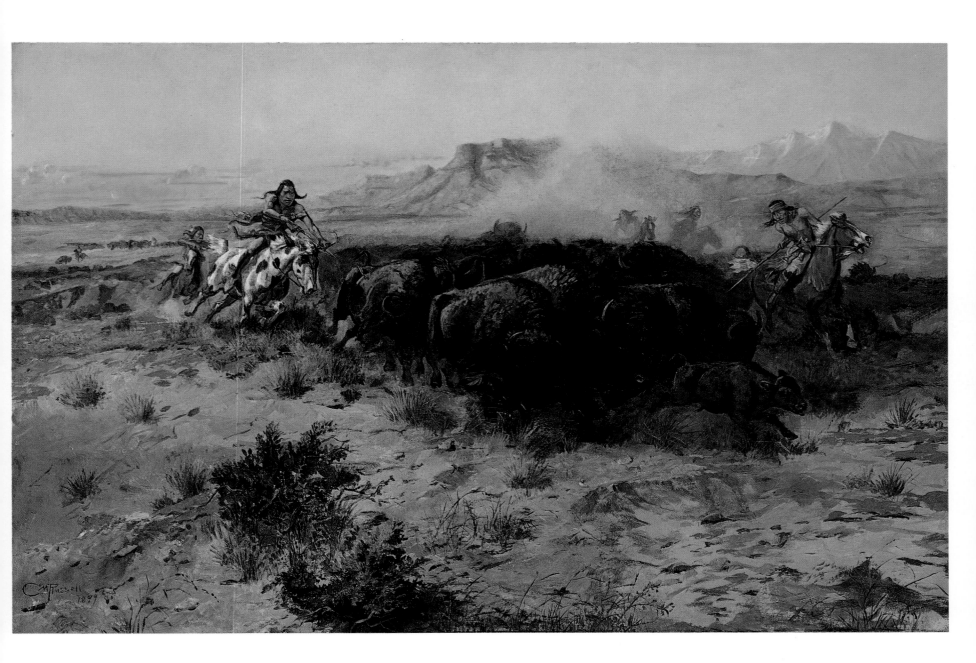

Buffalo Hunt No. 26

CHARLES M. RUSSELL, 1864–1926

1899. Oil on canvas, 30 x 48 in.
Amon Carter Museum, Fort Worth.

In 1900, when Charles M. Russell painted *Buffalo Hunt No. 26*, the free-ranging Indian hunter and the great bison herds were only memories. Russell had never seen a buffalo hunt such as the one he depicted. What he *had* seen as a youth growing up in St. Louis was Carl Wimar's 1860 painting *Buffalo Hunt* (pages 100–101). It became the basis for the more than 40 paintings that Russell created during his career, including the subtle variation on Wimar's classic image reproduced here. In *Buffalo Hunt No. 26*,

even the disposition of the Indians at left with bows and arrows and those at right with lances is strikingly similar to the figures in Wimar's picture, painted more than four decades earlier. So powerful was the impact of Wimar's painting on Russell, and so distant had Russell become from the reality of such a scene, that the younger artist includes a bison calf running ahead of the herd in an almost exact repeat of the equivalent young cow in the painting by Wimar.

The power of Wimar's archetypal image did not end with Russell. For through the Montana artist's many images and the tens of thousands of prints made after them, Wimar's painting of the legendary hunting scene was perpetuated in the art of yet another generation, the association of painters known today as the Cowboy Artists of America. These artists revere Russell and

Remington as the founders of the current sensibility in western American art, and in exhibitions of their works one is certain to see, through their adaptations of Russell's style, Wimar's lingering influence. Today's spectator may not realize how astonishingly influential these images are and how avidly each generation yearns for the nostalgic experience of the last of the buffalo.

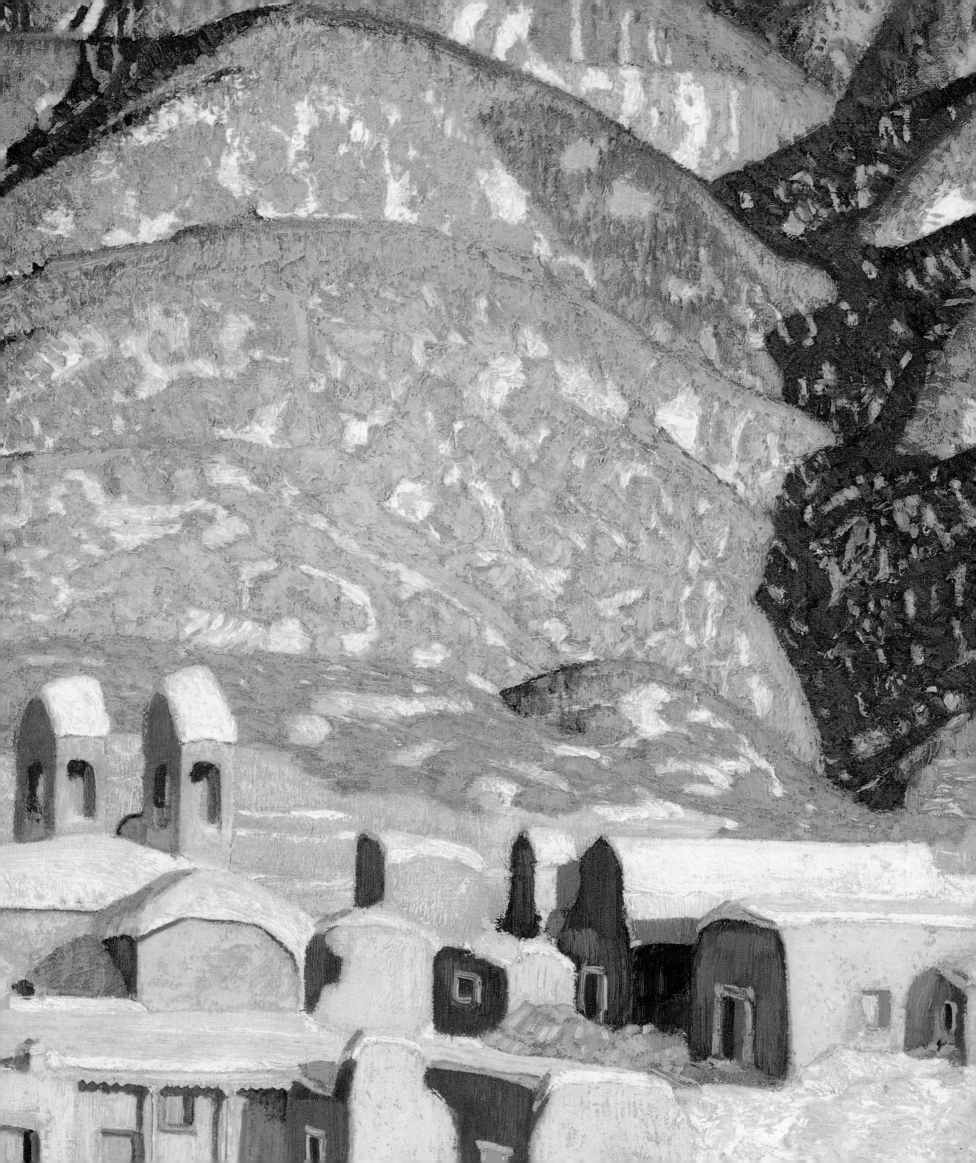

Visions of an
Enchanted Land

Visions of an Enchanted Land

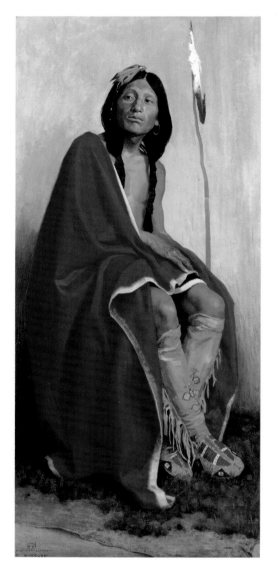

Elk-Foot of the Taos Tribe
EANGER IRVING COUSE

◄◄
Sangre de Cristo Mountains (detail)
ERNEST L. BLUMENSCHEIN

It was in the last decade of the 19th century that artists, along with writers and scientists, became captivated by the landscape and people of the American Southwest, and of New Mexico in particular. What emerged from their discovery of this enchanted land was a rich outpouring of 20th-century art to add to the legacy of earlier western imagery.

Artists were drawn to New Mexico because they realized that the territory (New Mexico did not become a state until 1912) represented one of the last vestiges of the old West, a place virtually untouched by national expansion. They also realized that the indigenous Indian culture was in grave danger of extinction and they wanted to capture it on canvas before it vanished altogether. It is ironic that Indian cultures became increasingly venerated in both myth and art, just at the moment of their near demise. Perhaps Anglo appreciation of Native American culture stemmed from feelings of guilt harbored by many over the oppression of the Indian.

For a time during the 1920s and 1930s it seemed as if every train that pulled into the stations at Santa Fe and Albuquerque disgorged a fresh contingent of eastern artists eager to capture picturesque scenes or depict the exotic natives. There was something undeniably novel about New Mexico. In appearance it was quite unlike the western landscapes painted by Bierstadt or Moran. Its vast arid expanses seemed so empty and yet they had played host to culture after culture—Indian, Hispanic, and Anglo—layered one upon another. Whether an artist came for a single season or stayed for a lifetime, he or she was likely to be profoundly touched by what writer D. H. Lawrence called the "spirit of the place." New Mexico, primitive, remote, far from the uncertainty and turmoil of the urban industrial society emerging in the East, possessed what was perceived as an authenticity and an "otherness," qualities that excited at least two generations of painters. For that matter, it continues to arouse the American imagination today.

To be sure, great corporate interests profited from the artists' depiction of this enchanting land. The ubiquitous advertisements, posters, and calendars of the Atchison, Topeka & Santa Fe railroad, Fred Harvey's chain of hotels, and other commercial enterprises contributed to the reputations of the artists from the colonies in Santa Fe and Taos who continued the 19th-century tradition of service to the tourist industries.

While they helped promote the area, New Mexico artists realized that the most lucrative sources of patronage for their work lay in the East and Midwest. To reach these markets they organized themselves into various societies, the most notable of which was the Taos Society of Artists (1915–1927), which organized traveling exhibitions. At least in part through the display of the New Mexico artists' work, the rest of the nation awakened to the magic of the Southwest.

The single most powerful intellectual idea motivating the New Mexico painters was primitivism. Its origins in America were virtually simultaneous with its rise in Europe, where appreciation for African tribal art found expression in the works of Picasso, Matisse, and other artists. Stimulated by the insights of a generation of anthropologists who advanced new ideas of cultural relativism, artists in the colonies of Taos and Santa Fe embraced the notion that so-called primitive peoples—the downtrodden American Indians in this case—survived through a simple, intuitive aesthetic and an emotional rapport with nature. In some respects, Anglo visitors even preferred these ancient unsophisticated cultures to the excesses of

their own overwrought, modern society. What emerged from the concept of primitivism was a new, more idealized vision of the Native American. He was seen not as warlike and savage, as America's 19th-century artists had painted him, but as peaceful and artistically oriented. The Hispanics who lived in the region were regarded in a similar fashion.

At least two generations of painters contributed to the visual discourse on the value and meaning of southwestern Indian life. The first generation included Joseph Henry Sharp, Ernest L. Blumenschein, Bert Geer Phillips, Oscar E. Berninghaus, E. Irving Couse, Victor Higgins, and Walter Ufer. They were mostly trained in a conservative European tradition and in varying degrees remained committed to academic conventions. After about 1917, a second generation began to arrive. Many of these newcomers were modernists, including John Marin, Marsden Hartley, and Georgia O'Keeffe. Committed to exploring formalist concerns like abstraction and the recognition of the actual means and processes of creating art, they added a new dimension of expression to the art of the region. They were also influenced by the idea of primitivism, but to it they added another layer of meaning, one stimulated by Surrealism and the psychoanalytical insights of Sigmond Freud and his followers. Georgia O'Keeffe, in particular, helped to define the region in a fundamental way. In the many decades in which she lived and worked in New Mexico, she contributed innumerable paintings of the state's haunting landscapes, ancient adobe churches, and *penitente* crosses.

Today, images of the West live on in the burgeoning art colonies of the Southwest. While Post-modernism has provided a surface veneer of respectability and contemporaneity to these works, the legacy of the old West survives just beneath the surface. It is manifest in the enduring belief in primitivism and in the modern acceptance of cultural relativism. Whatever the future may hold for western American art, its influence on the shaping of American culture over the last 200 years has been undeniably profound and its vitality will doubtless endure well into the 21st century.

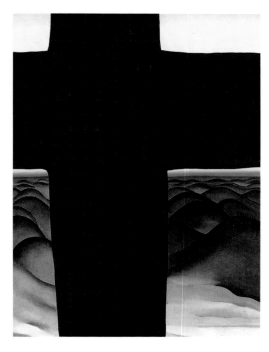

Black Cross, New Mexico
GEORGIA O'KEEFFE

Walpi
FREDERICK S. DELLENBAUGH

Santa Fe

THOMAS WORTHINGTON
WHITTERDGE, 1820–1910

*1866. Oil on paper mounted on canvas,
8¹⁄₈ x 23¹⁄₈ in.*

*Yale University Art Gallery, Gift from the estate of
William W. Farnam, New Haven, Connecticut.*

Worthington Whittredge's oil sketch of the old Spanish colonial city of Santa Fe, dated precisely 20 June 1866, is one of a series of *plein air* images that the artist executed on his first trip west. Typically, after his exploring party made camp in the afternoon, Whittredge would set out on a sketching trip (see pages 68–69). According to his autobiography, he carried his campstool, umbrella, sketch box, and, since the party was in hostile Indian territory, his revolver.

The sketch box contained his palette, brushes, knives, tubes of colors, and a special interior compartment that could hold two or three prepared canvases. The box was also designed so that it could rest on the artist's knees and serve as a portable easel. The *Santa Fe* sketch reproduced here preserves the panorama of the old adobe town with, in the artists' words, "its low adobe huts in the foreground and looking off over their flat grassgrown roofs to the great valley of the Rio Grande with the beautiful San Dia [sic] mountains in the distance."[1]

In his autobiography Whittredge related an amusing account of how a local patron attempted to acquire the painting from him. "The picture was . . . very nearly finished when an exceeding rough-looking fellow with a broken nose and hair matted like the hair of a buffalo stepped up behind me and, with a loud voice, demanded to know what I asked for the picture. I told him it was not for sale. He broke out with a volley of cuss words

and, putting his hand on his pistol, drew it forth and said he would like to know if there was anything in this world that was not for sale Things were getting pretty serious, especially as he kept brandishing his pistol near my head with his finger on the trigger. I . . . said: 'My friend, you look pretty rough but I don't believe you are a fool. It's a sketch to make a large picture from. I live in New York, and my business is to paint big pictures and sell them at a thundering price' This silenced him and I handed him my studio address. He took it, put up his pistol and marched off, and I have never seen him since."[2]

Walpi

FREDERICK S. DELLENBAUGH, 1853–1935

1884. Oil on canvas, 29⅞ x 38 in.
The Elisabeth Waldo-Dentzel Collection, Northridge, California.

As the Southern Pacific and Santa Fe railroads reached completion around the turn of the century, the Southwest, with its ancient Indian and Hispanic cultures and its colorful desert landscape, began to attract artists from the East. Santa Fe, Taos, and other New Mexico and Arizona pueblo villages had remained relatively untouched by the advancing line of American expansion, and the cultures of these old cities provided a wide range of appealing subjects for painters.

One of the earliest artists to visit the region was Frederick S. Dellenbaugh. He had studied in Munich and Paris and at the age of 17 was chosen by Major John Wesley Powell as the staff artist for the Colorado River expedition of 1871–1873, Powell's second foray into the region. Descending the raging Colorado River in one of three small wooden boats with the rest of the party, Dellenbaugh sketched the geological formations and helped with the mapping. This youthful venture inspired the artist's lifelong involvement with the rugged wilderness landscapes of the Southwest and its fascinating Indian culture. He later published two important books on the region, and he illustrated *Romance of the Colorado*, published in 1902, along with his friend Thomas Moran and the famed landscape photographer William Henry Jackson.

Dellenbaugh's *Walpi*, painted in 1884, is an early and especially interesting image of a picturesque Hopi village before artists had discovered Taos and Santa Fe. An intense light invests the architectural forms of the old pueblo with mysterious energy, while the figure of an Indian child playing with a top in the lower right casts an enormous shadow that is almost surreal. The irregular, asymmetrical architecture, with the brilliant red color of drying chili peppers, add to the picture's special power.

The Weaver

GEORGE DeFOREST BRUSH, 1855–1941

1889. Oil on canvas, 12 x 15 in.
Terra Museum of American Art, Daniel J. Terra Collection, Chicago.

George DeForest Brush began painting Indians in 1881, when he first went west. By 1889, the appalling treatment of Native Americans had so disheartened him that he abandoned the theme. The years between saw the creation of a small body of work that differed dramatically from the popular images of Indians as hunters and warriors by such artists as Remington, Russell, and Farny. Instead of showing the Native American as a fierce savage, Brush chose instead to portray him as an artisan—a weaver, a potter, and a sculptor.

Although Brush's portrait of *The Weaver* stands as one of his finest works, it has not been positively determined if the artist ever actually visited New Mexico to study Indians firsthand in their ancient pueblo villages. The weaver's simple but improbable appearance—nearly naked and without discernible facial features—and the stark interior with one blanket on the loom and another hanging on the wall, both patterned after traditional Navajo designs, would have appealed to any viewer unfamiliar with actual pueblo life in a southwestern setting. But, in Navajo culture, weaving was done outside the hogan and by both men and women. Thus, Brush's picture possesses an element of artifice calculated to appeal to the sentimental conception of the noble Indian.

The uniqueness of Brush's approach is that the Native American has been put to work as a thoughtful, sensitive craftsman creating colorful, attractive objects with cultural and commercial appeal to eastern audiences. This conception of Indian life became astonishingly popular in the early 20th century among artists like Joseph Henry Sharp, Bert Geer Phillips, and Eanger Irving Couse, all of whom worked in the artists' colony in Taos, New Mexico.

Elk-Foot of the Taos Tribe

EANGER IRVING COUSE, 1866–1936

*circa 1909. Oil on canvas, 78¼ x 36 ¡⅜ in.
National Museum of American Art, Smithsonian
Institution, Gift of William T. Evans, Washington,
D. C.*

Among the members of the Taos colony was E. Irving Couse whose training in the tradition of the French Academy decisively influenced his images of noble-spirited Native Americans. Couse's impressive portrait of *Elk Foot of the Taos Tribe* reproduced here is a prime example of that tradition at work, with its studied technique, deliberate composition, and idealized conception.

According to New York art critic Gustav Kobbe, "The subject of the portrait was chosen by Mr. Couse with great care from all the characters of the Taos pueblos as having the most characteristic and dignified traits of the Indian. In his hand Elk Foot holds a coup stick, from which floats the eagle feather, a sign that he is a warrior. The significance of the coup stick is that to the first brave who strikes the body of an enemy with this stick belongs the scalp, whether he or another has made the kill."[3]

The quiet dignity and air of heroic reserve in the figure of Elk-Foot effectively endow the subject with a noble mein equal to that of the classical figures that Couse had studied in Paris. This impression is furthered by the brilliant red blanket that shrouds Elk-Foot's shoulders, his colorful moccasins and leggings, and the Plains Indian coup stick that he holds in his left hand. In creating this effect, the artist has taken some liberties with his subject's attire and accouterments. The blanket that he wears was a commercial textile, probably imported from England, and while the Taos Indians did have relations with Plains Indians, the moccasins are clearly studio accessories. Moreover, Pueblo Indians did not count coup as the Plains tribes did.

The image of Elk-Foot is known to have been taken from a carefully posed studio photograph of Jerry Mirabal, one of Couse's favorite models, who also sat for Joseph H. Sharp. Mirabal also appears as the central figure in Couse's *A Vision of the Past* (page 119). While ethnologists may cavil at Couse's inexactness in costuming his figures, they miss the artist's true intent. His art, like that of other painters in the New Mexico colonies, was not about documenting culture or artifacts but expressing an American vision of the Indian spirit.

Crucita, A Taos Indian Girl

JOSEPH HENRY SHARP, 1859–1953

not dated. Oil on canvas, 40¼ x 48½ in.
Thomas Gilcrease Institute of American History and Art, Tulsa.

Around the turn of the 20th century a new perspective on Native American culture began to emerge, deeply influenced by the discoveries of anthropologists and by new ideas of cultural relativitism. Overlaid on this was a form of primitivism in which Indian art was viewed as containing an instinctive, almost unconscious, formalistic aesthetic. As a result of these intellectual developments, many writers and artists of the period came to view Indian life as equal to—if not in some idyllic way superior to—that of the crowded, depersonalized world of an urban, industrial civilization.

Among the founders of the Taos colony, Joseph Henry Sharp was most eager to promote this new vision of Indian life through paintings like his *Crucita, A Taos Indian Girl*, reproduced here. In a tonalist harmony of beige and subdued earthen colors, Sharp's Crucita—an Indian model the artist used repeatedly because her atypical features recalled a Renaissance madonna—is posed in a beautiful Hopi wedding dress with a brightly colored woven sash. At her feet is an earthen bowl filled with an arrangement of flowers, including zinnias, which are not native to the Southwest. Such a floral arrangement, as art historian William H. Truettner has noted, would not have been part of an Indian household. It is, in fact, a pictorial conceit that Sharp uses to portray an Indian culture as whites imagined it to be. Sharp's *Crucita*, like Brush's *Weaver* (page 212), is intended to suggest that the Indian created beautiful objects *instinctively*, a notion that says less about Native American craftsmanship than it does about the yearning for a union of art and life that white artists felt was missing in modern American society. This presumed love of beauty on the part of Native Americans, based purely on emotion, is furthered by Sharp's decision to leave Crucita's features virtually undefined. She thus embodies, in a generic sense, the penchant of all Indians for aesthetic harmony rather than the talents of a specific individual.

Song of the Aspen

BERT GEER PHILLIPS, 1868–1956

circa 1926-28. Oil on canvas, 40 x 27 in.
The Eiteljorg Museum of American Indian and
Western Art, Indianapolis.

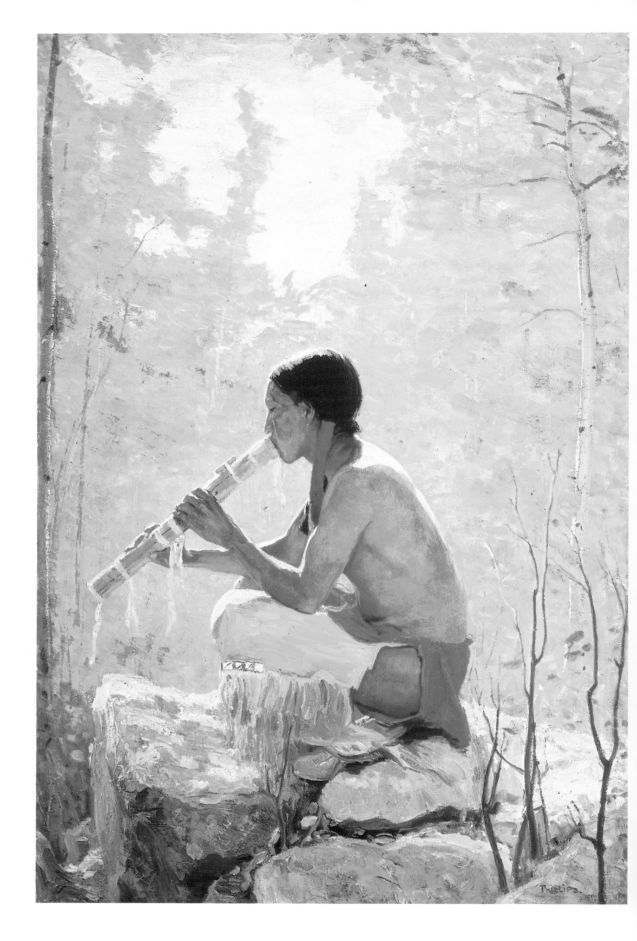

Like Sharp, Bert Geer Phillips was interested in creating idealized images of happy Indians engaged in artistic endeavors. His *Song of the Aspen*, like Sharp's *Crucita*, (pages 214–215) surrounds the figure of an Indian youth with an aura of golden tonalist color. The youth's clothes and his improbable flute serenade in an autumnal woods endow him with a sense of harmony, order, and aesthetic refinement that the Anglo painters were themselves seeking. To be sure, Taos Indian beaus were unlikely to wear such elaborate Plains Indian fringed leather leggings, and playing the flute as a courtship ritual was an uncommon practice among the Pueblo Indians.

Painted in the controlled environment of Phillips' studio, the work has a studied, posed quality that it shares with many other works created by artists from the New Mexico colony. Judging by the remarkable success of the Taos painters both during their own time and even more so today, however, it would seem that these images with their contrived qualities and their elements of unreality were precisely what patrons expected. The art of the Taos school—that is the fantasy they created about the art of the Native Americans of the Southwest—provided an indigenous American alternative to the influx of cosmopolitan styles of the period, including Post-Impressionism, Cubism, Dada, and Surrealism, styles for which the general public had little appreciation. Indeed, Indian art with its bold designs and bright colors was touted as actually superior to contemporary Euro-American art. The director of the Museum of Fine Arts in Santa Fe, Edgar L. Hewett, for example, boldly declared, "It is gradually dawning upon us that the Indians' race is a race of artists, and that their aesthetic culture towers above anything Caucasian, if we except a few points of supernormal development such as Greece and Italy."[4]

Among the artists of the Taos colony, Phillips was especially noted for his extensive studio collection of Indian costumes, accessories, and artifacts. These objects were employed repeatedly by the artist in his paintings. Many of the accouterments were of Plains Indian origin, although their incongruity in images of the Pueblo tribes did not seem to disturb either the artist or his patrons. Phillips was one of the earliest artists to settle permanently in New Mexico, where he devoted sixty years to the Taos community of artists, achieving a substantial degree of success with his high-keyed oils, which expressed an essentially idealized view of Pueblo life.

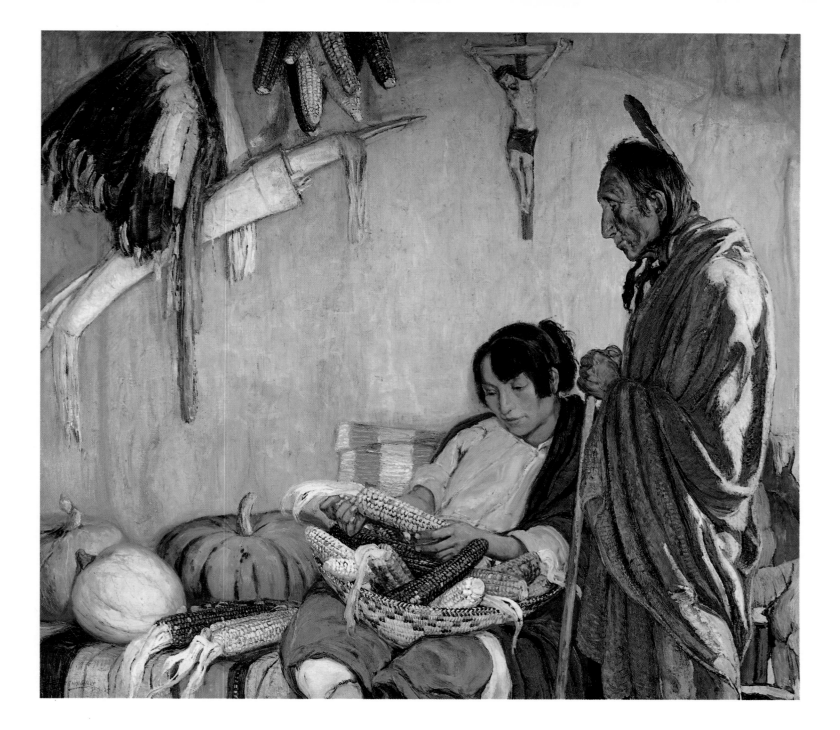

Peace and Plenty

OSCAR E. BERNINGHAUS, 1874–1952

1925. Oil on canvas, 35 x 39½ in.
The St. Louis Art Museum, Museum Purchase.

Where 19th-century artists had tended to depict warlike Indians, their early 20th-century counterparts in Taos and Santa Fe preferred images of a more peaceful, harmonious people. It was an idea of the Native American more suited, perhaps, to an era in which the threat of Indian hostility had finally been eliminated. An example of this new approach is Oscar E. Berninghaus' *Peace and Plenty*, a work that stresses the Pueblo Indian's easy access to nature and his absorp-

tion in a settled, peaceful agricultural life. It was painted in 1925, the same year that the artist moved permanently to Taos from St. Louis after frequent trips to the New Mexico art colony.

For the audience of Berninghaus' day, the appeal of the picture lay in the touching passivity of the figures, their implements of war—the war bonnet, bow, and quiver—hanging unused on the wall. Perhaps these implements belong to the old man who is now too frail to use them. His female companion is absorbed in thought, surrounded by colorful pumpkins and corn, symbols of the land's fertility. The carved crucifix above her head indicates that she and her husband have been converted to the white man's religion, Christianity, which emphasizes the acceptance of suffering and one's place in the

order of the universe. As art historian William Truettner has observed, the symbolic elements in the picture, representing the abandonment of warfare, the fertility of the land, and the power of religion create an elliptical composition that begins with the downward slant of bow and quiver, returns upward through the forms of the corn and the bowed back of the old man, and ends at the crucifixion. Through this compositional motif, Berninghaus evokes the relatively simple world of the early 20th-century Native Americans. These pacified Indians need not be feared, the artist unobtrusively asserts, for they, like the objects in the picture, are locked into an unchanging pattern of relationships dominated by custom, nature, and religion.

Where the Desert Meets the Mountain

WALTER UFER, 1876–1936

before 1922. Oil on canvas, 36½ x 40½ in.
The Anschutz Collection, Denver.

In addition to its exotic Indian and Hispanic cultures, New Mexico also offered artists the exciting challenge of its vast, sun-bleached landscapes and a strange desert environment. The brilliant sunlight that whitened colors in the dry thin air made the view across vast gorges and varicolored mesas to distant mountains an exhilarating experience. New Mexico was no ordinary setting. "The moment I saw the brilliant, proud morning shine high up over Santa Fe," recalled the novelist D. H. Lawrence, "something stood still in my soul, and I started to attend In the magnificent fierce morning of New Mexico one sprang awake, a new part of the soul woke up suddenly, and the old world gave way to the new."[5] Not only did the landscapes of the region stir the soul, they also seemed to dwarf human scale. Aldous Huxley, for example, wrote that "the New Mexican is an inhuman landscape. Man is either absent, . . . or, if present, seems oddly irrelevant. Nowhere are his works an essential part of the scene; nowhere has he succeeded in imposing his stamp on the country."

The Munich-trained Impressionist, Walter Ufer, powerfully expressed this sense of otherness about New Mexico in his painting *Where the Desert Meets the Mountain*. In this deceptively simple image, a small covered wagon in the foreground is swallowed up by the rolling emptiness, never to reach its destination. In the distance the sheets of rain and lighting appear to connect the heavens with the dark profile of the mountains, creating a mysterious effect.

Among the artists of Taos, Walter Ufer is one of the most appreciated, but he is also the least studied. The reasons for this are hard to determine, but they must surely be related to Ufer's radical views on politics, his condemnation of the capitalist establishment, and his tragic later years. He first visited New Mexico in 1914. Quickly befriended by the artists in the colony, he was at the height of his powers by the mid-1920s. But deeply imbedded contradictions in his character, his vaunting ambition, and his disdain for the established social order plus an excessive appetite for drink and a propensity for quarrelsome behavior combined to undermine his success. He died an indigent alcoholic in Albuquerque in 1936.

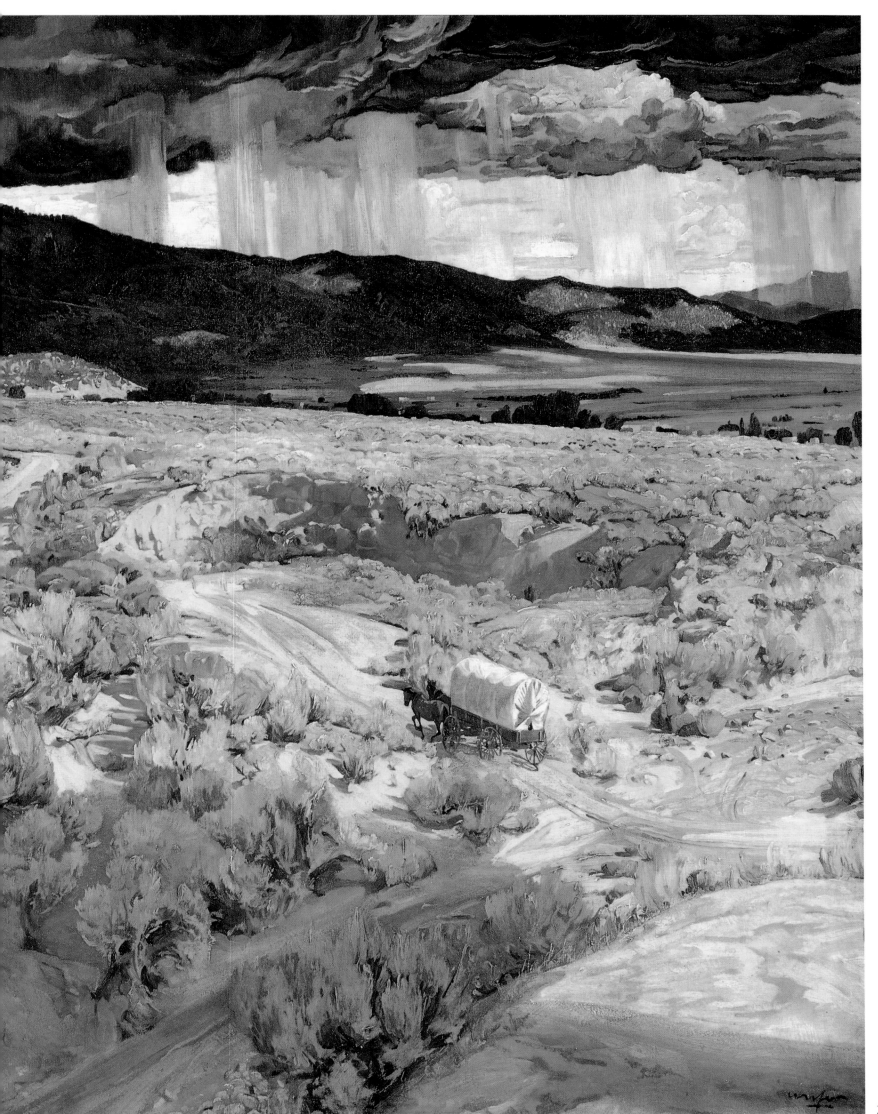

DETAIL ▶▶

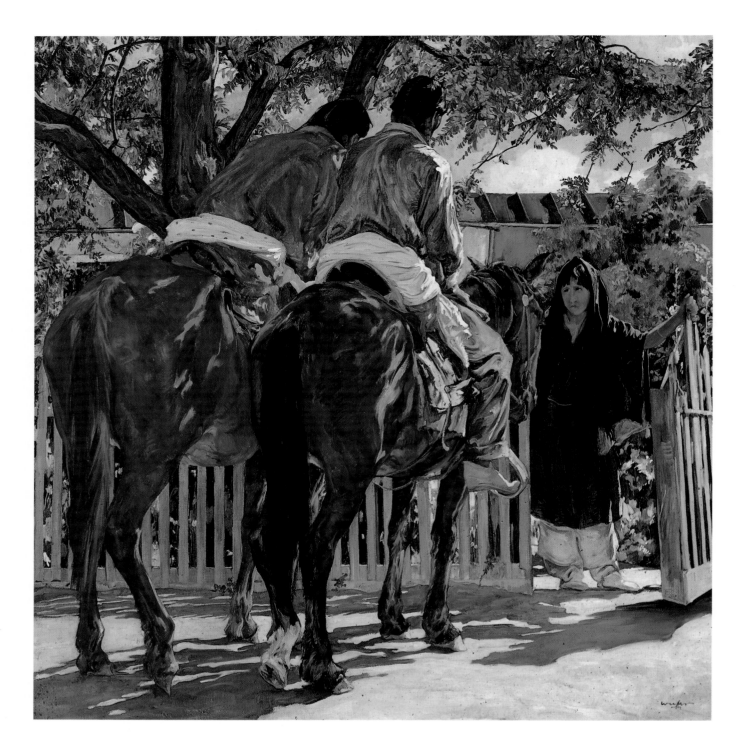

Callers, Indians on Horses

WALTER UFER, 1876–1936

circa 1926. Oil on canvas, 50½ x 50½ in.

National Museum of American Art, Smithsonian Institution, Gift of Mr. and Mrs. R. Crosby Kemper, Jr., Washington, D. C.

Among the artists of the Taos colony it was Walter Ufer who began to break with the tradition of blatantly idealizing the Pueblo Indians on canvas. Perhaps Ufer's unusually cosmopolitan artistic training in Europe and his radical social views allowed him to cast a more objective eye on the Taos scene when he arrived in New Mexico in 1914.

Ufer came to the Southwest on the advice of one of his patrons, former Mayor Carter Harrison of Chicago. Harrison believed that New Mexico was a good place for an artist of Ufer's temperament because "abundant artistic material could be found in painting Indians as they are today—plowing with their scrubby Indian ponies, digging in the fields, on horseback, and lying around the pueblo. This phase of Indian life has not yet received artistic treatment. The hunting with bows and arrows, stalking game in the costumes of the past, etc., has been done to death by talented men."[6] Ufer accepted Harrisons viewpoint, later writing, "I paint the Indian as he is. In the garden digging—in the field working—riding amongst the sage—meeting his woman in the desert—angling for trout—in meditation [The

Indian] is not a fantastic figure. He resents being regarded as a curiosity—as a dingle-berry on a tree."[7]

Callers, Indians on Horses is a good example of Ufer's relatively realistic attitude toward the Native American, apprehended in ordinary scenes far removed from the studio idealization of Sharp's *Crucita* (pages 214–215) or Phillips' *Song of the Aspen* (page 216). Despite what seems to represent an actual moment, especially the surprise of an Indian girl at two unexpected suitors at her gate, one may still question how deeply Ufer penetrates beneath the dazzling surface patterns and color-filled sunlight to express the deeper social and cultural realities of Indian life.

Pueblo of Taos

VICTOR HIGGINS, 1884-1949

before 1927. Oil on canvas, 43¾ x 53½ in.
The Anschutz Collection, Denver.

Presenting Indians in an architectural setting, framed by the surrounding landscape, became a common motif for the Taos artists, including Ufer, Sharp, Blumenschein, and John Marin. Victor Higgins' *Pueblo of Taos* possesses all the essential ingredients of this successful formula: Indians in brightly colored blankets with tall, cone-like hats are posed in front of the softly rounded adobe walls of an ancient pueblo that seems to have emerged organically from the earth. A brilliant light from the sky embraces the scene, blessing and illuminating the activity below.

But Higgins, who was perhaps attuned to the precepts of early 20th-century modernism to a greater degree than some of his more academically trained colleagues in the colony, took the formula in bold, new directions. For example, he stylizes his faceless figures, except for the three in the immediate foreground, and places them in colorful groups whose shapes correspond to the levels in the architecture, which is in turn modeled on the swelling forms of Taos mountains in the background. As William Truettner has observed, Higgins' use of this nearly abstract patterning gives the image order, balance, and harmony. These qualities, based on the formal progression of the picture's geometries, from man to that which is man-made to that which is enduring and natural, anchor the composition. The painting was purchased from the artist by the Santa Fe Railroad in

1927 as part of its art collection advertising the Southwest.

Victor Higgins came to serve as a link in the Taos colony between his more conservative colleagues and the emerging artistic developments of avant-garde modernism. Like Berninghaus, he was largely self-taught, although he had traveled extensively in Europe from about 1911 to 1913. Like Ufer, he was a protégé of ex-Mayor Carter H. Harrison of Chicago, who had urged both artists to travel to Taos and for a number of years purchased their works. Higgins, like Ufer, continued to divide his time between selling his pictures in Chicago during the winter and painting and sketching in New Mexico during the summer, an arrangement that lasted until about 1920 when he settled permanently in the New Mexico colony.

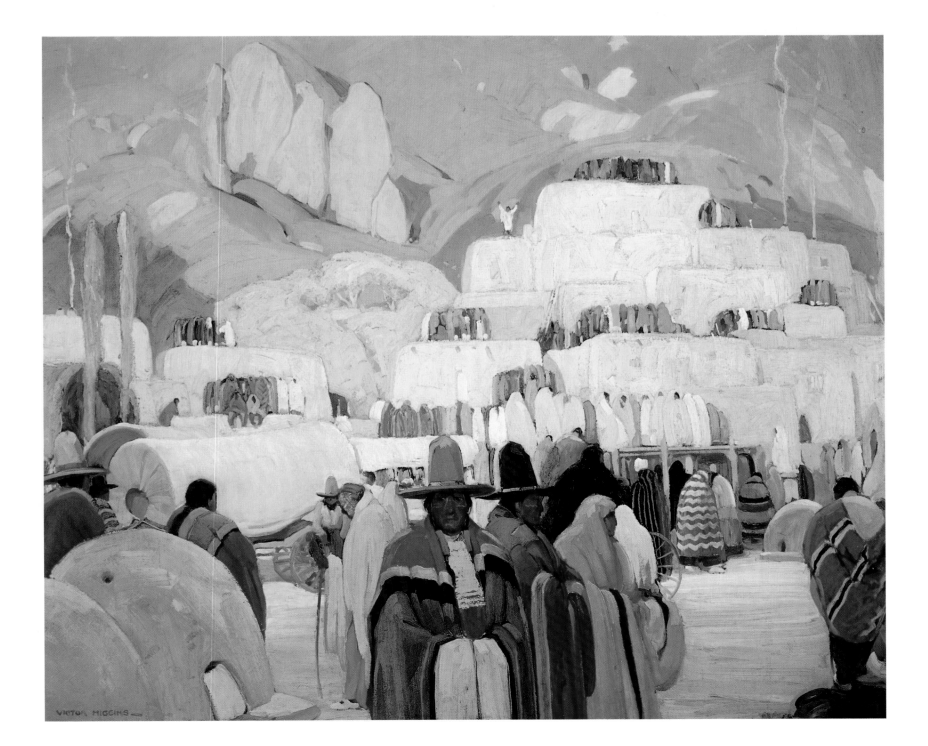

The Plasterer

ERNEST L. BLUMENSCHEIN,
1874–1960

1921. Oil on canvas, 42 x 30 in.
The Eiteljorg Museum of American Indian and
Western Art, Indianapolis.

In addition to the life and ancient customs of New Mexico's Pueblo Indians, artists in search of picturesque subjects were also drawn to the Hispanic culture of the region. In the first study of this attraction, art historian Julie Schimmel has observed that "Perhaps no perception of Hispanics was more routinely drawn in the visual arts than that of the persevering laborer, fatigued by servitude to the land, but somehow able to find repose in mere subsistence."[8] The result was a group of images that portrayed Hispanics as a passive people, mute in contemplation of their harsh fate, yet somehow also heroic in their struggle to survive.

Ernest Blumenschein's touching portrait of *The Plasterer* is an outstanding example of Hispanic iconography. It is an early work that reveals, in its solid, if conventional, modeling and brushwork, the lingering influence of the artist's training in the French Academie Julien. Blumenschein based this portrait, one of several, on the Taos handyman, Epimineo Tenoria. The weary Hispanic laborer sits with drooping shoulders, daubed with plaster. He holds out his tools—a trowel, and a flat smoother—symbols of his trade, and his dirty, ragged clothes seem out of place in the finely decorated room. Above him a large pre-Columbian ceramic shares his own blank, passive stare. In general, he seems more worn out from his work than ennobled by it. To be sure, the adobe architecture of the Pueblos called for constant labor on the exterior to protect it against rain and whitewashing of the interior walls to prevent flaking.

Blumenschein, who began his career as an illustrator, developed an understanding of modernism that was more progressive than most of the New Mexico painters of his generation, except Georgia O'Keeffe and John Marin, and the body of work that he created is recognized as one of the most significant of any of the New Mexico scene painters. He arrived in Taos for the first time in 1898, accompanied by Bert Phillips. As he entered the town he experienced something akin to a conversion. "No artist had ever recorded the New Mexico I was now seeing," he later recalled. "The sky was clear, clean blue with sharp moving clouds. The color, the effective character of the landscape, the drama of the vast spaces, the superb beauty and serenity of the hills stirred me deeply."[9]

Dance of Taos

**ERNEST L. BLUMENSCHEIN,
1874–1960**

1923. Oil on canvas, 40 x 45 in.
Museum of Fine Arts, Museum of New Mexico,
Santa Fe.

The colorful Indian ritual dances were among the most compelling and popular subjects painted by members of the New Mexico art colonies. In creating these works, the artists took their lead from the anthropologists and writers who asserted that the primitive rhythms and colorful costumes of the Pueblo dances expressed the deepest mys-teries of the tribes and revealed their sacred intuitive connections to nature and the psy-che. Generally such works were easy to sell to eastern and midwestern patrons and to tourists visiting the pueblos.

Blumenschein's *Dance at Taos* is an especially attractive version of this popular motif, painted in the stylized manner that charac-terized the artist's early attempts at mod-ernism in the 1920s. Here, he assumes a high vantage point, like that of a spectator seated on the walls above the dancers. The primi-tive vitality and rhythmic movements of the lines of dancers are nearly abstracted—most of the figures are completely depersonalized without faces—and their colorful blankets and ceremonial face paint are rendered so as to appeal to a sense of the intuitive and emo-tional concept of life as art.

In addition to Blumenschein, many of the other painters in New Mexico believed that for the Pueblo Indians art was an intensified form of life. "It is the incomparable under-standing of their own inventive rhythms that inspire and impress you as spectator," wrote painter Marsden Hartley. "They know, as perfect artists would know, the essential value of the materials at their disposal, and the eye for harmonic relationships is as keen as the impeccable gift for rhythm which is theirs."[10]

Sangre de Cristo Mountains

ERNEST L. BLUMENSCHEIN, 1874–1960

1925. Oil on canvas, 50¼ x 60 in.
The Anschutz Collection, Denver.

Artists in the New Mexico colonies were almost as fascinated by the Indian and Hispanic versions of Christianity as they were by these cultures' own indigenous customs and rituals, so seemingly in accord with the rhythms of nature. One sect of New Mexican Catholicism, the *penitentes*, drew the attention of Ernest Blumenschein. This group, which stressed the abnegation of the self to the suffering of the Lord, often actually tied members of its congregation to crosses in reenactments of the crucifixion. This practice can be seen in Blumenschein's *Sangre De Cristo Mountains*, literally the Blood of Christ Mountains, which attempts to suggests a connection between the small figures in the shadowy foreground and the looming presence of the mountains in the distance. In the center foreground there are three half-naked males, one dragging the huge cross through the snow, while his two companions flagellate themselves to the point of drawing blood. Below them a band of stooped and rounded female figures wrapped in colorful blankets follow the procession to its inexorable conclusion, when one of the penitents is strapped, and according to legend, even occasionally nailed to the cross and hoisted up. The artist subtly creates a parallel between the rounded forms of the mountains and the bowed and blanketed figures in the foreground. The brilliant light falling on the adobe buildings in the middle of the picture, their organic forms further softened by the freshly fallen snow, suggests the living culture of the New Mexico villages with their mystical union of nature, Indian culture, and primitive Christianity.

An Afternoon of the Sheep Herder

ERNEST L. BLUMENSCHEIN, 1874–1960

1939. Oil on canvas, 28 x 50 in.
The National Cowboy Hall of Fame and Western Heritage Museum, Oklahoma City.

With its vigorous design, massing of large shapes in a pattern that suggests movement, and elegant brush work in high impasto, *An Afternoon of the Sheep Herder* reveals Ernest Blumenschein's masterful use of the best tenets of modernism. In fact, the pattern of water in the canyon at left recalls similar organic forms in the work of the American painter Marsden Hartley, the massing of rocks and their austere forms are reminiscent of Cézanne's modeling of natural shapes, the bold simplification of the shepherd's gesture evokes the work of Rockwell Kent, and the distant sky, the mesas, and the mountains have strong affinities with the canvases of Georgia O'Keeffe.

Impressive though it is, Blumenschein's superb handling of form and surface texture does not exist as an end in itself. Rather, it has been marshaled by the artist to express the vastness and haunting beauty of the sun-blessed New Mexico landscape. The shepherd, perched on a high rock where he catches the last rays of warmth from the setting sun, provides a human dimension against which the distant landscape can be measured. The deepening shadows in the river canyon, the clouds over the purple mountains, and the huge pale moon rising at right complete the image of a mythical, haunting land where ancient civilizations and their modern interpreters are in perfect but fleeting harmony.

Despite its contrived quality, *An Afternoon of the Sheep Herder* beautifully captures Blumenschein's initial reaction to the New Mexico landscape, where, according to the artist, he could see "... whole paintings right before my eyes. Everywhere I looked I saw paintings perfectly organized ready for paint." [11]

Earth Knower

MAYNARD DIXON, 1875–1946

circa 1932. Oil on canvas, 40 x 50 in.
The Oakland Museum, Bequest of Dr. Abilio Reis,
Oakland, California, photograph by M. Lee
Fatherree.

Maynard Dixon's powerful *Earth Knower* expresses the aura of inscrutable mystery that so many artists since the 19th century have ascribed to the Native American. The style of the picture combines Cubism with Realism so that the major forms of the figure and landscape are reduced to geometric patterns of dark and light. This was a technique that Georgia O'Keeffe and other modernist painters like Marsden Hartley and John Marin employed with great success. Dixon scholar Wesley M. Burnside observes,

"The impassive, stonelike face is surrounded by deep-shadowed drapery which shrouds the head and body and which is echoed in the geometric shadows of the distant, stratified mesas. These deep-cut mesas also reflect a sympathetic color harmony in the robe of the figure, suggesting a primeval kinship between the aborigine and the earth."[12] The sense of timeless silence that pervades *Earth Knower* expresses Dixon's view of the Native American. In a letter of 1945 he wrote: "And there is the Indian who can withdraw into himself and be as silent and unresponsive as a stone. You cannot argue with silence. It returns your questions to you, to your own inner silence which becomes aware—a mystical something that is neither reason or intelligence nor intuition, a recognition of something nameless that may not be denied."[13]

In 1891 Maynard Dixon learned an early les-

son about art when he received a letter from Frederic Remington in response to his request for advice about becoming an artist. Remington, impressed by Dixon's sketches and his candor, responded at some length, "I do not 'teach,'" he stated, "and am unused to giving advice—The only advice I could give you is never take anyone's advice, which is my rule."[14] Dixon began his career as an illustrator in New York City from 1907 to 1912, but his work as a fine artist underwent a transformation as he came increasingly under the influence of modernism. *Earth Knower* was painted in 1931 when Dixon first visited Taos. During his brief, six-month stay, he produced some of his most important paintings, including a series entitled "Skies of New Mexico."

Black Cross, New Mexico

GEORGIA O'KEEFFE, 1887–1986

1929. Oil on canvas, 39 x 30¹/₁₆ in.
The Art Institute of Chicago.

No other modern artist is more identified with the enchanted vision of the New Mexico landscape than Georgia O'Keeffe. Her many paintings have endowed the place with a sense of mystery and beauty that is unparalleled in 20th-century American art. Ironically she never painted the picturesque Indian or Hispanic figures that were so popular with her contemporaries in the artists' colonies. Instead she concentrated on that most typical of 19th-century subjects, the landscape. In so doing, she resolved the struggle of those artists in Taos and Santa Fe who were seeking to adapt the tenets of modernism to the vast desert landscape of the Southwest. Under the brilliant light of New Mexico, O'Keeffe's art attained a new, earth-centered quality that abstracted the emotions of distant space and timelessness felt by so many artistic visitors to the region.

One of the most evocative of the paintings that resulted from O'Keeffe's first extended trip to New Mexico in 1929 is the famed *Black Cross, New Mexico*. The *penitentes*, a fanatical sect of Catholics, had erected numerous crosses in sacred places around northern New Mexico, and O'Keeffe painted the venerable symbol many times. The first known example of the image is the work reproduced here. In it, the heavy black cross is viewed frontally. Bonded to the picture plane, its edges truncated by the edges of the canvas and set against a sunset landscape, the cross suggests the dark tragic spirit of Spanish Catholicism in this land of the *penitentes*. As with most of O'Keeffe's paintings there is an implicit autobiographical aspect in the picture, for in 1929 she was pondering her own and her husband Alfred Stieglitz's mortality, experiencing deep feelings of rejection because of Stieglitz's affair with Dorothy Norman. This psychological upheaval resulted in her trip to New Mexico and her search for new images that would express her personal and artistic independence. O'Keeffe later explained that painting the crosses was a way of painting the country for her.

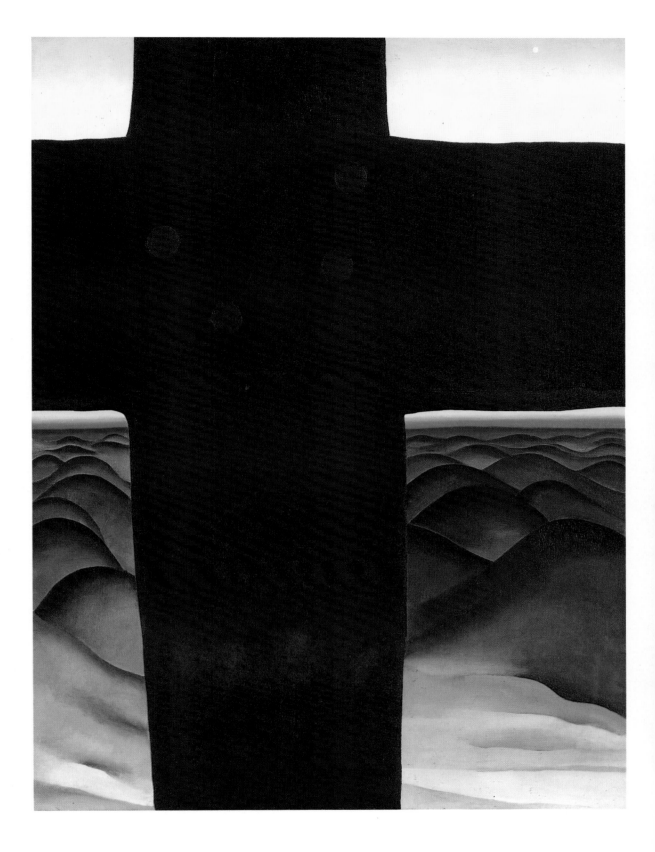

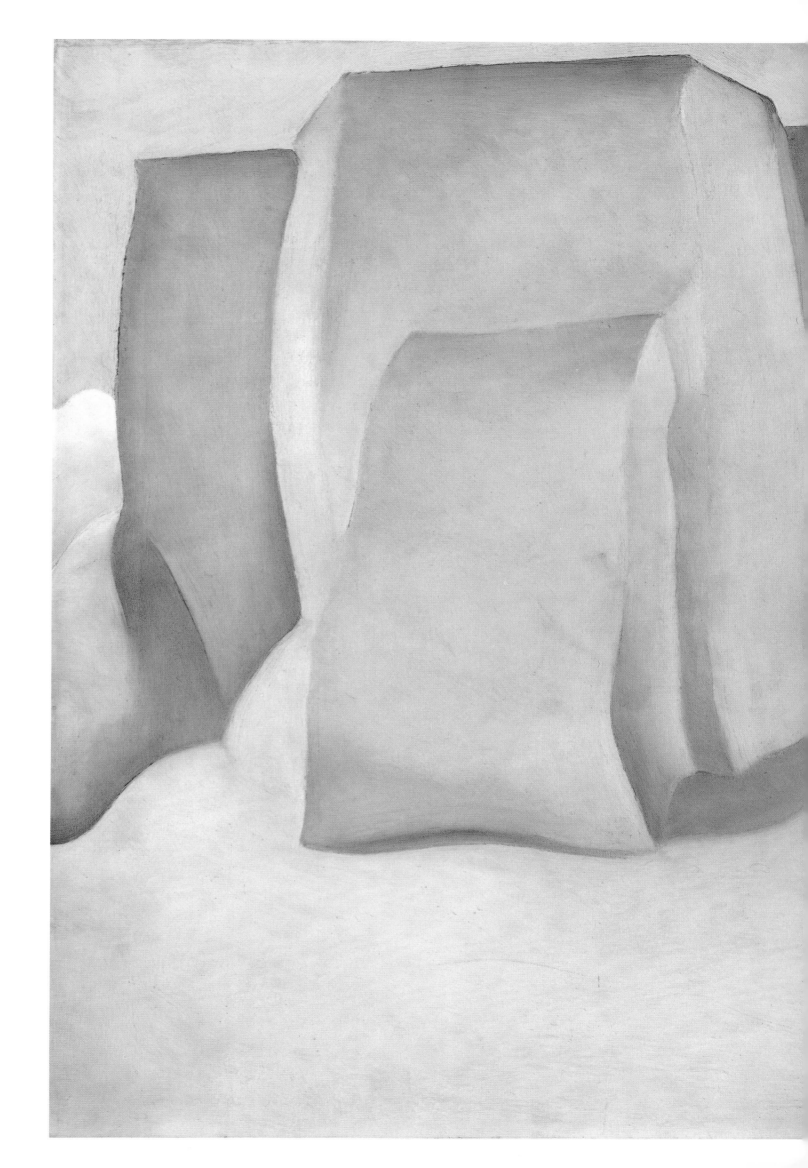

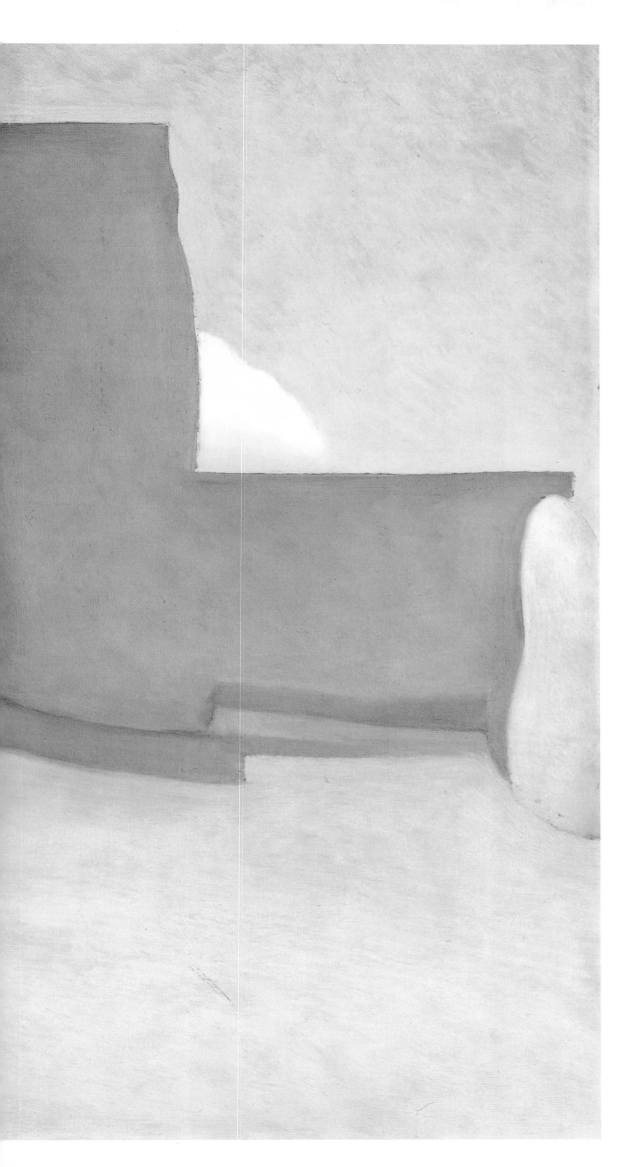

Ranchos Church No. 1
GEORGIA O'KEEFFE, 1887–1986

1929. Oil on canvas, 18¾ x 24 in.
Norton Gallery of Art, West Palm Beach, Florida.

Georgia O'Keeffe was a member of the inner circle of modernist artists who gathered around photographer, gallery owner, and magazine publisher Alfred Stieglitz, later O'Keeffe's husband. Her originality is strikingly evident in the unusual expression she gave to well-established subjects. Perhaps the most impressive example of her unique viewpoint and style was her treatment of Spanish colonial churches. The idea of showing these timeworn adobe structures, with their rounded, organic shapes, to suggest the mystical bond between religion and nature was not new. Many of the artists working in New Mexico had used them to express the idea that New Mexico Pueblo and Hispanic cultures possessed an intuitive harmony with the landscape, that for this simple, earthy people art and life were synonymous. But none of the artists who had gone before her had painted the Spanish colonial churches with O'Keeffe's understanding of the quality of light and radical modernist simplification of form. A compelling example is *Ranchos Church No. 1*, which resulted from the artist's transforming stay in New Mexico in 1929. Using a low impasto and understated brushwork, she unifies church, earth, and sky into a mysterious whole.

In creating these powerful images, it is possible that O'Keeffe was influenced by the photographs of fellow Stieglitz protégé Paul Strand. In any event, she would return to paint Ranchos church numerous times in the years to come.

From the Faraway Nearby

GEORGIA O'KEEFFE, 1887–1986

1937. Oil on canvas, 36 × 40⅛ in.
The Metropolitan Museum of Art, The Alfred
Stieglitz Collection, 1959, New York.

Through the 1930s and into the 1940s Georgia O'Keeffe created a series of memorable images of the New Mexican desert, such that today she is identified as the preeminent artist of the region.

While the spirit of New Mexico with its haunting wilderness landscapes and ancient cultures was integrated profoundly into her art, O'Keeffe's work by the late 1930s had also begun to take on overtones of Surrealism with disjunctures of space, form, and mean-ing. Nowhere are these surrealistic elements more evident than in her painting *From the Faraway Nearby*. According to scholar Charles C. Eldredge, in a provocative essay entitled "The Faraway Nearby," this haunt-ing image may have been inspired by D. H. Lawrence's 1925 tale, *St. Mawr*, which por-trayed an outlander, like O'Keeffe, who faces the reality of life in the desolate landscapes of northern New Mexico. The text from Lawrence, which O'Keeffe certainly had read, provides a very nearly perfect interpre-tation of her great picture. "But even a woman cannot live only into the distance, the beyond. Willy-nilly she finds herself jux-taposed to the near things . . . and willy-nilly, she is caught up into the fight with the immediate object. The New England woman had fought to make the nearness as perfect as the distance: for the distance was absolute beauty. She had been confident of success . . .

At the same time . . . while she revelled in the beauty of the luminous world that wheeled around and below her, the grey-rat-like spirit of the inner mountains was attack-ing her from behind . . . underlying rat-dirt, the everlasting bristling tussle of the wild life, with the tangle and the bones strewing. Bones of horses struck by lightning, bones of dead cattle, skulls of goats with little horns, bleached, unburied bones. The cruel electric-ity of the mountains. And then, most myste-rious but worst of all, the animosity of the spirit of the place."[15] O'Keeffe's picture merges, as Eldredge suggests, the near and the far, the mortal and the immortal, the tangible and the unknown, the personal and the infinite. Its endless wonder, like New Mexico's vast and magical landscapes, can-not be completely resolved by the rational mind.

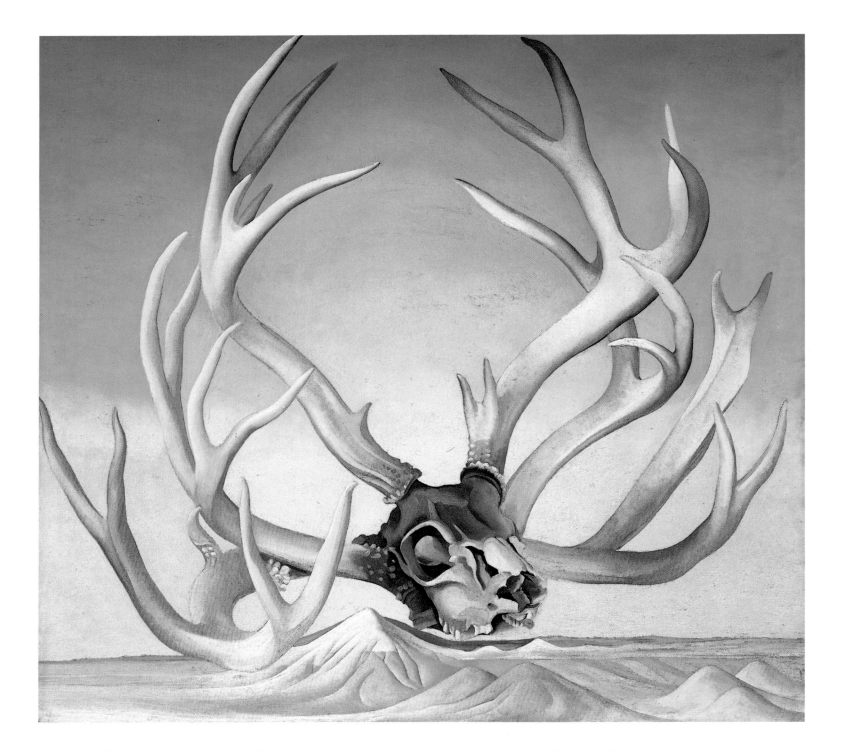

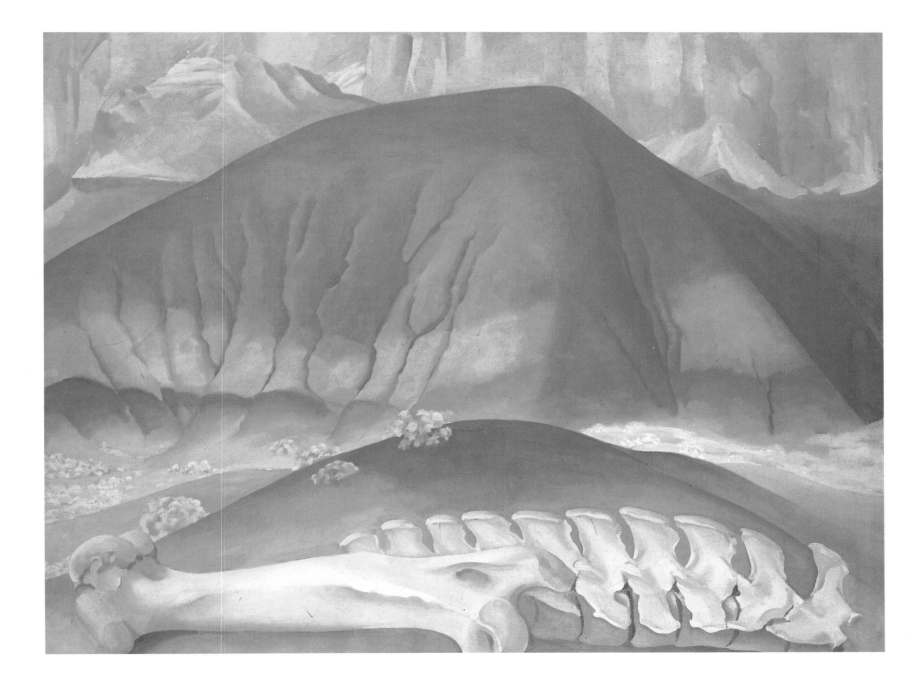

Red Hills and Bones

GEORGIA O'KEEFFE, 1887–1986

1941. Oil on canvas, 30 x 40 in.
Philadelphia Museum of Art, The Alfred Stieglitz Collection.

Georgia O'Keeffe always rejected the connection that others made between her art and Surrealism, just as she emphatically denied that her paintings of flowers had any erotic meaning. Such Freudian associations annoyed her because they seemed to trivialize her art, reducing its mystery to the knowable and common. Yet today, it is abundantly clear that O'Keeffe was in fact greatly influenced by the ideas of modernism and its fascination with the unconscious and with juxtapositions of form and meaning. At the same time, her art encompasses in a remarkable way certain archetypal concepts of nature that have persisted in American art since the early 19th century. This connection primarily manifests itself in O'Keeffe's vision of nature as a living, vital presence, animated by primordial sensations of creation, growth, death, and decay.

In a number of New Mexico landscapes from the 1930s and 1940s the painter vividly grapples with the theme of life's ebb and flow. Perhaps the most compelling of these images is *Red Hills and Bones*. In the foreground of this work, a surrealistically out-of-scale bone and vertebra of a long-dead cow is juxtaposed against the swelling, eroded forms of the distant red hills. The sense of the earth as a living organism pulsating with life, even amidst the presence of death, underlies this haunting picture.

O'Keeffe recognized the desert's emotional power, with its dramatic contrasts of life and death. She wrote in 1939, just a few years before she created the image, "I have wanted to paint the desert and I haven't known how. I always think that I can not stay with it long enough. So I brought home the bleached bones as my symbols of the desert. To me they are as beautiful as anything I know. To me they are strangely more living than the animals walking around The bones seem to cut sharply to the center of something that is keenly alive on the desert even tho' it is vast and empty and untouchable—and knows no kindness with its beauty."[16]

NOTES

CHAPTER 1

1. See Richard H. Saunders, *Collecting the West: The C. R. Smith Collection of Western American Art* (Austin, TX: University of Texas Press, 1988), 180.

2. See David C. Huntington, *The Landscapes of Frederic Edwin Church: Vision of An American Era* (New York: George Braziller, 1966), 27–8.

3. Scaeva [I. W. Stuart], *Hartford in Olden Times* (1853), 9, quoted in Huntington, *The Landscapes of Frederic Edwin Church*, 28.

4. Henry Adams, "A New Interpretation of Bingham's *Fur Traders Descending the Missouri*," *Art Bulletin* 65, no. 4 (December 1983): 675–80.

5. Alan Wallach, "Thomas Cole and the Aristocracy," *Arts Magazine* 56 (November 1981): 94–106.

6. Timothy Flint, *Biographical Memoir of Daniel Boone* (Cincinnati, OH: George Concoin, 1833), quoted in Francis S. Grubar, *William Ranney: Painter of the Early West* (Washington, DC: Corcoran Gallery of Art, 1962), 33.

7. Henry T. Tuckerman, "Over the Mountains, or The Western Pioneer," chap. in *The Home Book of the Picturesque* (New York: G. P. Putnam, 1852), 117.

8. E. Maurice Bloch, *The Paintings of George C. Bingham: A Catalogue Raisonné* (Columbia, MO: University of Missouri Press, 1986): 131.

9. Letter from G. C. Bingham to James S. Rollins, 30 March 1851, quoted in C. B. Rollins, ed., "Letters of George Caleb Bingham to James S. Rollins," *Missouri Historical Review* 32, no. 1 (October 1937): 21.

10. See Dawn Glanz, *How the West Was Drawn: American Art and the Frontier Setting* (Ann Arbor, MI: UMI Research Press, 1978), 23.

11. *Broadway Journal* 4 (January 1845): 13, quoted in *American Paintings From the Manoogian Collection* (Washington, DC: National Gallery of Art, 1989), 86.

12. George F. Ruxton, *Adventures in Mexico and the Rocky Mountains* (London: John Murray, 1861), 244, quoted in Glanz, *How the West Was Drawn*, 45.

13. Reginald Horsman, *Race and Manifest Destiny* (Cambridge, MA: Harvard University Press, 1981). Especially chapters 7, "Superior and Inferior Races," and 10, "Racial Destiny and the Indians."

14. Cited in Bloch, *The Paintings of George Caleb Bingham*, 189

15. Henry T. Tuckerman, *Book of the Artists: American Artist Life* (New York: G. P. Putnam & Son, 1867), 524.

16. *Commercial Advertiser* (New York), 7 May 1866, 2. See the author's "The Nude of Landscape Painting: Emblematic Personification in the Art of the Hudson River School," *Smithsonian Studies in American Art* 3, no. 4 (Fall 1989): 42–65, for an extended discussion of this type of symbolism.

CHAPTER 2

1. The first version of the poem was written in 1726, but not published until 1752. See A. A. Luce and T. E. Jessop eds., *The Works of George Berkeley, Bishop of Cloyne* 7 (London: Thomas Nelson and Sons, 1955), 369–73.

2. The *Literary World* in its review of the "Art-Union Pictures" found Bingham's *Jolly Flat Boat Men* a "vulgar subject, vulgarly treated," 38 (23 October 1847): 277.

3. Nancy Rash, "George Caleb Bingham's *Lighter Relieving a Steamboat Aground*," *Smithsonian Studies in American Art* 12, no. 2 (Spring 1988): 17–31.

4. "Paintings," *St. Louis Republican*, 21 April 1847, 2.

5. See Mount's diary entry for December, 1848, quoted in Alfred Frankenstein, *William Sidney Mount* (New York: Harry N. Abrams, 1975), 198.

6. Tuckerman, *Book of the Artists*, 425.

7. Fitz Hugh Ludlow, *The Heart of the Continent* (New York: Hurd and Houghton, 1870), 111–12.

8. Worthington Whittredge, *The Autobiography of Worthington Whittredge*, first published in 1905; reprint, John I. H. Baur, ed (New York: Arno Press, 1969), 45–6. See also Anthony Janson, *Worthington Whittredge* (New York: Cambridge University Press, 1989).

9. Susan Danly, and Leo Marx, eds., *The Railroad in American Art* (Cambridge, MA: MIT Press, 1988), 202. See also *The Railroad in the American Landscape: 1850–1950* (Wellesley, MA: Wellesley College Museum, 1981), 94.

10. Thomas Hill, *History of the Spike Picture and Why It Is Still In My Possession*. (Privately printed by T. Hill, 1884).

11. Ibid., 5.

12. George C. Pine, *Beyond the West* (Utica, NY: T. J. Griffiths, 1871), 385, quoted in Danly, *The Railroad in American Art*, 26.

13. Peter Hassrick, *Charles M. Russell* (New York: Harry N. Abrams, 1989; Washington, DC: National Museum of American Art, 1989), 65.

14. Cited in Brian W. Dippie, *Remington and Russell* (Austin, TX: University of Texas Press, 1982), 92.

15. Ibid., citing "Four Paintings by the Montana Artist, Charles M. Russell," *Scribner's Magazine* 70 (August 1921): 146.

CHAPTER 3

1. George Catlin, *Letters and Notes on Manners, Customs, and Conditions of the North American Indians. . .* (London: David Bogue, 1841), 105, quoted in Kathryn S. Hight, "'Doomed to Perish': George Catlin's Depictions of the Mandans," *College Art Journal* 49, no. 2 (Summer 1990): 122.

2. George Catlin, *Fourteen Ioway Indians* (London: 1844), 5–6, quoted in William H. Truettner, *The Natural Man Observed: A Study of Catlin's Indian Gallery* (Washington, DC: Smithsonian Institution Press, 1979), 294.

3. See Truettner, *The Natural Man Observed*, 294.

4. Cited in Rena N. Coen, "The Last of the Buffalo," *American Art Journal* 5, no. 2 (Summer 1973): 84.

5. Catlin, *Letters and Notes*, 260.

6. Ibid., 261.

7. William H. Goetzmann, *West of the Imagination* (New York: W. W. Norton, 1986), 43.

8. Tuckerman, *Book of the Artists*, 518.

9. Elliott Dangerfield, *Ralph Albert Blakelock* (New York: Privately printed, 1914), 17.

10. See Nicolai Cikovsky, Jr., *American Paintings from the Manoogian Collection* (Washington, DC: National Gallery of Art, 1989), 94.

11. Cited in Denny Carter, *Henry Farny* (New York: Watson-Guptill, 1978), 28.

12. Charles Baltzer, *Henry F. Farny* (Cincinnati, OH: Indian Hills Historical Museum Association, 1975).

13. Letter by Couse dated 5 May 1916. Courtesy of Couse Family Archives.

CHAPTER 4

1. Samuel Y. Edgerton, Jr., "The Murder of Jane McCrea: The Tragedy of an American *Tableau D'Histoire*," *Art Bulletin* 47, no. 4 (December 1965): 481–92.

2. Brian Dippie, *Catlin and His Contemporaries: The Politics of Patronage* (Lincoln, NE: University of Nebraska Press, 1990), 63, citing *New York Commercial Advertiser*, 30 September 1837.

3. Ibid.

4. *Broadway Journal*, 11 April 1845, 254, quoted in Carol Clark, "Charles Deas," *American Frontier Life* (Fort Worth, TX: Amon Carter Museum, 1987; New York: Abbeville Press, 1987), 65.

5. I am grateful to Joseph Ketner for sharing the results of his research on Wimar with me in conversation and in manuscript form.

6. Carl Wimar correspondence with his parents from Düsseldorf, 23 April 1855, Missouri Historical Society, St. Louis, quoted in Joseph Ketner, "From the Rhine to the Mississippi," draft manuscript for Wimar exhibition at the Washington University Gallery of Art, St. Louis. I am grateful to Ketner for graciously sharing this information with me in manuscript form.

7. *George De Forest Brush 1855–1941: Master of the American Renaissance* (New York: Berry-Hill Galleries, 1985), 23.

8. Childe Hassam to Remington, 20 December 1906, quoted in Peter Hassrick, *Frederic Remington* (New York: Harry N. Abrams, 1973), 159.

9. Cited in David McCullough, "Remington the Man," chap. in *Frederic Remington: The Masterworks* (Missouri: St. Louis Art Museum, 1988; New York: Harry N. Abrams, 1988), 29.

10. Cited in William C. Foxley, *Frontier Spirit* (Denver: Museum of Western Art, 1983), 74.

11. Cited in James Ballinger, *Frederic Remington* (New York: Harry N. Abrams, 1989), 138.

12. Clarence R. Lindner, "The Romance of a Famous Painter," *Leslie's Weekly*, 4 August, 1910, quoted in James Horan, *The Life and Art of Charles Schreyvogel* (New York: Crown Publishers, 1969), 51.

13. Charles M. Russell to Charles N. Pray, 5 January 1914 quoted in Dippie, *Remington and Russell*, 144.

14. Charles M. Russell, *Trails Plowed Under* (Garden City, NY: Doubleday, Page and Co., 1927), 135, quoted in Dippie, *Remington and Russell*, 156.

CHAPTER 5

1. "Twilight in the Wilderness," *Boston Evening Transcript*, 28 June 1860, 2.

2. "The New Pictures," *Harper's Weekly* 8 (26 March 1864), 194–95.

3. In Bierstadt's flyer "The Rocky Mountains," quoted in Patrica Trenton and Peter Hassrick, *The Rocky Mountains* (Norman, OK: University of Oklahoma Press, 1983), 128.

4. Cited in Gordon Hendricks, *Albert Bierstadt* (New York: Harry N. Abrams, 1974), 160.

5. Ludlow, *The Heart of the Continent*, 412.

6. Fitz Hugh Ludlow, "Seven Weeks in the Great Yo-semite," *Atlantic Monthly* (June 1864), 740.

7. "Artist and Author," *Daily Alta California* (San Franciso), 25 September 1863.

8. Gordon Hendricks, "Bierstadt's *The Domes of the Yosemite*," *American Art Journal* 3 (Fall 1971), 29.

9. Frederick L. Olmsted, "The Yosemite Valley and the Mariposa Big Trees, a Preliminary Report," 1865, reprinted in *Landscape Architecture*, 43 (1952): 16.

10. Thomas Starr King, "A Vacation Among the Sierras, No. 4," *Boston Evening Transcript*, 12 January 1860.

11. Clarence King, *Mountaineering in the Sierra Nevadas*, first published in 1871; reprint, Lincoln: University of Nebraska Press, 1970, 93.

12. Clarence Cook, "Art," *Atlantic Monthly* 34 (September 1874): 375.

13. William H. Holmes, "The Mountain of the Holy Cross," *Illustrated Christian Weekly*, 1 May 1875, 209. See also Joni L. Kinsey, "Sacred and Profane: Thomas Moran's *Mountain of the Holy Cross*," *Gateway Heritage* 11, no. 1 (Summer 1990): 4–21.

14. Linda C. Hults, "Thomas Moran's *Shoshone Falls*: A Western Niagara," *Smithsonian Studies in American Art* 3, no. 1 (Winter 1989): 89–102.

CHAPTER 6

1. Letter from Owen Wister to Frederick Remington, 25 August 1895, Remington Papers, Remington Art Museum, Ogdensburg, New York.

2. McCulloch, "Remington The Man," chap. in *Frederic Remington: The Masterworks*, 15.

3. Hassrick, *Frederic Remington*, 2

4. Cited in Dippie, *Remington and Russell*, 116.

5. Cited in Lonn Taylor, "The Cowboy Hero: An American Myth Examined," chap. in *The American Cowboy* (New York: Harper & Row, 1983), 64.

6. Steward Edward White, *Arizona Nights* (New York: McClure Company, 1907), 72.

7. Hendricks, *Albert Bierstadt*, 291.

CHAPTER 7

1. Whittredge, *Autobiography of Worthington Whittredge*, 49.

2. Ibid.

3. Gustave Kobbe, "Painters of Indian Life," *New York Herald*, 26 December 1909. I am grateful to Virginia Couse Leavitt for sharing this review with me.

4. Adolph F. Bandelier, and Edgar L. Hewett, *Indians of the Rio Grande Valley* (Albuquerque, NM: University of New Mexico Press, 1937), 14, quoted in William H. Truettner, "The Art of Pueblo Life," chap. in *Art in New Mexico 1900–1945* (Washington, DC: National Museum of American Art, 1986; New York: Abbeville, 1986), 61.

5. Cited in Charles C. Eldredge, "The Faraway Nearby," chap. in *Art In New Mexico 1900–1945* (Washington, DC: National Museum of American Art, 1986; New York: Abbeville, 1986), 153, citing D. H. Lawrence, "New Mexico," *Survey Graphic* (May 1931).

6. Truettner, *Art in New Mexico*, 84, citing Laura M. Bickerstaff, *Pioneer Artists of Taos*, first published in 1955; rev. and exp. (Denver: Old West Publishing Co., 1983), 126.

7. Bickerstaff, *Pioneer Artists of Taos*, 129.

8. Julie Schimmel, "The Hispanic Southwest," chap. in *Art of New Mexico 1900–1945* (Washington, DC: National Museum of American Art, 1986; New York: Abbeville, 1986), 116.

9. Bickerstaff, *Pioneer Artists of Taos*, 31.

10. Truettner, *Art in New Mexico*, 89.

11. Cited in "Walter Ufer" by Stephen L. Good, chap. in Bickerstaff, *Pioneer Artists of Taos*, 127.

12. Wesley M. Burnside, *Maynard Dixon* (Provo, UT: Brigham Young University Press, 1974), 105.

13. *Maynard Dixon: Images of the Native American* (San Francisco: California Academy of Sciences, 1981), 36.

14. Letter from Frederic Remington to Maynard Dixon, 31 September 1891, quoted in Burnside, *Maynard Dixon*, 215.

15. Cited in Eldridge, "The Faraway Nearby," chap. in *Art in New Mexico 1900–1945*, 179, citing D. H. Lawrence, *St Mawr: The Later D. H. Lawrence* (New York: Alfred A. Knopf, 1952), 177–78.

16. Cited in Lloyd Goodrich and Doris Bry, *Georgia O'Keeffe* (New York: Whitney Museum of American Art, 1970), 23.

BIBLIOGRAPHY

Allen, Douglas, and Allen Douglas, Jr. *N. C. Wyeth: The Collected Paintings, Illustrations and Murals.* New York: Bonanza Books, 1972.

Arkelian, Marjorie Dakin. *Thomas Hiu The Grand View.* Oakland, CA: The Oakland Museum, 1980.

_____. *William Hahn: Genre Painter 1829-1887.* Oakland, CA: The Oakland Museum, 1976.

Ballinger, James K. *Beyond the Endless River.* Phoenix, AZ: Phoenix Art Museum, 1979.

Bercovitch, Sacvan. *The American Jeremiad.* Madison, WI: University of Wisconsin Press, 1978.

Berkhofer, Robert F. *The White Man's Indian.* New York: Alfred Knopf, 1978.

Bickerstaff, Laura. *Pioneer Artists of Taos.* Denver: Old West Publishing Company, 1983.

Block, Maurice E. *The Paintings of George Caleb Bingham.* Columbia MO: University of Missouri Press, 1986.

Broder, Patricia Janis. *Taos: A Painter's Dream.* Boston: New York Graphic Society, 1980.

Brumm, Ursula. *American Thought and Religious Typology.* New Brunswick, NJ: Rutgers University Press, 1970.

Carr, Gerald L. *Albert Bierstadt.* New York: Alexander Gallery. 1983.

Carter, Denny, *Henry Farny.* New York: Watson-Guptil Publications, 1978.

Clark, Carol. *Thomas Moran: Watercolors of the American West.* Austin: University of Texas Press, 1980.

Coke, Van Deren. *Taos and Santa Fe: The Artist's Environment, 1882-1942.* Albuquerque, NM: University of New Mexico Press, 1963.

Brother Cornelius. *William Keith: Old Master of California.* New York: G. P. Putnam's Sons, 1942.

Dellenbaugh, Frederick S. *A Canyon Voyage: The Narrative of the Second Powell Expedition.* 1908; reprint, with a foreword by William H. Goetzmann. New Haven: Yale University Press, 1962.

Dippie, Brian W. *Catlin and His Contemporaries. The Politics of Patronage.* Lincoln, NB: University of Nebraska Press, 1990.

_____. *Looking at Russell.* Fort Worth: Amon Carter Museum, 1987.

Eldredge, Charles, Julie Schimmel, and William H. Truettner. *Art in New Mexico, 1900-1945.* New York: Abbeville Press, 1986.

Fees, Paul, and Sarah E. Boehme. *Frontier America: Art and Treasures of the Old West From the Buffalo Bill Historical Center.* New York: Harry Abrams, 1988.

Frantz, Joe B., and Julian E. Choate, Jr. *The American Cowboy: The Myth and Reality.* Norman, OK: University of Oklahoma Press, 1955.

Gerdts, William H., and Mark Thistlethwait. *Grand Illusions: History Painting in America.* Fort Worth, TX: Amon Carter Museum, 1988.

Glanz, Dawn. *How the West Was Drawn: American Art and the Settling of the Frontier.* Ann Arbor, MI: UMI Research Press, 1982.

Goetzmann, William H. *Exploration and Empire.* New York: Alfred A. Knopf, 1966.

_____, and William N. Goetzmann. *The West of the Imagination.* New York: W.W. Norton, 1986.

Goodrich, Lloyd, and Doris Bry. *Georgia O'Keeffe Retrospective Exhibition.* New York: Whitney Museum of American Art, 1970.

Hassrick, Peter H. *Charles M. Russell.* New York: Harry N. Abrams, 1989.

_____. *Artists of the American Frontier: The Way West.* New York: Promontory Press, 1988.

_____, and Michael Edward Shapiro. *Frederic Remington: The Masterworks.* New York: Harry N. Abrams, 1988.

Hendricks, Gordon. *Albert Bierstadt.* New York: Harry N. Abrams, 1973.

Henning, William T. Jr. *Ernest L. Blumenschein Retrospective.* Colorado Springs: Colorado Springs Fine Arts Center, 1978.

Hills, Patricia. *The American Frontier: Images and Myths.* New York: Whitney Museum of American Art, 1973.

Honor, Hugh. *The New Golden Land: European Images of America from the Discoveries to the Present Time.* New York: Pantheon Books, 1975.

Horan, James David. *The Life and Art of Charles Schreyvogel.* New York: Crown Publishers, 1969.

Horsman, Reginald. *Race and Manifest Destiny.* Cambridge, MA: Harvard University Press, 1981 .

Huntington, David C. *The Landscapes of Frederic Edwin Church: Vision of an American Era.* New York: George Braziller, 1966.

Jackson, Helen Hunt. *A Century of Dishonor.* New York: Harper & Brothers, 1884; reprint, New York: Avon Books, 1970.

Kasson, John F. *Civilizing the Machine: Technology and Republican Values in America, 1776-1900.* New York: Grossman, 1976.

Kelly, Franklin. *Frederic Edwin Church and the National Landscape.* Washington, DC: Smithsonian Institution Press, 1988.

Lewis, R. W. B. *The American Adam.* Chicago: University of Chicago Press, 1955.

Limerick, Patricia Nelson. *The Legacy of Conquest: The Unbroken Past of the American West.* New York: W.W. Norton & Co., 1987.

Marx, Leo. *The Machine in the Garden: Technology and the Pastoral Ideal in America.* New York: Oxford University Press, 1964.

Nash, Roderick. *Wilderness and the American Mind.* 3d ed., New Haven, CT: Yale University Press, 1982.

Parry, Ellwood C. *The Art of Thomas Cole: Ambition and Imagination.* Newark: University of Delaware Press, 1988.

Pearce, Roy Harvey. *Savagism and Civilization.* Berkeley, CA: University of California Press, 1988.

The Railroad in the American Landscape: 1850-1950. Wellesley, MA: The Wellesley College Museum, 1981.

Rathbone, Perry T. *Charles Wimar 1828-1862: Painter of the Indian Frontier.* St. Louis: City Art Museum of St. Louis, 1946.

Renner, Frederic G. *Charles M. Russell: Paintings, Drawings, and Sculpture in the Amon Carter Museum.* New York: Harry N. Abrams, 1984.

Sanders, Gordon E. *Oscar E. Berninghaus: Master Painter of American Indians and the Frontier West.* Taos: Taos Heritage Publishing Society, 1985.

Saunders, Richard H. *Collecting the West: The C. R. Smith Collection of Western American Art.* Austin, TX: University of Texas Press, 1988.

Savage, William. *The Cowboy Hero: His Image in American History and Culture.* Norman, OK: University of Oklahoma Press, 1979.

Shapiro, Michael Edwards, Elizabeth Johns, and others. *George Caleb Bingham.* New York: Harry N. Abrams, 1990.

Slotkin, Richard. *Regeneration Through Violence: The Mythology of the American Frontier, 1600-1860.* Middletown, CN: Wesleyan University Press, 1973.

_____. *The Fatal Environment: The Myth of the Frontier in the Age of Industrialization.* Middletown, CT: Wesleyan University Press, 1985.

Smith, Henry Nash. *The Virgin Land: The American West as Symbol and Myth.* New York: Vintage, 1950; reprint, Cambridge, MA: Harvard University Press, 1978.

Stein, Roger B. "Packaging the Great Plains: The Role of the Visual Arts." *Great Plains Quarterly* (Winter 1985): 5-23.

Stevens, Moreland L. *Charles Christian Nahl: Artist of the Gold Rush.* Sacramento, CA: E.B. Crocker Art Gallery, 1976.

Sweeney, J. Gray. *Themes in American Painting.* Grand Rapids, MI: Grand Rapids Art Museum, 1977.

Taft, Robert. *Artists and Illustrators of the Old West.* New York: Charles Scribner's Sons, 1953.

Taylor, Lonn, and Ingrid Maar. *The American Cowboy.* Washington, DC: American Folklife Center, Library of Congress, 1983.

Trenton, Patricia, and Peter H. Hassrick. *The Rocky Mountains: A Vision for Artists in the Nineteenth Century.* Norman, OK: University of Oklahoma Press, 1983.

Truttner, William H. *The Natural Man Observed.* Washington, DC: Smithsonian Institution Press, 1979.

Tuckerman, Henry T. *Book of the Artists.* 1867; reprint, New York: James F. Carr, 1967.

Tyler, Ron, Carol Clark, Linda Ayres, and others. *American Frontier Life: Early Western Paintings and Prints.* New York: Abbeville Press, 1987.

_____. *Visions of America: Pioneer Artists in a New Land.* New York: Thames and Hudson, 1983.

_____, ed. *Alfred Jacob Miller: Artist on the Oregon Trail.* Fort Worth: Amon Carter Museum, 1982.

Weston, Jack. *The Real American Cowboy.* New York: Schocken Books, 1985.

White, G. Edward. *The Eastern Establishment and the Western Experience.* New Haven, CT: Yale University Press, 1968.

Wilkin, Thurman. *Thomas Moran; Artist of the Mountains.* Norman, OK: University of Oklahoma Press, 1966.

INDEX OF ARTISTS AND ILLUSTRATIONS

▶▶

Santa Fe (detail)
THOMAS WORTHINGTON WHITTREDGE